Black Venus 2010

Black Venus 2010

They Called Her "Hottentot"

Edited by

DEBORAH WILLIS

With research assistance by
Carla Williams

TEMPLE UNIVERSITY PRESS
Philadelphia

TEMPLE UNIVERSITY PRESS
1601 North Broad Street
Philadelphia, Pennsylvania 19122
www.temple.edu/tempress

Chapter 11 copyright © 1998/2004 by Kellie Jones and the artists

Text design by Lynne Frost

Library of Congress Cataloging-in-Publication Data

Black Venus 2010 : they called her "Hottentot" / edited by Deborah Willis.
 p. cm.
 Includes bibliographical references and index.
 ISBN 978-1-4399-0204-2 (cloth : alk. paper)
 ISBN 978-1-4399-0205-9 (pbk. : alk. paper)
 1. Baartman, Sarah. 2. Arts, Modern. I. Willis, Deborah, 1948–

 NX652.B33B58 2010
 305.48'8961—dc22 2009036736

2 4 6 8 9 7 5 3 1

For S.B.

Contents

Acknowledgments *ix*

Prologue: The Venus Hottentot (1825) *1*
Elizabeth Alexander

Introduction: The Notion of Venus *3*
Deborah Willis

PART I
Sarah Baartman in Context

1 The Hottentot and the Prostitute: Toward an Iconography of
Female Sexuality *15*
Sander Gilman

2 Another Means of Understanding the Gaze: Sarah Bartmann in the
Development of Nineteenth-Century French National Identity *32*
Robin Mitchell

3 Which Bodies Matter? Feminism, Post-Structuralism, Race, and the
Curious Theoretical Odyssey of the "Hottentot Venus" *47*
Zine Magubane

4 Exhibit A: Private Life without a Narrative *62*
J. Yolande Daniels

5 crucifix *68*
Holly Bass

PART II
Sarah Baartman's Legacy in Art and Art History

6 Historic Retrievals: Confronting Visual Evidence and the Imaging of Truth *71*
Lisa Gail Collins

7 Reclaiming Venus: The Presence of Sarah Bartmann in Contemporary Art *87*
Debra S. Singer

8 Playing with Venus: Black Women Artists and the Venus Trope
in Contemporary Visual Art *96*
Kianga K. Ford

9 Talk of the Town *107*
Manthia Diawara

10 The "Hottentot Venus" in Canada: Modernism, Censorship, and the
 Racial Limits of Female Sexuality 112
 Charmaine Nelson

11 A.K.A. Saartjie: The "Hottentot Venus" in Context
 (Some Recollections and a Dialogue), 1998/2004 126
 Kellie Jones

12 little sarah 144
 Linda Susan Jackson

PART III

Sarah Baartman and Black Women
as Public Spectacle

13 The Greatest Show on Earth: For Saartjie Baartman, Joice Heth,
 Anarcha of Alabama, Truuginini, and Us All 147
 Nikky Finney

14 The Imperial Gaze: Venus Hottentot, Human Display, and World's Fairs 149
 Michele Wallace

15 Cinderella Tours Europe 155
 Cheryl Finley

16 Mirror Sisters: Aunt Jemima as the Antonym/Extension of Saartjie Bartmann 163
 Michael D. Harris

17 My Wife as Venus 180
 E. Ethelbert Miller

PART IV

Iconic Women in the Twentieth Century

18 agape 185
 Holly Bass

19 Black/Female/Bodies Carnivalized in Spectacle and Space 186
 Carole Boyce Davies

20 Sighting the "Real" Josephine Baker: Methods and Issues of Black Star Studies 199
 Terri Francis

21 The Hoodrat Theory 210
 William Jelani Cobb

 Epilogue: I've Come to Take You Home (Tribute to Sarah Bartmann
 Written in Holland, June 1998) 213
 Diana Ferrus

 Bibliography 215
 Contributors 223
 Index 229

A photo gallery follows page 182

Acknowledgments

J would like to express my sincere gratitude to Carla Williams for helping me to shape this project and for our years of collaborating, researching, and seeking out articles, essays, and artwork. I also thank all of the contributors who submitted their work for this project as well as friends, researchers, and writers whose work addresses the issues raised by the life of Sarah Baartman. Without their labors, this volume would not have been possible. Some of those who submitted their essays and art over the years have moved on to other projects, and I thank them for their patience and encouragement as this collection has moved forward to completion.

Permission given by all of the copyright holders, collections, institutions, and individuals who allowed their materials to be included is gratefully acknowledged. I also thank all of the artists who generously made their images available to me for reproduction. Finally, I extend my gratitude to my editor, Janet Francendese, to Emily Taber, and to Lynne Frost, Amrit Kaur Aneja, Patricia Snavely Vogel, Irene Cho, Sara Lynch, Stephanie Broad, Ellen Eisenman, E. Frances White, Sharon Howard, Francille Wilson, Henry Louis Gates Jr., Sharon Harley, Deirdre Visser, Leslie Willis Lowry, Lydie Diakhate, Kathe Sandler, Kalia Brooks, Derrick Biney Amissah, Zola Maseko, and Faith Childs.

Many of the essays in this collection were written before Sarah Baartman's remains were finally buried on Women's Day in South Africa, August 2, 2002, near the place of her birth, in the Gamtoos River Valley in the Eastern Cape, 187 years after she left for England. Like Sarah, this complex project has traveled a long journey in the years of its preparation, and I hope its many contributors will appreciate the transformation it has undergone along the way.

ELIZABETH ALEXANDER

Prologue

The Venus Hottentot (1825)

1. Cuvier

Science, science, science!
Everything is beautiful

blown up beneath my glass.
Colors dazzle insect wings.

A drop of water swirls
like marble. Ordinary

crumbs become stalactites
set in perfect angles

of geometry I'd thought
impossible. Few will

ever see what I see
through this microscope.

Cranial measurements
crowd my notebook pages,

and I am moving closer,
close to how these numbers

signify aspects of
national character.

Her genitalia
will float inside a labeled

pickling jar in the Musée
de l'Homme on a shelf

above Broca's brain:
"The Venus Hottentot."

Elegant facts await me.
Small things in this world are mine.

2.

There is unexpected sun today
in London, and the clouds that
most days sift into this cage
where I am working have dispersed.
I am a black cutout against
a captive blue sky, pivoting
nude so the paying audience
can view my naked buttocks.

I am called "Venus Hottentot."
I left Capetown with a promise
of revenues: half the profits
and my passage home. A boon!
Master's brother proposed the trip;
the magistrate granted my leave.
I would return to my family
a duchess, with watered silk

dresses and money to grow food,
rouge and powders in glass pots,
silver scissors, a lorgnette,
voile and tulle instead of flax,
cerulean blue instead
of indigo. My brother would
devour sugar-studded non-
pareils, pale taffy, damask plums.

That was years ago. London's
circuses are florid and filthy,
swarming with cabbage-smelling
citizens who stare and query,
"Is it muscle? bone? or fat?"
My neighbor to the left is
The Sapient Pig, "The Only
Scholar of His Race." He plays

at cards, tells time and fortunes
by scraping his hooves. Behind
me is Prince Kar-mi, who arches
like a rubber tree and stares back
at the crowd from under the crook
of his knee. A professional
animal trainer shouts my cues.
There are singing mice here.

"The Ball of Duchess DuBarry":
In the engraving I lurch
toward the *belles dames,* mad-eyed, and
they swoon. Men in capes and pince-nez
shield them. Tassels dance at my hips.
In this newspaper lithograph
my buttocks are shown swollen
and luminous as a planet.

Monsieur Cuvier investigates
between my legs, poking, prodding,
sure of his hypothesis.
I half expect him to pull silk
scarves from inside me, paper poppies,
then a rabbit! He complains
at my scent and does not think
I comprehend, but I speak

English. I speak Dutch. I speak
a little French as well, and
languages Monsieur Cuvier
will never know have names.
Now I am bitter and now
I am sick. I eat brown bread,
drink rancid broth. I miss good sun,
miss Mother's *sadza.* My stomach

is frequently queasy from mutton
chops, pale potatoes, blood sausage.
I was certain that this would be
better than farm life. I am
the family entrepreneur!
But there are hours in every day
to conjure my imaginary
daughters, in banana skirts

and ostrich-feather fans.
Since my own genitals are public
I have made other parts private.
In my silence I possess
mouth, larynx, brain, in a single
gesture. I rub my hair
with lanolin, and pose in profile
like a painted Nubian

archer, imagining gold leaf
woven through my hair, and diamonds.
Observe the wordless Odalisque.
I have not forgotten my Xhosa
clicks. My flexible tongue
and healthy mouth bewilder
this man with his rotting teeth.
If he were to let me rise up

from this table, I'd spirit
his knives and cut out his black heart,
seal it with science fluid inside
a bell jar, place it on a low
shelf in a white man's museum
so the whole world could see
it was shriveled and hard,
geometric, deformed, unnatural.

DEBORAH WILLIS

Introduction
The Notion of Venus

Bottoms were big in Georgian England. From low to high culture of all forms, Britain was a nation obsessed by buttocks, bums, arses, posteriors, derrieres, and every possible metaphor, joke, or pun that could be squeezed from this fundamental cultural obsession. From the front parlor to Parliament, to prostitution and pornography, Georgian England both exuberantly celebrated and earnestly deplored excess, grossness, and the uncontainable. Much of Saartjie's success was a result of a simple phenomenon: with her shimmying, voluptuous bottom, she perfectly captured the zeitgeist of later-Georgian Britain.
—Rachel Holmes, *African Queen*

This anthology of art, critical writings, poetry, and prose on and around the subject of Sarah, or Saartjie, Baartman, the so-called "Hottentot Venus," has been a long time coming. The contributions in this collection are scholarly and lyrical, historical and reflexive, capturing the spirit of a new body of literature about Baartman.

In 1991, I first read an article in the *Village Voice* titled "Venus Envy"[1] by Lisa Jones, and since then I have been intrigued with Baartman's life story. I began to create artwork about her and the notion of beauty in an effort to find a way to expose this story to a wider audience. This book began as a dialogue with artist and writer Carla Williams, my coauthor on *The Black Female Body in Photography: A Photographic History,* and with a number of friends and colleagues who were researching, writing, and making art about the body, all of whom had referenced Baartman in their work.

Although Baartman has become a focal point of reference for contemporary black artists, particularly women—from playwright Suzan-Lori Parks to novelist Barbara Chase-Riboud to photographer Carrie Mae Weems—few books have been written about her with regard to issues of representation.[2] Working closely for a number of years with Carla Williams, I initially became interested in organizing a collection about Baartman, her memory in our collective histories, and her symbolic history in the construction of black women as artists, performers, and icons.

Nearly two hundred years after her death and four years after her "homegoing" burial in South Africa, I have noticed a number of new books and films about Baartman. They include Zola Maseko's mesmerizing films *The Life and Times of Sara Baartman* and *The Return of Sara Baartman* and the riveting and informing books *African Queen: The Real Life of the Hottentot Venus* by Rachel Holmes and *Venus in the Dark: Blackness and Beauty in Popular Culture* by Janell Hobson.

Over the years I have been enriched by discussions in the classroom as Baartman's story continues to be written and as more and more writers and artists discover her and respond to her image. It is important to place Baartman in context within a discussion of images of women of African descent, particularly in Western culture. The inspiration behind this volume came from a wide variety of sources, some discovered while researching *The Black Female Body: A Photographic History* and others emerging more recently in images of the so-called video vixen in music videos. In 2002, at a reading and book signing for *The Black Female Body* at the Studio Museum in Harlem, performance artist and curator Rashida Bumbray, then a graduate student in my class at New York University, opened up the event with a presentation. For a class project, Bumbray had choreographed a performance to Jill Scott's 2001 poem/song "Thickness," in which Bumbray takes the "stage" (an overturned box) and slowly disrobes, "displaying" her full body à la Baartman as Scott sings/speaks about the sexual objectification and exploitation of a physically mature adolescent black girl. It was a provocative and powerful performance; Bumbray's courage in positioning herself as a physical spectacle challenged the contemporary viewer to imagine what it would be like to live in her skin, in her body, in a culture that persistently degrades her image.

Who was Sarah Baartman? The facts of her life have been distorted and mythologized, and misinformation abounds surrounding the details of Baartman's short life. To begin with, no one can really agree on the spelling of her name, though assuredly virtually none of the versions in use reflect her given name, which remains unknown. They include Ssehura (thought to be closest to her given name); Sartjee, Saartje, Saat-je, Saartji, Saat-Jee, and Saartjie (all derived from the Afrikaans pronunciation, diminutive forms of Sara); as well as the Anglicized Sara or Sarah. The Afrikaans diminutive ending "-tjie" is now generally regarded as patronizing,[3] thus Sarah is one of the most common spellings currently in use. Her surname, presumably given to her upon her baptism in Manchester, England, in 1811, has been represented as Baartman, Bartman, Baartmann, or Bartmann. Likewise, her captor/handler is represented variously as Hendrick, Henrik, or Hendrik Cesar, Caesar, or Cezar. Most of the contributors to this volume chose different spellings, and I felt it was more instructive to allow these variations, which in themselves speak to the way in which others have chosen to understand this woman and to interpret her life.

Born in South Africa in 1789, Baartman was brought to England and placed on exhibit in 1810. She was exhibited on stage and in a cage in London and Paris and performed at private parties for a little more than five years. The "Hottentot Venus" was "admired" by her protagonists, who depicted her as animal-like, exotic, different, and deviant. Rachel Holmes observes:

> Almost overnight, London was taken with Saartjie-mania. She instantly captured the public imagination. . . . There was an outpouring of "Sartjee"-themed popular poesy, ballads, broadsheet caricatures, articles, and printed satires. Her image proliferated, seemingly everywhere reproduced, on brightly colored posters pasted in shop windows, on penny prints held aloft by street sellers, the human tabloids who raised the cry of "Sartjee" and "Hottentot" throughout the metropolis.[4]

Sander Gilman describes the impact of Baartman on European society in this way:

> It is important to note that Sarah Baartman was exhibited not to show her genitalia but rather to present another anomaly which European audiences . . . found riveting. This was the steatopygia, or protruding buttocks, the other physical characteristic of the Hottentot female which captured the eye of European travelers. . . . The figure of Sarah Baartman was reduced to her sexual parts. The audience which had paid to see her buttocks and had fantasized about the uniqueness of her genitalia when she was alive could, after her death and dissection, examine both.[5]

Baartman's attribution as a Hottentot is widely agreed to be erroneous, and the term itself is contentious. According to contributor J. Yolande Daniels:

> The origin of the word "Hottentot" has been the source of debate. That the *Khoi-khoip* (*Khoi*: a person, *Khoip*: a man, *Khoi-khoip*: the men—a Hottentot) referred to themselves as "Hottentot," serves to illustrate how the European world view was superimposed onto the "natives" of Africa and their descendants. The language of the *Khoisan* peoples ("Hottentot" and "bushman"), consists of a range of phonetic clicking sounds. The *Khoisan* language was interpreted by the Dutch seamen of the Cape as stuttering and labeled with the Dutch slang then common.[6]

In Kimberly Wallace-Sanders's book *Skin Deep, Spirit Strong,* Anne Fausto-Sterling points out: "Some nineteenth-century words, especially *Hottentot, primitive,* and *savage,* contain meanings that we know today as deeply racist."[7] Usage of "Hottentot" throughout this volume should be understood in the same vein.

This book is arranged into four text sections with a Prologue, an Epilogue, and a separate section of illustrations. The Prologue, Elizabeth Alexander's 1990 poem "The Venus Hottentot," takes a provocative, postmodernist approach to the visualization of Baartman's dissection by introducing the scientist Georges Cuvier in the first stanza. In Baartman's voice, Alexander imagines her display in England, gives her agency, however flawed, and eventually offers the reader an imagined dialogue as the Venus talks back and takes back her identity. Referencing science and spectacle, Alexander's poem also sets the tone for the volume—a mixture of fact, fiction, pathos, and resistance.

The essays in Part I, Sarah Baartman in Context, introduce Baartman from both historical and contemporary frames of reference. Reprinted is Sander L. Gilman's groundbreaking and influential essay, "The Hottentot and the Prostitute: Toward an Iconography of Female Sexuality," from his 1985 book *Difference and Pathology: Stereotypes of Sexuality, Race, and Madness.* This essay is a revision of the often-cited "Black Bodies, White Bodies: Toward an Iconography of Female Sexuality in Late Nineteenth

Century Art, Medicine, and Literature," which appeared in the Henry Louis Gates Jr. volume *"Race," Writing, and Difference* (1986). Gilman's essay offers both a historical account and a contemporary analysis of the perception of sexuality and the black female in medicine and popular culture. Many of the contributors here reference this seminal work, so I am especially pleased to include the essay in this volume.

Historian Robin Mitchell's analysis, "Another Means of Understanding the Gaze: Sarah Bartmann in the Development of Nineteenth-Century French National Identity," provides the readers of this volume with the details of Baartman's life. This essay examines the role that Baartman played in the formation of French national identity in the early nineteenth century, going beyond a focus on Baartman's sexuality to discuss the economic and political climate in which she appeared.

Zine Magubane deconstructs the "biological essentialism" that she reads in much of the prevailing scholarship about Baartman through a discussion of the socioeconomic realities of nineteenth-century Europe. Like Mitchell, Magubane questions the basic premise of Gilman's essay, arguing that "'blackness' is less a stable, observable, empirical fact than an ideology that is historically determined and, thus, variable."[8]

Architect J. Yolande Daniels's "Exhibit A: Private Life without a Narrative" reenacts a case study that explores the physiological and psychological threshold of the space in which Baartman performed. Daniels discusses the female (biological) versus the feminine (cultural), physical versus psychological, white versus black. "What meaning could physical surroundings have had for one who was alienated from her physical body by voyeuristic audiences for up to eleven hours a day? When the first physical house, the body, is divorced from the mind, does a shed, or for that matter, city, register? What meaning could architecture have had in this life?" she asks.[9]

Holly Bass's engaging and seductive poem "crucifix" ends the section with a plaintive challenge of longing and desire: "look at me."

Part II, Sarah Baartman's Legacy in Art and Art History, focuses on contemporary art references and the art historical aspect of Baartman's legacy. Many people have asked one of the most obvious questions surrounding the interest in Baartman—why her? She was neither the first nor the only African woman on display in Europe. Numerous writers have noted that at least one other African woman was exhibited as a "Hottentot Venus" after Baartman's death, and as Debra Singer points out, "many other unidentified women from Africa with similar physiques were photographed naked into the 1880s.[10] (See Figure 7.) We have only to look at contemporary culture to see the way in which Sarah Baartman's image continues to be recycled as fashion in the works of some contemporary photographers. Baartman was the most *imaged* of these African women, and it is this plethora of visual representation that makes her so significant, so enduring. What she represented visually—even exaggerated and distorted—had a much greater audience and extended life and impact than her physical self ever could have. In England, her likeness illustrated the five of clubs in a deck of playing cards. (See Figure 2.) In France, Baartman posed for artists J.-B. Berré, Léon de Wailly, and Nicolas Huet le Jeune, whom Georges Cuvier had commissioned to make anatomical studies of her.[11]

The essays in Part II analyze contemporaneous and contemporary works that have imagined Baartman in different ways. Despite their common point of departure, the works demonstrate the multiple possibilities in recuperating Baartman's story as they traverse the crossroads of sexuality and specularity, past and present, production and reception of visual representations. Several emphasize concerns relating to ideals of feminine beauty and racialized notions of the erotic. Others make explicit connections between Baartman and Africa, pointing out how "looking at" may be perceived as a form of "possessing" and foregrounding issues of control over the display of the body.

Lisa Gail Collins's "Historic Retrievals: Confronting Visual Evidence and the Imaging of Truth" compares the visual evidence made of Baartman during her year in France with daguerreotypes made as visual evidence for Louis Agassiz in 1850. Collins concludes with a discussion of the works of Renée Green, Carla Williams, Carrie Mae Weems, and Lorna Simpson, contemporary African American women artists who confront and create images about Baartman and their own bodies. Debra S. Singer focuses on African American visual artists Green, Simpson, Weems, Renée Cox (with Lyle Ashton Harris), and Deborah Willis, as well as performance artist Joyce Scott. Using a wide spectrum of media, the artists Singer explores use Baartman's history and likeness to investigate the ways in which her story is theirs, is ours.

Kianga K. Ford examines the works of Kara Walker in "Playing with Venus: Black Women Artists and the Venus Trope in Contemporary Imaging." Manthia Diawara's "Talk of the Town" takes a historically grounding look at women's portraits in the work of the late African studio photographer Seydou Keïta.

In "The 'Hottentot Venus' in Canada: Modernism, Censorship, and the Racial Limits of Female Sexuality," Charmaine Nelson expands the discussion north to Canada, an often overlooked site of cultural production and representation. Calling for a postcolonial intervention in art history, Nelson examines the exclusivity of the definition of Modernism in art historical practice. Looking at art historian T. J. Clark's analysis of Manet's *Olympia* (1863) and the censorship of three female nudes at the International Exhibition of Modern Art in Toronto in 1927, Nelson asserts, "We need to ask what art historical discourse, especially its Modernist permutations, makes possible and what it suppresses as well as through what logic and apparatus its borders are policed."[12]

In the late 1980s, art historian Kellie Jones explored the possibilities of organizing an exhibition using the art of contemporary artists as a starting point to address the life, work, and afterlife of Baartman. Working in the format of exhibitions and installations featuring the works of contemporary artists, Jones explored the notion of female agency and how women claim and control their bodies and sexuality. Jones's essay "A.K.A. Saartjie: The 'Hottentot Venus' in Context (Some Recollections and a Dialogue), 1998/2004" is a collaborative one, including the voices of South African artists Bongi Dhlomo-Mautloa, Penny Siopis, Veliswa Gwintsa, Berni Searle, Marlaine Tosoni, and Tracey Rose, who responded in a transatlantic roundtable to a series of questions designed by Jones regarding their experiences in making art about Baartman and working on themes relating to sexuality.

To end the section, Linda Susan Jackson's poem, "little sarah," takes us on a biographical journey with Baartman from her homeland and back.

Nikky Finney's poem "The Greatest Show on Earth . . ." introduces Part III, Sarah Baartman and Black Women as Public Spectacle, forging a connection between Baartman and other black women in various forms of public display. Ranging from the carnival sideshow to *National Geographic* exhibitions, Finney's poem segues neatly into "The Imperial Gaze: Venus Hottentot, Human Display, and World's Fairs," Michele Wallace's discussion of human display in the context of international world fairs and expositions. Wallace reminds us of the prevailing role hegemony plays in the construction of the gaze.

Cheryl Finley discusses photographer Joy Gregory's work in "Cinderella Tours Europe." Using a pair of gold pumps, Gregory takes the body of the Caribbean woman on the Grand Tour of Europe. Focusing on a different kind of platform, Michael D. Harris's "Mirror Sisters: Aunt Jemima as the Antonym/Extension of Saartjie Bartmann" challenges the reader to consider the role of black servants and their relationships to their white "masters," in particular the mammy, embodied in the fictionalized persona of Aunt Jemima, who was viewed as the exemplar mammy in American culture and carried with her a message, a valuation, about the nature and characteristics of black women. Harris argues: "Like Baartman, she entered public life as a spectacle, a popular curiosity, and she served as a text for the delivery of certain sexual politics and definitions."[13]

Part III concludes with E. Ethelbert Miller's "My Wife as Venus," a thoughtful meditation on his wife's body—his relationship to it, and hers.

Part IV, Iconic Women in the Twentieth Century, includes essays that examine the lives of women who were and who remain icons today. Holly Bass's poem "agape" evidences a charged, complex sexual dynamic not unlike that in *Venus,* Suzan-Lori Parks's 1990 play, which introduced a contemporary audience to Baartman's experience through a spellbinding and controversial performance at the Public Theater in New York City, or in the work of Kara Walker, discussed earlier in Kianga Ford's essay.

Carole Boyce Davies's study of carnival and the carnivalized body, "Black/Female/Bodies Carnivalized in Spectacle and Space," offers a provocative characterization of the black female body as spectacle and performance art. She explores the difficulty of locating one's self as a woman, feminist, and intellectual yet willing carnival participant in the space of the spectacle.

In her essay "Sighting the 'Real' Josephine Baker: Methods and Issues of Black Star Studies," Terri Francis imagines Josephine Baker's agency in the public arena on stage and film. She writes, "one of my clearest agendas has been to distinguish and understand the issue of Baker's authorship—which goes to agency. Since most accounts of women (particularly black women) in film convincingly describe their being controlled in many ways by the apparatus of the film industry, the gaze, and the pleasures of the spectator, a feminist ethic asks: What role did Baker play in the choreography of her dancing? How did she contribute to her films other than through acting? These are some of the questions that address Baker's agency through textual specificity."[14]

In "The Hoodrat Theory," William Jelani Cobb, a professor at Spelman College in Atlanta, recounts his students' response to a 2004 music video by rapper Nelly for the song "Tip Drill" (slang for "an ugly woman with a big butt," not unlike the way Baart-

man was regarded by European men), in which Nelly swiped a credit card between the buttocks cheeks of a black woman portrayed by Atlanta performer White Chocolate.[15] Nelly rebuffed the students' request for dialogue, during a proposed campus visit, about the pervasive hypersexualized depiction of black women. Cobb reflects on these portrayals and on his role as an educator at a historically black women university.

The Epilogue is the perfect final chapter for this project. It is a poem by a woman of Khoisan descent, Diana Ferrus. Her words helped to convince the French government to return Sarah Baartman's remains to South Africa. Ferrus wrote "A Poem for Sarah Baartman" while she was a student in Utrecht, Netherlands, in 1998. She states, "One evening I was looking at the stars and I thought to myself, 'They're so far away. But if I were home, I'd be able to touch every one of them.' My heart just went out to Sarah, and I thought, 'Oh, god, she died of heartbreak, she longed for her country. What did she feel?' That's why the first line of the poem was 'I've come to take you home.'"[16]

Although initially conceived as integral parts of each section, the visual work is, of practical necessity, in a separate section of reproductions. Roshini Kempadoo's *Banking on the Image* series includes photographs she made over a period of ten years merged with images housed in public repositories. She re-examines and re-interprets images found in these collections and constructs tableaux referring to ways in which black women survived under oppression. "I work from archived images I would describe as stereotyped 'exotic,' provocative, sexually charged, titillating images 'existing to serve the ends of white male desires,'"[17] Kempadoo writes, "to render them into specific and different contexts. The photographic archive becomes a visual presentation of a matrix of experiences in which the white bourgeoisie male is at the centre, the norm, unexplained, whilst the identities of those seen as the Other are constantly interrogated, investigated and monitored."[18]

Using iconic images that circulated in the 1800s, Hank Willis Thomas conjures a moment in time for two renowned and revered women—Harriet Tubman and Sarah Baartman. His work acknowledges their presence in visual history, their clothed and unclothed bodies, as well as their significance today. Two of the most imaged women in the nineteenth century, these iconic figures are portrayed as markers for women who made history in different ways.

Photographs by Petrushka A. Bazin and Radcliffe Roye provide striking visual demonstrations of the sense of "freedom, movement, and resistance" of women taking space in the public arena that Carole Boyce Davies describes in her Part IV essay. Bazin's images of Jamaican dancehalls illustrate the complexity of representing women's bodies and how they choose to display themselves in public spaces. The young women in Roye's photograph demonstrate the power of posture and movement in expressing attitudes and states of engagement.

Finally, in a dramatically different portrayal of the woman's body, Simone Leigh's *Venus* series vessels were:

> conceived of as a way of memorializing [Baartman's] tragic life. . . . Venus is icon, fetish, me, reincarnated as African pot. It is also an exploration of the meaning of my own life and my own personal humiliations. I . . . explore what is the

"essential" pot, body, container, spiritual vessel; and also how that container—pot/body describes identity. . . . I am playing with the idea of the fertility goddess; the multiple breast form is taken directly from East Indian art. I am also exploring certain taboos: mixing up the sacred and the profane places that both the African-American woman and the "African pot" occupy in Western culture. I am approaching pain and humiliation in a typically African-American way: by transforming scars into something more beautiful. Each piece in this series involves going from hatred to scar to adornment.[19]

What of Baartman in the interim period between her institutionalization at the Musée de l'Homme in Paris in the early nineteenth century and her repatriation to South Africa in the early twenty-first? Reports vary as to exactly how long her physical remains were on public display, but, it was not until the late twentieth century that her remains were removed to storage before their return to her homeland. British historian Tony Kushner writes of finding her image in a reissued George Cruickshank print, *The Court at Brighton a la Chinese!,* for sale in the summer of 1996 at the Brighton Pavilion commercial heritage shop.[20] As historian Robin Mitchell discovered in late 2004, only Baartman's physical remains returned to South Africa; the plaster cast and all documentation remain at the Musée, and Mitchell was floored to find herself alone with "her" for a few minutes to quietly hold her hand. Indeed, I recall the moment I viewed the plaster cast and how it silenced me into a state of sorrow, as I remembered my early quest to find meaning about her life.

As many articles and as much information as I have collected about Baartman over the years, I know there is still much more work to be done. This unique project is but one of many. However, I believe that the collective voices and vision of the contributors in this volume offer another legacy of Baartman's display—a legacy that is personal and universal. *Black Venus 2010: They Called Her "Hottentot"* represents the most compelling writing and visual response to Baartman that I have witnessed today. It also represents the variety of responses to her by poets, historians, architects, ceramists, photographers, installation artists, and writers over the years. Some are scholarly, some are highly personal, a few are slightly humorous, yet each one grapples with the enduring legacy of how beauty is marked in difference.

Epigraph: Rachel Holmes, *African Queen: The Real Life of the Hottentot Venus* (New York: Random House, 2007), 43.

1. Lisa Jones, "Venus Envy," *The Village Voice,* vol. 36/28 (9 July 1991), 36.
2. T. Denean Sharpley-Whiting's *Black Venus: Sexualized Savages, Primal Fears, and Primitive Narratives in French* (Durham, NC: Duke University Press, 1999) was the first volume devoted primarily to a study of Baartman, but its focus was on literature, with one chapter devoted to Josephine Baker.
3. "Sarah Baartman, At Rest at Last," http://www.southafrica.info/about/history/saartjie.htm.
4. Holmes, 42.
5. Sander L. Gilman, "Black Bodies, White Bodies: Toward an Iconography of Female Sexuality in Late Nineteenth-Century Art, Medicine, and Literature" in Henry Louis Gates Jr. and Kwame Anthony Appiah, eds., *"Race," Writing, and Difference* (Chicago: University of Chicago Press, 1985), 223.

6. J. Yolande Daniels, "Black Bodies, Black Space: A-Waiting Spectacle" in Lesley Naa Norle Lokko, ed., *White Papers, Black Marks: Architecture, Race, Culture* (Minneapolis: University of Minnesota Press, 2000), 370. Daniels continues: "See *The Word 'Hottentot'*, State Library, Pretoria, 1971, for articles from the debates of the Philosophical Society of London (1866)."

7. Anne Fausto-Sterling, "Gender, Race, and Nation: The Comparative Anatomy of 'Hottentot' Women in Europe, 1815–17" in Kimberly Wallace-Sanders, ed., *Skin Deep, Spirit Strong: The Black Female Body in American Culture* (Ann Arbor: University of Michigan, 2002), 66.

8. Zine Magubane, this volume, 47.

9. J. Yolande Daniels, this volume, 62.

10. Deborah Willis, "Introduction: Picturing Us," in *Picturing Us: African American Identity in Photography*, ed. Deborah Willis (New York: The New Press, 1994), 19.

11. Z. S. Strother, "Display of the Body Hottentot," in *Africans on Stage: Studies in Ethnological Show Business*, ed. Berth Lindfors (Bloomington: University of Indiana Press, 1999), 25–34, including a reproduction of an engraving by Louis-Jean Allais after the painting by Berré.

12. Charmaine Nelson, this volume, 112.

13. Michael D. Harris, this volume, 163.

14. Terri Francis, this volume, 199.

15. dream hampton, "She's Got Game," *Suede* 1:1 (Fall 2004), 223.

16. "Sarah Baartman, At Rest at Last."

17. Quoted in bell hooks, *Black Looks: Race and Representation* (Boston: South End Press, 1992), 25.

18. Unpublished artist's statement, December 1998.

19. Unpublished artist's statement, 1998.

20. As Kushner notes, hers was the only likeness of a non-white person for sale in the shop. Tony Kushner, "Selling Racism: History, Heritage, Gender and the (Re)production of Prejudice," *Patterns of Prejudice* 33:4 (1999), 70–71.

PART I

Sarah Baartman in Context

SANDER GILMAN

1 The Hottentot and the Prostitute

Toward an Iconography of Female Sexuality

Looking at *Olympia* and *Nana*

One of the classic works of nineteenth-century art records the ideas of both the sexualized woman and the black woman. Edouard Manet's *Olympia,* painted in 1862–1863, first shown in the salon of 1865, documents the merger of these two images. (See Figure 3.) The conventional wisdom concerning Manet's painting states that the model, Victorine Meurend, is "obviously naked rather than conventionally nude,"[1] and that her pose is heavily indebted to such classical models as Titian's 1538 *Venus of Urbino,* Goya's 1800 *Naked Maja,* and Delacroix's 1847 *Odalisque,* as well as to other works by Manet's contemporaries, such as Gustave Courbet.[2] George Needham has shown quite convincingly that Manet was also using a convention of early erotic photography in having the central figure directly confront the observer.[3] The black female attendant, posed by a black model called Laura, has been seen as both a reflex of the classic black servant figure present in the visual arts of the eighteenth century and a representation of Baudelaire's "Vénus noire."[4] Let us juxtapose the *Olympia,* with all its aesthetic and artistic analogies and parallels, to a work by Manet which Georges Bataille, among others, has seen as modern "genre scene," the *Nana* of 1877.[5] Although Nana is unlike Olympia in being modern, a creature of present-day Paris (according to a contemporary),[6] she is like Olympia in having been perceived as a sexualized female and is so represented. Yet the move from a work with an evident aesthetic provenance, as understood by Manet's contemporaries, to one that was influenced by the former and yet was seen by its contemporaries as "modern," is attended by major shifts in the iconography of the sexualized woman, not the least of which is the seeming disappearance of the black female.

Black Sexuality and Its Iconography

The figure of the black servant is ubiquitous in European art of the eighteenth and nineteenth centuries. Richard Strauss knew this when he had Hugo von Hofmannsthal conclude their conscious evocation of the eighteenth century, *Der Rosenkavalier* (1911), with the mute return of the little black servant to reclaim the Marschalin's forgotten gloves.[7] But Hofmannsthal was also aware that one of the central functions of the black servant in the visual arts of the eighteenth and nineteenth centuries was as a maker of the sexualization of the society in which he or she was found. For the forgotten gloves mark the end of the opera but also the end of the relationship between Octavian, the

Knight of the Rose, and the Marschalin, an illicit sexual relationship that had opened the opera, just as the figure of the black servant closed it. When one turns to the narrative art of the eighteenth century, for example to William Hogarth's two great cycles, *A Rake's Progress* (1733–1734) and *A Harlot's Progress* (1731), it is not surprising that, as in the Strauss opera some two centuries later, the figures of the black servants mark the presence of illicit sexual activity. And, in Hofmannsthal's libretto, the servants and the central figure are of opposite sex. In the second plate of *A Harlot's Progress,* we are shown Moll Hackabout as the mistress to a Jewish merchant, the first stage of her decline. Present is a young black male servant. In the third stage of Tom Rakewell's collapse, we find him in the notorious brothel, the Rose Tavern in Covent Garden.[8] The entire picture is full of references to illicit sexual activity, all portrayed negatively. Present is a young black female servant.

The association of the black with concupiscence reaches back into the Middle Ages. The twelfth-century Jewish traveler Benjamin of Tudela wrote that "at Seba on the river Pishon . . . is a people . . . who like animals, eat of the herbs that grow on the banks of the Nile and in the fields. They go about naked and have not the intelligence of ordinary men. They cohabit with their sisters and anyone they can find. . . . And these are the Black slaves, the sons of Ham."[9] The black, both male and female, becomes by the eighteenth century an icon for deviant sexuality in general, almost always, however, paired with a white figure of the opposite sex. By the nineteenth century, as in the *Olympia,* or more crudely in one of a series of Viennese erotic prints by Franz von Bayros entitled *The Servant,* the central white female figure is associated with a black female in such a way as to imply a similarity between the sexuality of the two. In a contrastive image, Dante Gabriel Rossetti's *The Beloved, or The Bride* (1865) associates the unselfconscious innocence of the half-dressed young black serving girl with the sensuality of the "beloved." The association of figures of the same sex stresses the special status of female sexuality. In *The Servant* the hypersexuality of the black child signals the hidden sexuality of the white woman, a sexuality quite manifest in the other plates in the series. The relationship between the sexuality of the black woman and that of the sexualized white woman enters a new dimension when the scientific discourse concerning the nature of black female sexuality is examined.

Buffon, the French naturalist, credited the black with a lascivious, apelike sexual appetite, introducing a commonplace of early travel literature into a pseudoscientific context.[10] He stated that this animal-like sexual appetite went so far as to encourage black women to copulate with apes. The black female thus comes to serve as an icon for black sexuality in general. Buffon's view was based on a confusion of two applications of the "great chain of being" to the nature of the black. In this view, the black's position on the scale of humanity was antithetical to the white's. Such a scale was employed to indicate the innate difference between the races. This polygenetic view was applied to all human characteristics, including sexuality and beauty. The antithesis of European sexual mores and beauty is the black, and the essential black, the lowest exemplum of mankind on the great chain of being, is the Hottentot. It is indeed in the physical appearance of the Hottentot that the central icon for sexual difference between the European and the black was found, a deep physiological difference urged so plausibly on the basis of physical contrast that it gave pause even to early monogenetic theoreticians such a Johann Friedrich Blumenbach.[11]

The labeling of the black female as more primitive, and therefore more sexually intensive, by writers such as Abbé Raynal (1775) would have been dismissed as unscientific by the radical empiricists of late eighteenth- and early nineteenth-century Europe.[12] They would not have accepted generalizations but would have demanded the examination of specific, detailed case studies to evolve a "scientific" paradigm. They required a case study that placed both the sexuality and the beauty of the black in a position antithetical to those of the white. The paradigm had to be rooted in some type of unique and observable physical difference. Such a criterion was found in the distinction drawn between the pathological model and the healthy medical model. The absorption into that model of polygenetic difference between the races bears out William Bynum's observation that nineteenth-century biology constantly needed to deal with the polygenetic argument.[13]

The writer in whose work this alteration of the mode of discourse, though not the underlying ideology concerning the black female, took place was J. J. Virey. He was the author of the standard study of race published in the early nineteenth century, *Histoire naturelle du genre humain*. He also contributed a major essay (the only one on a specific racial group) to the widely cited *Dictionary of Medical Sciences* (1819).[14] In this essay Virey summarized his and many of his contemporaries' views on the sexual nature of black females in terms of accepted medical discourse. Their "voluptuousness" is "developed to a degree of lascivity unknown in our climate, for their sexual organs are much more developed than those of whites." Virey elsewhere cites the Hottentot woman as the epitome of this sexual lasciviousness and stresses the consonance between her physiology and her physiognomy (her "hideous form" and her "horribly flattened nose"). His central proof is a discussion of the unique structure of the Hottentot female's sexual parts, the description of which he takes from the anatomical studies of his contemporary Georges Cuvier. (See Figure 5.)[15]

The black female looks different. Her physiognomy, her skin color, the form of her genitalia mark her as inherently different. The nineteenth century perceived the black female as possessing not only a "primitive" sexual appetite, but also the external signs of this temperament, "primitive" genitalia. Eighteenth-century travelers to southern Africa, such as François Levaillant and John Barrow, have described the so-called "Hottentot apron," a hypertrophy of the labia and nymphae caused by manipulation of the genitalia and considered beautiful by the Hottentots and Bushmen as well as tribes in Basutoland and Dahomey.[16] In 1815 Saartje Baartman, also called Sarah Bartmann, or Saat-Jee, a twenty-five-year-old Hottentot female who had been exhibited in Europe for over five years as the "Hottentot Venus," died in Paris. (See Figure 1.) An autopsy that was performed on her was first written up by Henri Ducrotay de Blainville in 1816 and then, in its most famous version, by Georges Cuvier in 1817.[17] Reprinted at least twice during the next decade, Cuvier's description reflected de Blainville's two intentions: the likening of a female of the "lowest" human species with the highest ape, the orangutan, and the description of the anomalies of the Hottentot's "organ of generation."

Sarah Bartmann has been exhibited not to show her genitalia, but rather to present to the European audience a different anomaly, one that they (and pathologists such as de Blainville and Cuvier) found riveting: her steatopygia, or protruding buttocks, a physical characteristic of Hottentot female which has captured the eye of early travelers. (See Figure 6.) For most Europeans who viewed her, Sarah Bartmann existed only as a

collection of sexual parts. Her exhibition during 1810 in a London inflamed by the issue of abolition caused a public scandal, since she was exhibited "to the public in a manner offensive to decency. She . . . does exhibit all the shape and frame of her body as if naked."[18] The state's objection was as much to her lewdness as to her status as an indentured black. In France her presentation was similar. In 1829 a nude Hottentot woman, also called "the Hottentot Venus," was the prize attraction at a ball given by the Duchess du Barry in Paris. A contemporary print emphasized her physical difference from the observers portrayed.

The audience that had paid to see Sarah Bartmann's buttocks and fantasized about her genitalia could, after her death and dissection, examine both, for Cuvier presented "the Academy the genital organs of this woman prepared in a way so as to allow one to see the nature of the labia."[19] And indeed Sarah Bartmann's sexual parts serve as the central image for the black female throughout the nineteenth century, and the model of de Blainville's and Cuvier's descriptions, which center on the detailed presentation of the sexual parts of the black, dominates medical description of the black during the nineteenth century. To an extent, this reflects the general nineteenth-century understanding of female sexuality as pathological. The female genitalia were of interest in examining the various pathologies that could befall them, but they were also of interest because they came to define the sum of the female for the nineteenth century. When a specimen was to be preserved for an anatomical museum, more often than not the specimen was seen as a pathological summary of the individual. Thus, the skeleton of a giant or a dwarf represented "giantism" or "dwarfism," the head of a criminal, the act of execution which labeled him as "criminal."[20] Sarah Bartmann's genitalia and buttocks summarized her essence for the nineteenth-century observers, since they are still on display at the Musée de l'Homme in Paris. [*Editor's note:* This essay was originally published in 1985 and is reprinted in its original form. The preceding statement is no longer true.] Thus nineteenth-century autopsies of Hottentot and Bushman females focus on the sexual parts. The tone set by de Blainville in 1816 and Cuvier in 1817 was followed by A. W. Otto in 1824, Johannes Müller in 1834, W. H. Flower and James Murie in 1867, and Luschka, Koch, and Görtz in 1869.[21] Flower, the editor of the *Journal of Anatomy and Physiology,* included his and Murie's "Account of the Dissection of a Bushwoman" in the opening volume of that famed journal. His ideological intent was clear. He wished to provide data "relating to the unity or plurality of mankind." His description begins with a detailed presentation of the form and size of the buttocks and concludes with his portrayal of the "remarkable development of the labia minoria, or nymphae, which is so general a characteristic of the Hottentot and Bushman race." These were "sufficiently well-marked to distinguish these parts at once from those of any of the ordinary varieties of the human species." The polygenetic argument is the ideological basis for all the dissections of these women. If their sexual parts could be shown to be inherently different, this would be a sufficient sign that blacks were a separate (and needless to say, lower) race, as different from the European as the proverbial orangutan. Similar arguments were made about the nature of all blacks' (not just Hottentots') genitalia, but almost always concerning the female. Edward Turnipseed of South Carolina argued in 1868 that the hymen in black women "is not at the entrance to the vagina, as in the white woman, but from one-and-a-half to two inches from its entrance in the interior." From this he concluded that "this may be one of the anatomical marks of the non-unity of the races."[22] His views were seconded

in 1877 by C. H. Fort, who presented another six cases of this seeming anomaly.[23] When one turns to autopsies of black males from approximately the same period, what is striking is the absence of any discussion of the male genitalia. For example, in Sir William Turner's three dissections of male blacks in 1878, 1879, and 1896, no mention is made of the genitalia.[24] The genitalia and buttocks of the black female attracted much greater interest in part because they were seen as evidence of an anomalous sexuality not only in black women but in all women.

By mid-century the image of the genitalia of the Hottentot had acquired various important implications. The central view was that these anomalies were inherent, biological variations rather than adaptations. In Theodor Billroth's standard handbook of gynecology, the "Hottentot apron" is presented in detail in the discussion of errors in development of the female genitalia, an association that was commonplace by 1877. The author, H. Hildebrandt, links this malformation with the overdevelopment of the clitoris, which he sees as leading to those "excesses" which "are called 'lesbian love.'" The concupiscence of the black is thus associated with the sexuality of the lesbian.[25] More so, the deformation of the labia in the Hottentot is accounted a congenital error, and thus incorporated into the disease model. For the model of degeneracy presumes some acquired pathology in one generation which is the direct cause of the stigmata of degeneracy in the next. Surely the best example of this is the idea of congenital syphilis, widely accepted in the nineteenth century and vividly expressed in Ibsen's drama of biological decay, *Ghosts*. Thus the congenital error Hildebrandt sees in the "Hottentot apron" is presupposed to have some direct and explicable etiology, as well as a specific manifestation. While Hildebrandt is silent as to the etiology, his presentation clearly links the Hottentot's genitalia with the ill, the bestial, and the freak (medicine, biology, and pathology).

How is it that both the genitalia, a primary sexual characteristic, and the buttocks, a secondary sexual characteristic, function as the semantic signs of "primitive" sexual appetite and activity? A good point of departure for addressing this question is the fourth volume of Havelock Ellis's *Studies in the Psychology of Sex* (1905), which contains a detailed example of the great chain of being as applied to the perception of the sexualized Other.[26] Ellis believed that there is an absolute, totally objective scale of beauty which ranges from the European to the black. Thus men of the lower races, according to Ellis, admire European women more than their own, and woman of lower races attempt to whiten themselves with face powder. Ellis lists the secondary sexual characteristics that comprise this ideal of beauty, rejecting "naked sexual organ[s]" as not "aesthetically beautiful" since it is "fundamentally necessary" that they "retain their primitive characteristics." Only people "in a low state of culture" perceive the "naked sexual organs as objects of attraction." The secondary sexual characteristics that Ellis then lists as properly attracting admiration among cultured (i.e., not primitive) peoples, the vocabulary of aesthetically pleasing signs, begins with the buttocks. The nineteenth-century fascination with the buttocks as a displacement for the genitalia is thus reworked by Ellis into a higher regard for the beautiful. His discussion of the buttocks ranks the races by size of the female pelvis, a view that began with Willem Vrolik's 1826 claim that a wide pelvis is a sign of racial superiority and was echoed by R. Verneau's 1875 study of the form of the pelvis among the various races.[27] Verneau cited the narrow pelvis of Sarah Bartmann in arguing that the Hottentot's anatomical structure was primitive. While Ellis accepts this ranking, he sees the steatopygia as "a simulation of the

large pelvis of the higher races," having a compensatory function like that of face powder. This view places the pelvis in an intermediary role, as both a secondary and a primary sexual sign. Darwin himself, who held similar views as to the objective nature of human beauty, saw the pelvis as a "primary rather than as a secondary character" and the buttocks of the Hottentot as a somewhat comic sign of the black female's primitive, grotesque nature.[28]

When the nineteenth century saw the black female, it saw her in terms of her buttocks, and saw represented by the buttocks all the anomalies of her genitalia. In a mid-century erotic caricature of the Hottentot Venus, she is observed through a telescope by a white male observer, who can see nothing but her buttocks.[29] Again, in an 1899 British pornographic novel set in a mythic antebellum southern United States, the male author indulges his flagellistic fantasy on the buttocks of a number of white women. When he describes the one black, a runaway slave, being whipped, the power of the image of the Hottentot's buttocks captures him: "She would have had a good figure, only that her bottom was out of all proportion. It was too big, but nevertheless it was fairly well shaped, with well-rounded cheeks meeting each other closely, her thighs were large, and she had a study pair of legs, her skin was smooth and of a clear yellow tint."[30] The presence of exaggerated buttocks points to other, hidden sexual traits, both physical and temperamental, of the black female. This association is a powerful one. Indeed, Freud, in his *Three Essays on Sexuality* (1905), echoes the view that female genitalia are more primitive than those of the male.[31] Female sexuality is tied to the image of the buttocks, and the quintessential buttocks are those of the Hottentot.

The influence of this vocabulary on nineteenth-century perception of the sexualized woman can be seen in Edwin Long's 1882 painting, *The Babylonian Marriage Market*. This painting claimed a higher price than any other contemporary work of art sold in nineteenth-century London. It also has a special place in documenting the perception of the sexualized female in terms of the great chain of aesthetic beauty presented by Ellis. For Long's painting is based on a specific text from Herodotus, who described the marriage auction in Babylon in which maidens were sold in order of comeliness. In the painting they are arranged in order of their attractiveness according to Victorian aesthetics. Their physiognomies are clearly portrayed. Their features run from the most European and white (a fact emphasized by the light reflected from the mirror onto the figure at the far left) to the Negroid features (thick lips, broad nose, dark but not black skin) of the figure farthest to the observer's right. The latter figure possesses all of the physical qualities Virey attributes to the black. This is, however, the Victorian scale of acceptable sexualized women within marriage, portrayed from the most to the least attractive, according to contemporary British standards. The only black female present is the servant-slave shown on the auction block, positioned so as to present her buttocks to the viewer. While there are black males in the audience and thus among the bidders, the function of the only black female is to signify the sexual availability of the sexualized white women. Her position is her sign, and her presence in the painting is thus analogous to that of the black servant, Laura, in Manet's *Olympia*. In Hogarth, the black servants signify the perversities of human sexuality in a corrupt society; in Long's work of the late nineteenth century, on the other hand, the linkage between two female figures, one black and one white, represents the internalization of this perversity in one specific aspect of human society, the sexualized female.

The Iconography of Prostitution

The prostitute is the essential sexualized female in the perception of the nineteenth century. She is perceived as the embodiment of sexuality and of all that is associated with sexuality, disease as well as passion.[32] Within the large and detailed literature concerning prostitution written during the nineteenth century, most of which is devoted to documenting the need for legal controls and draws on the medical model as perceived by public health officials, there is a detailed analysis of the physiognomy and physiology of the prostitute. We can begin with the most widely read early nineteenth-century work on prostitution, the 1836 anthropological study of prostitution in Paris by A.J.B. Parent-Duchatelet.[33] Alain Corbin has shown how Parent-Duchatelet's use of the public health model reduces the prostitute to a source of pollution in much the same class as the sewers of Paris. Parent-Duchatelet believes himself to be providing objective description as he presents his readers with a statistical profile of the physical types of the prostitutes, the nature of their voices, the color of their hair and eyes, their physical anomalies, their characteristics in childbearing, and their sexually transmitted diseases. His descriptions range from the detached to the anecdotal. A discussion of the "embonpoint" of prostitutes begins the litany of their external signs. Prostitutes have a "peculiar plumpness" owing to "the great number of hot baths that the major part of these women take." Or perhaps to their lassitude, rising at ten or eleven in the morning, "leading an animal life." They are fat as prisoners are fat, from simple confinement. As an English commentator noted, "the grossest and stoutest of these women are to be found amongst the lowest and most disgusting classes of prostitutes."[34] These are the Hottentots on the scale of the sexualized female.

When Parent-Duchatelet turned to the sexual parts of the prostitutes, he provided two sets of information that merged to become part of the myth of the physical anthropology of the prostitute. The prostitute's sexual parts are in no way directly affected by their profession. He contradicts the "general opinion . . . that the genital parts in prostitutes must alter, and assume a particular disposition, as the inevitable consequence of their avocation" (42). He cites on case of a woman of fifty-one "who had prostituted herself thirty-six years, but in whom, notwithstanding, the genital parts might have been mistaken for those of a virgin just arrived at puberty" (43). Parent-Duchatelet thus rejected any Lamarckian adaptation, as well as any indication that the prostitute is physically marked as a prostitute. This follows from his view that prostitution is an illness of a society rather than that of an individual or group of individuals. But while he denies that prostitution per se alters the genitalia, he does observe that prostitutes are subject to specific pathologies of their genitalia. They are especially prone to tumors "of the great labia . . . which commence with a little pus and tumefy at each menstrual period" (49). He identifies the central pathology of the prostitute in the following manner: "Nothing is more frequent in prostitutes than common abscesses in the thickness of the labia majora" (50). In effect, Parent-Duchatelet's view that there is no adaptation of the sexual organ is overridden by his assertion that the sexual organ is especially prone to labial tumors and abscesses; the resultant image is of the prostitute's genitalia developing, through disease, an altered appearance.

From Parent-Duchatelet's description of the physical appearance of the prostitute—a catalogue that reappears in most nineteenth-century studies of prostitutes, such as

Josef Schrank's study of the prostitutes of Vienna[35]—it is but a small step to the use of such catalogues of stigmata to identify those women who have, as Freud states, "an aptitude for prostitution."[36] The major work of nineteenth-century physical anthropology, public health, and pathology to undertake this was written by Pauline Tarnowsky. Tarnowsky, one of a number of St. Petersburg female physicians in the late nineteenth century, wrote in the tradition of her eponymous colleague V. M. Tarnowsky, who was the author of the standard study of Russian prostitution, a study that appeared in both Russian and German and assumed a central role in late nineteenth-century discussions of the nature of the prostitute.[37] She followed his more general study with a detailed investigation of the physiognomy of the prostitute.[38] Her categories remain those of Parent-Duchatelet. She describes the excessive weight of prostitutes and their hair and eye color, provides measurements of skull size and a catalogue of their family background (as with Parent-Duchatelet, most are the children of alcoholics), and discusses their fecundity (extremely low), as well as the signs of their degeneration. These signs are facial abnormalities: asymmetry of the face, misshapen noses, overdevelopment of the parietal region of the skull, and the so-called "Darwin's ear." All of these signs belong to the lower end of the scale of beauty, the end dominated by the Hottentot. All of the signs point to the "primitive" nature of the prostitute's physiognomy; stigmata such as Darwin's ear (the simplification of the convolutions of the ear shell and the absence of a lobe) are a sign of atavism.

In a later paper, Tarnowsky provided a scale of the appearance of the prostitute in an analysis of the "physiognomy of the Russian prostitute."[39] The upper end of the scale is the "Russian Helen." Here, classical aesthetics are introduced as the measure of the appearance of the sexualized female. A bit further on is one who is "very handsome in spite of her hard expression." Indeed, the first fifteen on her scale "might pass on the street for beauties." But hidden even within these seeming beauties are the stigmata of criminal degeneration: black, thick hair; a strong jaw; a hard, spent glance. Some show the "wild eyes and perturbed countenance along with facial asymmetry" of the insane. Only the scientific observer can see the hidden faults, and thus identify the true prostitute, for the prostitute uses superficial beauty as the bait for her clients. But when they age, their "strong jaws and cheek-bones, and their masculine aspect . . . hidden by adipose tissue, emerge, salient angles stand out, and the face grows virile, uglier than a man's; wrinkles deepen into the likeness of scars, and the countenance, once attractive, exhibits the full degenerate type which early grace had concealed." Time changes the physiognomy of the prostitute, just as it does her genitalia, which become more and more diseased as she ages. For Pauline Tarnowsky, the appearance of the prostitute and her sexual identity are pre-established in her heredity. What is most striking is that as she ages, the prostitute begins to appear more and more mannish. Billroth's *Handbook of Gynecological Diseases* links the Hottentot with the lesbian; here the link is between two other models of sexual deviancy, the prostitute and the lesbian. Both are seen as possessing physical signs that set them apart from the normal.

The paper in which Pauline Tarnowsky undertook her documentation of the appearance of the prostitute is repeated word for word in the major late nineteenth-century study of prostitution and female criminality, *La donna delinquente,* written by Cesare Lombroso together with his son-in-law, Guglielmo Ferrero, and published in 1893.[40] Lombroso accepts all of Tarnowsky's perceptions of the prostitute and articulates one further

subtext of central importance, a subtext made apparent by the plates in his book. For two of the plates illustrate the Hottentot's "apron" and steatopygia. (See Figures 5 and 6.) Lombroso accepts Parent-Duchatelet's image of the fat prostitute, and sees her as being similar to Hottentots and women living in asylums. The prostitute's labia are throwbacks to the Hottentot, if not the chimpanzee; the prostitute, in short, is an atavistic subclass of woman. Lombroso uses the power of the polygenetic argument applied to the image of the Hottentot to support his views. His text, in its offhand use of the analogy between the Hottentot and the prostitute, simply articulates in images a view that had been present throughout the late nineteenth century. For example, an essay of 1870 by Adrien Charpy, published in the most distinguished French journal of dermatology and syphilology, presented an analysis of the external form of the genitalia of eight hundred prostitutes examined at Lyons.[41] Charpy merged Parent-Duchatelet's two contradictory categories, seeing all of the alterations as either pathological or adaptive. His first category of anomalies is those of the labia, and he begins by commenting on the elongation of the labia majora in prostitutes, comparing this with the apron of the "disgusting" Hottentots. The image comes as naturally to Charpy as it does to Lombroso two decades later. The prostitute is an atavistic form of humanity whose nature can be observed in the form of her genitalia. What Tarnowsky and Lombroso add to this description is a set of other physical indications that can aid in identifying women, however seemingly beautiful, who possess this atavistic nature. And still other signs were quickly found. The French physician L. Julien in 1896 presented clinical material concerning the foot of the prostitute, which Lombroso in commenting on the paper immediately labeled as "prehensile."[42] (Years later, Havelock Ellis would solemnly declare a long second toe and short fifth toe a "beautiful" secondary sexual characteristic in women—a conclusion consistent with Lombroso's.[43]) Lombroso's coauthor, Guglielmo Ferrero, described prostitution as the rule in primitive societies and placed the Bushman at the extreme end on the scale of primitive lasciviousness. Neither adultery nor virginity has any meaning in such societies, according to Ferrero, and the poverty of their mental universe can be seen in the fact that they have but one word for "girl, woman, or wife."[44] The primitive is the black, and the qualities of blackness, or at least of the black female, are those of the prostitute. The strong currency of this equation is grotesquely evident in a series of case studies on steatopygia in prostitutes by a student of Lombroso's, Abele De Blasio, in which the prostitute is quite literally perceived as the Hottentot.[45]

The late nineteenth-century perception of the prostitute merged with that of the black. Aside from the fact that prostitutes and blacks were both seen as outsiders, what does this amalgamation imply? It is a commonplace that the primitive was associated with unbridled sexuality. This hypersexuality was either condemned, as in Jefferson's discussions of the nature of the black in Virginia, or praised, as in the fictional supplement written by Diderot to Bougainville's voyages.[46] Historians such as J. J. Bachofen postulated it as the sign of the "Swamp," the earliest stage of human history.[47] Blacks, if both Hegel and Schopenhauer are to be believed, remained at this most primitive stage, and their presence in the contemporary world served as an indicator of how far humanity had come in establishing control over the world and itself. The loss of control was marked by a regression into this dark past, a degeneracy into the primitive expression of emotions, in the form of either madness or unbridled sexuality. Such a loss of control was, of course, viewed as pathological and thus fell into domain of the medical model.

Medicine, especially as articulated in the public health reforms of the mid and late nineteenth century, was centrally preoccupied with eliminating sexually transmitted disease through the institution of social controls. This was the intent of such writers as Parent-Duchatelet and Tarnowsky. The social controls they wished to institute were well known in the late eighteenth and early nineteenth centuries but in quite a different context. For the laws applying to the control of slaves (such as the 1685 French *code noir* and its American analogues) had placed great emphasis on the control of the slave as sexual object, in terms of permitted and forbidden sexual contacts as well as documentation as to the legal status of the offspring of slaves. The connection made in the late nineteenth century between this earlier model of control and the later model of sexual control advocated by the public health authorities came about through the association of two bits of medical mythology. First, the primary marker of the black is taken to be skin color; second, there is a long history of perceiving this skin color as the result of some pathology. The favorite theory, which reappears with some frequency in the early nineteenth century, is that the skin color and physiognomy of the black are the result of congenital leprosy.[48] It is not very surprising therefore to read in the late nineteenth century (after social conventions surrounding the abolition of slavery in Great Britain and France, as well as the trauma of the American Civil War, forbade the public association of at least skin color with illness) that syphilis was not introduced into Europe by Columbus's sailors but rather was a form of leprosy that had long been present in Africa and spread into Europe in the Middle Ages.[49] The association of the black and syphilophobia is thus manifest. Black females do not merely represent the sexualized female, they also represent the female as the source of corruption and disease. It is the black female as the emblem of illness who haunts the background of Manet's *Olympia*.

Reading Nana

Manet's *Olympia* stands exactly midway between the glorification of the sexualized female and her condemnation. She is the antithesis of the fat prostitute. Indeed, she was perceived as "thin" by her contemporaries, much in the style of the actual prostitutes of the 1860s. But Laura, the black servant, is presented as plump—something that can best be seen in Manet's initial oil sketch of her done in 1862–1863. In both the sketch and the final painting her face is emphasized, for it is the physiognomy of the black which points to her own sexuality and to that of the white female, who is presented to the viewer unclothed but with her genitalia demurely covered. The hidden genitalia and the face of the black female both point to the potential for corruption of the male viewer by the white female. This potential is even more evident in a work heavily influenced (according to art historians) by Manet's *Olympia*, his portrait *Nana*. In *Nana* the association would have been quite clear to the contemporary viewer. First, the model for the painting was Henriette Hauser, called Citron, the mistress of the Prince of Orange. Second, Manet places in the background the painting of a Japanese crane, the French word for which (*grue*) was a slang term for prostitute. The central figure is thus labeled as a sexualized female. Unlike Olympia's classical pose, Nana is not naked but partially clothed, and is shown being admired by a well-dressed man-about-town (a

flaneur). Manet draws further upon the vocabulary of signs associated by the late nineteenth century with the sexualized female. Fatness is one stigma of the prostitute, and Nana is fulsome rather than thin. This convention became part of the popular image of the sexualized female even while the idealized sexualized female was "thin." Constantin Guys presents an engraving of a fat, reclining prostitute in 1860, and Edgar Degas's *The Madam's Birthday* (1869) shows an entire brothel of fat prostitutes. At the same time, Napoleon III's mistress, Marguerite Bellanger, set a vogue for slenderness.[50] She was described as "below average in size, slight, thin, almost skinny." This is certainly not Nana. Manet places her in a position vis-à-vis the viewer (but not the male observer in the painting) which emphasizes the line of her buttocks, the steatopygia of the prostitute. Second, Nana is placed in such a way that the viewer (but again not the flaneur) can observe her ear. It is, to no one's surprise, Darwin's ear, a sign of the atavistic female. Thus we know were the black servant is hidden in *Nana*. She is hidden within Nana. For even her seeming beauty is but a sign of the black hidden within. All her external stigmata point to the pathology within the sexualized female.

Manet's *Nana* thus provides a further reading of his *Olympia*, a reading that underlines Manet's debt to the pathological model of sexuality present during the late nineteenth century. The black hidden within *Olympia* bursts forth in Pablo Picasso's 1901 version of the painting, in which Olympia is presented as a sexualized black, with broad hips and revealed genitalia, gazing at the nude flaneur bearing her a gift of fruit, much as Laura bears a gift of flowers in Manet's original. But the artist, unlike in the works of Manet, is himself present in the work as a sexualized observer of the sexualized female. Picasso owes part of his reading of *Olympia* to the image of the primitive female as sexualized object, as found in the lower-class prostitutes painted by van Gogh and the Tahitian maidens à la Diderot painted by Gauguin. Picasso saw the sexualized female as the visual analogue of the black. Indeed, in his most radical break with the Impressionist tradition, *Les demoiselles d'Avignon* (1907), he linked the inmates of a brothel in Barcelona with the black by using the theme of African masks to characterize their appearance. The figure of the male holding a skull in the early version of the painting is the artist as victim. Picasso's parody points toward the importance of seeing Manet's *Nana* in the context of the prevalent medical discourse concerning the sexualized female in the late nineteenth century. For the portrait of Nana is embedded in a complex literary matrix with many signs linking the sexualized female to disease. The figure of Nana first appeared in Emile Zola's 1877 novel *L'assommoir*, in which she is presented as the offspring of the alcoholic couple who are the central figures of the novel.[51] Her heredity assures the reader that she will eventually become a sexualized female, a prostitute, and indeed that identity is inaugurated at the close of the novel when she runs off with an older man, the owner of a button factory. Manet was taken by the figure of Nana (as was the French reading public), and his portrait of her symbolically reflected her sexual encounters presented in the novel.

Zola then decided to build the next novel in his Rougon-Macquart cycle on the figure of Nana as a sexualized female. Thus in Zola's *Nana* the reader is presented with Zola's reading of Manet's portrait of Nana. Indeed, Zola uses the portrait of the flaneur observing the half-dressed Nana as the centerpiece for a scene in the theater in which Nana seduces the simple Count Muffet. Immediately before this scene, Zola presents Nana's first success in the theater (or, as the theater director calls it, his "brothel"). She

appears in a review, unable to sing or dance, and becomes the butt of laughter until in the second act of the review she appears unclothed on stage: "Nana was in the nude: naked with a quiet audacity, certain of the omnipotence of her flesh. She was wrapped in a simple piece of gauze: her rounded shoulders, her Amazon's breasts of which the pink tips stood up rigidly like lances, her broad buttocks which rolled in a voluptuous swaying motion, and her fair, fat hips: her whole body was in evidence, and could be seen under the light tissue with its foamy whiteness."[52] What Zola describes is the sexualized woman, the "primitive" hidden beneath the surface: "All of a sudden in the comely child the woman arose, disturbing, bringing the mad surge of her sex, inviting the unknown element of desire. Nana was still smiling: but it was the smile of a man-eater." Nana's atavistic sexuality, the sexuality of the Amazon, is destructive. The sign of this, her voluptuousness, reappears when she is observed by Muffet in her dressing room, in the scene that Zola found in Manet's painting: "Then calmly, to reach her dressing-table, she walked in her drawers through that group of gentlemen, who made way for her. She had large buttocks, her drawers ballooned, and with breast well forward she bowed to them, giving her delicate smile" (135). Nana's childlike face is but a mask concealing a disease buried within, the corruption of sexuality. Thus Zola concludes the novel by revealing the horror beneath the mask. Nana dies of the pox. (This is a pun that works in French as well as in English, and that was needed because of the rapidity of decay demanded by the moral implication of Zola's portrait. It would not do to have Nana die slowly over thirty years of tertiary syphilis. Smallpox, with its play on pox, works quickly and gives the same visual icon of decay.) Nana's death reveals her true nature:

> Nana remained alone, her face looking up in the light from the candle. It was a charnel-house scene, a mass of tissue-fluids and blood, a shovelful of putrid flesh thrown there on a cushion. The pustules had invaded the entire face with the pocks touching each other; and, dissolving and subsiding with the grayish look of mud, there seemed to be already an earthy mouldiness on the shapeless muscosity, in which the features were no longer discernable. An eye, the left one, had completely subsided in a soft mass of purulence; the other, half-open, was sinking like a collapsing hole. The nose was still suppurating. A whole reddish crust was peeling off one cheek and invaded the mouth, distorting it into a loathsome grimace. And on that horrible and grotesque mask, the hair, that beautiful head of hair still preserving its blaze of sunlight, flowed down in a golden trickle. Venus was decomposing. It seems as though the virus she had absorbed from the gutters and from the tacitly permitted carrion of humanity, that baneful ferment with which she had poisoned a people, had now risen to her face and putrefied it. (464–465)

The decaying visage is the visible sign of the diseased genitalia through which the sexualized female corrupts an entire nation of warriors and leads them to the collapse at Sedan. The image is an old one; it is *Frau Welt,* Madam World, who masks her corruption, the disease of being a woman, with her beauty. It reappears in the vignette on the title page of the French translation (1840) of the Renaissance poem "Syphilis."[53] But it is yet more, for Nana begins in death to revert to the blackness of the earth, to assume

the horrible grotesque countenance perceived as belonging to the world of the black, the world of the "primitive," the world of disease. Nana is, like Olympia, in the words of Paul Valéry, "pre-eminently unclean."[54] And it is this uncleanness, this disease, which forms the final ink between two images of the woman, the black and the prostitute. For, just as the genitalia of the Hottentot were perceived as parallel to the diseased genitalia of the prostitute, so too the powerful idea of corruption links both images. Nana is corrupted and corrupts through sexuality.

Miscegenation is a word from the late nineteenth-century vocabulary of sexuality. It embodies a fear not merely of interracial sexuality, but of its supposed result, the decline of the population. For interracial marriages were seen as exactly parallel to prostitution in their barrenness. If they produced children at all, these children were weak and doomed. Thus Havelock Ellis, enlarging on his view of the objective nature of the beauty of humanity, states that "it is difficult to be sexually attracted to persons who are fundamentally unlike ourselves in racial constitution"[55] and approvingly quotes Abel Hermant:

Differences of race are irreducible and between two beings who love each other they cannot fail to produce exceptional and instructive reactions. In the first superficial ebullition of love, indeed, nothing notable many be manifested, but in a fairly short time the two lovers, innately hostile, in striving to approach each other strike against an invisible partition which separates them. Their sensibilities are divergent; everything in each shocks the other; even their anatomical conformation, even the language of their gestures; all is foreign.[56]

It is thus the innate fear of the Other's different anatomy which lies behind the synthesis of images. The Other's pathology is revealed in her anatomy, and the black and the prostitute are both bearers of the stigmata of sexual difference and thus pathology. Zola sees in the sexual corruption of the male the source of political impotence and provides a projection of what is basically a personal fear, the fear of loss of power, onto the world.[57] The "white *man's* burden," thus becomes his sexuality and its control, is displaced into the need to control the sexuality of the Other, the Other as sexualized female. For the colonial mentality that sees "natives" as needing control easily shifts that concern to the woman, in particular the prostitute caste. Because the need for control was a projection of inner fears, its articulation in visual images was in terms which were the polar opposite of the European male. The progenitors of the vocabulary of images of the sexualized female believed that they were capturing the essence of the Other. Thus when Sigmund Freud, in his essay on lay analysis (1926), discussed the ignorance of contemporary psychology concerning adult female sexuality, he referred to this lack of knowledge as the "dark continent" of psychology, an English phrase with which he tied female sexuality to the image of contemporary colonialism and thus to the exoticism and pathology of the Other.[58] It was Freud's intent to explore this hidden "dark continent" to reveal the hidden truths about female sexuality, just as the anthropologist-explorers, such as Lombroso, were revealing further hidden truths about the nature of the black. Freud continues a discourse that relates images of male discovery to images of the female as the object of discovery. The line from the secrets possessed by the Hottentot Venus to those of twentieth-century psychoanalysis runs reasonably straight.

1. George Hamilton, *Manet and His Critics* (New Haven: Yale University Press, 1954), 67–68. I am ignoring here the peculiar position of George Mauner, *Manet: Peintre-Philosophe: A Study of the Painter's Themes* (University Park: Pennsylvania University Press, 1975) that "we may conclude that Manet makes no comment at all with this painting, if by comment we understand judgment or criticism" (99).

2. For my discussion of *Olympia* I draw on Theodore Reff, *Manet: Olympia* (London: Allen Lane, 1976), and for my discussion of *Nana,* on Werner Hofmann, *Nana: Mythos and Wirklichkeit* (Cologne: Dumont Schauberg, 1973). Neither of these studies examines the medical analogies. See also E. Lipton, "Manet: A Radicalized Female Imagery," *Artforum* 13 (1975): 48–53.

3. George Needham, "Manet, Olympia and Pornographic Photography," in Thomas Hess and Linda Nochlin, eds., *Woman as Sex Object* (New York: Newsweek, 1972), 81–89.

4. P. Rebeyrol, "Baudelaire et Manet," *Les temps modernes* 5 (1949): 707–725.

5. Georges Bataille, *Manet,* trans. A. Wainhouse and James Emmons (New York: Skira, 1956), 13.

6. Edmund Bazire's 1884 view of *Nana* is cited by Anne Coffin Hanson, *Manet and the Modern Tradition* (New Haven: Yale University Press, 1977), 130.

7. See my *On Blackness without Blacks: Essays on the Image of the Black in Germany* (Boston: G. K. Hall, 1982). On the image of the black see Ladislas Bugner, ed., *L'image du noir dans l'art occidental* (Paris: Bibliothèque des Arts, 1976–). The fourth volume, not yet published, will cover the post-Renaissance period. In the course of the nineteenth century the female Hottentot becomes the black female *in nuce,* and the prostitute becomes the representative of the sexualized woman. Likewise, while many groups of African blacks were known in the nineteenth century, the Hottentot continued to be treated as the essence of the black, especially the black female. Both concepts fulfilled an iconographic function in the perception and representation of the world. How these two concepts were associated provides a case study for the investigation of patterns of conventions within multiple systems of representation.

8. See the various works on Hogarth by Ronald Paulson as well as R. E. Taggert, "A Tavern Scene: An Evening at the Rose," *Art Quarterly* 19 (1956): 320–323.

9. M. N. Adler, trans., *The Itinerary of Benjamin of Tudela* (London: H. Frowde, 1997), 68.

10. See John Herbert Eddy, Jr., "Buffon, Organic Change, and the Races of Man" (diss., University of Oklahoma, 1977), 109; as well as Paul Alfred Erickson, "The Origins of Physical Anthropology" (diss., University of Connecticut, 1974); and Werner Krauss, *Zur Anthropologie des 18. Jahrhunderts: Die Frühgeschichte der Menscheit im Blickpunkt der Aufklärung,* ed. Hans Kortum and Christa Gohrisch (Munich: Hanser, 1979). See also George W. Stocking, Jr., *Race, Culture and Evolution: Essays in the History of Anthropology* (Chicago: University of Chicago Press, 1982).

11. Johann Friederich Blumenbach, *Beyträge zur Naturegeschichte* (Göttingen: Heinrich Dietrich, 1806). Even though a professed "liberal" who strongly argued for a single source for all the races, Blumenbach was puzzled about the seemingly radical difference in the anatomy of the African (read: black woman).

12. Guillaume Thomas Raynal, *Histoire philosophique et politique des éstablissements et du commerce des Européens dans les deux Indes* (Geneva: Chez les libraires associés, 1775), 2:406–407.

13. William F. Bynum, "The Great Chain of Being after Forty Years: An Appraisal," *History of Science* 13 (1975): 1–28, and his dissertation, "Time's Noblest Offspring: The Problem of Man in British Natural Historical Sciences" (Cambridge University, 1974).

14. *Dictionnaire des sciences médicales* (Paris: C.L.F. Panckoucke, 1819), 35:398–403.

15. J. J. Virey, *Histoire naturelle du genre humain* (Paris: Crochard, 1824), 2:151. My translation.

16. George M. Gould and Walter L. Pyle, *Anomalies and Curiosities of Medicine* (Philadelphia: W. B. Saunders, 1901), 307; and Eugen Holländer, *Äskulap und Venus: Eine Kultur- und Sittengeschichte im Spiegel des Arztes* (Berlin: Propyläen, 1928). Much material on the indebtedness of the early pathologists to the reports of travelers to Africa can be found in the accounts of the autopsies presented below. One indication of the power of the image of the Hottentot still possessed in the late nineteenth century is to be found in George Eliot's *Daniel Deronda* (1876). On its surface the novel is a hymn to racial harmony and an attack on British middle-class bigotry. Eliot's liberal agenda is nowhere better articulated than in the ironic debate concerning the nature of the black in which the eponymous hero of the novel

defends black sexuality (376). This position is attributed to the hero not a half-dozen pages after the authorial voice of the narrator introduced the description of this very figure with the comparison: "And one man differs from another, as we all differ from the Bosjesman" (370). Eliot's comment is quite in keeping with the underlying understanding of race in the novel. For just as Deronda is fated to marry a Jewess and thus avoid the taint of race mixing, so too is the Bushman, a Hottentot equivalent in the nineteenth century, isolated from the rest of humanity. That a polygenetic view of race and liberal ideology can be held simultaneously is evident as far back as Voltaire. But the Jew is here contrasted to the Hottentot, and, as we have seen, it is the Hottentot who serves as the icon of pathologically corrupted sexuality. Can Eliot be drawing a line between outsiders such as the Jew and the sexualized female in Western society and the Hottentot? The Hottentot comes to serve as the sexualized Other onto whom Eliot projects the opprobrium with which she herself was labeled. For Eliot the Hottentot remains beyond the pale, showing that even in the most Whiggish text the Hottentot remains the essential Other. (George Eliot, *Daniel Deronda,* ed. Barbara Hardy [Harmondsworth: Penguin, 1967].)

17. De Blainville, "Sur une femme de la race hottentote," *Bulletin des Sciences par la société philomatique de Paris* (1816), 183–190. This early version of the autopsy seems to be unknown to William B. Cohen, *The French Encounter with Africans: White Response to Blacks, 1530–1880* (Bloomington: Indiana University Press, 1980). (See esp. 239–245, for his discussion of Cuvier.) See also Stephen Jay Gould, "The Hottentot Venus," *Natural History* 91 (1982): 20–27.

18. Quoted from the public record by Paul Edwards and James Walvin, eds., *Black Personalities in the Era of the Slave Trade* (London: Macmillan, 1983), 171–183. A print of the 1829 ball in Paris with the nude "Hottentot Venus" is reproduced in Richard Toellner, ed., *Illustrierte Geschichte der Medizin* (Salzburg: Andreas & Andreas, 1981), 4:1319. (This is a German reworking of Jacques Vie et al., *Histoire de la médecine* [Paris: Albinmichel-Laffont-Tchon, 1979].) On the showing of the "Hottentot Venus" see Percival R. Kirby, "The Hottentot Venus," *Africana Notes and News* 6 (1949): 55–62, and his "More about the Hottentot Venus," *Africana Notes and News* 10 (1953): 124–134; Richard D. Altick, *The Shows of London* (Cambridge, Mass.: Belknap Press of Harvard University, 1978), 269; and Bernth Lindfors, "'The Hottentot Venus' and Other African Attractions in Nineteenth-Century England," *Australasian Drama Studies* 1 (1983): 83–104.

19. Georges Cuvier, "Extraits d'observations faites sure le cadavre d'une femme connue à Paris et à Londres sous le nom de Vénus Hottentote," *Memoires du Musée d'histoire naturelle* 3 (1817): 259–274. Reprinted with plates by Etienne Geoffroy Saint-Hilaire and Frédéric Cuvier, *Histoire naturelle des mammifères avec des figures originales* (Paris: A. Belin, 1824), 1:1–23. The substance of the autopsy is reprinted again by Flourens in the *Journal complémentaire du dictionnaire des sciences médicales* 4 (1819): 145–149; and by Jules Cloquet, *Manuel d'anatomie de l'homme descriptive du corps humain* (Paris: Béchet jeune, 1825), plate 278. Cuvier's presentation of the "Hottentot Venus" forms the major signifier for the image of the Hottentot as sexual primitive in the nineteenth century. This view seems never really to disappear from the discussion of difference. See the discussion of the "bushmen" among French anthropologists of the 1970s, especially Claude Rousseau, as presented by Patrick Moreau, "Die neue Religion der Rasse," in Iring Fetscher, ed., *Neokonservative und "Neue Rechte"* (Munich: C. H. Beck, 1983), 139–141.

20. See for example Walker D. Greer, "John Hunter: Order out of Variety," *Annals of the Royal College of Surgeons of England* 28 (1961): 238–251. See also Barbara J. Babiger, "The *Kunst- und Wunderkammern*: A *catalogue raisonné* of Collecting in Germany, France and England, 1565–1750" (diss., University of Pittsburgh, 1970).

21. Adolf Wilhelm Otto, *Seltene Beobachtungen zur Anatomie, Physiologie und Pathologie gehörig* (Breslau: Wilibald Holäafer, 1816), 135; Johannes Müller, "Über die äusseren Geschlechtstheile der Buschmänninnen," *Archiv für Anatomie, Physiologie und wissenschaftliche Medizin* (1834), 319–345; W. H. Flower and James Murie, "Account of the Dissertation of a Bushwoman," *Journal of Anatomy and Physiology* 1 (1867): 189–208; Hubert von Luschka, A. Koch, and E. Görtz, "Die äusseren geschlechtstheile eines Buschweibes," *Monatsschrift für Geburtskunde* 32 (1868): 343–350. The popularity of these accounts is attested by their republication (in extract) in *The Anthropological Review* (London), which was aimed at a lay audience (5 [1867]: 316–324, and 8 [1870]: 89–318). These extracts also stress the sexual anomalies described.

22. *Richmond and Louisville Medical Journal,* May 1868, 194, cited by Edward Turnipseed, "Some Facts in Regard to the Anatomical Differences between the Negro and White Races," *American Journal of Obstetrics* 10 (1877): 32–33.

23. C. H. Fort, "Some Corroborative Facts in Regard to the Anatomical Difference between the Negro and White Races," *American Journal of Obstetrics* 10 (1877): 258–259. Paul Broca was influenced by similar American material concerning the position of the hymen, which he cited from the *New York City Medical Record* of 15 September 1868 in *Bulletins de la société d'anthropologie de Paris* 4 (1869): 443–433. Broca, like Cuvier before him, supported a polygenetic view of the human races.

24. William Turner, "Notes on the Dissection of a Negro," *Journal of Anatomy and Physiology* 13 (1878): 382–386, and "Notes on the Dissection of a Second Negro," 26. This was not merely a British anomaly. Jeffries Wyman reported the dissection of a black male suicide victim in the *Proceedings of the Boston Society of Natural History* on 2 April 1862 and 16 December 1863 and did not refer to the genitalia at all. *The Anthropological Review* 3 (1865): 330–335.

25. H. Hildebrandt, *Die Krankheiten der äusseren weiblichen Genitalien,* in Theodor Billroth, ed., *Handbuch der Frauenkrankheiten III* (Stuttgart: Enke, 1877), 11–12. See also Thomas Power Lowry, ed., *The Classic Clitoris: Historic Contributions to Scientific Sexuality* (Chicago: Nelson-Hall, 1978).

26. Havelock Ellis, *Studies in the Psychology of Sex,* vol. 4, *Sexual Selection in Man* (Philadelphia: F. A. Davis, 1920), 152–185.

27. Willem Vrolik, *Considérations sur la diversité du bassin des différentes races humaines* (Amsterdam: Van der Post, 1826); R. Verneau, *Le bassin dans les sexes et dans les races* (Paris: Baillière, 1876), 126–129.

28. Charles Darwin, *The Descent of Man and Selection in Relation to Sex* (1871; Princeton, NJ: Princeton University Press, 1981), 2:317 on the pelvis, and 2:345–346 on the Hottentot.

29. John Grand-Carteret, *Die Erotik in der französischen Karikatur,* trans. Cary von Karwath and Adolf Neumann (from the manuscript), Gesellshaft Österreichischer Bibliophilen 16 (Vienna: C. W. Stern, 1909), 195.

30. *The Memories of Dolly Morton: The Story of a Woman's Part in the Struggle to Free the Slaves: An Account of the Whippings, Rapes, and Violences That Preceded the Civil War in America with Curious Anthropological Observations on the Radical Diversities in the Conformation of the Female Bottom and the Way Different Women Endure Chastisement* (Paris: Charles Carrington, 1899), 207.

31. Sigmund Freud, *The Standard Edition of the Complete Psychological Works of Sigmund Freud,* trans. James Strachey (London: Hogarth, 1953–1974), 7:186–187, especially the footnote added in 1920 concerning the "genital apparatus" of the female. Translations from other works are mine except where otherwise stated.

32. The best study of the image of the prostitute is Alain Corbin, *Les filles de noce: Misère sexuelle et prostitution aux 19e et 20e siècles* (Paris: Aubier, 1978). On the black prostitute see Khalid Kistainy, *The Prostitute in Progressive Literature* (New York: Schocken, 1982), 74–84. On the iconography associated with the pictorial representation of the prostitute in nineteenth-century art see Hess and Nochlin, eds., *Woman as Sex Object*; as well as Linda Nochlin, "Lost and Found Once More the Fallen Woman," *Art Bulletin* 60 (1978): 139–153; and Lynda Nead, "Seduction, Prostitution, Suicide: *On the Brink* by Alfred Elmore," *Art History* 5 (1982): 310–312. On the special status of medical representations of female sexuality see the eighteenth-century wax models of female anatomy in the Museo della Specola (Florence), reproductions of which are in Mario Bucci, *Anatomia come arte* (Firenze: Edizione d'arte il Fiorino, 1969), esp. plate 8.

33. A.J.B. Parent-Duchatelet, *De la prostitution dans la ville de Paris* (Paris: J. B. Baillière, 1836), 1:193–244.

34. *On Prostitution in the City of Paris* (London: T. Burgess, 1840), 38. It is of interest that it is exactly the passages on the physiognomy and appearance of the prostitute which this anonymous translator presents to an English audience as the essence of Parent-Duchatelet's work.

35. Editor's note: See Sander Gilman, "Male Stereotypes of Female Sexuality in Fin-de-Siècle Vienna," Difference and Pathology (Ithaca: Cornell, 1985), 39–58.

36. Freud, *Standard Edition,* 7:191.

37. V. M. Tarnowsky, *Prostitutsija I abolitsioniszm* (St. Petersburg: n.p., 1888); *Prostitution und Abolitionismus* (Hamburg: Voss, 1890).

38. Pauline Tarnowsky, *Etude anthropométrique sur les prostituées et les voleuses* (Paris: E. Lecrosnier et Bebé, 1889).

39. Pauline Tarnowsky, "Fisiomie di prostitute russe," *Archivio di Psichiatria, scienze penali ed antropologia criminale* 14 (1893): 141–142.

40. Cesare Lombroso and Guglielmo Ferrero, *La donna delinquente* (Turin: Roux, 1893). On the photographs of the Russian prostitutes, 349–350; on the fat of the prostitute, 361–362; and on the labia of the Hottentots, 38.

41. Adrien Charpy, "Des organes génitaux externes chez les prostituées," *Annales des Dermatologie* 3 (1870–1871): 271–279.

42. *Congrès international d'anthropologie criminelle* (1896) (Geneva: Georg et Co., 1897), 348–349.

43. Ellis, *Psychology of Sex,* 4:164.

44. Guglielmo Ferrero [Guillaume Ferrero], "L'atavisme de la prostitution," *Revue scientifique* (Paris, 1892), 136–41.

45. Abele De Blasio, "Steatopigia in prostitute," *Archivio di psichiatria* 26 (1905): 257–264.

46. Jefferson commented on the heightened sensuality of the black in slavery in his *Notes from Virginia* (1782); Diderot, in his posthumously published fictional *Supplément au voyage de Bougainville* (1796), represented the heightened sexuality of the inhabitants of Tahiti as examples of the nature of sexuality freed from civilization. See the general discussion of this theme in Alexander Thomas and Samuel Sillen, *Racism and Psychiatry* (New York: Brunner/Mazel, 1972), 101ff.

47. On Bachofen's view of primitive sexuality see the Introduction, Chapter 9, and selections by Joseph Campbell in J. J. Bachofen, *Myth, Religion & Mother Right,* trans. Ralph Manheim (Princeton, NJ: Princeton University Press, 1973).

48. See Winthrop Jordan, *White over Black: American Attitudes toward the Negro, 1550–1812* (New York: W. W. Norton, 1977), 3–43.

49. Iwan Bloch, *Der Ursprung der Syphilis,* 2 vols. (Jena: Gustav Fischer, 1901–1911).

50. Reff, *Manet: Olympia,* 57–58, also 118.

51. See Auriant, *La véritable histoire de "Nana"* (Paris: Mercure de France, 1942). See also Demetra Palamari, "The Shark Who Swallowed His Epoch: Family Nature and Society in the Novels of Émile Zola," in Virginia Tufte and Barbara Myerhoff, eds., *Changing Images of the Family* (New Haven: Yale University Press, 1978), 155–172; and Robert A. Nye, *Crime, Madness, and Politics in Modern France: The Medical Concept of National Decline* (Princeton, NJ: Princeton University Press, 1984).

52. All the quotations are from Charles Duff's translation of *Nana* (London: Heineman, 1953), here, 27. The position described by Zola mirrors Manet's image of Nana. It emphasizes her state of semi-undress (echoing the image of the half-dressed "Hottentot Venus"). In Manet's image she is in addition corseted, and the corset stresses her artificially narrowed waist and the resultant emphasis on the buttocks. Both Manet's and Zola's images recall the bustle that Nana would have worn once dressed. (Nana is, for Zola, a historical character, existing at a very specific time in French history, in the decade leading up to the Franco-Prussian War of 1872.) The bustle (or *tounure*) was the height of fashion between 1865 and 1876 (and again in the mid-1880s). Worn with a tightly laced bodice, the bustle gave the female a look of the primitive and the erotic while staying safely within the bounds of middle-class fashion. Both the woman wearing a bustle and those who observed her knew the accessory was artificial but they were also aware of its symbolic implications. The "bum rolls" of the seventeenth century and the "cork rumps" of the eighteenth century had already established a general association. But the bustle of the late nineteenth century, stretching out at the rear of the dress like a shelf, directly echoed the supposed primitive sexuality of the Hottentot. Thus the dress implied by Nana's state of semi-undress and by her undergarments, in Manet's painting and in Zola's description, also points to the primitive hidden within. See Bryan S. Turner, *The Body and Society: Explorations in Social Theory* (Oxford: Blackwell, 1985).

53. August Barthelemy, trans., *Syphilis: Poème en deux chants* (Paris: Béchet junior et Labé & Bohaire, 1840). This is a translation of a section of Fracastorius's Latin poem on the nature and origin of syphilis. The French edition was in print well past mid-century.

54. Cited by Bataille, *Manet,* 65.

55. Ellis, *Psychology of Sex,* 4:176.

56. Abel Hermant, *Confession d'un enfant d'hier,* cited in ibid., 4:176 n. 1.

57. Joachim Hohmann, ed., *Schon auf den ersten Blick: Lesebuch zur Geschichte unsere Feindbilder* (Darmstadt: Luchterhand, 1981).

58. Freud, *Standard Edition,* 25:212. See also Renate Schlesier, *Konstruktion der Weiblichkeit bei Sigmund Freud* (Frankfurt: Europäische Verlagsantalt, 1981), 35–39.

ROBIN MITCHELL

2 Another Means of Understanding the Gaze

Sarah Bartmann in the Development of Nineteenth-Century French National Identity

All representations require editing.
—Darcy Grimaldo Grigsby, *Extremities:*
Painting Empires in Post-Revolutionary France

When Sarah Bartmann first appeared in London, the famous actor Charles Mathews went to the exhibition. Later, in his memoirs, his wife wrote that when Mr. Mathews arrived, Bartmann was:

> surrounded by many persons, some *females*! One pinched her, another walked round her; one gentleman *poked* her with his cane; and one *lady* employed her parasol to ascertain that all was, as she called it, '*natural*'. This inhumane baiting the poor creature bore a sullen indifference, except upon some great provocation, when she seemed inclined to resent brutality, which even a Hottentot can understand. On these occasions it required all authority to subdue her resentment. At last her *civilized* visitors departed.[1]

Mrs. Mathews seemed surprised that females would join in the viewing of Bartmann, and even more by their participation in her ill treatment. Nevertheless, Mrs. Mathews still relegates Bartmann to a subhuman status, remarking that "even a Hottentot" can "resent brutality." It is not clear what type of authority was needed to "subdue her resentment," although the quote from the London *Times* indicates that her handler was not above physical (or the threat of physical) coercion.[2] The outrageous spectacle of Bartmann on display, the belief that she had to be controlled, and the remarkable ease of those who abused her, cuts to the center of the long-standing Western manipulation of black women's bodies.

After London, Bartmann was taken to Paris; the reaction to her and her usefulness as a cultural marker there illuminate the translation of black women's bodies in a particularly public fashion in nineteenth-century Paris, and demonstrate how deeply rooted representations of black women are in French culture.[3] The production and the viewing of black women's bodies—by both men and women—complicated already unstable ideas of race, class, gender, and sexuality. French social, cultural, and political upheavals in this era resulted in an emerging need for a more concrete national identity, often augmented by oppositional and specific definitions of blackness. Images of and writings

about Sarah Bartmann articulated a means by which white French men and women could work out their fears and anxieties over political and social transitions, often in an indirect fashion. This rhetoric, whether expressed explicitly or implicitly in popular culture, colonial publications, or scientific discourse, facilitated this self-construction. In the case of developing French national identity, the concomitant conflation of whiteness within this definition required constant reminders and multiple revisions.

The Bartmann phenomenon facilitated several recurring colonial themes: the attempts to control and contain the black female body, to manage the white female body, and to shore up a flailing white male body. In addition, it promised redemption through the advent of scientific discourse, returning white men to a position of male power and potency.[4] By uncovering (literally and metaphorically) the source of black women's power, gender and racial roles could return to pre-Colonial norms. This chapter looks at some of the enormous literature on Sarah Bartmann, focusing on her so-called scientific value to the French academy; it also explores the cultural aspects of her representations and the play written about her. An investigation of how Sarah Bartmann was (re)presented in Paris during the nineteenth century provides key insights into how the French conceived their own identity. The manner in which the French (re)constructed her, not in their own images, but in an oppositional one that intensified and conflated ideas of race, class, gender, and sexuality, reveals nationalist and colonialist tensions at their most volatile levels. How did the production of Bartmann as a "type" function on the one hand as "proof" of France's need to dominate Africa, and to minimize the excruciating loss of Saint Domingue (Haiti), while on the other hand shoring up racial, gender, class and sexual boundaries at home? How did Bartmann function as a way of working out anxieties over French national identity? How might these insights cause us to ask different questions about the formation of national identity in general? While it is problematic to make comprehensive statements about French national identity based on one example, it is possible to begin a dialog on how specific representations speak to these larger issues.[5] Bartmann's story in connection with French anxieties underlines and complicates the fluid construction of both French whiteness and collective identity. Her genitalia and her image were used to establish nationalistic boundaries; thus her supposed differences were exaggerated to articulate all that was excessive and therefore dangerous in middle-class society. Because Sarah Bartmann was seen as a representation of everything that opposed white French identity, she was *constructed* as a living, breathing embodiment of ultimate difference.

Her metamorphosis into "The Hottentot Venus" highlights the way that science and popular culture work to *mutually* inform and regulate cultural behavior, and contests existing categories that separate scientific discourse from popular entertainment. Moreover, it illustrates how these constraints contribute to an analytical misreading about the overall significance of black women in French culture.[6] These narratives are revealing about particular French fears—such as transgressing social and political boundaries, and of miscegenation—critical in creating a cohesive white French identity. By refocusing the gaze away from Bartmann solely and back upon itself, I highlight her importance in the construction of French nationalism. This analysis offers an important mechanism for interpreting both the people who created these representations, and those who "merely" viewed her. While scientific discourse offered intellectual reasons for the inferiority of blacks (and legitimated an often-sexualized viewing of them), literature,

theater, art, and other cultural venues provided an access point for the French bour-
geoisie to contemplate and know the black Other. Any sexual titillation would not be
the viewer's fault—after all, there she was, almost naked. So Sarah Bartmann, the Hot-
tentot Venus, moved from the realm of popular culture into the scientific arena, packed
for articulation by the masses.

Bartmann's complicated story can easily move the reader from feelings of
incredulousness to horror. Bartmann was born somewhere within the boundaries of
Caffraria (to the west of Great Fish River) around 1788.[7] At the approximate age of
twenty, she was taken from South Africa by a man named Hendrik Cezar (the brother
of her master/employer, Peter), who "arranged" her passage to Europe.[8] According to
Percival Kirby, Bartmann was smuggled out of South Africa by Hendrik without knowl-
edge of the Governor.[9] Aboard ship (or perhaps prior), Cezar entered into a partnership
of sorts with the ship's surgeon, Alexander Dunlop (who sold his "stake" in her upon
reaching London).[10] The contract (if indeed there was one) between the two men and
Bartmann stated that she was to be responsible for domestic duties, and also that she
would be exhibited in England and Ireland.[11] She was to be given a portion of the pro-
ceeds from her exhibition and repatriated back to South Africa after a period of two
years.[12] For reasons unknown, she was baptized in Manchester, England, by a Rev.
Joshua Brookes in December 1811, at which time her name appears on her baptismal
certificate not as the Dutch "Saartje Baartmann" but as the Anglicized "Sarah Bart-
mann."[13] Between 1810 and 1814, she was paraded through London—usually in a
flesh-colored costume designed to tightly conform to her body, often in a cage. The
Times in London stated that "a stage [was] raised about three feet from the floor, with
a cage, or enclosed place at the end of it; that the Hottentot was within the cage; [and]
that on being ordered by her keeper, she came out, and that her appearance was highly
offensive to delicacy."[14] The paper continued that

> the Hottentot was produced like a wild beast, and ordered to move backwards
> and forwards, and come out and go into her cage, more like a bear on a chain
> than a human being. . . . She frequently heaved deep sighs; seemed anxious and
> uneasy; grew sullen, when she was ordered to play on some rude instrument of
> music. . . . And one time, when she refused for a moment to come out of her
> cage, the keeper let down the curtain, went behind, and was seen to hold up his
> hand to her in a menacing posture; she then came forward at his call, and was
> perfectly obedient. . . . The dress is contrived to exhibit the entire frame of her
> body, and spectators are even invited to examine the peculiarities of her form.[15]

The circus-like atmosphere surrounding Bartmann is difficult for twenty-first-
century readers to fathom, as is the considerable stress that Bartmann displays. In fact,
the shocked response by some to Bartmann's London showings led to a court case in
November 1810 brought about by Zachary Macaulay and other abolitionists—aptly yet
derogatively titled "The Case of the Hottentot Venus"[16]—to determine whether she was
being held against her will.[17] The court documents highlight the contradictions sur-
rounding her voyage to England and the ambiguities of the exact nature of her status.

According to an examination made of her on November 27, she seems to corroborate an agreement with Dunlop, and yet the document also states that she cannot read or write (Bartmann's first-person voice never appears in the text). The transcript goes so far to say, "She understands very little of the Agreement made with her by Mr. Dunlop on the twenty ninth October 1810."[18] Nevertheless, another affidavit signed by A. J. Guitard says that when questioned about her well-being or her desire to go back to the Cape of Good Hope, Bartmann responded that she was well treated and wanted to stay in England.[19] It is notable how much effort goes into making Bartmann appear a willing participant in her own exploitation. By proving she was executing her own free will, something impossible under the slave system operating throughout most of Europe, it also absolved those viewing her and any discussion of the institution of slavery, or calls for its abolition, ended before it began. Thus, her treatment by Cezar and Dunlop simply became part of the job that she had already *consented* to do, and not an indictment against her possible enslavement. Despite the enormous disparity in testimonies, the case was dismissed and Bartmann's exhibitions continued, at least until her next major appearance—in France.[20]

Before turning to a more focused examination of both Sarah Bartmann's representations and her usefulness in the formation of French identity, it is important to understand France's active involvement with peoples of African descent, both economically and as a means of articulating a face of ultimate difference. France's participation in and benefit from buying and selling people of African descent significantly preceded the nineteenth century. The *Code Noir* of 1685,[21] for example, made clear the need to articulate the appropriate placement of blacks in France and, significantly, blacks in French colonies. Moreover, it reveals the process of the French defining themselves in opposition to black "Others." French involvement in the Antilles was in full swing by the beginning of the eighteenth century, and astounding economic returns showed how profitable it could be to do business in black colonies such as Saint Domingue.

According to Robert Louis Stein, the eighteenth century saw more than 3,000 French ships involved in transportation of Africans, and more than one in ten jobs in France were dependent upon the slave trade.[22] Christopher Miller states that "between 1640 and 1700 the French took 75,000 slaves into their colonies; from 1700 to 1760, 388,000."[23] Moreover, he asserts that "Saint Domingue (which doubled its production between 1783 and 1789) alone accounted for two-thirds of France's overseas trade and was 'the most profitable colony the world had ever known.'"[24] But, as would rapidly become clear, both enslaved and free blacks in Saint Domingue heard the rumblings from Paris, took the promises of the French Revolution of 1789 to heart, and re-asserted their desire for freedom with brutal intensity. The Haitian Revolution of 1791–1803 resulted in a stunning and ego-bruising loss of France's most important colony, Saint Domingue, and led to the creation of the Negro State of Haiti.[25] When those so-called "savages" defeated the French military, France's previous vision of its own racial and tactical superiority suffered a profound setback. Slavery in France's colonies was abolished for the first time in 1794, then re-established in 1802; the slave trade was prohibited after 1818, although it continued for some time after.[26] William Cohen notes that the re-establishment of slavery brought back a renewal of racial legislation, including

barring blacks and colored peoples entry into France.[27] Moreover, Britain's colonial expansion undermined France's self-assertion of global dominance, and France's precarious position as the most civilized of all European countries seemed neither safe nor fixed. The volatile relationships between France and its black colonies, including French West Africa, Martinique, and Guadeloupe, heightened tensions over the diminishing power of France's political and social hegemonies and fuelled questions over what it meant to be truly French, as well as how to impose that French-ness at home and abroad. Even though the latter part of the nineteenth century is rightly considered a time of colonial expansion for France (as well as an opportunity to re-assert itself as a world power), I argue that the early part of the century can also be seen as a time of French division and colonial tension, especially with regard to its failures in Haiti and in its contemplation of future colonial expansion in Africa.[28]

France's desire to civilize outside (and inside) the "hexagon"[29] was intricately related to the creation of a French identity, one steeped in Enlightenment principles and moral fortitude. Feelings about the Dark Continent and, importantly, Haiti—which Bartmann could exemplify—needed to be controlled. Yet civilizing missions are rarely bloodless, or civilized. Like most self-proclaimed Great Powers, France believed itself to be the most civilized nation in the world. Why would lesser nations not want to become French? Ironically, it was in the process of civilizing others that what was considered "truly" French had to be examined, articulated, and implemented. Frederick Cooper and Ann Stoler contend that we must investigate "how . . . civilizing missions provided new sites for clarifying a bourgeois order, new definitions of social welfare, new ways in which the discourses and practices of inclusion and exclusion were contested and worked out."[30] Questions of what made France civilized—a word that would have greater and greater meaning—were hotly debated. The fear of the *classe dangereuse* (laborers), as well as peasants from the provinces and immigrants from abroad, drove the more genteel to lament France's potential loss of status, and bourgeois fears of internal "contamination" eroded the belief in their own cultural superiority.

France in the nineteenth century was a time and place where money, status, position, and one's social "breeding" were closely scrutinized and interpreted; reputations were often difficult to make, yet could be destroyed for involvement in the most minor of scandals, especially for women. The new domestic ideas of the bourgeoisie in nineteenth-century Paris also heightened tensions around the shift in gender boundaries.[31] Social status—no longer contingent upon birth—was dependent on successfully negotiating ever-changing rules of legitimacy. The aristocracy did not have to justify their standing; it was a result of birth. The bourgeoisie, however, were now in a situation where social class depended upon merit: "A ruined aristocrat was still an aristocrat; a ruined bourgeois was *déclassé*."[32] As such, status needed to be earned *and* confirmed constantly.[33] The *Journal des débats* wryly stated, "the bourgeoisie isn't a class, it's a position; you acquire it, you lose it."[34] Membership into the bourgeoisie was tenuous, and depended in part on proper behavior. This new emphasis on proper conduct turned greater scrutiny upon the peasants and workers in their midst, and it affected bourgeois relationships with other representations of difference or perceived abnormalities. Many members of the middle classes did not believe that the uncivilized lived only in Africa. As one Parisian mused about the urban poor, "You don't need to go to America to see

savages."[35] With the shift to a bourgeois worldview, "civilization" was no longer a given—it needed to be constructed as a product of work and effort. At the same time, while the French bourgeoisie was looking internally, it was also looking abroad to the Caribbean and Africa. Discourse surrounding Bartmann played a part, bringing the external home for scrutiny by all. Even amid this internal tension, the presence of an individual marked as different could codify a cohesive French identity. Bartmann's presence allowed the French to unite themselves by defining what was "French-ness." By holding themselves up against a specially defined and racialized "Other," elites could still claim cultural, racial, and political dominance; furthermore, the lower classes could throw off the shackles of perceived racial difference, while simultaneously imposing their previous status onto blacks.

Bartmann arrived in Paris in September 1814, having been abandoned by Cezar and sold or transferred to a man named Réaux.[36]

> At rue de Castiglione and for the same admission price, Réaux was also exhibiting a five-year-old male rhinoceros. Here, Parisians could view two animals for the price of one—one male and one female. Bartmann was also exhibited from 11am to 10pm at the ground level of 188, rue Saint-Honoré.[37]

Here, she proved to be every bit as popular (or notorious) as she had been in London, even though the cost of a ticket to "view" her (three francs) was prohibitive for anyone without disposable income.[38] At least at the beginning, this enabled the bourgeoisie to disseminate its thoughts about her first.

The *Journal des Dames et des Modes*[39] had this to say about one startling appearance: "The doors of the salon open, and the Hottentot Venus could be seen entering. She is a 'Callipygian Venus.' Candies are given to her in order to entice her to leap about and sing; she is told that she is the prettiest woman in all society."[40] It is a safe assumption that being told she was "the prettiest woman in all society" was received with great amusement by the viewing audience in this very proper salon, and that giving her candies in order to make her perform would reinforce the belief that, as with a dog, treats must be proffered in order to make her entertain. And the use of "Callipygian" was meant to be as amusing as "Venus," given that a large part of the fascination with her was because of her supposedly ill-formed and enormous buttocks.

For those who could not gaze upon her in person, the *Journal de Paris* displayed her picture, juxtaposed with that of a white actress (Anne Françoise Hyppolyte Boutet) who went by the stage name of Mademoiselle Mars and who had appeared in at least two plays by Alexandre Dumas.[41] The writer states: "Opposite this portrait [of The Hottentot Venus] we see that of Mademoiselle Mars, who in such a neighborhood is made to appear still more beautiful than she is, and, were we to be taxed with originality, we prefer the French Venus to the Hottentot one."[42] Bartmann is compared with the "classic" beauty of a famous French actress and found sadly lacking in charms. Measured against Bartmann's picture, Mademoiselle Mars becomes even more alluring. The irony of the two women's stage names is a point that cannot be overlooked. Mademoiselle Mars, named

for a decidedly masculine god of war and destruction, is upheld as the embodiment of feminine loveliness and delicacy, whereas the Hottentot Venus represents all that white French society sees as ugly, impure and revolting: a Venus in no one's estimation.

Bartmann's presence in Paris so permeated French consciousness that a play, titled *The Hottentot Venus, or Hatred of Frenchwomen,* premiered on November 19, 1814, at the Theater of Vaudeville.[43] Opening just months after her arrival, the play, which does not feature Bartmann herself, nevertheless attempts to portray the "essence" of her. The play's twice-divorced protagonist, Adolph, renounces future liaisons with Frenchwomen, whom he now finds distasteful. He determines that he will only marry a woman from an uncivilized race, a savage. His cousin Amelia, who desires him, dresses up like the Hottentot Venus in order to woo Adolph, who cannot tell that she is, in fact, a white Frenchwoman of noble breeding. Amelia is eventually revealed as his cousin (and equal), and they all live happily ever after.[44]

The construction of racial boundaries and the fears of miscegenation in the play are revealing of the culture's attitudes and satiric interests at the time, especially with regard to fluctuating and transgressive gender roles. While the play simultaneously skewers the stupidity of the aristocracy and instructs the bourgeois on proper conduct, it also casts Bartmann as the antithesis of acceptable French behavior and identity.

When the Baroness informs Amelia that her cousin Adolph will not see her, Amelia expresses indignation. The Baroness tells Amelia that Adolph, having been betrayed by Frenchwomen in two previous marriages, is determined to marry someone "foreign," a decision that makes him mentally unstable in his Aunt's eyes:

> **AMELIA:** I would have wagered so! This poor cousin! And since that time he has sworn an eternal hatred for all women?
> **BARONESS:** No; for all Frenchwomen.
> **AMELIA:** He doesn't have any *nationalist* spirit!
> **BARONESS:** And without having renounced marriage altogether, he has made a vow to only marry a women absolutely foreign to our customs and morals.
> **AMELIA:** You mean, a savage?
> **BARONESS:** Precisely.[45]

Here, Adolph's desire to abandon Frenchwomen is seen not only as madness, but also as an affront to French nationalism. And any woman not French must, by Amelia's estimation, be a savage. Later, Amelia meets with the Chevalier, who has designs to make her *his* bride. As they speak, he tells her of what is happening in Paris, including a new and amusing "spectacle":

> **AMELIA:** This is a striking tableau; it must be especially interesting to see a Hottentot woman.
> **CHEVALIER:** A woman! She is a Venus, madame! A Venus, who has arrived here in France from England, and who, at this moment, incites the admiration of all connoisseurs.
> **AMELIA:** So she is beautiful?

CHEVALIER: Oh! Of a frightening beauty. [*Singing a short song*]

AMELIA: Chevalier, no doubt they speak of her a great deal?

CHEVALIER: It is a question only of her. . . . She has some little Hottentot songs that are so gay! She takes little Hottentot steps that are so light, and in Paris they so cherish all that which is exquisite. All our ladies have already ordered for this winter dresses and overcoats in Hottentot styles.

AMELIA: (*aside*) This idea is bizarre. We will perform a comedy at my aunt's home.[46]

Amelia hatches her plan (which will, in effect, be a comedy) to win Adolph as her husband. With aid of the Baroness, she "transforms" herself into the Hottentot Venus. While she is disguised, Adolph is struck by her lack of civilized behavior, yet overcome by her beauty. He sings:

> You do not have all
> That strange and savage countenance of a country
> far away,
> Your gaze is sweet and serene,
> Grace animates your face,
> Charming object, in truth
> If it were not for your candor, your innocence,
> I would have believed, such as your beauty,
> That your fatherland was France.[47]

She is beautiful; therefore she must be from France, where true beauty resides. Interestingly, it is her "candor and innocence" which differentiate her from Frenchwomen, yet she remains, as he states, a "charming *object*."

Adolph decides to marry this perplexing creature, with whom he immediately and irrationally falls in love. But, in typical Vaudevillian style, reality sets in. First, Amelia is revealed as a fraud (the Chevalier shows the family a "real" picture of the Hottentot Venus, all of whom "cry out in fright" and exclaim, "with such a face / She cannot be a Venus").[48] The Baron exclaims, "Do you aim to make us believe, sir, that one there is a Hottentot, a people whose women are most renowned for their beauty?"[49] Finally, Adolph, understanding the unsuitability of marriage with a black savage, tells Amelia he will chance marriage again with a Frenchwoman. The family is greatly relieved to have prevented such a calamity, and all sing of the imperative of "not abandoning France."[50]

Is it possible that Amelia could be mistaken for a black Hottentot? How could Amelia have fooled Adolph in the first place? One reason, ironically, is because of her supposed "similarity" to white Frenchwomen. When Amelia (in Hottentot disguise) laughs at Adolph's advances, his response is telling:

ADOLPH: Why does she laugh at my tenderness?

BARON: It's the custom of her country! / They always laugh at their suitors there.

ADOLPH: Everywhere is thus like Paris.[51]

Another reason is due to prior deceit. When Adolph speaks with his uncle, the Baron, the Baron tells Adolph he "knows" about all women. This of course is a lie. Yet it is this deception that propels Adolph to seek out his "savage" in the first place.

> **BARON:** Yes, I know that you do not want a Frenchwoman; you must have an exotic one, and I applaud your resolve.
>
> **ADOLPH:** I was so disgracefully deceived!
>
> **BARON:** It is true that except for Native American women and Hottentots, I have not seen any who are prettier. Avoid them with care until my return. I promise to search for the woman you want, if I have to scour the four corners of the globe.[52]

The Baron, who has never once been to the four corners of the globe, has no idea about the beauty of these "exotic" women. All of his exploits and adventures have only happened in the confines of his imagination. Sarah Bartmann, the Hottentot Venus, emerges only as a series of representations, first by Amelia, and second in a picture that causes horror. Adolph's disgust "cures" him of his infatuation with Bartmann and, thus, blackness. Amelia is able to fool Adolph because he is foolish and because he believes the Baron when he is told that Amelia is "legitimately" a Hottentot: "I confess it, / She is really a Hottentot / Of the most beautiful sort."[53] Moreover, Amelia, a white French-woman, can appropriate Bartmann simply by hearing about her. Amelia "knows" the Hottentot Venus enough to impersonate her and to deceive Adolph, who, judging by his responses, can really only love white Frenchwomen. That Amelia is *always* known by the audience to be French is paramount.

The play is particularly informative in terms of the anxieties about proper roles for men and women. While on the one hand the play revolves around Adolph accepting Amelia—and thus French-ness—Adolph only reaches this point through Amelia's trans-gression (through the adoption of a racialized and sexualized persona). Adolph and Amelia marry, and interracial coupling is thus prevented. In his acceptance of Amelia, Adolph resumes his proper role as patriarch, while Amelia returns to her proper domes-tic role and her public persona, albeit as one who can reincarnate herself as the exotic and wild Hottentot woman in private. In this way, the play serves to both unsettle and reaffirm racial and gender categories.

Bartmann exacerbated these anxieties while she, because of her race and gender, simultaneously provided an outlet for the articulation of those very same tensions. Black women like Bartmann were entitled to none of the protection (or respect) afforded certain white French women like Amelia, yet still afforded a gender-specific discussion. They were also too few in number within the Metropole (unlike in a place such as Haiti) to offer much resistance.[54] Blackness as an ideology became a marker of ugliness and sexual deviance, and importantly, allowed white women a role in the definition of race and nation.

Bartmann's importance to French society unfortunately did not end when she died.[55] Scientists Georges Léopold Cuvier and Johann Friedrich Blumenbach were among those credited with the establishment of the field of physical anthropology.[56] European sci-entific communities (particularly French and German) made considerable effort to evaluate and classify people of African descent via medical journals and conferences,

anthropological studies, and legal statutes. The emergence and importance of so-called hard sciences in France in the eighteenth and nineteenth centuries as a means to explain nature cannot be underestimated in the defining of race and nation, because the "empirical knowledge" provided by scientific study became an important way to make sense of so many confusing reorganizations; long-standing discussions on race merged with these studies. Race and gender became inextricably intertwined with scientific constructs, merging ideas of classifications of humans and animals, as well as writings about where and in whom sexual pathology resided. Here again, the tensions first raised in eighteenth-century French thought gave way to pondering within the French middle classes over acceptable societal boundaries. These questions would be worked out, this time, under the guise of "impartial" scientific rhetoric.

A perfect opportunity presented itself to Cuvier (appointed Surgeon General by Napoleon Bonaparte) when Bartmann died in Paris in 1815; upon her death, Cuvier requested and obtained permission to study her more closely. He made a plaster molding of her body and dissected her buttocks; he then preserved her brain and her genitals in specimen jars. But the real prize of Cuvier's anatomical dissection was found when he moved between her legs:

> The famous "Hottentot apron" is a hypertrophy, or overdevelopment, of the labia minora, or nymphae. The apron was one of the most widely discussed riddles of female sexuality in the nineteenth century. . . . As Cuvier . . . noted: "There is nothing more famous in natural history than the apron of the Hottentots, and at the same time nothing has been the object of so many debates."[57]

Cuvier explained: "We did not at all perceive the more remarkable particularity of her organization; she held her apron . . . carefully hidden, it was between her thighs, and it was not until her death that we knew she had it."[58] Although Cuvier had made his "amazing discovery" between the legs of the infamous Hottentot Venus, he still needed to *enter* her "darkness" to really know her. So he examined

> the interior of her vulva and womb, and finding nothing particularly different, he move[d] on to her "compressed" and "depressed" skull and pelvic bone, [which he likened to those of a monkey]. . . .
> . . . In 1816, closing his chapter on the black female body, he "had the honor of presenting the genital organs of this woman to the [French] Académie, prepared in a manner so as not to leave any doubt about the nature of her apron."[59]

Cuvier stated that the "secrets" that the Hottentot hid between her legs had now been definitively uncovered and analyzed.[60]

European males could establish the "inherent superiority" of their own racial intelligence, simultaneously contributing to the elevation of white women, just by showing how different black females were. Anne McClintock shows that

> All too often, Enlightenment metaphysics presented knowledge as a relation of power between two gendered spaces, articulated by a journey and a technology

of conversion: the male penetration and exposure of a veiled, female interior; and the aggressive conversion of its "secrets" into a visible, male science of the surface.[61]

Having already arranged (along with Henri de Blainville) to have Bartmann sketched and examined for three days at the *Jardin du roi* in March 1815, these new findings added a certain weight to Cuvier's final conclusions. In revealing his discoveries, Cuvier took pains to compare Bartmann with European women, which he did by highlighting the difference in genitalia.[62] Tellingly, he determined that the black female was much closer to monkeys than to European women.

Anne Fausto-Sterling points out that "Cuvier most clearly concerned himself with establishing the priority of European nationhood; he wished to control the hidden secrets of Africa and the woman by exposing them to scientific daylight."[63] But his gaze at Bartmann was not entirely scientific; and his obsession with her sexuality cannot be subsumed under scientific rhetoric. Although he stated that her movements resembled an orangutan, he noted, "she spoke several languages, had a good ear for music, and possessed a good memory."[64] He also commented that her neck and arms were some-what "graceful," and that her hands were "charming," not exactly scientific analysis. Yet he took pains to state that her face repelled him.[65] His own gaze reveals interesting slippages, for Bartmann was clearly fascinating to him in ways that exceeded his scientific authority.

Cuvier "proved" the Otherness of Sarah Bartmann, showed her as a deformed being in comparison with white Frenchwomen, and re-asserted European white male scientific dominance over both white and black women. But he did more than that. He helped to further legitimate France's colonial project.

Critically, the middle class was complicit and an important factor in this updated definition of French citizenship. What is explicit is that France's national identity was "natural," while black identity was not. Bartmann was the icon[66] the French used to direct their gaze; use of such an icon was, in fact, a way for bourgeois Frenchmen and women to raise their own expectations of normative race, gender, class, and sexual identity. The Hottentot Venus became the terrain for projecting all that was dangerous for French national identity, such as gender inappropriateness, class transgressions, and racial miscegenation.[67] At the same time, command over her made up for losses in the Caribbean colonies and gave further justification for the African colonial project. Furthermore, her availability to be viewed meant that one could use her body (either for fantasy or as a substitute for articulating those fantasies) without personal accountability. It seemed to invite the gaze, even as it allegedly repelled the viewer—flagrant public semi-nudity was proof of her corruption. Lowering their gazes upon Sarah Bartmann reminded the French middle-class that Africans needed to be resisted, even if Africa was to be dominated.

Acknowledgments: The author wishes to thank Stephanie Li and Sarah Horowitz for their excellent insights; any errors, of course, remain the author's own.

Epigraph: Darcy Grimaldo Grigsby, *Extremities: Painting Empire in Post-Revolutionary France* (London: Yale University Press, 2002), 87.

1. Mrs. Mathews (Anne Jackson), *Memoirs of Charles Mathews, Comedian* (London: Richard Bentley, 1839), vol. IV, 137. Apparently, touching Bartmann required an "additional fee," 139.

2. The London *Times*, 26 November 1810, 3.

3. The common belief that representations of black women in French culture are a twentieth-century phenomenon is not surprising, especially given the enormous impact of Josephine Baker on 1920s Paris. In fact, art historian Petrine Archer-Straw makes an interesting observation in her text dealing with what she calls "Negrophilia" and the Avant-Garde in Paris. Archer-Straw concludes that the white artistic interactions with black culture in the 1920s were not about blackness. Rather, they "were really about whiteness and about providing Europeans with a new sense of direction," *Negrophilia: Avant-Garde Paris and Black Culture in the 1920s* (New York: Thames & Hudson, 2002).

4. For discussions of this topic see Londa Schiebinger, *Nature's Body: Gender in the Making of Modern Science* (Piscataway, NJ: Rutgers University Press, 2004), Donna Haraway, "Situated Knowledges: The Science Question in Feminism and the Privilege of Partial Perspective," *Feminist Theory Reader: Local and Global Perspectives*, eds. Carole R. McCann and Seung-kyung Kim (New York: Routledge, 2003), and Gyan Prakash, *Another Reason: Science and the Imagination of Modern India* (Princeton, NJ: Princeton University Press, 1999).

5. My dissertation (University of California, Berkeley, 2010) examining representations of black women in nineteenth-century Parisian society will substantially expand this discussion.

6. The historiography of blacks in France is multifaceted and rapidly growing (this list is by no means comprehensive), from historian Sue Peabody's brilliant and painstaking work of (re)inserting black histories in eighteenth-century France, *There Are No Slaves in France: The Political Culture of Race and Slavery in the Ancien Regime* (New York and Oxford, UK: Oxford University Press, 1996) to Petrine Archer-Shaw's *Negrophilia: Avant-Garde Paris and Black Culture in the 1920s*. Documentation of blacks in France began as early as 1961, when historian Shelby Thomas McCloy wrote *The Negro in France* (New York: University of Kentucky Press, 1961). Hans Werner Debrunner's work, *Presence and Prestige: Africans in Europe, A History of Africans in Europe before 1918* (Switzerland: Baster Africk Bibliographen, 1979) is an important bibliography on Africans throughout Europe; William B. Cohen's newly reprinted *The French Encounter with Africans: White Response to Blacks, 1530–1880,* foreword by James D. Le Sueur (Bloomington: Indiana University Press, 2003, 1980) and Pierre H. Boulle's *Race et esclavage dans la France de l'Ancien Régime* (Paris: Perrin, 2007) are arguably the most helpful works on the history of France and its early interactions with blacks. Research on blacks in literary and post-war France is especially rich; Michel Fabre introduced a long overdue work on black American writers in France in *From Harlem to Paris: Black American Writers in France, 1840–1980* (Urbana and Chicago: University of Illinois Press, 1991). Tyler Stovall's book, *Paris Noir: African Americans in the City of Lights* (Boston and New York: Houghton Mifflin Company, 1996) presents a compelling look at black life in Paris in the twentieth century. Christopher L. Miller's *Blank Darkness: Africanist Discourse in French* (Chicago and London: University of Chicago, 1985) investigates the Africanist image in French literature to determine a linguistic discourse. Other useful works include Gen Doy, "More than Meets the Eye: Representations of Black Women in Mid-19th Century French Photography," *Women's Studies International Forum* 21 (3; May 1998). See also *The Image of the Black in Western Art,* with a foreword by Amadou-Mahtar M'Bow (Fribourg: Office du livre, 1976–1989).

7. T. Denean Sharpley-Whiting, "The Dawning of Racial-Sexual Science: A One Woman Showing, A One Man Telling, Sarah and Cuvier." *FLS: Ethnography in French Literature,* vol. 23 (Amsterdam: Editions Rodopi, 1996), 116. See also Percival Kirby, "More about the Hottentot Venus," *Africana Notes and News* (Johannesburg, South Africa) 10 (4; September 1953), 128. Percival Kirby is one of the first historians to take Sarah Bartmann on as a historical "subject." From 1935 to 1954, Kirby, often in breathy tones, regaled his readers with tales of this "abnormal specimen." Kirby deserves credit for bringing Bartmann to historical attention, particularly as early as he did; however, he must also be recognized as continuing a strategy of (re)making her into a public spectacle, ripe for the titillated gaze (his illustrations include skeletal measurements, as well as engravings of Bartmann). Thus, his writings, however important, must be read both cautiously and critically.

8. See "The Following Is the Result of the Examination of the Hottentot Venus—27th Nov. 1810," a sworn deposition of the court signed Samuel Solly, representative for Zachary Macaulay, and John George Moojen, representative for Alexander Dunlop and Henrick Caesar, dated 28 November 1810. Record PFF 723 (J18/462), Public Records Office, London.

9. Kirby, "More on the Hottentot Venus," 125.

10. Bernth Lindfors, "'The Hottentot Venus' and Other African Attractions in Nineteenth-Century England," *Australasian Drama Studies* 1 (1983), 86. See also Percival Kirby, "The Hottentot Venus," *Africana Notes and News* (Johannesburg, South Africa) 6 (3; June 1949), 55. Dunlop is also notable for his penchant for exporting "museum specimens" from South Africa.

11. Sharpley-Whiting, "The Dawning of Racial-Sexual Science," 117.

12. Court records claim the period of servitude to be six years. See Bernth Lindfors "'The Hottentot Venus' and Other African Attractions in Nineteenth-Century England," 86–87.

13. See Bartmann's Baptismal Certificate, 7 December 1814, *Musée de l'Homme,* Paris, France. The move to baptize Bartmann may have been a ploy to wrap her in a cloak of religion, thus minimizing criticism of her sexualized display in England.

14. The London *Times,* 26 November 1810, 3.

15. Ibid. Critics seized upon her countenance as a way to prove she was being held against her will.

16. Bartmann's new moniker, given to her in London, announces a shift in her public identification. See "Transcripts of the Sworn Affidavits Filed During the Trial of 1810," deposition of Zachary Macaulay, Thomas Gisborne Babington, and Peter Van Wageninge, dated 17 October 1810, Record PFF 747 (KB1/36), Public Records Office, London.

17. Kirby, "The Hottentot Venus," 57.

18. See "The Following Is the Result."

19. A sworn deposition of the court signed A. J. Guitard, dated 27 November 1810. Record PFF 723 (J18/462), Public Records Office, London.

20. I do not mean to imply that because British abolitionists sought to end Bartmann's display that Londoners were somehow better behaved than their French counterparts. The caricatures of Bartmann underscore her importance in establishing Englishness as well, albeit often in political cartoons. Unfortunately, it is beyond the scope of my discussion to give Bartmann's time in England the full attention it deserves.

21. Louis Sala-Molins, *Le Code Noir ou le calvaire de Canaan* (Paris: Quadrige/PUF, 1987).

22. Robert Louis Stein, *The French Slave Trade in the Eighteenth Century: An Old Regime Business* (Madison: The University of Wisconsin Press, 1979), xiii.

23. Christopher L. Miller, *The French Atlantic Triangle: Literature and Culture of the Slave Trade* (Durham, NC, and London: Duke University Press, 2008), 22.

24. Miller, 26.

25. See C.L.R. James, *The Black Jacobins: Toussaint L'Ouverture and the San Domingo Revolution,* 2nd Ed. Rev. (New York: Vintage Books Edition, 1969). See also Laurent Dubois, *A Colony of Citizens: Revolutions and Slave Emancipation in the French Caribbean, 1787–1804* (Chapel Hill and London: University of North Carolina Press for the Omohundro Institute of Early American History and Culture, Williamsburg, Virginia), 2004.

26. Martin Klein, *Slavery and Colonial Rule in French West Africa* (Cambridge: Cambridge University Press, 1998), 19.

27. William B. Cohen, *The French Encounter with Africans,* 119–120.

28. See Cohen, *The French Encounter with Africans,* passim.

29. The hexagon refers to the six-sided shape of France; hence the nickname.

30. Cooper and Stoler maintain that rather than a one-sided trajectory from the metropole to the colony, the metropole was equally shaped by its colonial experiences. Moreover, Cooper and Stoler assert that analysis of these interconnections creates a new space for understanding how different locations in Europe constructed and reconstructed themselves and their colonial "others." See Frederick Cooper and Ann Laura Stoler, "Between Metropole and Colony: Rethinking a Research Agenda," *Tensions of Empire: Colonial Culture in a Bourgeois World,* ed. Frederick Cooper and Ann Laura Stoler (Berkeley, Los Angeles, and London: University of California Press, 1997), 16.

31. Just as it is impossible to compartmentalize France as a single-acting entity, to speak of the multifaceted peoples who inhabited nineteenth-century Paris as a homogenous group is simplistic, ignoring the masses populating the capital. Even dividing the so-called bourgeoisie into more manageable categories—the grande bourgeoisie, the petite bourgeoisie—ignores the fluidity of the participants therein and assumes that these categories do not need to be further analyzed or examined. What has been established with relative certainty is that the middle classes were in a much more powerful position

by 1792 than they had been under the previous monarchy, and that with their new standing, past categories of acceptable behavior needed to be updated.

32. Jesse R. Pitts, "Continuing and Change in Bourgeois France," in Stanley Hoffman et al., eds., *In Search of France* (Cambridge: Harvard University Press, 1963), 252, as quoted in James Johnson, *Listening in Paris: A Cultural History* (Berkeley, Los Angeles, London: University of California Press, 1995), 231.

33. As Johnson puts it, "bourgeois identity was in large part dependent upon confirmation by others members of the bourgeoisie," *Listening in Paris,* 233.

34. *Journal des débats,* 17 December 1847, as quoted in Johnson, *Listening in Paris,* 231.

35. Eugen Weber, *Peasants Into Frenchmen: The Modernization of Rural France, 1870–1914* (Palo Alto: Stanford University Press, 1976), 3.

36. Her Parisian handler, Réaux was also a "showman of wild animals in a traveling circus." See "Bring Back the Hottentot Venus," *Weekly Mail & Guardian* (formerly *The Weekly Mail & Guardian*), June 15, 1995.

37. T. Denean Sharpley-Whiting, "Writing Sex, Writing Difference: Creating the Master Text on the Hottentot Venus," in *Black Venus: Sexualized Savages, Primal Fears, and Primitive Narratives in French* (Durham, NC: Duke University Press, 1999), 19.

38. The cost of a loaf of bread at this time was over one franc; the average male laborer earned less than 3 francs daily, women even less. See Johannes Willms, *Paris: Capital of Europe: From the Revolution to the Belle Époque,* trans. Eveline L. Kanes (New York and London: Holmes & Meier, 1997), 154–162.

39. According to Sharpley-Whiting, this journal was very popular and widely read. See "Writing Sex, Writing Difference," 18.

40. *Journal des Dames et des Modes,* 12 February 1815, quoted in Sharpley-Whiting, "Writing Sex, Writing Difference," 19. See also Bernth Lindfors, "'The Hottentot Venus' and Other African Attractions," 88.

41. See Shelby T. McCloy, *The Negro in France,* 169.

42. *Journal de Paris,* quoted in Kirby "More about the Hottentot Venus," 130.

43. Marie-Emmanuel-Guillaume-Marguerite Théaulon, Armand Dartois, and Brasier, *La Vénus hottentote, ou haine aux Françaises.* The original is located in the Bibliothèque Nationale de France, Paris, Department of Printed Matter, Microfilm, call #* Yth 18862. An English translation of the play in its entirety appears in T. Denean Sharpley-Whiting, *Black Venus: Sexualized Savages, Primal Fears, and Primitive Narratives in French* (Durham, NC: Duke University Press, 1999), 127–164. There was also a song about Bartmann that appeared around the same time, entitled "La Vénus Hottentote du Jardin d'Acclimatation," Actualité créée par Melle. Derley et paroles de M.M.A. Porte and H. Vernet; Musique de L. Mayeur (Imp. H. Sicard, Paris).

44. Théaulon et al., *La Vénus hottentote, ou haine aux Françaises,* as translated by T. Denean Sharpley-Whiting in *Black Venus,* 162–164.

45. Ibid., 130 [emphasis mine].

46. Ibid., 138–139.

47. Ibid., 155.

48. Ibid., 160–161.

49. Ibid., 161.

50. Ibid., 162–163.

51. Ibid., 150.

52. Ibid., 149.

53. Ibid., 132.

54. Black women are critically important for analysis because of how scientists fixated on their bodies to articulate disease, abnormality (especially as opposed to bourgeois white women), and sexual pathology. Anne McClintock posits women as the boundary markers of empire, stating that "women served as mediating and threshold figures by means of which men oriented themselves in space, as agents of power and agents of knowledge." See McClintock, *Imperial Leather: Race, Gender and Sexuality in the Colonial Contest* (New York and London: Routledge, 1995), 24.

55. According to Lindfors, her smallpox was misdiagnosed by the doctor who treated her. See Kirby, "'The Hottentot Venus' and Other African Attractions," 89.

56. See Johann Friedrich Blumenbach's essay, "The Degeneration of the Races," and Georges Cuvier's essay, "The Race from Which We Are Descended Has Been Called Caucasian . . . the Handsomest on Earth," in *Race and the Enlightenment: A Reader,* ed. Emmanuel Chukwudi Eze (Malden, MA, and Oxford, UK: Blackwell, 1997).

57. Sharpley-Whiting, "Writing Sex, Writing Difference," 27–28.

58. Georges Cuvier, quoted in Sharpley-Whiting, "Writing Sex, Writing Difference," 27. Cuvier had apparently attempted to see between her legs while she was alive, but she would not let him.

59. Sharpley-Whiting, "Writing Sex, Writing Difference," 29–30.

60. Georges Cuvier, "Extraits d'observation faites sur le cadavre d'une femme connue à Paris et à Londres sous le nom de Vénus Hottentote," in *Discours sur les révolutions du globe* (Paris: Passard, 1864), 266.

61. McClintock, *Imperial Leather,* 23.

62. Cuvier, "Extraits d'observation," 269.

63. Fausto-Sterling, "Gender, Race and Nation," 35.

64. Ibid., 36.

65. Ibid., 37.

66. Gilman states: "Rather than presenting the world, icons represent it. Even with a modest nod to supposedly mimetic portrayals it is apparent that, when individuals are shown within a work of art (no matter how broadly defined), the ideologically charged iconographic nature of the representation dominates. And it dominates in a very specific manner, for the representation of individuals implies the creation of some greater class or classes to which the individual is seen to belong. These classes in turn are characterized by the use of a model which synthesizes our perception of the uniformity of the groups into a convincingly homogeneous image." Sander L. Gilman, "Black Bodies, White Bodies: Toward an Iconography of Female Sexuality in Late Nineteenth-Century Art, Medicine, and Literature" in *"Race," Writing, and Difference,* ed. Henry Louis Gates Jr. and Kwame Anthony Appiah (Chicago: The University of Chicago Press, 1986), 223.

67. This usefulness extended several decades after her death; a poster for the Grand Musée Anatomique, dated 1870/71, advertises a showing of "La Véritable Vénus Hottentote," Musée de la Publicité, reference #10859.

3 Which Bodies Matter?

Feminism, Post-Structuralism, Race, and the Curious Theoretical Odyssey of the "Hottentot Venus"

Any scholar wishing to advance an argument on gender and colonialism, gender and science, or gender and race must, it seems, quote Sander Gilman's "White Bodies, Black Bodies: Toward an Iconography of Female Sexuality in Late Nineteenth-Century Art, Medicine, and Literature." First published in a 1985 issue of *Critical Inquiry,* the article has been reprinted in several anthologies. It is cited by virtually every scholar concerned with analyzing gender, science, race, colonialism, or their intersections (Haraway 1989; Vaughan 1991; Crais 1992; Gordon 1992; hooks 1992; Rattansi 1992; Schiebinger 1993; Wiss 1994; Fausto-Sterling 1995; McClintock 1995; Pieterse 1995; Stoler 1995; Abrahams 1997; Thomson 1997; Loomba 1998; Lindfors 1999; Sharpley-Whiting 1999; Strother 1999).[1]

In the article Gilman uses Sarah Baartmann, the so-called "Hottentot Venus," as a means of showing how medical, literary, and scientific discourses work to construct images of racial and sexual difference. The basic premise of Gilman's argument is summed up in this frequently quoted passage:

> The antithesis of European sexual mores and beauty is embodied in the black, and the essential black, the lowest rung on the great chain of being, is the Hottentot. The physical appearance of the Hottentot is, indeed, the central nineteenth-century icon for sexual difference between the European and the black. (1985a, 212)

Gilman's analysis of Baartmann was the genesis for a veritable theoretical industry. After the publication of Gilman's article Baartmann was, in the words of Z. S. Strother, "recapitulated to fame" and became "an academic and popular icon" (1999, 1). The theoretical groundswell her story precipitated cannot be separated from the growing popularity of post-structuralist analyses of race and gender. The ways in which science, literature, and art collectively worked to produce Baartmann as an example of racial and sexual difference offered exemplary proof that racial and sexual alterity are social constructions rather than biological essences. Thus, her story was particularly compelling for anyone interested in deconstructing difference and analyzing the "Othering" process.

The fact that Gilman's article has been "instrumental in transforming Baartmann into a late-twentieth century icon for the violence done to women of African descent"

(Strother 1999, 37) makes it even more critical that we reconsider the ways in which Baartmann, as both subject and object, has been deployed theoretically. In the pages that follow, I will argue that although most studies that discuss Baartmann (or Gilman's analysis of her) are scrupulous in their use of words like "invented," "constructed," and "ideological," in their practice they valorize the very ground of biological essentialism they purport to deconstruct.

Thus, in this article I examine the parameters of inquiry that have structured how scholars have posed their research questions. I am particularly interested in looking at what assumptions about racial and sexual difference inform the theoretical orthodoxy about Baartmann. I argue that most theorists have, following Gilman's theoretical lead, focused obsessively on Baartmann's body and its difference. As a result, they have accepted, without question, his core assertion that "by the eighteenth century, the sexuality of the black, both male and female, becomes an icon for deviant sexuality in general" (Gilman 1985a, 209). They have not, however, asked, "What social relations determined which people counted as black?" "For which people did blacks become icons of sexual difference and why?" Nor have they investigated the important differences that marked how social actors in different structural locations saw and experienced Baartmann—in particular her very different interpellation into French versus British medicine and science. As a result, their work has actually placed Baartmann *outside* history.

In the interest of placing Baartmann (and racial and sexual alterity) back within history, the remainder of this essay will take issue with and disprove three of Gilman's core assertions. The first assumption I disprove is that Europeans' fears of the "unique and observable" physical differences of racial and sexual "Others" was the primary impetus for the construction and synthesis of images of deviance. The second assumption I challenge is that ideas about "blackness" remained relatively static and unchanged throughout the nineteenth century. The final assumption I critique is that Baartmann evoked a uniform ideological response, and her sexual parts represented the "core image" of the black woman in the nineteenth century. The article will conclude with a discussion of the theoretical lapses that precipitated Baartmann's recent theoretical fetishization.

Ways of Seeing: Hierarchies of Value and the Social Construction of Perceptions

Long before the first post-structuralist put pen to paper, Emile Durkheim (1982, 34) argued that "social life is made up entirely of representations" (34). His strongest criticisms were directed against social theorists who naturalized these representations, treating them as the result of universal sensory impressions rather than historically specific cultural creations. He thus argued that

> consciousness allows us to know them [representations] well up to a certain point, but only in the same way as our senses make us aware of heat or light, sound or electricity. It gives us muddled impressions of them, fleeting and subjective, but provides no clear, distinct notions or explanatory concepts. (36)

Durkheim argued that representations must be analyzed like social facts (1982, 36). Viewing representations as social facts, he explained, "is not to place them in this or that category of reality; it is to observe towards them a certain attitude of mind." He was essentially arguing that analyses of psychic impressions must give way to analyses of social relations if the theorists are to arrive at a sophisticated understanding of how we perceive and order our world.

It appears that Gilman (1985a) was determined not to repeat the mistakes of a generation of theorists before and after Durkheim when he began his essay with this compelling question: "How do we organize our perceptions of the world?" His analysis suggests that he sees differences as "myths" that are "perceived through the ideological bias of the observer" (204). However, the ahistorical perspective he adopts on how human beings perceive "difference" and organize hierarchies of value belies this seemingly radical constructivist stance. Gilman essentially argues that ideas about difference are the unmediated reflex of psychic impressions. In his analysis, the visible stigmata of racial and corporeal abnormality—what he terms "unique and observable physical difference"—are of key importance (212). He argues that the scientific discourse of degeneracy, which was key in pathologizing the Other, devolved primarily in relation to non-European peoples as an expression of fears about their corporeal difference:

> It is thus the inherent fear of the difference in the anatomy of the Other which lies behind the synthesis of images. The Other's pathology is revealed in anatomy. . . . The "white *man's* burden" thus becomes his sexuality and its control, and it is this which is transferred into the need to control the sexuality of the Other. . . . This need for control was a projection of inner fears; thus, its articulation in visual images was in terms which described the polar opposite of the European male. (237)

Despite his ahistoricism and psychological determinism, a number of feminist scholars wholeheartedly embraced Gilman's analysis. Several, following Gilman's theoretical lead, argued that Cuvier's dissection was an expression of his inner fears of Baartmann's anatomical difference and his need for control (Haraway 1989; Schiebinger 1993; Fausto-Sterling 1995; Sharpley-Whiting 1999). Fausto-Sterling was clearly drawing on Gilman when she argued:

> Cuvier most clearly concerned himself with establishing the priority of European nationhood; he wished to control the hidden secrets of Africa and the woman by exposing them to scientific daylight. . . . Hence he delved beneath the surface, bringing the interior to light; he extracted the hidden genitalia and defined the hidden Hottentot. Lying on his dissection table, the wild Baartmann became the tame, the savage civilized. By exposing the clandestine power, the ruler prevailed. (1995, 42)

Anne McClintock also employed Gilman in support of her claim that it was necessary to invent visible stigmata to represent—as a commodity spectacle—the historical atavism of the degenerate classes. As Sander Gilman has pointed out, one answer was

found in the body of the African woman, who became the prototype of the Victorian invention of primitive atavism (1995, 41).

In following Gilman's lead and analyzing the discourse of degeneracy as a product of psychological dispositions, these accounts cannot explain the paradoxical stance of the founder of the science of degeneracy, Augustine Benedict Morel. Morel argued "between the intellectual state of the wildest Bushman and that of the most civilized European, there is *less difference* than between the intellectual state of the same European and that of the degenerate being" (emphasis mine; Pick 1989, 26). Morel's comments become even more striking when we recall that many scientists and travelers believed that Baartmann was a female member of the so-called 'Bushman' tribe.

Morel's comments become much more understandable if we proceed from the assumption that social relations, rather than psychological dispositions, provide the background and context for human encounters. Degeneration, as an explanatory framework, did not develop in response to external "Others" and their corporeal alterity. Rather, the discourse was a response to fears about the blurring of class and status differences within the European polity. This was considered far more threatening than the racial and sexual alterity of non-European peoples. Malik explains that, "for the ruling classes equality and democracy were themselves symptoms of degeneracy" (1996, 112). What was distinctive about the idea of degeneration was that external features were *not* reliable indicators of its existence. Degeneration was not always (or even primarily) associated with "unique and observable physical differences." As Pick (1989) explains, degeneration was considered so dangerous precisely because it was a process capable of usurping all boundaries of discernible identity. Degeneracy was marked by its slow, invidious, and *invisible* proliferation.

The importance of analyzing social relations, rather than enumerating psychological dispositions, is nowhere more evident than in Georges Cuvier's stance on the Great Chain of Being. The Great Chain of Being was a theory that speculated all creatures could be arranged on a continuous scale from the lowliest insect to the most highly evolved human. After the publication of Gilman's article, Cuvier became popularly (and erroneously) associated with the Great Chain of Being (Gordon 1992; Sharpley-Whiting 1999; Strother 1999). Wiss, for example, asserts that "Cuvier, by fractioning the gradual continuities of the 'great chain of being' was able to divide humanity into four distinct races" (1994, 29).

What these analyses do not and cannot account for is Cuvier's stubborn and enduring *resistance* to the doctrine. As Appel explained:

> Of all the speculative theories, the one that most aroused Cuvier's passions was the eighteenth-century doctrine of the chain of being. It became in effect his *bete noire*. . . . Cuvier's main stated objection to the chain was that it was a speculative *a priori* scheme that went beyond the facts. . . . By 1812 Cuvier had already renounced even the possibility of arranging classes along a scale of perfection. (1987, 50–51)

Cuvier's stance can be better understood if it is analyzed in relation to nineteenth-century European class dynamics, rather than simply concluding that his actions reflect the generalized psychological dispositions and fears of European males. Indeed, his

disaffection for the notion of a Great Chain of Being stemmed equally from socio-political sources as it did from scientific or psychological sources.

In Cuvier's day, it was commonly believed that speculative philosophies had been the source behind the French Revolution. During the Revolution scientific theories had been intensely politicized. Thus, Cuvier was acutely aware of the power that unregulated ideas, political or scientific, could have on the masses. The ideas of Mesmer, for example, had been joined to the revolutionary ideas of Rousseau, as were Felix Pouchet's ideas about spontaneous generation. Cuvier associated speculative theories with materialism and feared that the two taken in tandem could be used to promote social unrest. Speculative theories could, in his opinion, be more easily exploited by the masses, who were intent on overturning the social order.

Thus, although Cuvier's observations about Baartmann suggest that he viewed her as sharing a number of affinities with apes, it is important to note that he never explicitly stated that she was the "missing link." His reluctance to do so tells us less about his attitudes toward racial and sexual alterity than it does about his attitudes toward class. It demonstrates his profound aversion to any action that could potentially endow the claims of the "dangerous classes" to equality and legitimacy. This aversion was strong enough to prevent him from drawing the "logical" conclusion about Baartmann, based upon his own empirical observations. As strong as Cuvier's fears about Baartmann's corporeal difference were, it appears his fears about the potential political equality of his fellow Frenchmen were even greater.

The actions of Cuvier demonstrate that the social relations of nineteenth-century France tell us far more about the process of constructing boundaries between Self and Other than do blanket generalizations about the psychological dispositions of European males. His behavior makes evident the truth of Barbara Fields's claim that "the idea one people has of another, even when the difference between them is embodied in the most striking physical characteristics, is always mediated by the social context within which the two come into contact" (1982, 148).

Sex and Savagery:
Africa in the Historical Imagination

The ahistorical and psychologically determinist perspective Gilman adopts in his discussions about degeneration and the Great Chain is even more pronounced in his discussions about race. The publication of "Black Bodies, White Bodies" in the anthology *"Race," Writing, and Difference,* edited by Henry Louis Gates Jr. and Kwame Anthony Appiah, was instrumental in securing the article's place as a foundational text in a "post-foundationalist" world. The anthology soon became one of the most cited texts in the fields of post-structuralism, feminism, critical race studies, and post-colonial studies. It is not difficult to ascertain why. In the introduction Gates explains that the purpose of the text was "to deconstruct the ideas of difference inscribed in the trope of race" (1986, 2). The title's use of quotation marks around the word race announced the volume's emphasis on critically engaging race as a discursively and socially constructed phenomenon. The characterization of race as a trope, and thus similar to any other kind of figurative language, was clearly meant to decisively and permanently

disrupt any notion of race as referring to innate biological or physical differences. Race, as a trope, is the ultimate empty signifier.

Although Gilman's intention is to argue that perceptions of difference are socially constructed, he focuses on Baartmann's "inherent" biological differences. He argues that "her physiognomy, her skin color, the form of her genitalia label her as inherently different" (1985a, 213). Gilman argues that because of her "unique and observable" physical differences, Baartmann represented "the black female *in nuce*" (212, 206). He thus concludes that, "while many groups of African blacks were known to Europeans in the nineteenth century, the Hottentot remained representative of the essence of the black, especially the black female" (206).

Gilman's theoretical adherents, with little question and much enthusiasm, took up the idea that Baartmann's physical stigmata transformed her into a representation of "the black female *in nuce*" (Schiebinger 1993; Wiss 1994; Fausto-Sterling 1995; McClintock 1995; Sharpley-Whiting 1999). Donna Haraway, for example, uses Gilman to support her claim that, because of their perceived biological differences, "Black women were ontologically the essence of animality and abnormality" (1989, 402).

Most scholars, in accepting Gilman's declaration about Baartmann's racial representativeness, have neither historicized nor problematized the idea of "blackness." They have made "the assumption that race is an observable physical fact, a thing, rather than a notion that is profoundly and in its very essence ideological" (Fields 1982, 144). However, as Wacquant observed, American conceptions of race are better thought of as "folk conceptions" which reflect the "peculiar schema of racial division developed by one country during a small segment of its short history" (1997, 223). The fact that many Baartmann scholars have unthinkingly reproduced commonsense understandings of "blackness" as it exists in the contemporary United States is evidenced by two historically untenable assumptions they make about race. The first assumption is that Baartmann's color and sexual difference not only marked her as "different" but also rendered her fundamentally *the same* as all other "black" people. The second assumption is that ideas about what constitutes "Africanity" and "blackness" have remained relatively unchanged over time.

The assumption that Khoikhoi people were considered broadly representative of Africans as a whole is central to Gilman's argument. It allows him to move from a discussion about Baartmann to making much broader claims about perceptions of African people as a whole. This theoretical maneuver allows him to argue that Baartmann represented "the black female *in nuce*." However, the reports of nineteenth-century travelers demonstrate that this particular assertion does not withstand historical scrutiny.

Travelers made much of the fact that the Khoikhoi were not "black" or "brown" but "yellow" or "tawny" and thus different in important respects from Africans living further North, as well as from those on the West coast (Barrow 1801; Lichtenstein 1812; Burchell 1822; Thompson 1827; Pringle 1834). Travelers and naturalists also drew sharp divisions between different classes of Khoikhoi people based on their color, culture, geographical location, and appearance. Barrow, for example, distinguished the so-called "colonial Hottentots" or "bastard Hottentots," who lived inside the colony, from those in the outlying regions ("savage Hottentots") who "retained more of their original character" (1801, 151). He went on to note that, although the "elongated nymphae [Hottentot apron] are found in all Hottentot women . . . in the bastard Hottentot

it ceases to appear" (1801, 281). Other travelers testified to the existence of different "races" within the "Hottentot nation." George Thompson, for example, remarked that "in personal appearance the Korannas are superior to any other race of Hottentots. Many of them are tall with finely shaped heads and prominent features" (1827, 269).

Even those travelers who did not make such fine distinctions between individual Khoikhoi people drew sharp distinctions between the Khoikhoi and other "black" ethnic groups within the Cape Colony. It was widely agreed that the Xhosa (called variously Kaffirs, Caffirs, and Caffers) and the San (pejoratively referred to as Bushmen) were wholly unlike the Khoikhoi. An article in the *Quarterly Review* remarked that, "no two beings can differ more widely than the Hottentot and the Caffre" ("Review of *Lichtenstein's Travels*": 1812, 388). Barnard Fisher likewise commented that "three races more distinct and unlike than the Hottentot, Caffre, and Bushman cannot possibly well be" (1814, 7). James Prior echoed Fisher when he marveled at the "marked differences as appear in the three races of Kaffir, Hottentot, and Bushman" (1819, 14).

The fact that historical evidence suggests that the Khoikhoi did *not* represent blackness *in nuce* is important because it forces us to return to the central question posed earlier: "How do we organize our perceptions of the world?" Gilman imputes a timeless stability to the idea of race. He argues that "the primary marker of the black is his or her skin color" (1985a, 231). However, skin color and hair textures were not stabilized as markers of racial difference until fairly late in the nineteenth century. Barrow, for example, observed that the Xhosa were "dark glossy brown verging on black." He also described them as having "short curling hair" (1801, 168). Nevertheless, he concluded that they had "not one line of the African Negro in the composition of their persons" (1801, 205). Lichtenstein concurred with Barrow that "the Kaffirs have in many respects a great resemblance to Europeans. Indeed they have more resemblance to them than either to Negroes or Hottentots" (1812, 303). Thomas Pringle echoed Barrow when, after describing the Xhosa as being "dark brown" and having "wooly hair," he declared them as having features that "approached the European model" (1834, 413). What these historical observations suggest is that "blackness" is less a stable, observable, empirical fact than an ideology that is historically determined and, thus, variable.

The profoundly ideological nature of "blackness" becomes even more apparent when we consider that, as Englishmen continued to speculate as to whether the "dark skinned" (by contemporary standards) Xhosa should be classified as Negroes, they were convinced that the "pale skinned" (again by contemporary standards) Irish most definitely *should* be. As Cheng noted, "the Irish/Celtic race was repeatedly related to the black race not merely in terms of tropes, but insistently as *fact*, as literal and biological relatives" (1995, 26). Indeed, much was made of the "unique and observable physical differences" (to borrow a phrase from Gilman) that separated the Anglo-Saxons from the Celts. Dr. John Beddoe, founding member of the British Ethnological Society, devoted most of his career to establishing that the Irish Celts were not only genetically distinct from and inferior to Anglo-Saxons, but also bore biological affinity to Negroes. His work served to "confirm the impressions of many Victorians that the Celtic portions of the population in Wales, Cornwall, Scotland, and Ireland were considerably darker or more melanous than those descended from Saxon and Scandinavian forbears" (Curtis 1997, 20). Beddoe was by no means alone in his estimation of the "Africanoid" origin of the Irish (Price 1829; Bentham 1834; Prichard 1857).

I have gone to such lengths to demonstrate that (1) the Khoikhoi were not considered representative of Africans; (2) not all Africans were thought of as Negroes; and (3) not all Negroes were "black" for two reasons. My first objective is to challenge Gilman's core assertions and thus unsettle the theoretical orthodoxy about Baartmann. My second objective is to make a larger sociological point about ideologies about "racial differences" (or any other kind of differences for that matter).

As the above selections from British travel writing, missionary reports, and related ephemera so graphically illustrate, there was no uniform opinion on the Khoikhoi or other Africans with regard to sexuality, appearance, habits, or otherwise. This is because "race is not an idea but an ideology. It came into existence at a discernible historical moment for rationally understandable historical reasons and is subject to change for similar reasons" (Fields 1990, 101). Races are not clearly demarcated and bounded groups existing "out there" in the world, prior to the process of categorization. English perceptions of the Irish make it clear that the characteristics that we currently identify as important for establishing difference (i.e., "dark" skin) were not pre-existing in the world, simply waiting for someone (scientists, colonialists, travelers, Europeans) to come along and construct a hierarchy of value. Rather, what we "see" when we look at each other is profoundly mediated by social context. Whether we are looking at the source of discourses of degeneration or at impressions of biological characteristics, the end result is the same. An analysis that does not go beyond psychological impressions to consider the importance of social relations will do nothing more than produce theories that explain "not the facts . . . but the preconceptions of the author before he [sic] began his research" (Durkheim 1982, 38).

When and How Do Bodies Matter?
Science, Sex, and Ideological Struggle

There is no doubt that the express aim of post-structuralist scholarship on Baartmann has been to critique racism and biological essentialism. The question must be asked, therefore, why the theoretical orthodoxy has reproduced the very assumptions it purports to destabilize? Part of the problem stems from the fact that, despite theorists' claims that race is a notion that is essentially ideological, their analyses fail actually to treat it as such. This fact becomes especially clear when we subject Gilman's most popular theoretical claim to a rigorous sociological analysis.

Writing almost a decade and a half after the article was first published, Z. S. Strother (1999, 38) observed that Gilman's assertion that Baartmann's sexual parts "serve as the central image for the black female throughout the nineteenth century" remains its most frequently cited statement. This assertion, perhaps more than any other, was taken up without question (Haraway 1989; Crais 1992; Fausto-Sterling 1995; McClintock 1995; Pieterse 1995; Sharpley-Whiting 1999). Londa Schiebinger, for example, argued that "African women were seen as wanton perversions of sexuality. . . . They served as foils to the Victorian ideal of the passionless woman, becoming, as Sander Gilman has written, the central icon for sexuality in the nineteenth century" (1993, 159). Similarly, bell hooks also cites Gilman, writing that "Gilman documents the development of this image

. . . he emphasizes that it is the black female body that is forced to serve as an icon for sexuality in general" (1992, 62).

Although writing about ideology, these scholars fail to appreciate the very essence of ideology—what makes them so *ideological*—is the fact they are riddled with contradictions and marked by continuous conflicts and struggles over meaning. As Mannheim explained in *Ideology and Utopia*:

> It is with this clashing of modes of thought, each of which has the same claims to representational validity, that for the first time there is rendered possible the emergence of the question which is so fateful, but also so fundamental in the history of thought, namely, *how is it possible that identical human thought-processes concerned with the same world produce divergent conceptions of that world.* And from this point it is only a step further to ask: Is it not possible that the thought-processes which are involved here are not at all identical? May it not be found, when one has examined all the possibilities of human thought, that there are numerous alternative paths which can be followed? (1936, 9; emphasis mine)

Theorists who contend that there was a single ideology, central icon, or core image about blackness and sexuality in the nineteenth century make two mistakes. First, they discount the extent to which ideas about blackness were still emerging. Second, their analysis implies that this particular ideology magically escaped the types of conflicts that all other ideologies are subject to. Only by underplaying the existence and importance of ideological conflict can they sustain Gilman's argument that people from such widely different social locations as French aristocrats, English merchants, displaced peasants, gentlemen scientists, and factory workers held a singular and unified opinion about and image of "black" women and sexuality.

The available historical evidence strongly contradicts Gilman's claims about the alleged ideological unanimity of such diverse social actors. Historical sources demonstrate quite clearly that the issue of whether or not steatopygia was a general attribute of Khoikhoi women, and whether Baartmann was considered a typical example of a Khoikhoi person, remained open to debate. Fisher, who compiled a compendium of his journey to the Cape, noted that "there is something like symmetry in the person of a Hottentot, their limbs being neatly turned, but they are for the most part of a diminutive stature, and no just idea of them can be formed from the specimens seen in this country [England], particularly that singular character the Hottentot Venus" (1814, 8). William Burchell made a similar observation in his *Travels in the Interior of Southern Africa*. After describing a Khoikhoi woman with "a very large and protuberant behind," he hastened to add that this was not a general condition of the Khoikhoi people:

> The exhibition of a woman of this description, in the principal countries of Europe has made the subject well known to all those who are curious in such matters. . . . I ought not to allow this occasion to pass by without endeavoring to correct some erroneous notions. . . . It is not a fact that the whole of the Hottentot race is thus formed. Neither is there any particular tribe to which

this steatopygia, as it may be called, is peculiar. Nor is it more common to the Bushman tribe than to other Hottentots. It will not greatly mislead if our idea of its frequency be formed by comparing it with the corpulence of individuals among European nations. (1822, 216)

It might be tempting to conclude that some people are simply more prescient observers than others are or, alternatively, that some people simply harbor less racial prejudice. Although important differences marked the standpoints of travelers in Africa versus pseudo-scientists and lay people in England, the access to a wider array of empirical evidence is not the only reason that opinions varied so widely. Rather, what these examples make clear is that ideologies about racial and sexual alterity display the same basic characteristics as other ideologies do. They are internally inconsistent, they are constantly subject to struggle, and they reflect the structural locations of their adherents.

Most studies of Baartmann, following Gilman, have focused their attentions on the role of science in establishing her sexual alterity (Haraway 1989; Wiss 1994; Fausto-Sterling 1995; McClintock 1995; Sharpley-Whiting 1999). However, because scholars have so readily accepted Gilman's claim that the mere sight of Baartmann produced a uniform and unvarying ideological response, few have noticed or been motivated to investigate the important differences between British and French representations of her. None have questioned Gilman's assertion that Baartmann's "genitalia and buttocks summarized her essence for the 19th century observer" (235). Thus, they have neither noticed nor analyzed Baartmann's relatively weak interpellation into British medical and scientific discourses as compared to French. However, as Fausto-Sterling observed (but did not analyze), "although a theater attraction and the object of a legal dispute about slavery in England, *it was only in Paris,* before and after her death, that Baartmann entered into the scientific accounting of race and gender" (1995, 33; emphasis mine).

A second key question that goes unremarked and unanalyzed is how and why Baartmann came to reside in Paris at all. Despite the importance of this move, most scholars, following Gilman's lead, do not take up the issue at all (Schiebinger 1993; Wiss 1994; McClintock 1995). Strother, for example, simply states that "Baartmann moved to Paris in 1814" (1994, 33). Likewise, Fausto-Sterling takes note of it only to comment that after 1814 she "somehow ended up in Paris" (1995, 29). However, Baartmann did not simply "move to" or "end up in" Paris. Writing to the *Morning Chronicle,* Baartmann's original captor, Henrik Cezar, explained that he quickly sold her to "an Englishman" because his "mode of proceeding at the place of public entertainment seems to have given offense to the Public" (23 October 1810). According to Baartmann's own testimony, she was subsequently abandoned in Paris "by another Englishman" and thus came to be the property of a showman of wild animals.

We might ask why a commodity of such value to the English, both commercially and ideologically, passed through so many hands before she had to be taken out of the country and abandoned. Why didn't British theaters of anatomy, schools of medicine, or museums jump at the chance to examine and display this bit of curiosity from their newest imperial outpost? Science was critical for rescripting conquest as both a necessary and essentially humanitarian act. Why, then, didn't British science make greater use of Baartmann's alterity?

It is important to note that at the time of Baartmann's exhibition in London, medical science was no less developed or commercialized than in France. There were many large medical hospitals and "theaters of anatomy" wherein the nongentlemanly members of the British scientific community earned their livelihoods. A large portion of these scholars combined medical practice with teaching as a form of economic support. Furthermore, the popularity of medical and anatomical lectures amongst the lay community was even more pronounced in Britain than it was in France. French scientists were employed by secular public institutions and wrote mainly for other scientists. In London, however, the line between science and show business was easily and often traversed. As Hays explained, "lectures on biological subjects could draw on another London resource in addition to the talent of the medical community. They could exploit London's position as the center of entertainment, spectacle, and display" (1983, 106).

The fact that Baartmann failed to arouse commensurate amounts of scientific interest in England and France illustrates my earlier point that social relations, rather than biological essences, are critical for determining what individuals see when they look at one another. I maintain that Baartmann represented far more in the European imagination than a collection of body parts. Indeed, closer examination of the furor that ensued in the wake of her exhibition demonstrates that what she represented varied (as ideologies are wont to do) according to the social and political commitments of the interested social actors. Baartmann's exhibition provoked varying and contradictory responses. These responses can be better understood if they are analyzed as part and parcel of larger debates over liberty, property, and economic relations, rather than seen as simple manifestations of the universal human fascination with embodied difference.

Despite the popularity of contemporary claims that Baartmann was seen "only in terms of her buttocks" (Wiss 1994, 31), a substantial portion of the British public actually saw her as representing much more. When many people looked at Baartmann, they saw not only racial and sexual alterity, but also a personification of current debates over the right to liberty versus the right to property. For many, Baartmann's captivity encapsulated the conflict between individual freedom and the interests of capital.

The contemporary debates over slavery provided the context to the Baartmann controversy, and it is within their parameters that it must be understood. Many individuals who opposed slavery on humanitarian grounds nevertheless were reluctant to infringe upon the property rights of slaveholders. Reformers also balked at ideas of personhood that had the potential to complicate the relationship between capital and "free" labor. There was "a wish to attack slavery but not to infringe upon legally acquired property rights or to question long term indenture or even service for life" (Malik 1996, 64). Thus, Lindfors incorrectly characterizes the legal battle that occurred over Baartmann's exhibition as "a classic confrontation between heated humanitarianism and commerce, between the abolitionist conscience and the entrepreneurial ideal, between love and money" (1985, 138). There is a clear connection between the legal furor over the exhibition and how the British envisioned incorporating the Cape into the British Empire.

It is important to note that the society that sued Henrik Cezar, Baartmann's captor, on her behalf was called "The African Association for Promoting the Discovery of the Interior of Africa" and sought to play a leading role in opening a new phase in the exploitation of the Continent. It was to this end that subscriptions were paid which

were then used to subsidize sending travelers and explorers to Africa. Thus, the pertinent contest was never *between* "love and money." Humanitarianism, as expressed in the actions of the African Association, served the interests of the landed and mercantile elite. These men were concerned with securing the global expansion of capitalist relations of production. Commercially minded men recognized the importance of Africa as a place where tropical products such as tea, coffee, tobacco, sugar, and rice, desired by the growing middle class market, might successfully be grown at less cost. They also saw Africa as a potential market for British manufactures.

High hopes were held out that the Cape Colony could be transformed to meet the objectives of both the merchant and landed elites. However, this transformation was contingent upon a proletarianization of the indigenous labor force. This proletarianization required that slavery, the existing system of labor relations, be overturned in favor of a capitalist legal order wherein the Khoikhoi would be legally "free" but more completely open to subjugation as laborers in the developing frontier economy (Keegan 1996). As John Philip, director of the London Missionary society, explained:

> By raising all the Hottentots of the colony . . . a new and extensive market would be created for British goods. We say nothing of the increased consumption of British manufactures . . . or the increase of our exports which would necessarily arise from the additional stimulus which would be given to the industry of the Hottentots by the increase of their artificial wants. (1828, 365)

Thus, it was no accident that the goals of progressively minded landed elites, the mercantile and commercial classes, and humanitarians coalesced so readily in the goals of the African Association. Despite the many points of disagreement between merchants, missionaries, and explorers over how it would be accomplished, most agreed that the Khoikhoi would eventually be proletarianized and made to understand the value (and responsibility) of self-commodification. Humanitarianism readily and easily embraced the cause of economic liberalization, particularly in the areas of productive and commercial relations. The rhetoric of anti-slavery (which provided a critical backdrop to the opposition to Baartmann's forced captivity) merged (almost) seamlessly with that of imperial expansion.

The discussions around the Khoikhoi at the Cape thus paralleled the legal furor over Baartmann's exhibition. The question of the ownership of labor power took center stage in both. The immediate concern of the African Association (which sued Baartmann's captor, Henrik Cezar, on her behalf) was to ascertain whether she owned her own labor. As Macauley stated in the affidavit filed on her behalf, his purpose was to determine "whether [Baartmann] was made a public spectacle with her own free will and consent or whether she was compelled to exhibit herself" (quoted in Strother 1999, 43). Those opposed to Baartmann's exhibition debated less about whether her confinement represented a moral blight than over whether she was owned by someone else, and hence subject to forced exhibition, or if she belonged to herself, and thus was acting freely. For example, the *Morning Chronicle* argued:

> The air of the British Constitution is too pure to permit slavery in the very heart of the metropolis, for I am sure you will easily discriminate between those beings

who are sufficiently degraded to shew [sic] themselves for their own immediate
profit where they act from their own free will and this poor slave. (12 October
1810)

Thus, in a number of ways, the Baartmann exhibition encapsulated in miniature the
debates that were occurring over the labor more generally. Henrik Cezar, her brutal
Dutch master, represented the old economic order at the Cape, based on enslavement,
forced captivity, and despotism. The African Association represented the coming of a
new colonial order based upon a "voluntary" commodification of the self and a "willing"
capitulation to the dominant logic of capital.

I have explored the widely divergent actions and reactions of the African Association,
British travelers, missionaries, and the British viewing public at such length to demon-
strate that when Europeans looked at Sarah Baartmann, it was not that they saw *only*
her buttocks. Although her body represented sexual alterity, that was not all it repre-
sented. Some observers looked at her and her captivity and "saw" a particular system
of productive relations they wanted to overthrow. Others "saw" a new area of the world
ripe for exploitation and a new way to exploit it. And still others looked and "saw" the
aesthetic antithesis of themselves. Most probably saw a combination of these and more.
Although the members of the African Association, no less than Cuvier, Cezar, and the
hordes of British and French citizens who came to gawk at Baartmann's most intimate
parts no doubt took notice of her difference and believed in some notion of white
supremacy, it is a mistake to take their actions as expressions of a *single, trans-historical,
and uni-dimensional* ideology. If that were the case, it would be impossible to explain
why Baartmann's alterity led one group of social actors to fetishize her exhibition and
another to call for its immediate cessation.

Baartmann's exhibition also makes clear that white supremacy was never the simple
expression of color prejudices. Each group of social actors, whether its particular interest
was in looking at Baartmann, dissecting her, or sending her home, had its particular
brand of racialist ideology which was reflected in its political program. These political
programs, in turn, reflected the social positions of their advocates. Thus, the only way
French scientists (or any other group of social actors for that matter) could have imposed
their exact understanding of Baartmann, black women, and black sexuality on any other
group would have been if they could have transformed the lives and social relations of
the relevant actors into exact replicas of their own.

Conclusion: Whose Bodies Matter?

Artist and scholar Jean Young (1997, 699) writes that Sarah Baartmann has been "re-
objectified" and "re-commodified." Yvette Abrahams, a South African scholar, also argues
that, "the genital encounter is not over. It may be seen in much recent scholarship on
Sara Bartmann" (1997, 46). The question must be asked why *this* woman has been made
to function in contemporary academic debates as *the* preeminent example of racial and
sexual alterity. This question becomes even more compelling when we consider that
Sarah Baartmann was one of thousands of people exhibited and transformed into medi-
cal spectacles during the course of the nineteenth century (Altick 1978; Corbey 1993;

Lindfors 1999). Examples abound of women with excessive hair (who were primarily of European and Latin American ancestry) who were exhibited in circuses and "freak shows." These women were not only believed to be the "missing links" between the human and animal worlds, but also hermaphrodite hybrids, caught between the male and female worlds (Bogdan 1988; Thomson 1997). However, none of these women (nor the category of excessively hairy women more generally) have been made to stand as "icons" of racial or sexual difference.

We might also return to the example of the Irish. Londa Schiebinger (1993, 156) maintains that "male skulls remained the central icon of racial difference until craniometry was replaced by intelligence testing in the late 19th and early 20th centuries." Nancy Stepan (1990, 43) has also argued that the systematic study and measurement of male skulls was "especially significant for the science of human difference and similarity." We might also add that nineteenth-century ethnologists speculated about the biological basis for the "effeminancy" of the Celtic male. As Curtis explains, "there was a curiously persistent and revealing label attached to the Irish, namely their characterization as a feminine race of people. This theme of Celtic femininity appears repeatedly" (1968, 61). Yet, to my knowledge, the Irish male skull has never had the dubious distinction of being "the central 19th century image for racial and sexual difference between the European and the Black." The fact that Irish male skulls have not been thus characterized reflects less about the available historical evidence than about scholars' abilities to free themselves from contemporary understandings about what, historically, has constituted a "black" experience. For if we compare the amount of ink spilled, the volume of studies done, and the number of corpses examined, it becomes apparent that Irish male skulls were of far more interest, and caused far more speculation about the nature of racial and gender differences, than steatopygious African backsides ever did.[2]

Some critics of post-foundationalist theories, like post-modernism and post-structuralism, have argued that they "simply appropriate the experience of 'Otherness' to enhance the discourse" (hooks 1994a, 424). The lacunae and lapses that mark much of the contemporary feminist scholarship on Baartmann make us pause and ask: Is this simply another case of what Margaret Homans identified as the tendency for feminist theory to make black women function as "grounds of embodiment in the context of theoretical abstractions" (Homans 1994)? Although some might argue that this is the case, this argument fails to consider the diverse strands within feminist theory and the long and intensely varied tradition of feminist thought and praxis. It also discounts the contributions of the many feminists of color that employ post-modernism and post-structuralism in their work (Spillers 1987; hooks 1994a; Carby 1999).

Sarah Baartmann's curious and problematic "theoretical odyssey" cannot simply be explained as stemming from a lack of theoretical "fit" between post-foundationalist theory and the historical experiences of African and African American women. Rather, the ways in which she has been constructed as a theoretical object highlight the inherent dangers in the deployment of any theory without due attention to historical specificity. In particular, it points to the problems that occur when race and gender are universalized and, thus, reified; or in other words, when "commonsense understandings of these categories as they exist in the United States are elevated to the status of social scientific concepts" (Loveman 1999, 894).

Baartmann's curious theoretical odyssey also points to the dangers of analyzing the construction and perception of human difference as primarily a product of inner psychological drives. Gilman's pronouncements about Baartmann (and the theoretical "industry" that emerged therefrom) would not have been possible had her exhibition not been largely abstracted from its political and historical context. It was this theoretical abstraction (coupled with a healthy amount of psychological determinism) that made it easier for scholars to momentarily forget that "blackness," as an ideological construction, could not possibly have inspired a singular and uniform response. Privileging psychological dispositions over social relations also allowed scholars to give Baartmann's corporeal alterity the power to produce history, while momentarily forgetting this alterity was, at the same time, a historical product. Thus, in the final analysis, the theoretical lapses of contemporary social scientists, rather than the actions of nineteenth-century pseudo-scientists, are the ones that threaten to succeed finally in transforming "the Hottentot Venus" into the central nineteenth-century icon for racial and sexual difference between the European and the black.

Credit: Zine Magubane, "Which Bodies Matter? Feminism, Poststructuralism, Race, and the Curious Theoretical Odyssey of the 'Hottentot Venus,'" *Gender and Society* (Vol. 15, No. 6), pp. 816–834, copyright © 2001 by SAGE Publications. Reprinted by Permission of SAGE Publications.

1. Full citations for sources cited in this chapter are included in the Bibliography at the end of the book, page 215.

2. By Fausto-Sterling's estimate there were a mere seven articles published between 1816 and 1836 (including Cuvier and de Blainville's dissection reports on Baartmann) on the subject of Khoikhoi women and steatopygia. There was not a single book-length monograph. Compare this to the hundreds of monographs and articles, published both in Britain and in the United States, that used craniology to establish the racial inferiority and Negroid ancestry of the Irish Celt. These articles appeared in such journals as *The Journal of the Anthropological Institute of Great Britain* and *The Anthropological Review.*

J. YOLANDE DANIELS

4 Exhibit A

Private Life without a Narrative

This essay is a case study that explores the space of liminal constructions through the body of the "black" female.[1] This liminal space is a physiological threshold with psychological dimensions that has been instrumental to symbolic and discursive order.

The biologic construction "female" applies to humans and animals and is not synonymous with the cultural distinction or, perhaps, discipline of the "feminine." The "feminine," those attributes that mark or distinguish the female, has been defined by Eurocentric and patriarchal definitions of the civil. The feminine has and continues to be an embodiment that displays the threshold or limit of "civility" itself. Through discourse on the female and feminine, we enter into the space of female difference.

In "The Hottentot and the Prostitute: Toward an Iconography of Female Sexuality," Sander Gilman illustrates the correspondence of physiognomic categorizations of the female body, both interior and exterior, with categorizations of difference or otherness (sex, race, and class) in his interpretation of Enlightenment and Early Modern artistic and "scientific" production.[2] The study of physiognomic distinctions has tended to conflate the physical with the psychological and is exemplified in the history of the category "woman." In addition, Gilman's examples of black female bodies as attendants to white women illustrate the use of the adjacency of the black body to signify a whiteness that was rendered impure.[3] The black body is in this case an attribute of the white body that signifies a character or "other" flaw.

In *Playing in the Dark,* Toni Morrison's critique of American literary works illustrates the manner in which a positive or "white" presence has been enabled through a "black" construction using various techniques of negation.[4] The construction of a negative or "black" subject has afforded the agency of a "white" subject. A pattern of the black body as instrument, dictated by a white body with agency, has emerged.

In the realm of difference, the contingent terms "black" and "white" are shown to be a reflexive binary set. In the construction of the "black" female body, a "white" female has been purified by a "black," or other, Self. Although both bodies, as women, were constructed as "other" within larger patriarchal discourses that rendered the status of each through structural negations, the "black female" has been conscripted to the female form as an attribute or an aberration—as an othered "other."[5]

✦ ✦ ✦

> Cranial measurements
> crowd my notebook pages,
>
> and I am moving closer,
> close to how these numbers
>
> signify aspects of
> national character.
>
> Her genitalia
> will float inside a labeled
>
> pickling jar in the Musée
> de l'Homme on a shelf
>
> above Broca's brain[6]

Saartjie Baartman, Sarah Bartmann, the "Hottentot Venus," framed by the Dutch, the English, the French, the spectacle, exhibited in London from 1810 and in France from 1814 to her death in 1815, and until recently preserved in a jar in the Musée de l'Homme, was arguably not a "Hottentot." "Hottentot" referred to a people, distinguished from, yet confused with, the "bushmen" from the coastal regions in South Africa; however, by the late 1600s, the "Hottentots" were Christianized, scattered, and bred, perhaps, into extinction.

Bartmann was not the sole "Hottentot" female to have been exhibited or dissected in the early nineteenth century or to receive the distinction "Hottentot Venus." Thus to write of the "Hottentot Venus" is to invoke a construction that originated and grew within the European psyche, was classified in nineteenth-century scientific texts, and was elaborated on in dailies, popular song, and theater in the nineteenth-century urban centers of London and Paris.[7]

London, 1809–1810, Piccadilly Circus, the Egyptian Hall: The decency of the exhibition was questioned by some viewers and resulted in a hearing by the attorney general in the Court of Chancery in November 1810. Although the court decided against an indecency ruling in judging that it was appropriate for the "Hottentot" to be viewed "just as she was," the hearing and the publicity it drew led to the departure of the "Hottentot Venus" attraction from London.[8]

In March 1815, the exhibition, implicitly regarded as indecent, was offered to the prurient gaze of scientific rationalism. The zoologists and physiologists from the Museum of Natural History in Paris examined Bartmann in the "King's Garden" for three days. Here, we enter the space of Bartmann's corporeal dissection by scientific inquiry, although it was preceded by a spiritual dissection under a consuming colonialist gaze.

The scientific classification of the "Hottentot" physiognomy as degenerate occurs in several texts authored by Baron Georges Cuvier. In an oral report to the Société Philomatique de Paris in 1815, Cuvier's assistant, Henri de Blainville, described their intentions to make "'a detailed comparison of this woman with the lowest race of humans, the Negro race, and with the highest race of monkeys, the orangutan,' and . . . to provide 'the most complete account . . . of her reproductive organs.'"[9]

Although Cuvier and de Blainville were most interested in the inspection of the "Hottentot apron," it was Bartmann's steatopygia that figured in the public imagination.[10] The public's attention was on the butt: foul, fecund, abject, seductive.

Bartmann's projected bestiality made her the object of popular curiosity and sexual projection. One very popular French vaudeville play, *The Hottentot Venus, or Hatred of Frenchwomen,* involved the masquerade of a European belle as a "Hottentot" to get the attention of the gentleman she desired (who had declared he could only love an "exotic"); the required plot twists notwithstanding, the play ended with the gentleman enamored with his "othered" lover.[11] The spectacularized "Hottentot" served the society in which she was projected as a liberating medium.

Paris, 1829: Another "Hottentot Venus" was exhibited in the accepted "Hottentot" costume at a party of the Duchess du Barry. As depicted in a tabloid illustration, the "Hottentot" stands beyond two Parisian couples, separated by a rope that seems to connect the three women in a tripartite construction. The bodies of the Parisian ladies are revealed, through a thinness of material, as they turn away from the "Hottentot." One male peers through a magnifying glass at the attraction; the other points. In the age of the scientific construction of (white) female sexuality as an anomaly to the (white) male ideal, the "Hottentot" represented the latent sexuality within the European feminine ideal.[12]

"Venus" defines a sexualized frame. Bartmann was a "Venus" with elongated labia minora—a physical manifestation of the potential for female pleasure. To the civilized Victorian, from whom the characteristics of the "Hottentot apron" would have been concealed (except within scientific texts), the "Hottentot's" visible steatopygia represented the concealed "hyper-sexuality" that was confirmed by the "apron." The "Hottentot Venus" reinforced as scientific proof a savage humanity, and by comparison, reinforced the binary framework of European civilization as it transformed itself in scientific rationalism and colonial exploits.

Civilized femininity was contrasted by a Bartmann clothed only in a beaded apron— by a woman reconstructed as bestial. The "primitive" construction as double has served as a latent site of projection and reflection. In 1830, fifteen years after the metropolitan appropriation and consumption of the "Hottentot," Victorian women adopted the posterior housing that amplified and masked the "posterior": the bustle. There continues to be conjecture on this instance of a fashioned steatopygia.[13]

Upon viewing today, the illustrations of the "Hottentot Venus" remain curiosities with sexual connotations intact. Her physical characteristics fluctuate depending on the context in which she is described, displayed, caricatured, desired. Yet the "Hottentot" remains within the range of the "abnormal," appearing "on a stage two feet high, along which she was led by her keeper . . . being obliged to walk, stand, or sit as he ordered her."[14]

The display of the "natural" (people, artifact, site) is mediated by the preconceptions of the receiving public. On the stage in London, Bartmann would have been elevated in such a manner that her sexual physiognomy would have been within view of the greatest number of spectators, her height having been four feet seven inches. She was exhibited for two pence, or three francs. Was it a salon, tent, or shed in which she worked eleven hours each day until her death? Was she viewed within a representation of a "primitive reality" as was the convention of ethnographic exhibits? More than any artifact, the "Hottentot" body qualified the exhibit.

Was there sunlight? Enough to see her by. What did she, the object of our gaze, see? Did she care to view those who viewed her? Did she speak? Could she disrupt the acts of education and amusement that masked voyeurism? Did she sit, stand, and perform as directed? What liberty has a "free" possession?

> She was often heard, also, to heave deep sighs in the course of the exhibition, and displayed great sullenness of temper.[15]

In Paris, on 29 December 1815, as Cuvier reported, or on 1 January 1816, as indicated in the documentation at the Musée de l'Homme—as a "Hottentot," a "bushwoman," or of mixed race—Bartmann died, her birth name lost in translation, her identity subsumed by the spectacularization of race and sex. In the narrative of her death, she was brought again to the King's Garden for scientific dissection. Bartmann was by all accounts modest, and it was not until her death that the "Hottentot apron" was revealed and preserved in the interest of science.

What meaning could physical surroundings have had for one who was alienated from her physical body by voyeuristic audiences for up to eleven hours a day? When the first physical house, the body, is divorced from the mind, does a shed, or for that matter, city, register? What meaning could architecture have had in this life?

Of the spaces that lurk in her recorded history, the circus and the King's Garden figure most prominently. Perhaps, in viewing two alternate spaces, we may bridge from this site of alienated spectatorial urbanization to private dwelling space. This gesture is not to posit an idyllic point prior to a somewhat diasporic urbanization, but to entertain the likelihood and ramifications of private space.

The first alternate space is revealed in the gap in time between the close of the London exhibition in 1810 and the opening of the Paris exhibition in 1815. During this time when the exhibition toured, Bartmann was baptized in Manchester in December 1811.[16] Given this fact, it seems possible that within the schedule of the human exhibition, time was made for domestic constructions. Bartmann was believed to have married and to have conceived "one or two children."[17] The accounts of Bartmann are not personal accounts—accounts that would relate her personal relationships or private desires. Her interior projections and the spaces they may have settled in were not detailed for public view.

The second alternate space is indicated in an image entitled "House from which the female in Piccadilly called the Hottentot Venus was taken—Not 2 miles from Cape." The drawing is from the sketchbook of the missionary John Campbell, a member of the London Missionary Society.[18]

A rectangular barrack-like structure with a flat roof, a central door on line with a chimney, and paired grated windows indicating either window mullions or bars, it sits adjacent to a shore with two forms (perhaps ships) receding in the distance. The house has been described as "a crude drawing of a typical Cape 'pondokkie'" (the Afrikaans pejorative for a mud hut).[19] The house construction provokes more questions than it answers as the house type is after European models. The bars at the windows put one in the mind of a garrison rather than a home, and the isolation at the shore reinforces

this reading. Could this be the home from which Bartmann purportedly embarked as a servant to a Boer family from the Cape of Good Hope to Piccadilly Circus?[20] The drawing, a simple construction, is reportedly from her telling as interpreted by the draftsman.

As evidenced in the life of Bartmann, the "black" body is a lived hyper-corporeal abstract representation framed within external systems. In resisting the construction of a narrative for Bartmann, the structure of the characteristic exteriority in which she was framed—a condition particular to objects—is highlighted. Once scale shifts to include an interior—a private space—the possibility for the construction of subject positions has arisen.

The accumulation and exhibition of animals, wares, technologies, and people—the objects of colonial expansion—created the need for their classification. In this manner, the collections gathered by traders and merchants laid the ground in which scientific determination and methodology would flourish. The exhibition of "primitive" peoples in the context of the "culture of abundance" and pleasure has had lasting influence in the spatial localization of the "other" within the dominant order.[21]

Peter Stallybrass and Allon White note the occurrence of nineteenth-century narratives as an example of how the bourgeoisie body formed itself through such narratives.[22] In this example, the congruence between constructions of private space and constructions of subjectivity becomes visible. Likewise, many constructions of public space (especially that of the metropolis) often indicated the degradation of the subject.

Travel narratives, and the collections for which they often accounted as part of the process of nation building, were incorporated into early scientific discourses. Anne Fausto-Sterling notes that it was in travel narratives of the eighteenth century that the "Hottentot apron" was first detailed.[23] In this way, race narratives of a "savage" and "primitive" humanity served to locate European culture in scientific discourses such as that of Cuvier.[24] Like cultural narratives, scientific narratives not only reflect but construct subjectivity, society, and space.

Language is the structure through which we situate the visual frame. However, the visual frame creates vision as it sights. At the incidence of an overdetermined exterior construct (the "Hottentot Venus") and an underdetermined internal life (Sarah Bartmann), the tendency toward surface readings or exteriority is turned on itself, to open a critique of private being or subjectivity at the incidence of the construction of private and public knowledge, private and public property, and private and public space.

Credit: A portion of this essay originally appeared in "Black Bodies, Black Space: A-Waiting Spectacle," *White Papers, Black Marks: Architecture, Race, Culture,* Lesley Naa Norle Lokko, ed., University of Minnesota Press, 2000.

1. As employed here, "black" is an abstract term of difference or alterity which on one hand reinforces absolute negation and, on the other, reinforces a diverse and differentiated diasporic community localizable by physiognomic characteristics.
2. Sander Gilman, "The Hottentot and the Prostitute: Toward an Iconography of Female Sexuality," this volume, 15.

3. Ibid.

4. Toni Morrison, *Playing in the Dark: Whiteness and the Literary Imagination* (Cambridge, MA: Harvard University Press, 1992).

5. One cannot help but muse over the double negative grammatical rule (A double negative equals a positive) and the practice within black American vernacular of breaking or negating this grammatical rule. To be an othered other is to be in one sense other primed or indivisible; in other words, it is to be a Subject.

6. Elizabeth Alexander, "The Venus Hottentot," this volume, 1.

7. Percival Kirby, "More about the Hottentot Venus," *Africana Notes and News* (Johannesburg, South Africa; vol. 10, no. 4, September 1953), 126–133.

8. Percival Kirby, "The Hottentot Venus," *Africana Notes and News* (Johannesburg, South Africa; vol. 6, no. 3, June 1949), 58.

9. Anne Fausto-Sterling, "Gender, Race, and Nation: The Comparative Anatomy of 'Hottentot' Women in Europe, 1815–1817," in *Deviant Bodies,* Jennifer Terry and Jacqueline Urla, eds. (Bloomington and Indianapolis: Indiana University Press, 1995), 33.

10. Steatopygia: protruding buttocks. The apron was literally a fabric train secured at the hips; however, the "apron" also served as a euphemism for elongated female genitalia. For Cuvier's reflections, see Fausto-Sterling, "Gender, Race, and Nation," 35.

11. Kirby, "More about the Hottentot Venus," 130–133. The play is translated and reprinted in T. Denean Sharpley-Whiting, *Black Venus: Sexualized Savages, Primal Fears, and Primitive Narratives in French* (Durham, NC: Duke University Press, 1999), 127–164.

12. Sander Gilman has written of Edouard Manet's painting *Olympia* of 1862–1863 as an image that symbolically represents genitalia. It is a frank depiction of nakedness, which directly confronts the observer, in which the sexualized nature of the central figure, a "white woman," is reinforced by the presence of a "black" servant in the background. See Sander Gilman, *Sexuality: An Illustrated History, Representing the Sexual in Medicine and Culture from the Middle Ages to the Age of AIDS* (New York: Wiley, 1989), 287–290.

13. *Fairchild's Dictionary of Fashion,* cited in Lisa Jones, "Venus Envy," *The Village Voice* (New York; July 9, 1991), 36.

14. Robert Chambers, *The Book of Days,* quoted in Kirby, "The Hottentot Venus," 57.

15. Kirby, "The Hottentot Venus," 57.

16. Kirby, "More about the Hottentot Venus," 128–129.

17. Kirby, "The Hottentot Venus," 59.

18. Kirby, "More about the Hottentot Venus," 133–134.

19. Ibid.

20. Fausto-Sterling, "Gender, Race, and Nation," 29.

21. Robert Rydell, *World of Fairs: The Century of Progress Expositions* (Chicago: University of Chicago Press, 1993), 35.

22. Peter Stallybrass and Allon White, *The Poetics and Politics of Transgression* (Ithaca: Cornell University Press, 1986), 82–83.

23. Gilman, *Sexuality,* 292.

24. Fausto-Sterling, "Gender, Race, and Nation," 21, 35.

HOLLY BASS

5 crucifix

*In the center of the outer edge of each petal there will be nail prints, brown with
rust and stained with red, and in the center of the flower, a crown of thorns.*
 —*Legend of the Dogwood*, author unknown

picture me
my mouth a hornet's nest
my lips the sting
my tongue
seeps pink
out of spaces
between my teeth
making the sign
of the cross
as if I were holding
a dogwood blossom
inside
my mouth

Yes, I love myself
My every thought
centers around me
My every word
a tribute to me
I make Narcissus
look gentle next
to my savage egotism
I am
a beautiful slave
A Hottentot
waiting
to be dissected
I want
my genitals
to be on display
I want you
to look at me
Look at me
My hornet's nest lips
the dogwood blossom

picture me
my black vagina
presenting itself
like a star
a supernova, folding
in upon itself
imploding to form a
black hole absorbing
two hundred centuries
of the world's oppression

You can't escape this pull

more irresistible than Eve
more seductive
than a pomegranate—sweet
seed, thick skin—cracked
open, exposing
jewel-like berry, unbruised
Do look at me
Look at me
My stinging lips
the dogwood blossom
the black crucifix
I make against
this white backdrop of sky
the black crucifix
I make against
this white
 white
 white
backdrop
of hate

PART II

Sarah Baartman's Legacy
in Art and Art History

LISA GAIL COLLINS

6 Historic Retrievals

Confronting Visual Evidence and the Imaging of Truth

Visual documentation emboldens and lends credence to myth. Similarly, visual corroboration of scientific theory enhances its power and extends its reach. Given this, it is not surprising that those who try to make such meaning have eagerly sought visual evidence that can explain or confirm racialized myths and theories. Producers of images have been a part of these systems of meaning-making, and some have used their skills to provide visual "proof" of the inherent difference and inferiority of people of African descent. In the first part of this essay, I examine some of these processes by charting two instances of collaborations between mythmakers, scientists, and image-makers during the first half of the nineteenth century. Specifically, I analyze the attempts to document Saartjie Baartman's body as inferior by the acclaimed French comparative anatomist Georges Cuvier and the illustrators he commissioned to help him with his task. In addition, I study the efforts to reveal the essential difference of enslaved African people by Cuvier's protégé Louis Agassiz and his hired photographer J. T. Zealy. Examination of these highly visual events enables me to unveil some of the ways images were complicit on both sides of the Atlantic Ocean in offering "proof" for white supremacist notions and affirming racist claims to "truth" during the early 1800s.

Furthermore, as direct confrontation with these particular processes and histories is recurrent in contemporary art practice, I complete this essay with an aesthetic retort: an exploration of how several African American women artists approach these particular lineages of visual violence through their work. By laying bare how their art is in dialogue with these histories, I hope to chart the ways this work reveals, dismantles, and attempts to alter the course of these still visible legacies.

Visualizing Myth

Slavery was dependent upon myths that attempted to explain controlling practices and beliefs.[1] For example, the myth of the Jezebel was created during slavery to mask the sexual and economic exploitation of black women. Jezebel was an abstraction, a violent creation, which slavery's defenders worked to attach to the bodies of young black women. This abstraction constructed and portrayed black women—in science, law, and popular culture—as primitive, seductive, and always eager for sex. When employed to justify or enforce the status quo, myths can have material effects. The myth of the Jezebel, for example, worked to naturalize rape and other acts of sexual violence carried

out on the bodies of black women by white men, by suggesting that all sexual inter-course with black women was inherently consensual and thus rape was not rape.

Myths gain strength when linked to visual representations. Likewise, since myths work by creating compelling and desired stories, they frequently cannot be displaced by evidence that directly contradicts them. Perhaps nowhere is this more graphically revealed than in the tragedy of Saartjie Baartman, who was used and abused as a visual personification of myth: the myth of African difference and inferiority. Europeans paid to see Baartman, "The Hottentot Venus," because they wanted to witness—ostensibly through the fact of her large protruding buttocks—a woman who was thought to embody "the essential black, the lowest rung on the great chain of being."[2] Juxtaposition of the words "Hottentot" and "Venus" conjured up images of the ivory-skinned Roman goddess of love and beauty only to draw attention to the irreconcilable gap between the mythic muse and the African woman, for Baartman was thought by many to repre-sent "the antithesis of European sexual mores and beauty."[3] By putting down money to view Baartman, European viewers revealed their faith in the visual; they were eager to link the myth of African inferiority with a visible representation of this difference.

Baartman first appeared in England where visitors to Piccadilly and various shows outside of London viewed her as popular entertainment. However when she was taken to Paris in 1814, she was viewed in two types of venues. In addition to being displayed as a curiosity for the entertainment-seeking public, Baartman was also exhibited as an ethnographic specimen for the scientific community and, by extension, as a model for artists. After physically examining the young African woman, Cuvier employed a small cadre of artists to depict her likeness for a collection of illustrations showing the diversity of "flora and fauna" housed in the library of the French natural history museum.[4] For the creation of this art-in-service-to-science, Cuvier had Baartman pose entirely nude—something which she had not done at the popular shows—in the Jardin du Roi.[5]

These 1815 commissioned watercolor illustrations reveal two related yet somewhat competing strategies for attempting to document Baartman's difference and answering Cuvier's call for "accurate visual records."[6] For example, Nicolas Huet le Jeune's painting shows a clinical approach, one that portrays Baartman in strict profile standing on a wedge of earth which is sparsely covered with grass. Emphasizing her large backside by placing it at the center of the picture, lightening it in contrast to the rest of her body, and revealing its curves and crevices in comparative detail, the artist's illustration makes evident that the interests of amusement-seekers and the interests of the scientific com-munity were somewhat linked in their shared fascination with one part of the African woman's anatomy. By employing an artistic approach that draws viewers directly and exclusively to the model's posterior, the work suggests that Baartman's value to science lies in the empirical investigation of her generous buttocks.

Léon de Wailly, another project artist, shifted somewhat from his colleague's raw empirical approach. Wailly's watercolor includes two views of the African woman. (See Figure 1.) In the foreground of his painting Baartman stands on a hill face forward, her eyes confronting the viewer. Just behind this representation of Baartman is a second depiction of her, and here she is shown in three-quarters view and appears substantially smaller as she is further removed in space from the viewer. In contrast to his peer's portrayal, Wailly takes a step away from the former's clinical style. Whereas Baartman in Huet le Jeune's work fills the picture plane allowing the viewer scant sense of context,

Wailly's illustration positions her in a landscape of low hills with a pair of palm trees in the distance. This situating of Baartman in a place removed from the expected site of examination not only reminds viewers of the young woman's connections to a world beyond the circus and laboratory, but also affords the young woman the power of vision. Here she is represented as having the capacity to see. Thus, although she is shown from the side in order to enable an unhindered view of her backside, the placement of Baartman within an expansive setting symbolically allows her to look beyond the parameters of her containment. Accordingly, the front-facing Baartman looms large and commands her presence as her eyes pierce the viewer.

Baartman died shortly after she was pressed to pose for these illustrations intended for researchers in natural history. After her death, the scientific community's interest in her shifted somewhat from her prominent buttocks to her enlarged genitalia. Cuvier subjected her body to a thorough dissection. By closely examining parts of her genitalia, his study attempted to uncover the source of what was both popularly and scientifically thought to be the deviant sexual lasciviousness of African women. Cuvier's dissection report was first published in 1817, and in 1824 it was reprinted alongside the commissioned illustrations.[7] In his report, the esteemed scientist focused on the woman's already fetishized body parts and stressed her racial difference and inferiority by drawing attention to "any point of superficial similarity" between her body and manners and that of a monkey or ape.[8] In this way, although the illustrators had demonstrated two varying approaches for representing Baartman, both of their works were eventually placed within a narrative of racial deviance and used by Cuvier in an attempt to visually corroborate his claim of the African woman's inferiority.

Baartman's humanity was elided twice in Europe. While alive, she was displayed; contained in various exhibitions and pressed to pose nude, she was positioned as popular and scientific entertainment for those who longed to stare at a woman thought to be their opposite. After her death, her body was moved to a laboratory for further investigation and dissection and then to a museum shelf at the Musée de l'Homme, where her genitals were stored in a jar and sat ready for the next exploration. The desecrations of Baartman lay bare a desperate desire to strengthen myth by linking it to visual representations. A visual matrix of exhibition, dissection, and display enabled Cuvier and the community that produced him to believe they were documenting black female difference and containing African inferiority. This process makes apparent the hunger of the powerful to fix subjects of interest, to restrain them in order to capture what is thought to be the essence of their difference and the reason for their subordination. Relatedly, this process also reveals a sense of weakness on the part of the powerful, for the need to immobilize subjects suggests an unstable authority.[9] Both of these tendencies would be heightened a quarter of a century later in the United States with the arrival of photography.

Documenting Science

Early photography and the institution of slavery are linked. Soon after the 1839 discovery in France of the daguerreotype—the first practical photographic process—photography was being used in efforts to document the essential difference of people of African descent.

In 1846, the celebrated Swiss zoologist Louis Agassiz arrived in Cambridge, Massachusetts. Agassiz, who had dedicated his first book to Georges Cuvier and saw himself as his successor, was famous for his work in natural history, particularly his work on fossil fishes.[10] Before accepting a position at Harvard University, Agassiz toured and gave a series of lectures along the East Coast. In Philadelphia he had his first significant contact with black people. After this jarring encounter, he wrote a letter to his mother revealing how this experience had toppled his previous beliefs concerning the brotherhood of man.

> It was in Philadelphia that I first found myself in prolonged contact with negroes; all the domestics in my hotel were men of color. I can scarcely express to you the painful impression that I received, especially since the feeling that they inspired in me is contrary to all our ideas about the confraternity of the human type [genre] and the unique origin of our species. But truth before all. Nevertheless, I experienced pity at the sight of this degraded and degenerate race, and their lot inspired compassion in me in thinking that they are really men. Nonetheless, it is impossible for me to repress the feeling that they are not of the same blood as us. In seeing their black faces with their thick lips and grimacing teeth, the wool on their head, their bent knees, their elongated hands, their large curved nails, and especially the livid color of the palm of their hands, I could not take my eyes off their face in order to tell them to stay far away. And when they advanced that hideous hand towards my plate in order to serve me, I wished I were able to depart in order to eat a piece of bread elsewhere, rather than dine with such service. What unhappiness for the white race—to have tied their existence so closely with that of negroes in certain countries! God preserve us from such a contact.[11]

Agassiz's impassioned letter reveals a division in his thoughts concerning people of African descent: while he considers their plight at a distance, when they are simply a "sight," he writes that he is filled with pity and what he labels compassion; however, when he finds himself face-to-face with the black men who work in the hotel, especially as the men move toward him, he is overcome with horror and disgust. In his letter Agassiz contends that black bodies are repulsive to him, yet he is not able to shift his gaze from the faces and hands of the black men. Clearly, he is both repelled and compelled by the black Philadelphians. Perhaps Agassiz's violent reaction was due to the fact that these men were not contained as Baartman had been in Europe; instead, these men were both intimate with him and comparatively autonomous.

Black people were touching and serving his food, offering him bread, and most likely, cleaning the room where he washed, dreamt, and slept. As hands are tools of work, intimacy, and agency—they labor, touch, and enable movement—it is worthy of note that Agassiz locates his repulsion in the hands of black men. He claims to feel disgust at the sight of the "large curved nails" and the "livid color" of the palms, and his distress multiplies as the hands advance toward his plate. The sight of the laboring black hands—and in service to him, no less—sickens him. Yet he cannot protest their movement toward him, for he is also fixated on the faces of the black men.

Like his mentor Cuvier, Agassiz was curious about African bodies and sought to study anatomical details. In his study of Agassiz, art critic Brian Wallis draws attention

to the scientist's particular interest in "sorting and classifying" in order to gather evidence and make claims about the subjects of his studies. In addition, he reveals Agassiz's desire to apply this methodology to the study of African bodies. Concerning this Wallis contends, "In attempting to organize his data regarding Africans, Agassiz sought firsthand evidence."[12] However, Agassiz, like Cuvier, sought not only "firsthand evidence," but one-way contact. And thus he needed a site for his study, a place where he could explore black bodies unhindered by the relative freedom of their movement. Cuvier accomplished this through dissection. Agassiz achieved it through studying the bodies of black people in a location where their freedom of movement was severely curtailed—as an honored guest on a plantation.

In 1847 Agassiz arrived at the Charleston, South Carolina, plantation home of a zoologist colleague and his wife and immediately found an environment conducive to satisfying his scientific curiosities. There, as an honored guest, he eagerly walked the plantation fields, observing enslaved Africans and African Americans at work.[13] These observations, along with his experiences in Philadelphia and the pressures placed upon him by his white southern hosts, pressed him to transpose his theory of separate creation—which had been designed to account for the origins of plants and animals—to people. Agassiz now insisted that man had not one origin, but plural origins. This notion went against the prevailing—pre-Darwinian—manner of accounting for the origin of man. Most people at the time explained the phenomenon of apparent racial differences by way of the Bible, which asserts that all of the world's peoples are descendants of Noah's sons.

In March 1850, Agassiz gave a lecture at the Association for the Advancement of American Science in Charleston. After his lecture, in which he posited that races were distinct and neither came from a "common center" nor a "common pair," Agassiz conducted first-hand observations of African-born slaves and their children.[14] Along with his host, Dr. Robert Gibbes, Agassiz examined what Gibbes described as "Ebo, Foulah, Gullah, Guinea, Coromantee, Mandrigo, and Congo Negroes" on plantations near Columbia, South Carolina.[15] Through his research, the Swiss scientist sought "to define the anatomical variations unique to 'the African race'" as well as to see if these racial characteristics remained among descendants of African people born in the United States.[16] After completing his study—in which he recorded such factors as limb size and muscle configuration—Agassiz was assured that his subjects were indeed a separate race from his own.[17] Four years later he published an article in a volume entitled *Types of Mankind* where he declared the existence of eight human "types," which included the Caucasian, the Negro, the American Indian, and the Hottentot. This pro-polygenesis volume proved very popular, especially with slavery's defenders.[18]

At the end of his month-long study around Columbia, Agassiz asked his host to obtain photographic evidence for his research. Dr. Gibbes hired J. T. Zealy, a local daguerrean, to photograph the enslaved people whom Agassiz had studied. Fifteen of these daguerreotypes depicting enslaved Africans were discovered at Harvard's Peabody Museum of Archaeology and Ethnology in the mid-1970s. These 1850 pictures depict nude and semi-nude African men and women photographed from the front, side, and back. Some of the photos are labeled with first name, occupation on the plantation, name of the plantation, and slaveholder's name. As Agassiz was interested in both anatomical differences unique to African peoples and how these differences were or were

not retained in the United States, Zealy photographed both African-born slaves and their adult American-born children.[19]

Alfred, Fassena, Renty, Delia, Drana, Jack, and Jem are the names that accompany the daguerreotypes.[20] Delia was identified as the American-born daughter of Renty, who was thought to be born in the Congo, and Drana was labeled as the American-born daughter of Jack, who was said to be from Guinea. (See Figure 9.) Each person appears alone in the photographs. Most of the pictures focus on the chests, breasts, and heads of the enslaved; however, there are also full body shots. Ritual scarifications on the chest and cheek are evident in some of the pictures of the men. Yet the possibility of movement, contact, and agency—precisely the acts that had so disturbed Agassiz about the black men in the Philadelphia hotel—is prevented by the pictures. Here lies the place where Agassiz's project and the daguerreotype process mutually reinforced each other. As the daguerreotype could not capture motion, the enslaved people were positioned against headrests, away from and held steady for the photographer, rendering both contact and movement impossible. This inability of the daguerreotype to capture movement corresponded with Agassiz's project of trying to catalog difference without the burden of mutual contact or exchange.

Ironically, however, although movement on the part of the enslaved people was curtailed, looking straight at the white cameraman by way of the camera was required. In other contexts, this form of direct staring at a white man could have contradicted the slave codes and been deemed a punishable offense.[21] Yet although the necessity of this charged act and the newness of the medium might have momentarily disturbed established conventions, the central tenet of the slave codes—the maintenance of discipline and authority—was retained as the people in front of the camera were denied clothing while the man behind it was fully dressed. Because Zealy tried to create a visual record of the parts of the body that Agassiz had examined, mid-nineteenth-century social conventions of dress and modesty were disallowed in the studio and by extension in the photographs. Recalling the positioning of Baartman in the Jardin du Roi, these refusals attempted to negate the humanity of the enslaved Africans and African Americans and worked to position them as ethnographic specimens or types for scientific inquiry. At the same time, however, both cases betrayed a contingent authority, a somewhat precarious command that needed to be enforced continually and adaptively.

A Teacher and His Student: Georges Cuvier and Louis Agassiz

Baartman's humanity was partially denied and her body was constructed as an object of curiosity through a visual process of exhibition, dissection, and display. Agassiz used a similar strategy in his efforts to document the enslaved African and African American people as essentially different from those in power. He carried out his study on a southern plantation because only there was he able to secure relatively one-way contact with African people. He was an honored guest on a plantation and given license to observe. He treated laboring Africans and African Americans as the pleasure-seekers and scientists had treated Baartman in London and Paris: as a curious exhibit. The process of

dissection, however, was different for Cuvier and his student. Whereas Cuvier had to wait for Baartman to die before he was fully able to explore her, Agassiz hired a photographer to examine the enslaved people further. The camera became, in this case, an instrument of dissection: it was used to locate and obtain difference. In this way, the work of the scientific laboratory was transferred to the photographer's studio, and the camera replaced the microscope. Furthermore, the daguerreotype process proved a useful tool for dissection as it insisted upon a static, fixed subject.

The third step, the display of difference, was accomplished in Paris through the shelving of Baartman's genitals. In the case of the Zealy photographs, this final step was achieved through the fixing of the hard copy, the daguerreotypes which would be cataloged and stored at Harvard. And similar to the jar that contained a piece of Baartman's body, the daguerreotypes were labeled and left, ready to be solicited from the archive.[22] Like the tragedy of Baartman, the Zealy photographs represent links between imperialism, slavery, and the visual documentation of difference, and they expose relations between the hunger for visual evidence, the abuses of science, and the complicity of visual media.

The use of Saartjie Baartman's body by Georges Cuvier and of the bodies of the enslaved African and African American people by Louis Agassiz makes plain the potential dangers of evidentiary projects that investigate black bodies for visual corroboration of theories of white superiority. In both cases, black people were denied freedom, subjected to containment, and pressed to pose for an imagemaker, so that he could try to capture and reveal their difference from those who exerted more power. Likewise in both cases, these acts hinted at the uncertainty of that power. Finally, in both instances the visual documentation of reputed differences was commissioned by science, and painters and photographers were readily employed.

Photography and History

The fact that some of the earliest photographs of black people were created to demonstrate that people of African descent were a separate and inferior race challenges a central tenet of photographic history. Since the medium's inception, critics have frequently touted photography's democratic properties and potential.[23] Yet as Agassiz's daguerreotypes of enslaved African and African American people make evident, the medium is neither inherently democratic, as all do not have equal access to the camera or the ability to deny its gaze, nor does it necessarily foster identification or empathy with others, for just as it can be used to place people in contexts and tell stories of humanity, it can also be used in endeavors to dehumanize and catalog difference.

Photography is burdened by this legacy of visual violence. Yet the medium simultaneously holds promise; it is widely accessible, appealing to many, and has a long history both of exposing societal ills and of agitating for change. Nowhere is this dual nature of photography more evident than in representations of the disenfranchised, for images of the less economically powerful often reveal both the progressive and repressive tendencies of photography. Since the 1980s a number of African American women artists have grappled with the medium's complicated lineage, particularly in relation to the histories of people of African descent. Many of these visual artists previously worked

with documentary photography and still employ aspects of the genre; however, they have also shifted away from an "unmanipulated" or "straight" approach—often by juxtaposing images, incorporating text, and situating photographs within installations—in order to expose, critique, and dismantle the visually assaultive potential of photography while concurrently laying claim to its social power.[24] In the second part of this essay, I will analyze how a few of these artists approach the legacy of evidentiary projects and the visual documentation of difference—particularly the histories of Baartman and the enslaved African and African American people photographed by J. T. Zealy—and work to alter the course of these histories through their art.

Exposing the Power of Looking

One project that does not explicitly include photography is nonetheless central to my discussion, in that it directly confronts systems of containing, looking, and naming—the exact systems which make evidentiary projects possible. It is a 1990 installation by conceptual artist Renée Green titled *Anatomies of Escape,* a multi-media, multi-unit, and participatory work installed at the Clocktower Gallery in New York City. This installation graphically exposes the power inherent in looking. Critical of the ways dominant forms of visual empiricism attempt to prove the inferiority of the less powerful and, thus, justify their subordination, Green draws viewers' attention to these very processes. Likewise, by focusing on the ways black female bodies have been viewed by those with influence in the West, she places this specific history at the center of her project.

Evoking two of the most fetishized black bodies in European history, one section of the installation approaches the legacy of two women called Venus: "The Hottentot Venus" and "The Black Venus" (Josephine Baker). Keenly aware of the women's bodily overvisibility, both in their time and in our own, the artist avoids reproducing a context for the continued consumption of their overexposed bodies; instead, she creates a contemplative site, a space to consider the structural mechanisms that enable some people to look and others to be looked at. Concerning this aspect of her project, Green explains: "Power is related to seeing and vision. Being able to see and name something implies a certain amount of power. I keep trying to make viewers aware of the process involved in seeing, so that it doesn't just seem self-evident."[25]

Drawing from anthropological, literary, and scientific texts and using objects such as platforms, display cases, screens, and binoculars, Green's installation makes evident systems of "othering," particularly the construction of the black female body as an exotic curiosity or an ethnographic specimen. In one piece called *Seen,* for example, subject positions are reversed as the unwitting viewer gets up on a stage to glean information about "The Hottentot Venus" and suddenly finds herself displayed as a black shadow for all to see. (See Figure 21.) As getting up on stage is necessary to understand the piece, participants are tricked into performing as a curio, partially mirroring the deception of Baartman. One shaken viewer explained her experience with the piece:

> In order to get a sense of the work one had to ascend some stairs to what resembled a gallows or an auction block, masked off on one side by a lighted white scrim. There, stencilled on the floor, I read excerpts from the autopsy

report of the Hottentot Venus, and listened to a recording of Josephine Baker's voice. But my concentration was divided, because not only could I see people watching me like a performer on a stage, I sensed those I could not see observing my shadow through the scrim. I clearly recall my feelings of vulnerability and fear of exposure. My curiosity, in that context, had led me to experience a small, personal trial.[26]

Seen retells Baartman's story as well as implicating her past and present audience. It lays bare the power in defining vision. Through retelling and recontextualizing the saga of "The Hottentot Venus," as well as foregrounding the power relations involved, her work suggests that evidentiary projects can best be understood not as clear confirmation of a subordinate group's difference or inferiority, but rather as stark evidence of an imbalance of power.

Returning to the Scene

Contemporary artists frequently point to the saga of "The Hottentot Venus" as a defining moment in the representation of black women in visual culture and one that needs to be retold, either to remind us of our past or to redirect our future. In her 1990–1991 photo-text installation *How to Read Character,* photographer Carla Williams joins artists such as Green, Lyle Ashton Harris, Renée Cox, Deborah Willis, and Joyce Scott, as well as writers Elizabeth Alexander and Suzan-Lori Parks, in returning to Baartman's trials and rearticulating their meaning. Like Green and others, Williams challenges systems of power, viewing, and defining through her art. Williams, however, places the woman from southern Africa directly within the context of mid-nineteenth-century science to pose her critique. *How to Read Character* is composed of six large black-and-white photographs of the artist paired with period images and texts. The accompanying texts serve as labels and referents for the pictures and are borrowed from influential works in phrenology and physiognomy.

Brashly challenging and mocking the desire to read bodily evidence for one's worth, one photo-text work consists of a juxtaposition of manipulated photocopies of Huet le Jeune's and Wailly's commissioned scientific illustrations of Baartman and a gilt-framed close-up of the artist's backside. (See Figure 17.) By reclaiming these examples of art-in-service-to-science, this bold pairing reminds viewers of the complicity of imagemakers in providing visual "proof" for scientists seeking to make racist claims to truth. This pairing also links biography and autobiography as well as past and present. By joining self-portraits—head shots and profiles of the artist's head as well as close-ups of her body—with nineteenth-century scientific works, the installation prompts viewers to reflect on the inanity, pain, and contemporary resonance of empirical visual practices that attempt to measure the majority of the world's peoples against a mythical European ideal and, not surprisingly, find the majority lacking.

Williams's installation, however, also does something else. By inserting her own body into history as both photographer and photographed, she offers viewers a rare image of an unclothed black woman who is in her own studio and trying to define her own representation. Tellingly, she uses her body to inform and instruct. When Carla Williams

began photographing her naked self, she assumed that there was precedent for her actions; at the age of eighteen it felt mature and right. Yet upon reflection years later, she realized that there was no precedent; she had never seen an example of a black female nude.[27] Thus, *How to Read Character* challenges historical and contemporary projects to define character and intelligence based on bodily criteria, and it offers us some of the first images of the unclothed black female body—produced by the model— in visual art in the United States.

To accomplish this, Williams pulls the black female body from the harsh gaze of positivist science. At the same time, however, she retains visual evidence of the body's embeddedness in science; that is, through her photo-text pairings she shows how the black female body has been partially constructed by nineteenth-century scientific theories and practices. Yet after reappropriating art-made-in-service-to-science, she also repositions the body as worthy of aesthetic and critical reflection. Williams frames the body in gold—the same body that was previously seen as an object of curiosity and as evidence of inferiority—and keeps the faith that the museum or gallery setting will both honor the gilt-framed body and serve as a site of positive instruction. Given that the shows of London, the gardens of Paris, and the natural history museum archive were all unable to serve Baartman in this way, perhaps only brave and compassionate interventions like this one will make positive instruction a possibility.

Evidence of What?

Challenging systems of viewing and defining is also central to the photography of Carrie Mae Weems. After getting her start as a documentary photographer in the late 1970s and early 1980s in California, Weems began to question the genre's implications, particularly its convention of offering images of lone disempowered people, especially black Americans, to viewers for their curiosity, pity, and pleasure. She started to wonder if documentary photography could allow her to create images of African American people that would be able to "rise above the depiction of blacks always as the victim of the gaze."[28]

Deeply interested in issues of intent, use, and influence, Weems frequently unmasks the repressive potential of documentary photography at the same time as she continues to draw from it to create her art. Accordingly, her work often reveals a dual purpose of exposing the abuses of "straight" photography as well as expanding its possibilities. Of her engaged critical-participant approach, she explains:

> Even after realizing the nontruth value of documentary photography, I find it still remains an important form to explore and use. That photographs are only half-true is just fine with me, indeed it's that one half-truth that is the half most interesting and in the greatest need of illumination.[29]

In the early 1990s Carrie Mae Weems embarked on a project to rework Agassiz's daguerreotypes of enslaved Africans and African Americans and to infuse them with new meaning. These explanatory photographs, which had been taken as visual docu-

mentation of the inherent difference of enslaved people, and which had implicitly attempted to explain and justify their enslavement, now were to take on a new role. The artist traveled to Harvard's Peabody Museum where the daguerreotypes are housed, took photographs of the images, enlarged them, reversed some of them, and toned them in indigo blue. Then she framed and repositioned the photographs as three triptychs and placed them at the opening of her installation on the South Carolina and Georgia Sea Islands, the place where Africa is often thought to be most present and Africanisms most evident in the United States. (See Figure 8.) In so doing, she symbolically reunites the family that these images quite possibly depict—for in the originals Drana was listed as the daughter of Jack—and places them in a cultural context where they can be viewed not as evidence of African anatomical difference, but as the creators and sustainers of a powerful and unique black diasporic culture.

The wresting of the black body from the grip of visual empiricism—where it has often been used by more powerful others observing it for evidence of deviance and difference—is central to the photography of both Williams and Weems. By retrieving and recontextualizing images, enlarging and framing them, and placing them on the walls of the gallery and museum, they attempt to honor the formerly subjugated by positioning them within the conventions of the portrait, the very form that those in control of their representation often choose for their own likenesses. Explaining this strategy of genre manipulation and critique, Williams offers: "The choice of representation, i.e., scale of images, framing, and lighting, is intended to comment on the history of the formal portrait, especially the fact that certain subjects were not given this kind of aggrandizement and importance."[30]

Photographer and critic Allan Sekula contends that the photographic portrait is "a double system of representation capable of functioning both *honorifically* and *repressively*."[31] Furthermore, he considers these tendencies to be opposing but related poles of portrait practices. Yet what the photographs of Williams and Weems reveal is that these double functions can be evident simultaneously. Their works do not erase the imprint of the repressive institutions that have used black bodies to corroborate theories of deviance and inferiority; instead, their photographs make plain the repression and compel viewers to reflect on this legacy and its currency in our present. However, their work also enables fresh and honorable ways of looking that allow us to see anew the images of black people found in mid-nineteenth-century popular culture and science. For instance, as Weems is a student of folklore and shares an affinity with anthropologist Zora Neale Hurston, her positioning of the photographs of enslaved Africans and African Americans within a context of black diasporic folk practices and beliefs opens the possibility of understanding these people who look so intently at the camera and cameraman as conjurers using their skills of concentration to gain control over their predicament.[32] Of her interest in constructing new environments for these images, Weems states:

> I wanted to uplift them out of their original context and make them into something more than they have been. To give them a different kind of status first and foremost, and to heighten their beauty and their pain and sadness, too, from the ordeal of being photographed.[33]

By traversing the boundaries of science, art, and popular culture and wielding various strategies of reclamation and recontextualization, the art of Green, Williams, and Weems presses us to reflect on the ways that visual images trafficked and continue to traffic in history.

Undermining Proof

Undermining photography's use as evidence and proof has also been a recurring theme in the photo-text work of Lorna Simpson. Like Weems, Simpson's training is in social documentary photography; however, while still a young photographer, she turned away from this genre because she had become frustrated with viewers' limited expectations for it. Specifically, Simpson found herself troubled by the manner in which documentary photography purported to convey truth.[34] In addition, she was disturbed by the seemingly insatiable desire of privileged viewers to access and assess the "truth" of the less privileged—the typical subjects of the genre—in the comfort of the gallery or their living room chair. Thus in the late 1980s she set out to expose and interrupt this imbalanced visual relationship. To lay bare the established conventions of social documentary photography that encouraged savvy viewers to believe they could read a photograph as evidence of poverty or proof of dignity, Simpson tried to undermine this overly familiar exchange by giving "the viewer something they might not interpret or surmise, due to their 'educated' way of looking at images."[35]

One of the ways Simpson did this was by leaving a frequent site of documentary photography, the street, and bringing her models inside the studio. Obviously this strategy is not without risks—Zealy followed this same trajectory in bringing his subjects in from the plantation fields and into the studio. Yet Simpson uses this tactic not to decontextualize her subjects in order to define them and justify their subordination, but to press viewers to consider how they have associated and defined black people and, most importantly, to confront the processes through which they have done so. Indoors, Simpson has more freedom to place models into contexts of her own design. This freedom is crucial for her project because one result of "straight" photography is that certain groups of people become linked with certain locales; for example, African Americans have frequently been identified with the urban street in twentieth-century popular imaginations. Thus, the studio is where Simpson can best interrupt learned and limiting tendencies to read images of black people simplistically, while simultaneously encouraging viewers to participate in the creation of more nuanced interpretations.

Another strategy that Simpson employs to subvert the prevalent understanding of photographs as claims to truth is to deny access to her models' faces, the site which many look to for evidence of a person's interior life. Unlike either social documentary subjects, whom photographers pose as visual proof of various social problems, or Baartman and the enslaved African people, who were posed to provide visible evidence of their difference, Simpson refrains from giving viewers this form of definitive authority and control. Instead, she typically photographs her models from behind or presents just their torsos. This denial of access to the faces of her subjects frustrates our cravings

for the information that is usually provided for us in documentary photography, information that affords us a feeling of mastery over the subjects. Concerning this key aspect of her late 1980s and early 1990s work, the artist explains:

> The viewer wants so much to see a face to read "the look in the eyes" or the expression on the mouth. I want viewers to realize that that is one of the mechanisms which they use to read a photograph. If they think, "How am I supposed to read this, if I don't see the face?" they may realize that they are making a cultural reading that has been learned over the years, and then perhaps see that it is not a given.[36]

Discouragement of facile interpretations and superficial mastery is also enhanced by Simpson's tactical use of text; she uses words to contradict and destabilize her images further. Simpson began inserting text into her work because she found "straight" photography inadequate to the task of conveying complexity. There were things, she says, "that the photograph would not speak of and that I felt needed to be revealed, but that couldn't be absorbed from just looking at an image."[37]

One of Simpson's 1989 photo-text works, *Three Seated Figures,* demonstrates her signature tactics for dispelling viewers' yearnings for simplicity and authority by presenting a series of images of a model's torso in a stark studio environment surrounded by simultaneously pointed and open-ended text. (See Figure 15.) The piece consists of three large Polaroid prints girded by five engraved plaques. The pictures are repetitive and depict the body of a young black woman in a white shift; the woman is seated and appears virtually the same in all three pictures except for minor changes in the positioning of her hands. Framing her body on either side are the phrases "her story" and "each time they looked for proof." Above the figure, where her forehead would be if it were visible, are the words "Prints," "Signs of Entry," and "Marks." Seemingly connoting violation, these words as well as the spare white shift—a hospital gown? a slip? the insufficient dress of an enslaved woman?—evoke a sense of forced penetration. Furthermore, as the tops of the picture frames cut directly through the woman's mouth, she is rendered mute. Perhaps recalling other black women positioned as curiosities and ethnographic specimens like Baartman and the enslaved women Delia and Drana, this woman is unable to verbally convey the horror of the violation of her bodily integrity or, more precisely, to be publicly heard.[38]

Visible signs or marks of violation, however, are missing from the triptych. This is indication that "her story" cannot be entirely found here. Although fragments of her story are indeed present and can be inferred by a patient and imaginative viewer, the work also tells another story, one that certainly concerns "her," but one that is also systemic and larger than her. Through its subversion of documentary practices, Simpson's *Three Seated Figures*—like the works of Green, Williams, and Weems—challenges systems of meaning-making that position the black female body as evidence of difference and deviance in order to enforce subordination. Yet Simpson's work also complicates this critique by pointing to a central paradox in the search for evidence: that this search for evidence to justify dominant ideologies and practices has been matched with the simultaneous suppression of the history of this exploitation. Thus, although the

photo-text piece does not reveal "her story," and in fact, all attempts to see and under-stand "her story" are consistently disallowed through the artist's strategies of refusal and denial, the work exposes this frequently overlooked contradiction. By foreground-ing, through its use of image and text, both the problem of the history of evidence ("each time they looked for proof") and the evidence of this history ("her story"), Simpson's work points to their entanglement and presses us to consider the complexity of both searches for visual evidence and searches for visible history.

Early nineteenth-century visualizations of black women's bodies as contained, enslaved, and detained provided corroboration to scientific justifications for their sub-ordination. The work of artists and intellectual historians Green, Williams, Weems, and Simpson invites viewers to participate in conversations about the contours and mean-ings of these legacies. Their work also poses questions about how this history can be represented. Taken together, their art serves as an artistic retort: it powerfully exposes, analyzes, and subverts violent visual legacies that have been in place since the first half of the nineteenth century. In addition, their bold creative interventions implore us to question and change the course of these still visible histories.

Credit: Collins, Lisa Gail. *The Art of History: African American Women Artists Engage the Past.* Copyright © 2002 by Lisa Gail Collins. Reprinted by permission of Rutgers University Press.

1. In this essay, I use "myth" somewhat ominously. I see it as a powerful way to describe the world, its inhabitants, and their relations. I also see myth as frequently explaining, justifying, naturalizing, and thus reinscribing the status quo.

2. Sander L. Gilman, "Black Bodies, White Bodies: Toward an Iconography of Female Sexuality in Late Nineteenth-Century Art, Medicine, and Literature," *Critical Inquiry* 12:1 (Autumn 1985): 212.

3. Ibid.

4. Hugh Honour, *The Image of the Black in Western Art,* Vol. 4: *From the American Revolution to World War I,* Part 2 (Houston: Menil Foundation, 1989; distributed by Harvard University Press), 54.

5. Stephen Jay Gould, "The Hottentot Venus," *Natural History* 91:10 (October 1982): 22.

6. Honour, 54.

7. Gilman, 240.

8. Gould, 22.

9. Richard Leppert, *Art and the Committed Eye: The Cultural Functions of Imagery* (Boulder: Westview Press, 1996), 176. Informed by Michel Foucault's notions of power, Leppert writes, "The presence of the Other—the Not Us—provides a visual measure by which distinctions of social and cultural merit may be drawn. To be greater, in other words, the lesser *must* be acknowledged. The danger to the greater that is posed by the lesser's presence may be circumscribed by limiting the latter's agency." In *History of Sexuality,* Foucault described power as being "everywhere" and constantly in various processes of negotiation. He explained power as "a moving substrate of force relations which, by virtue of their inequality, constantly engender states of power, but the latter are always local and unstable." Michel Foucault, *The History of Sexuality,* Vol. 1: *An Introduction,* trans. Robert Hurley (New York: Random House, 1978; reprint, New York: Vintage, 1990), 93.

10. Edward Lurie, *Louis Agassiz: A Life in Science* (Chicago: University of Chicago Press, 1960), 40, 81.

11. Louis Agassiz to his mother, December 1846. Original letter in Houghton Library, Harvard University, Cambridge, MA; quoted in Stephen Jay Gould, *The Mismeasure of Man* (New York: Norton, 1981), 44–45. Brian Wallis also quotes part of this passage in his investigation of Louis Agassiz's scientific methods and their relation to museum and archival systems and practices. Brian Wallis, "Black Bodies, White Science: Louis Agassiz's Slave Daguerreotypes," *American Art* 9:2 (Summer 1995): 42–43.

12. Wallis, 44.

13. Lurie, 143.

14. Elinor Reichlin, "Faces of Slavery," *American Heritage* 28:4 (June 1977): 4.

15. Ibid.

16. Ibid., 5.

17. Alan Trachtenberg, *Reading American Photographs: Images as History, Mathew Brady to Walker Evans* (New York: Hill and Wang, 1989), 53.

18. Lurie, 264. For more on Agassiz's theories and their influence on defenders of slavery, see George M. Fredrickson, *The Black Image in the White Mind: The Debate on Afro-American Character and Destiny, 1817–1914* (New York: Harper Row, 1971; reprint, Hanover, NH: Wesleyan University Press, 1987), 75.

19. As Congress had passed legislation prohibiting the importation of slaves into the United States in 1807—forty-three years before these pictures were taken—at least some of the African-born slaves whom Zealy photographed must have been illegally brought into the country. The illicit slave trade was not uncommon at this time. In fact, W.E.B. Du Bois charted the continuance of the trade from 1820 to 1860 and deemed the Act of 1807 virtually a "dead letter," for when Congress banned the slave trade they did not set up a national structure to enforce the act. Thus the ban, along with the development of new industries, led to an increased market for slaves and many people were willing to violate the law in order to cash in on this illicit market. See W.E.B. Du Bois, *The Suppression of the African Slave-Trade to the United States of America, 1638–1870* (Cambridge, MA: Harvard Historical Studies no. 1, 1896; reprint, Millwood, NY: Kraus-Thomson Org. Ltd., 1973), 109.

20. Wallis, 46. In his article, Brian Wallis publishes the daguerreotypes in their entirety for the first time as well as provides the names that accompany them.

21. Kenneth M. Stamp, *The Peculiar Institution: Slavery in the Ante-Bellum South* (New York: Knopf, 1956; reprint, New York: Vintage, 1989), 207–208. In his discussion of slave codes and their under-lying "requirement that slaves submit to their masters and respect all white men," Stamp notes a North Carolina judge who understood a range of acts as constituting "insolence." Stamp quotes the judge's statement: "a look, the pointing of a finger, a refusal or neglect to step out of the way when a white person is seen to approach. But each of such acts violates the rules of propriety, and if tolerated, would destroy that subordination, upon which our social system rests." I am grateful to John S. Wright for pointing out this aspect of the slave codes.

22. For a helpful discussion of the relations between photography, the body, and the archive in the mid-nineteenth century, see Allan Sekula, "The Body and the Archive," in *The Contest of Meaning: Critical Histories of Photography,* ed. Richard Bolton (Cambridge, MA: MIT Press, 1989). For a discussion of the links between ethnographic study, photography, and claims to truth, see Melissa Banta and Curtis M. Hinsley, eds., *From Site to Sight: Anthropology, Photography, and the Power of Imagery* (Cambridge, MA: Peabody Museum Press, 1986).

23. For an example of this tendency in the history of photography see Alan Trachtenberg, *American Daguerreotypes from the Matthew R. Isenburg Collection* (New Haven, CT: Yale University Art Gallery, 1990), 19. He writes, "The moment of the daguerreotype held perhaps the highest promise yet achieved in the United States for an art founded on egalitarian premises: an art of equal access to self-presentation."

24. For more on the strategies contemporary photographers employ to challenge the conventions of documentary photography, see Brian Wallis, "Questioning Documentary," *Aperture* 112 (Fall 1988): 60–71. For an analysis of the photo-text work of a select group of black women artists from the U.S. and U.K., see Kellie Jones, "In Their Own Image," *Artforum* 29:3 (November 1990): 132–138.

25. Russell Ferguson, "Various Identities: A Conversation with Renée Green," in *World Tour: Renée Green* (Los Angeles: Museum of Contemporary Art, 1993), E56.

26. Julie Lazar, "Foreword," in Ferguson, *World Tour: Renée Green,* A1.

27. Carla Williams, "The Erotic Image Is Naked and Dark," in *Picturing Us: African American Identity in Photography,* ed. Deborah Willis (New York: New Press, 1994), 133.

28. Susan Benner, "A Conversation with Carrie Mae Weems," *Artweek* 23:15 (7 May 1992): 5.

29. Kellie Jones, "A Contemporary Portfolio," *Exposure* 27:4 (Fall 1990): 30.

30. Carla Williams, "How to Read Character," quoted in Deborah Willis, "Women's Stories/Women's Photobiographies," in *Reframings: New American Feminist Photographies,* ed. Diane Neumaier (Philadelphia: Temple University Press, 1995), 86.

31. Sekula, 345.

32. For mention of conjurers and the practice of the "evil eye," see Norman E. Whitten, Jr., "Contemporary Patterns of Malign Occultism Among Negroes in North Carolina," in *Mother Wit from the Laughing Barrel: Readings in the Interpretation of Afro-American Folklore,* ed. Alan Dundes (Englewood Cliffs, NJ: Prentice-Hall, 1973; reprint, Jackson: University Press of Mississippi, 1990), 406.

33. Vince Aletti, "Dark Passage," *Village Voice* (22 December 1992): 102.

34. For an analysis of how practitioners assume that "socially concerned" photography reveals "truth," see Susan Sontag, *On Photography* (New York: Farrar, Straus and Giroux, 1977; reprint, New York: Anchor, 1990), 106.

35. Regina Joseph, "Lorna Simpson Interview," *Balcon* 5/6 (1990): 35.

36. Trevor Fairbrother, "Interview with Lorna Simpson," *The Binational: American Art of the Late 80's* (Boston: Institute of Contemporary Art, 1988), 178.

37. Joseph, 35. For more on Simpson's use of language, see Coco Fusco, "Uncanny Dissonance: The Work of Lorna Simpson," in *English Is Broken Here: Notes on Cultural Fusion in the Americas* (New York: New Press, 1995), 97–102.

38. See Saidiya V. Hartman's powerful reading of this woman as a victim and survivor of rape in her essay "Excisions of the Flesh," in *Lorna Simpson: For the Sake of the Viewer,* ed. Beryl J. Wright and Saidiya V. Hartman (Chicago: Museum of Contemporary Art, 1992), 62.

DEBRA S. SINGER

7 Reclaiming Venus

The Presence of Sarah Bartmann in Contemporary Art

> America is past-free; we rely on a swift evaporation of the what was. We move
> forward. And a protruding posterior is a backward glance, a look which, in this
> country, draws no eyes. Has no place. No rest. . . . What do we make with the
> belief that the rear end exists?
>
> —Suzan-Lori Parks, "The Rear End Exists"

Numerous contemporary artists and writers in recent years have created
works reclaiming the historical figure of Sarah, or Saartje, Bartmann. Exhibited, osten-
sibly as a paradigm of what her culture valued as physical beauty, Bartmann was viewed
by European audiences as a grotesque yet exotic, deviant yet desirable, presentation of
black sexuality. Her presence in European popular culture extended far beyond her five
years of display. After Bartmann's death, at least one other African woman was brought
to Europe and presented as a "Hottentot Venus," and many other unidentified women
from Africa with similar physiques were photographed naked into the 1880s.[1] Images
labeled the "Hottentot Venus" developed into such a phenomenon that they circulated
as one of the nineteenth-century's most prevalent representations of a black female.[2] As
a result, Bartmann became an icon within Western society not only of all black women
but also, more broadly, of the "mystery" of female sexuality. Equally significant, the
"Hottentot Venus" also symbolized the perceived sexual difference between the white
European and the black African and became a metonym for a feminized and subordi-
nated Africa. More than a century later, her image remains a complicated site for the
examination of the representation of the black female body in Western culture, sexuality,
and ideals of femininity as well as visuality as a colonizing tool.

Many of the artists and writers to engage Bartmann's story have been women of
African descent for whom the original circumstances of Bartmann's exploitation continue
to have a strong resonance. Their renewed interest in this previously overlooked subject
of history follows in the wake of academic efforts by historians such as Sander Gilman,
whose influential 1985 book *Difference and Pathology: Stereotypes of Sexuality, Race, and
Madness* was one of the first widely available publications to examine the cultural impli-
cations and sociological context of Bartmann's display. While examples can be found
internationally across the literary and performing arts, my discussion will focus on
works by six African American visual artists: Renée Cox, Renée Green, Joyce Scott,
Lorna Simpson, Carrie Mae Weems, and Deborah Willis. Engaging diverse artistic meth-
ods ranging from photography to quilting and from installation to performance art,

each recognizes Bartmann as a powerful symbol of the continuing objectification of the black female body. Despite this common point of departure, their works demonstrate the multiple possibilities in recuperating Bartmann's story as they traverse the crossroads of sexuality and specularity, past and present, production and reception of visual representations. Several of the artists emphasize concerns relating to ideals of feminine beauty and racialized notions of the erotic. Others make explicit connections between Bartmann and Africa, pointing out how "looking at" may be perceived as a form of "possessing" and foregrounding issues of control over the display of the body. In still other instances, artists highlight the resonance of this nineteenth-century example with constructions of blackness in popular culture today.

These artists explore the various ramifications of Bartmann's story by working through the body, identified as a complex site for the production of difference. Each of these women offers either new formations of the self or presents what Abigail Solomon-Godeau has described as "hybrid forms" of self-representation, in which we witness the absorption of the personal into the social to discover how black women's subjectivity in the present moment is shaped by references to prior determinations.[3] According to Solomon-Godeau, these "hybrid forms" are generally marked by the absence of an image of the artist's physical body within the work, but nonetheless, they engage with issues of self-representation.[4] Central to all of the works is the repossession of an ignored past in order to formulate new possibilities of black female subjectivity in the present. Analogous to how Bartmann served as a vehicle for redefining issues of race, gender, and sexuality in the nineteenth century, in the late twentieth and early twenty-first centuries she symbolizes the need to reinvestigate how discursive formations of race inscribe onto the body particular concepts of sexuality, femininity, desirability, and beauty.

In investigating the subject of Sarah Bartmann, Joyce Scott and Renée Cox employ familiar self-representational forms. Each uses her own body, not necessarily to connect her own life directly to Bartmann's, but rather as a surrogate for a collective subject that can alternately be read as black, female, or both. Bartmann surfaces as a character in Joyce Scott's performance *Women of Substance* (1985), which is a series of short vignettes, both humorous and emotional, about being an overweight black woman in American society. Scott and actress Kay Lawal performed *Women of Substance,* in which the two worked together as the "Thunder Thigh Revue."[5] Like many of Scott's meticulously crafted beaded works, the performance explores stereotypical notions about body shapes and how dominant Western ideals of beauty and femininity have an impact upon one's self-image. In its positive embrace of alternative figures, it is ultimately a dynamic presentation of self-empowerment.

The character of Bartmann first surfaces as a projected image depicting the life-cast made of Bartmann's body after her death. The image is accompanied by Lawal and Scott singing a moving lament about the circumstances of Bartmann's life and the lack of compassion for her feelings. Later, Lawal appears as a sassy Venus on a half-shell and performs a comic routine about various "Venuses" throughout history. Scott then enters as "the African Venus," clothed in a costume modeled after Bartmann's naked silhouette, with an emphasis on projecting buttocks. Through this embodiment of stepping into Bartmann's skin, Scott assumes the position and voice of the "Hottentot Venus" as she recites a sobering and contemplative monologue about the public conditions of Bartmann's life. Scott's engagement of the first-person voice counters the historical precedent

of black women as silenced subjects and is a particularly moving gesture given that no written record exists of Bartmann's thoughts about her life in Europe. As conveyed by Scott, Bartmann's situation also remains poignant in today's world. As Lowery Stokes Sims has observed, the character's mournful chant about "the violation of her [Bartmann's] privacy . . . traverses time from the slave auction block to the welfare mothers in city shelters, and eloquently captures the reality of poor and minority women in American society."[6]

Renée Cox chooses a similar tactic of role-playing in order to express notions of a social and historical African American female subjectivity. She created a black-and-white, photographic self-portrait titled *Hottentot* (1994) in which a nude Cox dons an armature of "tits and ass," which she found accidentally in a Halloween store. This paraphernalia resonates with how Bartmann was essentially reduced to her sexual parts in the eyes of European audiences. Cox's image is reminiscent of images of many unidentified black women with physical builds similar to Bartmann's, which circulated as a kind of pornography. At the same time, her sideways pose also recalls both "scientific" illustrations of Bartmann and later anthropological black-and-white photographs depicting non-Western individuals from front, side, and rear views. Such nineteenth-century drawings and photographs focused directly on isolated bodies or body parts from multiple perspectives in order to document shapes and proportions. These visual records were then used by scientists, such as Louis Agassiz, as "proof" in the development of categories of discrete racial typologies and of their theories that the various "races" of mankind constituted separate and unequal species.[7] While drawing on various strains of documentary photographic practices, Cox's image complicates these references to past traditions: as she looks straight out and meets the viewer's gaze, the image resists assumptions about the structure of "the gaze" as an active male scopic drive onto a passive female object. This type of resignifying echoes Stuart Hall's observation of a pattern that many black artists choose to use their own bodies "as the 'canvas', light-sensitive 'frame' or 'screen', so that the work of translation and re-appropriation is literally a kind of 're-writing of the self on the body.'" This process, Hall explains, involves a kind of "re-working of the abjected black body through desire," which he refers to as "the production of a new 'black narcissus.'"[8]

Cox's *Hottentot* begs comparison with a closely related and better-known work by Lyle Ashton Harris titled *Venus Hottentot 2000* (1994), which he produced collaboratively with Cox. (See Figure 30.) *Venus Hottentot 2000* is a unique, large-format color Polaroid that is part of Harris's series *The Good Life* (1994). This series brings together self-portraits, portraits of family and friends, and archival family photographs taken by his grandfather. In each case, Harris asked his subjects how they would like to be photographed, thus reversing a conventional dynamic between the photographer and the photographed. Similar to his own self-portraits, Harris's collaborative portraits of friends reflect a performative notion of identity in which gender, race, and sexuality are all forms of masquerade to be manipulated. In *Venus Hottentot 2000,* Cox presents herself in the same costume as in her own black-and-white version; however she assumes a slightly different pose and more confrontational gaze, thereby suggesting what Carrie Mae Weems has called "creating a space in which black women are looking back."[9] Significantly, the translation of the image into color brings *Venus Hottentot 2000* into other associative realms. With an emphasis on its vibrant, glossy surface, the image

clearly appropriates the vocabulary of commercial photography. Furthermore, the heightened attention to additional signifiers of sexualized femininity, such as visible eye makeup and lipstick, relates to other media images of women at the level of spectacle. Harris has remarked on his relationship to this specific work:

> I am playing with what it means to be an African diasporic artist producing and selling work in a culture that is by and large narcissistically mired in the debasement and objectification of blackness. And yet, I see my work less as a didactic critique and more as an interrogation of the ambivalence around the body. Engaging the image of the Hottentot Venus has deepened my understanding of the body as a sight of trauma and excess.[10]

Despite the distinct strategies of drawing on anthropological as opposed to advertising photographic languages, both Cox's and Harris's versions of the "Hottentot Venus" present the body as an ambiguous site onto which various forms of "otherness" are inscribed, such as the fetishization of skin as a signifier of racial difference. The body is also posited as a site of struggle through which interdependent concepts of identification and desire and the sexualization of the gaze, as well as its relationship to power or control, are explored.

Departing from the transformations of the "self" evidenced in Scott's and Cox's works are two photo-quilts by Deborah Willis that pay homage to Bartmann's life. Willis's reconnection to the past is manifested not only in her appropriation of Bartmann's story but also through her choice of media. Her photo-quilts reflect the important place of quilt-making within her own family history as well as the larger tradition of African American story quilts. Willis has commented, "Quilts are made to remind us who we are and what our ancestors have been to us and the larger society."[11] By choosing to produce quilts as her art-making practice, Willis, like Scott with her hand-sewn costume and beaded creations, adopts a feminist tactic dating back to the 1970s. Seventies feminist artists consciously employed labor-intensive methods, such as stitching or weaving, that had traditionally been denigrated as "feminine," coded as "craft," and thereby excluded from high art discourse.

One quilt, *Tribute to the Hottentot Venus* (1992), is constructed from sensuous red fabrics and built around a central relief-image of an abstract vaginal form. (See Figure 26.) Along the periphery, Willis reproduces nineteenth-century illustrations of Bartmann, ranging from scientific renderings of her genitalia to political cartoons mocking her presumed sexual difference. The central image intimates how Bartmann's body was autopsied after her death by scientists who then donated her preserved genitalia to the Musée de l'Homme in Paris. These trophies of colonial science remained on view in a glass jar for more than a century. Willis's juxtaposition of specific images of Bartmann with the abstract sexual form not only reclaims these images in honor of Bartmann, but also indirectly links her predicament to those of other women who are exploited as spectacles to be consumed in contemporary contexts.

Another piece, *Hottentot/Bustle* (1995), makes more explicit connections to the present day. (See Figure 25.) As the title implies to the viewer, the popular display of Bartmann's body is thought to have led to the development of the bustle, which was designed to simulate an exaggerated shape of the buttocks.[12] The quilt is composed of three panels.

Each shows a different headless, silhouetted figure: a nude composed of brown fabric; a bustle dress made up of a mosaic of different nineteenth-century French fabric patterns; and a figure comprised of striped, multicolored fabrics. These figures are outlined with handwritten texts and accompanied by reproductions of lithographs depicting Bartmann. The story unfolds in succession from left to right, beginning with an abbreviated account about the circumstances of Bartmann's public life. The narrative continues with an appropriated text by the Italian photographic archivist Nicolas Monti, in which he describes how the black woman was imagined "without a head," as just an available body to sate man's pleasure.[13] The third panel concludes with comments about how black women are still objectified within popular culture, citing the fashion designer Vivian Westwood's mini-skirt bustle and Sir Mix-A-Lot's 1992 rap song, *Baby's Got Back.* Once again, Willis sets the abstraction of her black silhouette on the left against the multicolored one on the right, suggesting a broader reading that speaks not only to the predicament of black women but to that of all women.

Moreover, Willis's silhouetted figures can be interpreted as mirroring the approximate contours of the continent of Africa and evoke a connection between the topographical and the corporeal. The rhyming of the outlined figures with the shape of Africa recalls Ann Fausto-Sterling's argument about how "early explorers linked the metaphor of the innocent virgin (both the woman and the virgin land) with that of the wildly libidinous female." Fausto-Sterling has explained that it is this "discovery" and subsequent construction of these "wild women" which raised questions about European women's sexuality. It then became necessary to distinguish the "'savage' land/woman from the civilized female of Europe."[14] Such distinctions were played out through the paradigmatic example of the "Hottentot Venus," who was positioned in Western culture as the antithesis of ideal European beauty and sexual mores.[15]

Unlike the aforementioned artists, Lorna Simpson, Carrie Mae Weems, and Renée Green have produced works which refuse to re-present Bartmann's body visually. Rather, they invoke the body primarily through *verbal* means in order to focus on how structures of voyeurism and the spectacle affect the construction of desire and sexuality and how these relationships consequently influence formations of black female subjectivity. Lorna Simpson's *Unavailable for Comment* (1993) is a three-paneled, photo-text work bringing together images of a broken glass jar, a pair of backward-facing, high-heeled shoes, and an abstracted image of unbounded waves of water. (See Figure 35.) The photograph of the high-heeled shoes, a signifier of desirable femininity, prompts the viewer to imagine a body she cannot see. The accompanying text, written in French, plainly announces Sarah Bartmann's "unexpected" visit to the Musée de l'Homme, during which she "disrupts" the daily life of the museum. Simpson's narrative, referencing the display of Bartmann's genitalia at the museum, invites viewers to envision a provocative scene in which Bartmann returns to the site, smashes the jar, and literally reclaims control over her body. She offers an inverted twist of the metaphor of the female body as "vessel": here is a broken vessel/body that refuses to be contained, one that is released, liberated. The title—*Unavailable for Comment*—not only hints at how Bartmann is nowhere to be found to be "questioned" in this incident, but also points to our lack of a first-hand account by Bartmann about her life. Simpson's resurrection of Bartmann's presence brings the past into an imagined present and rewrites her story with an empowering end that transcends the subjugation of Bartmann's life.

Carrie Mae Weems's piece *The Hottentot Venus* (1997) similarly shows images only indirectly linked to Bartmann's body and deliberately provides specific references only within the texts. (See Figure 18.) In this photo-text diptych, Weems presents two contemporary views of the zoological garden in Paris. The garden is the location where Bartmann was put on display and studied by scientists such as George Cuvier, who wrote the most famous version of her autopsy, in which he describes her genitals. One view depicts a large, outdoor animal cage while the other focuses on a sculpture of a black man playing the flute and dancing with a snake at his feet. A dialectic between the two images is therefore set up, evocative of the exploitative circumstances of Bartmann's life: an entertaining spectacle placed on view like an animal at a zoo. Weems's focus on re-presenting a space that Bartmann might actually have inhabited is developed further in the elegantly engraved texts below the photographs. The left panel reads: "In a 19th century zoological garden, I passed Monsieur Cuvier; he fixed his gaze onto me; a sudden chill rose and the hairs on the nape of my neck stood on end, in defense, I touched myself, & fled." Given the narrative, one can infer that the first-person voice in this story is Bartmann's. By contrast, the right panel reads: "I've heard that after the King set eyes upon you, the bustle became all the rage with ladies of the court." The "I" in this case is more ambiguous, but may be understood to represent the artist herself—thereby establishing an imagined conversation between Bartmann and Weems and situating the work simultaneously in both past and present moments. The specific invocation of two male figures, Cuvier and the "King," and the implied attraction to the "Hottentot Venus," comments on issues of control over the display of the body and the intertwining of the politics of gender with the politics of desire.[16] Although Bartmann's figure is nowhere represented, the texts recollect how she was viewed as desirable and not simply as a "freak." As Weems has commented, this is an important dimension to the story of the "Hottentot Venus" that carries over into today, since there are still very few contexts in which black women are presented as desirable. The tragedy is that the making of this desire was beyond Bartmann's control.[17]

Renée Green also interrogates issues of desirability in her explorations of the production of Bartmann as a spectacle and likewise carefully chooses what is accessible and what is denied to viewers. Perhaps more than any other artist, Green has worked through the various implications of Bartmann's story, producing six works between 1989 and 1991. Three of these—*Permitted, Sa Main Charmante,* and *Seen*—were exhibited together alongside other works in Green's exhibition "Anatomies of Escape" at the P.S. 1 Contemporary Arts Center's Clocktower Gallery in 1990.[18] The focus of these installations is not Bartmann herself, but rather the scientists who studied her as well as the public who paid to see her. This perspective reflects Green's interest in investigating how Western systems of classification and description construct non-Western subjects as sites for the collective projections of repressed fantasies and desires.

In *Permitted* (1989) Green created an installation attempting to place the viewer in the same position as early nineteenth-century audiences. (See Figure 22.) At the center of the work is an enlarged reproduction of an engraving depicting Bartmann. On top of this image, Green placed wood slats embossed with rubber-stamped texts excerpted from Sir Francis Galton's description of measuring from a distance with a land-surveying device the buttocks of another "Hottentot" woman. Purportedly scientific analysis is presented in a capitalized font which alternates with hand-scripted, subjective com-

mentaries expressing Galton's fascination with her figure. Recreating the basic setup of Bartmann's original exhibition, a peephole is provided through which the viewer can see an image of Bartmann standing on a crate. The apparatus of the peephole, which is associated with transgression or taboo, references how nineteenth-century "ethno-graphic" images of naked women also served as a kind of substitute pornography.[19] As Green's title—*Permitted*—indicates, a white European woman could not have been presented in this manner, given the cultural mores of the day. It is only because Bart-mann was constructed as an exotic specimen from a distant land that her naked form could be displayed in public contexts.

Green's interest in technologies of vision that mediate the action of looking are further evident in *Sa Main Charmante* and *Seen*. Both recreate situations alluding to the space in which Bartmann would have been exhibited and are designed to make viewers conscious of their desire to look. In *Sa Main Charmante,* or *Her Charming Hand* (1989), a box with two painted footprints is placed on the floor in front of the viewer. (See Figure 20.) The footprints exist as residual traces of Bartmann's presence and, like Simpson's high-heeled shoes, ask the viewer to imagine her position as the object of a public's gaze. Behind the box and attached to the wall, wood slats are stamped with two alternating texts about Bartmann, both taken from her autopsy report. Green's use of medical reports in this and other works points to how the inter-rogating eye of science, under the pretense of analytical concerns, transforms the subjects participating in their studies into dehumanized objects of observation. The box is bracketed by a peephole on its left and a spotlight on its right. As the viewer bends down to look through the peephole, the spotlight shines directly onto the person, preventing the viewer from potentially seeing anything. The irony is that there is, in fact, nothing to see. Instead, this spotlight instantly transforms the viewer into the object of attention. The dynamics of "looking" are, therefore, reversed as the "viewer" becomes the "viewed."[20]

This approach of determining viewing relations is elaborated in Green's installation *Seen* (1990). (See Figure 21.) In this work, she includes texts describing two entrances—the first by Bartmann from a cage into an arena and the second by Josephine Baker onto the stage. These descriptions are alternately rubber stamped across a platform's surface.[21] In order to read the texts, the viewer has to step up onto the platform, at which point a spotlight from across the room casts the person's shadow against a background scrim. The viewer presumably moves across this platform and perhaps even stoops down to decipher the words—in effect, "performs" on this impromptu "stage." During this time, other gallery visitors are able to watch the moving black silhouettes from the opposite side of the scrim.[22] In addition, people standing on the platform are also surveyed from below by mechanical, moving eyeglasses with eyes that wink through an illuminated hole up toward the viewer's crotch.[23] Green, therefore, shifts the spectacle of performing bodies from Bartmann and Baker to the viewers themselves.

In each of these examples, Green's focus on the structural dynamics of vision—the power in "looking" and the objectification experienced by the subject of the gaze—posits "looking at" as a form of "possessing." This relates to what Green refers to as "people's ability to colonize things with their eyes."[24] As Jan Pieterse has stated: "Knowing the colonized is one of the fundamental forms of control and possession. One application of this knowledge is that the subject peoples are turned into visual objects."[25] The works

are designed to foreground how the biological function of sight or vision is always mediated by one's preconceptions about the world and to highlight the continuing tendency of people to make assumptions about other people's characters based on their physical appearance. Green's engagement, therefore, with the construction of particular African diasporic subjects, such as Bartmann, within Western historical narratives, reflects her more expansive concern with provoking viewers to contemplate how legacies of the social sciences of the nineteenth century manifest themselves in racist or sexist attitudes today.

Grounding contemporary social concerns in the historical framework of Bartmann's life, each artist discussed in this essay reclaims the story and image of the "Hottentot Venus," not only to commemorate this suppressed past, but also to construct an alternative, empowering legacy for the present. Whether they use their own bodies, assume a first-person narrative, create imagined scenarios, or construct a conceptual space, these artists' representations of Bartmann signal the continuing fetishization of the black female body within the white imagination of Western culture. As they experiment with how women's bodies can be represented, both visually and verbally, they undermine the hierarchical structures of "othering" that are embedded in both the production and reception of language and visual images, and in so doing, invent new formations of black female subjectivity. Their methods resemble tactics of counter-appropriation that Kobena Mercer has referred to as the "stereotypical sublime"—identifiable racial tropes which are "so low you can't get under it and so high you can't get over it," so that artists resort to the production of alternative meanings by "passing through it, repeating . . . with a critical, signifying difference."[26] These artists' "repetitions with a difference" that "pass through" Bartmann represent an implosion of forms of fixed racial signification that seeks to forge new positions of identification and articulation which endow black female subjects with cultural and political agency. Although offering no prescriptions for the future, their reinterpretations challenge us to assume responsibility and accountability for the past and echo Suzan-Lori Parks's provocative question: "What do we make with the belief that the rear end exists?"[27]

Epigraph: Suzan-Lori Parks, "The Rear End Exists," *Grand Street* 55 (Winter 1996), 11–17.

1. Deborah Willis, "Introduction: Picturing Us," in *Picturing Us: African American Identity in Photography,* ed. Deborah Willis (New York: The New Press, 1994), 19.

2. See Sander Gilman, "The Hottentot and the Prostitute: Toward an Iconography of Female Sexuality," this volume, 15.

3. Abigail Solomon-Godeau, "Representing Women: The Politics of Self-Representation," in *Reframings: New American Feminist Photographies,* ed. Diane Neumaier (Philadelphia: Temple University Press, 1995), 304–305.

4. Solomon-Godeau, 310.

5. This performance piece is included in a discussion of the visual arts because Joyce Scott is primarily known as a visual and performance artist, not as a playwright per se.

6. Lowry Stokes Sims, "Aspects of Performance by Black American Women Artists," in *Feminist Art Criticism: An Anthology,* ed. Arlene Raven, Cassandra Langer, and Joanna Frueh (Ann Arbor, MI, and London: UMI Research Press, 1988), 219.

7. Brian Wallis, "Black Bodies, White Science: Louis Agassiz's Slave Daguerreotypes," *American Art* (Summer 1995), 40.

8. Stuart Hall, "The After-life of Frantz Fanon: Why Fanon? Why Now? Why *Black Skin, White Masks?*" in *The Fact of Blackness: Frantz Fanon and Visual Representation,* ed. Alan Read (Seattle: Bay Press, 1996), 20.

9. Statement by Carrie Mae Weems from "Talking Art with Carrie Mae Weems," in bell hooks, *Art on My Mind* (New York: The New Press, 1995), 85.

10. Statement by Lyle Ashton Harris from "Artists' Dialogue," in *The Fact of Blackness: Frantz Fanon and Visual Representation,* 150.

11. Quotation of Willis taken from an essay by Trudy Wilner Stack for the gallery brochure accompanying the exhibition *Deborah Willis: African American Extended Family* (Tucson: Center for Creative Photography, University of Arizona, 1994).

12. Although the example of the bustle may indicate how European audiences also perceived Bartmann as desirable, her figure was primarily regarded as an exceptional example of her culture's notions of beauty which, by implication, were thought to be opposite to prevailing European tastes.

13. Willis, 19.

14. Fausto-Sterling, 22.

15. Gilman, this volume, 15.

16. See bell hooks, *Art on My Mind,* 76.

17. Telephone conversation with Carrie Mae Weems on August 4, 1997.

18. Green's other works relating to Bartmann, not discussed here, are *The Uses of Mathematics and Landscape* (1989), *Untitled* (1991), and *Revue* (1990).

19. Jan Nederveen Pieterse, *White on Black: Images of Africa and Blacks in Western Popular Culture* (New Haven, CT, and London: Yale University Press, 1992), 94.

20. Interview conducted by Miwon Kwon for the exhibition catalogue *Emerging New York Artists* (Caracas, Venezuela: Sala Mendoza, 1991), 2.

21. Josephine Baker, the early twentieth-century entertainer, is introduced in this work as another specific example of a black woman who was constructed as an icon of an exoticized black sexuality within Western culture. Green also brings together Bartmann and Baker in the work titled *Revue.*

22. This description of the installation is based on Green's statements from an unpublished paper by the artist titled "Give Me Body: Freaky Fun, Biopolitics, and Contact Zones," 1995.

23. Incorporating multiple registers of perception, the installation also allowed visitors to hear the sound of Josephine Baker singing "Voulez Vous de la Canne" playing on a tape loop.

24. Interview conducted by Donna Harkavy for the exhibition catalogue *Insights: Renee Green's Bequest* (Worcester, MA: Worcester Art Museum, 1991), 2.

25. Pieterse, 94.

26. Kobena Mercer, "Busy in the Ruins of Wretched Phantasia," in the exhibition catalogue *Mirage: Enigmas of Race, Difference and Desire* [including essays by David A. Bailey, Frantz Fanon, Kobena Mercer, and Catherine Ugwu] (London: Institute of Contemporary Arts and Institute of International Visual Arts, 1995), 29.

27. Parks, "The Rear End Exists."

KIANGA K. FORD

8 Playing with Venus

Black Women Artists and the Venus Trope in Contemporary Visual Art

Black folks in grass skirts crowd around fires where some are suspended in anticipation of a cannibalistic feast; a black woman's anatomy is shown in a series of frontal and profile photographs with accompanying text about the relationship of her physiognomic characteristics to her character and capacity; a pickaninny struggles to free himself from bonds. These are the images that we avoid but still expect to find in museum archives, in private collections, and, most recently, recycled in the new frenzy of memorabilia. They are oft-repressed visual reminders of legacies of oppression and inequity, retired to "appropriate" and innocuous spaces where only the brave and the curious need bother to tread. So what are they doing on the walls of major museums like the Whitney and the San Francisco Museum of Modern Art, in international art reviews, and on major collectors' must-have lists? These scenes have not, as you may expect, been dragged from the anthropological archives or recovered from eugenics societies; they have been wholly reborn in the works of several contemporary visual artists. Turning to characters derived from the tales of popular history, the controversial work of young black artists like Michael Ray Charles and Kara Walker has invigorated art conversations across the country and brought well-worn questions about the roles and responsibilities of black artists back to the fore of many discussions.

Plenty of ink and many hours have already been spent on discussions of the issues of accountability and impact—more precisely on how naïve reappropriations regress rather than advance African American interests in equity as well as how they feed a white consumer audience's need for excessive and abject black images. Outrage at the misuse and manipulation of the historical character has prompted letter-writing campaigns and boycotts;[1] interest in the innovativeness of their styles has generated grants for these young artists and produced a veritable collecting frenzy. Less concern has surfaced, however, over the question of why these historical characters—the cannibal, the pickaninny, the sambo, the hottentot—have been resurrected and why now.

Artists like Charles and Walker would suggest that the players from such historical scenes deserve a place in contemporary art because they have never abandoned their place on the stage of American racial fantasy. The re-presentation of these historical characters gives recognition to the situation of contemporary subjects who are still interpreted through the residue of deeply racially inflected collective fantasies that fade from the foreground but never entirely disappear. Fanon best describes the process of being constituted from the tidbits of these historical scenes.

Below the corporeal schema I had sketched a historico-racial schema. The ele-
ments that I used had been provided for me . . . by the other, the white man,
who had woven me out of a thousand details, anecdotes, stories. . . . I could no
longer laugh, because I already knew that there were legends, stories, history,
and above all *historicity*. . . . I subjected myself to an objective examination, I
discovered my blackness, my ethnic characteristics; and I was battered down by
tom-toms, cannibalism, intellectual deficiency, fetishism, racial defects, slave-
ships, and above all else, above all: "Sho' good eatin'."[2]

Fanon detailed this scenario more than forty years ago, yet it still provides great
insight into the impulse of the contemporary art under discussion here.[3] What has
transpired between the time of Fanon's writing and now depends on the geography of
your recollection, but in the American context, the civil rights movement rose and
receded. We have now come full circle to face an aged but still relevant description of
Antillean colonial subjectivity that resonates with a contemporary black American expe-
rience. Fanon's account of the relentless presence of the historical in the present sets us
up well to consider what Stuart Hall talks about as the "new politics of the black signi-
fier," a politics which is built around the practices of "resignification"[4] and the recogni-
tion of previously unacknowledged psychic artifacts from not-long-past but more gran-
diose ideologies of racism. If Hall leads us to reflect on a postmodern approach to race
wherein the signs of blackness throughout history might become available as materials,
then our invocation of Fanon will drive us to also consider the primacy of psychic rep-
resentation in the field of race and the import of what is not real but is imagined none-
theless. A new politics of resignification, with its resurrection of dated specters of racial
fantasy, comes into conflict with the well-seated strategies of civil rights–born visual
discourse, which call for progress toward increasing representation and more positive
content in those representations. Such ideas about the role and the imperatives of the
image have dominated black visual discourse since the late sixties and have made certain
demands of the artists who would attempt to respond to the call. This is the discursive
context into which the historical character has been reborn and which defines a great
deal of the resistance to her re-emergence.

Much of the discussion responding to new art practices that invoke and re-present
images that are seen as historical insults has drawn its categorical distinctions along
generational lines. Those who have noted the generational divide suggest that an older
generation tends to frame their concerns about this work within the language of "com-
munity" allegiance and "positive" versus "negative" images, while Generation X respon-
dents who are the age peers of the artists under discussion seem more interested in the
shifting social context of image production and their need to reflect the distinct vicissi-
tudes of post–civil rights environs.[5] While this might, to some degree, be an accurate
demographic reflection of the responsive divide, interpretive paradigms are much more
significant than age, as artists like Carrie Mae Weems and Robert Colescott prove very
significant contributors and precursors to these new modes of visuality that employ
critical citation. To be fair, it is not strictly a generational divide, but more substantively
a rift in contextual assessment and strategic investments. Though no doubt the contro-
versial resuscitations of figures once excised from the lexicon of black representation

are mainly associated with a younger generation of artists like Lyle Ashton Harris, Renée Cox, Kara Walker, Carla Williams, and Michael Ray Charles, it is not so much that their current experience in the here and now differs from that of the previous set of black artists, but that the interregnum of civil rights does not tear at their loyalties. Born after the height of the movement, perhaps the generation reared on civil rights nostalgia may claim the historical fantasy as their native province. They have always had Black History Month, and their systems of logic have been developed in late capitalism with its characteristic synchronicity and penchant for historical cannibalism. It may come as no surprise that the temporal and geographic compressions that are so characteristic of the "now," which have given rise to a national obsession with retro fashion and brought sushi to every suburban mall, have also led to the artistic moment in which historical recuperation of suppressed black characters takes center stage.

As a new strategy which responds to an old (albeit newly articulated) set of concerns, contemporary art is using historical figures as a vehicle to engage the fantasies and prevalent perceptions of race in the supposed absence of the extraordinary racism which motivated civil rights–era activism. It is, in fact, the context of post–civil rights liberality which calls forth such strategies of historic representation. By mining the historical chest, this strategy looks to the array of characters from history that make up the cast of the repertory theatre of American racial fantasy. The slave, the Sambo, the plantation owner, the mammy, Aunt Jemima, and a host of less recognizable though undoubtedly familiar characters have found a place on the stage of contemporary visual debate. Situated in a time when racism's overtness has been somewhat dulled by slow though persistent advances in equal rights, these characters are invoked to expand our awareness beyond the immediate and ever-present nightly news characters—the gang banger, the violent urban youth, the welfare mother—to consider the residual ideologies which help to construct and sustain them. It is not, as it has been suggested in some discussions of this new work, about a resurrection or valorization of the antiquated stereotype, but rather about identifying and holding up to the light the constitutive elements of contemporary fantasy with all of its concomitant contradictions, much like Fanon's powerful recount of undertaking to see himself through the fantasy of others. Characters like the heroines of the historical romance, which people Kara Walker's work, are not resurrected from the dead, but are instead revealed as the small "men" behind the wizard screen. Images like those by Walker demonstrate the ways in which these characters have not been put to rest but continue to play behind the scenes of our daily interactions. It may be argued that this is one of few potentially effective strategies in a liberal climate that does not, for the most part, acknowledge the persistence of racist entrenchments. By exploding an inapplicable diachronic model of progress in racial relations, these images are fundamentally premised on an accretive rather than an evolutionary model. They reveal the possibilities of simultaneity between the abject slave and the well-liked co-worker. As a strategy which is more taken with the workings of desire rather than with actions, it produces an appropriate response to the transition from overt racist expressions like cross burning to the more enigmatic Benetton-style consumptive adoration.

While there is a range of figures that are invoked in this genre (dare we call it a genre?) of visual art, some immediately recognizable and some slightly more obscure,

it is apropos to consider how the Hottentot Venus figures in as a principal in its cast of characters. To talk about playing with Venus should be especially elucidating as an instance of the deployed historical character, especially when the idea of "play" is allowed its due multifariousness: to amuse, to self-pleasure, to act—as in a theater.

Venus in Brief

In the midst of the Napoleonic Wars, the South African Cape, which had already endured two centuries of Dutch control, passed into British hands. While rapidly expanding British imperialism would go on to claim vast amounts of territory in Africa and beyond, the South African colony would be a cornerstone in early British conceptions of Africa and the far away; its people would be foundational in a developing iconography of difference. As one of the earliest of Britain's African colonization projects and as a very prominent point along one of the period's most-traveled trade routes, the Cape and its inhabitants became central players in the Victorian imaginary. The idea and curiosity of the Hottentot as oddity, already much circulated through travel narratives and popular lore, would well precede the introduction of the live Hottentot specimen to the untraveled British subject. By the time of the introduction of the Hottentot Venus to London crowds, she was already foreshadowed by several centuries of European representations of the physically and morally "grotesque" Hottentot. The most ethnographically represented African group in this time, the Hottentot stood in a metonymic relationship to Africa as the thing itself, much as the female Hottentot would come to stand in for the general depravity of the dark-skinned woman.

Sarah "Saartjie" Baartman would become one of the most famous of these people. What remains of this spectacle are her brain, her genitalia (dubbed the *vagina dentata* or *Hottentot apron*), and a plaster cast of her "abnormally" large buttocks. These "pieces" are scarcely able to suggest the enormity of their significance. What remains of the Hottentot Venus, the name by which Baartman would be known during her brief time in Europe and preserved in historical record, exceeds the peculiar tale of Baartman's travels and the well-preserved fragments of her anatomy.

The legacy of the Hottentot Venus is undoubtedly larger than Baartman herself. In 1829, not long after Baartman's death, another so-named Hottentot Venus appeared on the European scene. This second Venus, whose name is not so readily available in the annals of history as is Baartman's, would be followed by a host of figurative successors for whom the designation Hottentot Venus would operate not as a reference to the particularity of an individual but to a category and criteria of (e)valuation. What concerns us, then, is not necessarily Sarah Baartman, but the symbolic Venus. Just as conversations about Aunt Jemima are not about Rosie Lee Moore Hall or any of the scores of black women paid to dress up and give cooking demos as Aunt Jemima in the 1930–1960s,[6] the legacy of the Hottentot Venus is not equivalent to the life or memory of Sarah Baartman. Contemporary representations of the Venus are in no way about recovering the original object; their presentation is neither about accuracy nor facticity but instead about the longevity of impression, the perceptions of popular

culture. The Hottentot Venus functions as a visual signpost that points toward the rampant indulgence in the fantasy of the extreme other. As a foundational element of the discourse of deviance, the figure of the Venus is understood to stand in as the iconic evidence of the spectacular and peculiar sex of the black woman. This body and nomenclature would come to represent the general deviance of black female sexuality by representing "excess," both evident (the Hottentot buttocks[7]) and imagined (the Hottentot apron[8]). Much scholarship, notably that of Sander Gilman, points to the image of the Hottentot Venus as a transitional marker of the medicalization of racialized bodies and the biologization of race itself, noting the specific credibility lent by her study and display to early nineteenth-century popular notions of excessive black female sexuality. Functioning as an encapsulation of the prevalent racial (and racist) ideology of her day, the Hottentot Venus has since then been used as an interpretive frame for black women across both temporal and geographic boundaries. Her recurrence in popular representation preserves her not as a peculiar phenomenon, but as a moment of "proof" upon which histories and futures would come to rely. Re-presented in new images, the Venus figure invokes these ideological contexts of interpretation rather than operating as the content of the images. As the background for considering the interpolations and interpretations of contemporary black female subjects, Venus is profoundly useful to artists who are working to illustrate the germaneness to the contemporary subject of what might otherwise be interpreted as distant historical schemas.

The image and the story of Sarah Baartman and the more enduring legends of the Hottentot Venus have become crucial elements in black feminist contestations of the common perceptions and misconceptions of black female sexuality. In this discussion, she represents, if not the origin of the myth of excessive black female sexuality, then at least evidence of its continuity and of the profound significance of colonial, imperial, and eugenic ideologies in the myth's formation. Alongside a number of historical characters, black women's art has seen a deliberate revival of the exemplary body of the Hottentot Venus. The remainder of this essay seeks to consider both the depth and import of the artistic encounter with the Venus and to situate the resurgence of the Venus within a set of historical reclamation projects. With such an aim in mind, I will try to surmise the basic elements of the strategy of historical reclamation as well as to locate what is specific to or particularly significant about the Hottentot Venus.

The Hottentot Venus has been frequently welcomed to the stage over the past few years, finding herself in works by Deborah Willis, Renee Green, Carrie Mae Weems, Kara Walker, Carla Williams, Jean Weisinger, and Renee Cox to give a partial list. These works trace the genealogies of their critical projects to different moments and issues in African American history including the antebellum south, physiognomic and eugenics movements, and contemporary lesbian sexuality, but each references, in some way, the life and representations of the so-called Hottentot Venus. Many of the artists work in and against the tradition of self-portraiture, presenting themselves as the indexical signs which literally stand in for their historical counterparts. Others, like Walker, choose to work in an extended narrative style, examining, collecting, and reversioning the multiple constitutive elements of the Negress,[9] a character who is closely linked to Walker herself.

Reduce, Reuse, Recycle

By now we know that the use of the historical character is on the rise, that these projects are not historiographic in the sense that they aim to recover the truth of the objects they employ, and that the Hottentot Venus is a prominent player among them. The mechanisms by which we recover the historical character and the context that motivates such recovery are perhaps less clear. Two concepts may be useful to consider how characters like Venus circulate in popular perception and then how they function when they are deliberately recalled in art contexts. The first, *condensation,* is borrowed from psychoanalysis. The second, *recycling,* is taken from environmental practice. It is my hope that both of these, once made clear, will counter the frequent charge leveled against these historical "recycling" projects as unnecessary resurrections of stereotypes,[10] inasmuch as the function of the stereotype is thought to be fundamentally operating against the premise of "art":

> Stereotypes flatten—squash a world of troublesome variety, an extravagant range of depths, substances, textures into smooth, neat, intellectual fast-food orders. In their ability to dull our senses and clog our mental arteries, stereotypes are the antithesis of art.[11]

Condensation

One of Freud's early postulations, condensation is a term borrowed from a discussion of dreamwork.[12] In psychoanalysis, the dream represents a manifestation of unconscious ideas which are not permissible to conscious thought. The dream allows the impermissible to come into representation by disguising the significance of its representable elements such that the content remains objectionable and obscured but its visual manifestations are rendered more or less benign. As one of two possible strategies that unconscious ideas have of making themselves available, though not entirely transparent, *condensation* groups ideas together to form a composite figure, whereas *displacement* substitutes one form for another.[13] Condensation produces a dream figure which has your cat's voice, your mother's face, and the same gait as the derelict who lurked outside your childhood playground, while displacement produces a dream figure which appears to be your cat but stands in to signify your mother (or, of course, the derelict, should that be necessary). Both terms allow us to distinguish between the *manifest* content of the dream—that which is evident—and the *latent* content of the dream—that which is ultimately signified via the manifest content. Condensation provides three useful insights for the current discussion: (1) the relevance of the composite figure, (2) its need for disguise in conscious thought, and (3) a strategy for considering its chains of association. Additionally, while displaced characters often seek disguise in the least obvious and extremely different habitus, the condensed character always maintains some element of its original.

Perhaps the most important element of the contemporary reclamation work is in the very recognition that the contemporary character has deeper roots than its surface presentation suggests. The contemporary players are many and varied, and we are familiar

with some of the extreme distillations, such as the welfare mother and the gangbanger (close cousin of the drug dealer). But our experiences are also shaped by the somewhat more nuanced and slightly less obvious castings: the licentious black woman, the aggressive black woman, the lazy black man, and so forth. Let us take the example of the welfare mother. While she may appear as the unfortunate remainder of 1990s political contests, she is as inflected by the characters of Harriet Beecher Stowe's imaginary as she is by real conditions of impoverishment. Attempts to prove the inaccuracy of the stereotype of the black welfare mother often fail to take into account the indispensable imaginary elements of her construction. Read only for her potential threat to laissez-faire processes or as a failing of the new black middle class to care for its own, she is denied the latent elements of her construction, which reconstitute a history of racial anxieties around the image of the proper mother, the scientific proof of racial difference, miscegenation anxieties, industrial work ethics, religious convictions about worthiness, moral designations of right and wrong, and so forth. While savvy critics have discussed the ways that this figure *displaces* the statistically more relevant white welfare mother (who will already have obscured the intrinsic necessity of the underclass in capitalist models), condensation goes further to attend not only to what she obscures, but to what she herself is constructed of, to the conditions which make her creation possible if not necessary.

As I have already suggested, we are somewhat beyond the opportunity to represent our basic racist aggressions in visually transparent ways. The primary impetus of condensation is precisely such a need to obscure. Condensation is related to censorship in Freud's view, not in the sense that censorship is either its primary goal or explicit aim, but by its mechanisms, inasmuch as it serves the function of removing "unacceptable" figures from the frames of representation. Both averting and responding to censorship, condensation allows a thought or idea to continue to survive in a less obviously offensive form. When characters like the welfare mother replace the mulatta whore and the Sambo, we become susceptible to the consideration that this particular figure is justifiable (even quantifiable) because of the limitations of observation, which restricts itself to the manifest. From this perspective, it would not be a history of class/race associative connections, but a series of verifiable facts which coalesce to produce this deviant mother. Until we can restore to her the constitutive fascination with deviant sexuality, longstanding presumptions of the inferiority of her intellect, and the whispers of discourses regarding her need to be cared for, we will remain unable to address the true insult of this character. The point, however, ought not get bound to an analysis of a character so extreme. The idea that a varied mélange of characters and recirculating ideologies frame day-to-day interpretive interactions[14] is equally applicable to figures like Tyra Banks and Brandy; its applicability extends to anyone who has the occasion to be interpreted, though in this case we are particularly concerned with artifacts that shape conceptions of the contemporary black female figure.

Artists like Walker who work to make the frame of historical interpretations more apparent begin us on the associative path toward drawing the latent figures from the scenes of our daily interactions. By placing a recognizable figure between themselves and their interpretation, they demand that the viewer confront the multi-layered fantasy of the subjects that they are interpreting. As the living, breathing, "now" figures, they position themselves as obvious composites and demand a re-evaluation of the interpretive criteria by offering one representative constituent from the chest of fantasies with

which they imagine themselves to be read in conjunction. These artists contribute to understanding the latent content of contemporary figures by leaving a roadmap of associative links, figures that allow us to take a more critical perspective on how and through what mechanisms we are interpreted. Kara Walker points to this roadmap by including scraps of the research that motivate her characters.

Recycling

> recycle, *v.t.*, to pass through or undergo again, as for further treatment, change, use, etc.

Condensation's complement, recycling, is able to illuminate for us what may still be dim; it draws from the common language of daily practice, the stuff of trash, bags, bins, trucks, plastics, metals, paper. The analogy allows us to draw a series of basic conclusions very similar to the processes which condensation helps to illustrate:

1. The process of recycling never produces exactly the same object, though it may be constituted of much the same material.
2. Recycling takes items whose value for use seems exhausted and that would ordinarily be covered over (as in a landfill) and turns them into new and useful products.
3. Recycling does not produce wholly new texts though it may add to them in order to renew their effectiveness.
4. We are often incognizant of the presence of "post-consumer" materials in the things that we use unless they are explicitly called to our attention.

Despite her veritable invisibility in the epithets and popular consciousness of the day, the Venus is a particularly useful insight in deciphering the contemporary figure. Because so much of the context of interpretation that framed nineteenth-century conclusions about Baartman and directed the scientific inquiries of her person endures, the Venus figure remains relevant, legible, and reconstitutable, and she is able to represent single handedly the intersection of a plethora of often unacknowledged ideas. It is likely that she was chosen as a far link down an associative path which many have begun to ponder. The search for Venus, which is ultimately a search for the blatant discourse of the sexual deviance of the black woman, is perhaps spurred by the popularity on the contemporary stage of players like Lil' Kim, whose very believability depends on the premise of the Venus as does the notoriety of her noteworthy antecedents like Grace Jones and Josephine Baker. But the Venus, importantly, is not *the* answer; she is *an* answer, one logical end along one potential trail of associations. As a prompt, the Venus specifically calls up legacies of sexual deviance and spectacle where the figure of the slave may help us to recollect themes of violence and anxieties of revolt. What the visual prompts in images by these artists provide us is an opportunity to assess the environmental impact of these residual characters. Each image begins from the premise that the characters depicted are still having an impact. In this capacity, Venus functions not as a stereotype proper—as has been suggested in some interpretations—but as an indicative marker, as a frame for interpretation.

Finding Venus

There are a number of strategic approaches by which the Venus intervenes in visual spaces. She is not always represented recognizably. In Kara Walker's work she is reproduced as a behind-the-scenes story, one of the many elements which inspire the composite character. But, in each case, the Venus elucidates meaning, even where she is not competent to contain it.

Known for her silhouette installations, which attend to the remainders of historical experiences like slavery in the contemporary imagination, Walker includes the classificatory image of the apron[15] (see Figure 23) and Grainger's *The Voyage of the Sable Venus, from Angola to the West Indies*[16] (see Figure 24) in the artist's journal reproduced for her 1997 Renaissance Society show. In so doing, she suggests the ways in which Venus and the Negress (the character that might most easily be considered the protagonist of Walker's work) are mutually informative as historical characters. Central to the underlying conception of her work are the ways in which both of these figures collapse into the present and shape the ways that Walker herself has been interpreted as a young black woman in the South. Walker has been very candid about her mining of popular and historical texts in the generation of her large-scale cycloramic silhouette scenes of the antebellum South. She has also had no reservations about talking about the autobiographical impulse of the work and has spoken a good deal about how the characters from her work relate to her own experience:

> I thought I could act out a couple of roles I was unwittingly playing down South, that I could kind of embody an assortment of stereotypes and cull the art out of them . . . as the tantalizing Venus Noir, the degraded nigger wench, the blood-drenched lynch mob. I wanted to seduce an audience into participating in this humiliating exercise/exorcise with me.[17]

Though her work has been cohesive in its focus on slavery and the immediate post-emancipatory period, the sources which inform her fantastic constructions are not limited by period, topic, or locale. Perhaps the most significant insight into the process of her production, her Renaissance Society journal, includes a range of collected images, extending from stills from blaxploitation movies to the illustrations of the Hottentot, as well as influential writings and her own personal notes and prose. The wide reach of these collected materials demonstrates the flexibility of time and the ability of multiple remembrances to converge on each body. Though they do not make their way explicitly to the large-scale, silhouette cut cycloramas for which Walker is best known, these found images are the allusions of images like Figures 23 and 24. The child who picks cotton from her vagina and the woman who leaps through the air while "birthing" a horn and eating corn reveal the means through which some of the thematics of the Venus are reincorporated into principal work as a fascination with the product and potential of black female genitalia. In Walker's case, the mode itself is reminiscent of the Venus with its emphasis on form and outline. Strikingly, writing on the Hottentot Venus before the rise in popularity of Walker's images but anticipating her formal choices, writer Francette Pacteau described Venus as "simply a shape, a breathing silhouette, displaying the outline of her protruding buttocks."[18] Walker's formal choices

address the emptiness of the characters, staking their claim as impression rather than detail and enabling their extreme malleability in fantastic arenas. Virtually all of Walker's figures are composite figures and represent the fantastic image of the black from slavery through the jazz age, colonization to reconstruction and the Harlem Renaissance.

What Cox, Williams, and Walker do in common is imagine themselves as composite images, suggesting their own layeredness and potential chains of association through an allusion to another recognizable and incontestably layered character. By beginning along the backward trail of associative possibilities, they show the very possibility of association. By foregrounding visually explicit references to the body and representations of Venus, they call attention to the ways in which Baartman's "hyper-sexuality" and genital "excess" are always already present as frames through which black women and their representations are read and interpreted. Using quite varied strategies, Cox, Walker, and Williams make visually evident not only the collective fantasies of black female sexuality, but also, by invoking the nineteenth-century figure of Sarah Baartman, point to the historical and ideological continuities of this particular fantastic lens.

1. The most high profile of these campaigns was led by veteran artists Betye Saar and Howardena Pindell which included images by Kara Walker with the accompanying text:

> Please take a good look at the images below. Are they racist? Are they sexist? Are they disturb-ing? Are African-Americans being betrayed under the guise of art? Are we being degraded by plantation mentalities? Is this white back-lash, art elitist style? The below images are by a young (27) African-American artist, Kara Walker. She was recently rewarded for this imagery with a $190,000 award from the prestigious MacArthur Foundation. Why?

Readers wanting additional information were directed to write to "artist [sic] against negative black images."

2. Frantz Fanon, *Black Skin, White Masks* (New York: Grove Press, 1967), 111–112.

3. This was the subject of the 1995 *Mirage* exhibit at the Institute of Contemporary Arts in London. This event was followed by the publication: Alan Read, ed. *The Fact of Blackness: Frantz Fanon and Visual Representation* (Seattle: Bay Press, 1996).

4. Stuart Hall, "The After-life of Frantz Fanon: Why Fanon? Why Now? Why *Black Skin, White Masks?*" In Read, *The Fact of Blackness,* 12–37.

5. For an in-depth look at these debates, see *International Review of African American Art* 14, no. 3 (1998).

6. Marilyn Kern-Foxworth, *Aunt Jemima, Uncle Ben, and Rastus: Blacks in Advertising, Yesterday, Today and Tomorrow* (New York: Greenwood Publishing Group, 1994), 66–70.

7. Also known as steatopygia, the "Hottentot buttocks" referred to the generous proportion and oblong shape of the Hottentot posterior.

8. Also known as the *tablier,* this designation refers to her elongated labia, popularly held to be a "natural deformation" of the primary sex organs, it was actually the result of deliberate manipulation common as a mark of adornment among the Khoikhoi. According to Sander Gilman's accounts, Baart-man would not allow her genitals to be displayed publicly, which is among the reasons for the extreme cathexis of her secondary sexual organs.

9. The Negress is a composite character who might be understood as the protagonist of Kara Walker's installations.

10. Many thanks to Gina Dent for much useful conversation on the necessity of moving this dia-logue beyond a discussion of the stereotype.

11. Judith Wilson, "Stereotypes, Or a Picture Is Worth a Thousand Lies," in *Prisoners of Image: Ethnic and Gender Stereotypes* (New York: The Alternative Museum, 1989), 20–21.

12. Sigmund Freud, *The Interpretation of Dreams,* trans. James Strachey, reprint of 1953 Standard Ed. (New York: Avon Books, 1900/1965).

13. Certainly it is true that condensation may involve a series of displacements.

14. One very significant reason that a psychoanalytic term such as *condensation* is so particularly useful here is that it does not presume that we are aware of the ways in which these ideas frame our interpretations. It is premised, in fact, upon the idea that many unconscious processes affect our behavior and interpretations. In this case, what concerns us are ideas that circulate in the *popular preconscious,* a space of shared foundational conceptions of objects and everyday practice.

15. "The 'Hottentot Apron' [panels a and b] and other genital anomalies," plate 1 in Cesare Lombroso and Guillaume Ferrero, *La donna delinquente: La prostituta e la donna normale* (Turin: L. Roux, 1893). The Lombroso and Ferrero plate on which Walker based her work is reproduced in this volume (Figure 5).

16. *The Voyage of the Sable Venus, from Angola to the West Indies,* colored engraving by W. Grainger after a painting by T. Stothard. First printed in *Bryan Edwards, The History, Civil and Commercial, of the British Colonies in the West Indies* (1794), where it accompanied the poem "The Sable Venus," written by Edwards. Reprinted in the introduction of John Stedman's *Narrative of a Five Years Expedition against the Revolted Negroes of Surinam* (Baltimore: Johns Hopkins University Press, 1992; reprint). Though the image is not of the Hottentot Venus, as a project contemporaneous with early representations of the Hottentots, it works with much the same documentary premise.

17. Kara Walker, *No Place Like Home* (Minneapolis: Walker Art Center, 1997), 126.

18. Francette Pacteau. *The Symptom of Beauty, Essays in Art and Culture* (London: Reaktion Books, 1994).

9 Talk of the Town

When an exhibition of Seydou Keïta's photographs opened in 1997 in SoHo, I was intrigued by the statement made by a West African colleague of mine: *This is exactly like it was in those days.* That yellow convertible, the first Cadillac in Mali, everyone remembers as belonging to Sylla, the antique dealer in Bamako. And this one, with the long tribal scars from his sideburns to his chin, must have been a Mossi soldier. The one over there's a grande dame with her fancy scarf, her gold rings alongside the strands of her cornrowed hair, her tattooed lower lip, and her gold choker necklace with a large pendant.

To say that Seydou Keïta's portraits tell the truth about the people in Bamako, the capital city of the former French Sudan (now Mali) in the 1940s and 1950s, is in fact to say that his camera made them into Bamakois. To get at this truth, which so excited my West African friend in SoHo, one must examine the relationship between Keïta's work and the myth of Bamako—to ask what was being acted out by his subjects, what they hoped to achieve by posing for his camera. Finally, there is the question as to what we see in these pictures today that so stubbornly grabs hold of our attention.

Keïta's Bamako is the Bamako at the birth of modernity in West Africa. Each one of his portraits reveals an aspect of that moment, its mythology and attendant psychology. In his attempt to create great Bamakois "types" with his camera, Keïta participated in shaping the new image of the city, which emerged in 1946 (with the first meeting of the francophone Congrès de Bamako) as an important French colonial center. His studio was located not far from the train station, which served to link the city and Dakar, in turn bringing it closer to Paris, and was near another great agent of modernization, the large market of Bamako (le Marché Rose), a trading center that was the envy of every other West African city. There, commerce and consumption brought together villagers of various ethnic groups and redefined them as Bamakois. Other key sources of the modern experience, the central prison and the Soudan Ciné movie theater, were landmark sites in Bamako-Coura (the new Bamako), Keïta's neighborhood. The proximity of his studio to the Soudan Ciné explains the impact the cinematic, black-and-white mise-en-scène would have on his style. The tough-guy looks and gangsterlike demeanor found in his photos seem straight out of a B-movie still.

Having a portrait taken by Keïta signified one's cosmopolitanism. It registered the fact that the sitter lived in Bamako, had seen the train station, the big market, and the central prison, and went to the movies: in short, it signified that the sitter was modern. If such urbanity was one of the enduring markers of Bamako identity, another concerned the beauty of the city's women: "*A Bamako les femmes sont belles,*" in the words

of the popular song. For women, Keïta's camera was a guarantee of beauty, fulfilling the truth of their being Bamakoise. His portraits were said to make any woman beautiful: give her a straight and aquiline nose, emphasize her jewelry and makeup, and capture a sense of her modernity through the attention paid to her high-heel shoes and handbag.

In contrast to other Bamako photographers (e.g., Sakaly in the neighborhood of Medina-Coura, and Malick Sidibé in Bagadadji), Keïta remained seriously committed to the genre of studio photography. He rigorously maintained a mise-en-scène that dictated the camera position and angle in relation to the subject. The décor often included such props as chairs, flowers, wristwatches, pens, radios, and a curtain in the background. The subjects, desirous of becoming Bamakois, stood, sat, or reclined for him like models in front of a painter. They always came out idealized, always already belonging to the past like objects of nostalgia, and stamped as the photographer's products.

The painterly quality of Keïta's portraits derives from the way the subjects are absorbed by the environment of his studio. Take, for example, his portrait of two women sitting on the grass in front of his curtain backdrop with its signature arabesque patterns. The two women—one wears a black dress with large white dots, the other a flower-print number—fit comfortably in this artificial landscape. They sit shoulder to shoulder as if Siamese twins, their headscarves falling in the back like foliage and revealing gold ornaments in their hair. The two mimic each other's every movement, with their loose dresses spread out to cover their knees and feet. Each rests an arm on a knee, with an equal number of gold bracelets on their bared wrists as well as a single band on their respective ring fingers. Somehow the grass surrounding the women conveys the passage of nature into the portrait, which the arabesque background and colorful dresses do nothing to negate. In fact, looking at the image, one gets the feeling of being in front of an Impressionist tableau, in which civilization imitates nature.

Yet there is an atmosphere of excess in the portrait that derives not just from the gold ornaments and the uncanny sense that one woman is a duplicate of the other. Crucially, it is the artifice of the backdrop that prevents nature from taking over completely. The curtain reduces the depth of field, flattening the picture, and helps the artist to control the mise-en-scène and frame the space. It signifies Seydou Keïta's presence and defines the women as Bamakoises enjoying a picnic. Here, as elsewhere, the curtain allows Keïta to create a sense of domesticated space, a studio effect.

No portraits show off the mythical beauty of the Bamakoises to better effect than those that feature a woman in a reclining pose on the bed in the studio. In one, the familiar arabesque backdrop takes on the appearance of living-room wallpaper rather than the photographer's prop. The bed is covered with a checkered black-and-white blanket. Wearing a loose flowered gown, the woman reclines with a white pillowcase under her arm, which forms an angle at the elbow to support the head. Her scarf is slightly tilted to the side to reveal her hair and earrings. The small incisions on her forehead and cheeks simultaneously register as tribal marks and beauty signs. On her neck, several strands of glass beads make her look even more desirable. What is remarkable about the portrait is not just the décor, which reveals the photographer's eye for striking arrangements (the marriage of checkered blanket, flowered dress, and arabesque curtain). Even more arresting is the way it suggests a mistress waiting for a lover.

In fact, the portrait is as important for what it doesn't show as for what it does. Of the woman herself, we only see the face down to the neck, the forearm under the chin, the hand resting limply on the waist, and parts of the feet. The rest of the body is covered by the loose dress and the scarf. Faced with such details as the luxurious blanket, the white pillow, the dress, the beads, and the curtain, we become convinced that we are looking at an important, beautiful woman, a Bamakoise who is not just anybody. This portrait is Seydou Keïta's *Olympia*.

It is interesting that the reclining pose on a bed was among the most popular for women who wanted their picture taken. The pose, which immediately registers for us as an expression of contemporary leisure, indicates the subject's social status. Traditionally, this kind of portrait is associated with an unmarried woman who invites a suitor to her home, usually in the evening. The woman is sometimes pictured making tea, leaving the suitor to admire her elegance and manners. In some images in the genre, he may join her in bed. Unlike other Keïta portraits of young ladies, though, in which the figure typically occupies the foreground, reclining on the front side of the bed, almost on its edge, and dominates everything else in the shot, Keïta's *Olympia* reclines sideways in bed, her head turned slightly toward the back, her knees obscured by the loose dress toward the front. The camera divides the space equally between an unoccupied part of the bed in the foreground, the woman in the middle ground, and the curtain in the back. It is this economy of space that is absent in similar portraits, which, for all their verisimilitude, seem cramped and deficient in the photographer's trademark control over the composition.

By the time Keïta turned to his neutral, gray backdrops in the mid-1950s, he had already photographed his masterpieces. Though the gray background of the later studio portraits signaled his commitment to realism in photographing the Bamakois, this turn in the work entailed a loss in the compositional harmony derived from the use of the patterned backdrops. But where the products of Keïta's painterly eye generally succeed as photography, particularly in the case of the earlier compositions, the subjects of the portraits, regardless of their backdrop, send us looking for stories and explanations beyond the history of the medium.

For example, one of my favorite Keïta portraits features two sisters, their arms wrapped around each other, shot against the arabesque backdrop. The girls both wear patterned dresses with ruffled shoulders. The older sister's scarf, tied under her chin, covers the back of her head down to her left ear. In the front, one can make out her hair, which is still growing in after the shaving required of young girls in the Soninke ethnic group. Now feeling old enough to have her hair braided with gold ornament, she may have covered her head to conceal her girlish hairstyle, revealing only her right ear full of gold earrings to signify her maturity (in contrast to her sister, who has only a single such adornment). The younger girl's hair is shaved in the style of her ethnic group, leaving only two large swaths on her uncovered head.

The seriousness with which these two Soninke girls look at the camera speaks volumes about the role Keïta's camera played in giving shape to modernity at the time of its birth in Bamako. On one level, the two sisters represent ethnic influences and traditional aesthetics that are not yet assimilated to modern life in the city. The way they hold each other emphasizes a complex relationship of identification. The little girl wants to be seen in the same way as her older sister, that is, a Bamakoise whose hairstyle does

not identify her as a villager. The older sibling, on the other hand, leans her head against her sister as if to offer her the Bamakoise hairdo. Both girls seem to be hiding something that Keïta's camera captures so well.

On another level, the little girl's clumsiness in front of the camera defines the awkwardness of Bamako modernity. As the modern institutions democratize the city's social relations, they also impose a savoir-fair that distinguishes Bamakois from villagers, an imposition that seems to extend to everyone in a generalized anxiety about how he or she is seen. To go before Keïta's lens is to pass the test of modernity, to be transformed as an urbane subject even if one has no power in the market or at the train station.

Insofar as photography offers a mirror of familiar images, stereotypes involving our own effigy, what do Seydou Keïta's portraits of Bamakois tell us today? I ask this question not only because of the excitement the portraits aroused in my West African colleague, but also because the SoHo show was very successful with sophisticated New Yorkers. The portraits give us back our individuality. In fact, I get the same feeling looking at Keïta's portraits that I get watching Chaplin's 1936 film *Modern Times*. Even though Keïta's subjects look like us, they are not us. They are our history, the history of modernity. In this sense, the portraits have the uncanny sense of representing us and not-us.

Take, for example, the man in white holding a flower in his left hand. He is wearing glasses, a necktie, a wristwatch, and, in the embroidered handkerchief pocket of his jacket, a pen—tokens of his urbanity and masculinity. He looks like a perfect Bamakois. However, the way he holds the flower in front of his face constitutes a punctum in the portrait, a moment in which we recognize the not-us. The flower accentuates his femininity, drawing attention to his angelic face and long, thin fingers. Is also calls to mind the nineteenth-century Romantic poetry of Alphonse Lamartine, Victor Hugo, and Stéphane Mallarmé, which was taught at that time in the schools of Bamako. In fact, the man with the flower reminds me of certain Bamako schoolteachers in the 1950s who memorized Mallarmé's poetry, dressed in his dandied style, and even took themselves for him.

Elsewhere the not-us appears to comic effect. In one portrait, three identically dressed girls are pictured with a remarkable quantity of gold rings attached to their braids and long strands of glass beads around their necks. Everything seems normal until one examines the girl on the right. Rather than simply rest an arm on the middle girl's shoulder as does the one on the left, she has a hand on the breast of the girl in the center and the other around her waist. This unusual detail interrupts our reading of the beauty of these three Bamakoises. We say to ourselves that the hands of the girl on the right are in the wrong place. She has not yet learned to pose in a cool and collected style— a modern style—in front of the camera. But we can empathize from a distance with this girl (who isn't afraid of the camera?), knowing that the photograph can also catch us unaware, or unprepared, or uninhibited, and reveal the truth about us.

Keïta is caught with his own hand in the wrong place in a portrait he took of himself and a Moorish family. The portrait shows the family in the foreground: the patriarch dressed in a white gown, with his two wives sitting on either side. The wife on the left, who seems older, holds a baby in front of her. Behind the family crouches the photographer, wearing an open shirt and a felt hat and leaning over the patriarch and

his younger wife on the right, with one arm on her shoulder, and the other on the shoulder of the patriarch.

This is a strange, complex portrait in many ways. In terms of composition, there's really only room in the photo for three people. When one focuses on the polygamous patriarch and his wives, it seems that Keïta's presence is what spoils the composition, that he should have never been in the picture. But when one focuses on the triangle formed by Keïta, the patriarch, and his younger wife, the wife on the left and her baby become invisible. It is interesting to note that the figure of the father is what both imagined compositions have in common. He is also the only one in the portrait not looking at the camera. This fact alone renders him more mysterious, and subject to a different interpretation depending on which composition we choose to privilege. When we look at him sitting between his two wives, who appear considerably younger than he, we put the institution of polygamy on trial. However, if we look at him at the same time with his younger wife and Keïta, it is the youth and urbanity of the photographer that we oppose to the age of the patriarch on the one hand and relate to the beauty of the wife on the other. The portrait could stand for Keïta's photography as a whole: the relation between the two readings could stand for the two functions of his work— a decorative one that accentuates the beauty of the Bamakoises and a mythological one wrapped up with modernity in West Africa. It is these dual functions—and their revelation as photographic constructions—that continue to draw us to Keïta's work.

Credit: © *Artforum,* February 1998, "Talk of the Town," by Manthia Diawara.

CHARMAINE NELSON

10 The "Hottentot Venus" in Canada

Modernism, Censorship, and the Racial Limits of Female Sexuality

There is an indelible mark in the memories of my Canadian undergraduate education as a student of western art history.[1] If I had been given a penny for every time a professor had lectured on Edouard Manet's *Olympia* (1863; see Figure 3), only to refuse to discuss the conspicuous presence of the black maid, I would be quite a wealthy woman today. Noting the historical compulsion to erase her presence, Lorraine O'Grady has argued that

> She is the chaos that must be excised, and it is her excision that stabilizes the West's construct of the female body, for the "femininity" of the white female body is ensured by assigning the not-white to a chaos safely removed from sight.[2]

While my claim may seem like an extraordinary exaggeration, when art historical discursivity, especially its Modernist permutations,[3] is scrutinized for its ability or willingness to accommodate race, my point as a comment on the dominating Eurocentrism of art historical disciplinarity becomes painfully clear.

Modernism refers to a cultural movement and a historical moment but, more importantly for art history, to a specific artistic practice generally designated by a dominating, often formalistic interest in issues of style and aesthetic concerns. Modernism however must also be acknowledged as a specific art historical discourse which dictates the limits of art production and interpretation. Historically western Modernism has privileged painting above all other media and has further privileged aesthetic practices which reinforce and celebrate the two-dimensionality of painting. This explicit focus upon materiality has often elided social, historical, and political issues from the discourse. The Modernism of visual culture has also historically been the exclusive domain of white male artistic production centered around notions of urbanity, voyeurism, and bohemianism. Ironically, Modernism's obvious dependence upon the bodies of transgressive female subjects (often prostitutes or courtesans) and the appropriation of African, Native, and Oceanic arts has only recently been given critical attention. Manet's *Olympia* is not an arbitrary choice on my part. The utter disavowal of race as a valid issue of art historical inquiry is evidenced in T. J. Clark's otherwise archivally exhaustive chapter on this painting, "Olympia's Choice."[4] Clark's social art historical analysis of the painting is fundamentally based upon class identity. Griselda Pollock has noted Clark's unwillingness to deal with the obvious gender and sex issues which are latent within the painting.[5] However, my concern is with his almost complete disregard for the racially "other" subject of the painting—the black maid who is clearly visible. For a student of

art history or for the uninitiated, the uncontested value of this painting is indexed by the extent to which scholars of art history need not identify it to their canonically indoctrinated audiences. As Pollock has warned:

> Canonical art history may be defined as a kind of border police, monitoring the visibility of which links, which borrowings, which genealogies are to be acknowledged, while others, become aberrant, ignorant, incorrect or plain invisible.[6]

Although Manet's name and the basic formalistic and stylistic concerns of the art object as a seminal painting which marked the celebrated beginnings of western Modernism need not be re-stated, I would argue that what has been consistently disavowed and what needs now to be urgently examined and retrieved is the body of the black female maid, her colonial context, and the psycho-social constraints which have facilitated the erasure of her obvious presence and significance in the first instance. Elaborating upon the focus of her book, *Negrophilia: Avant-Garde Paris and Black Culture in the 1920s*, and its decidedly post-colonial methodology, Petrine Archer-Straw writes:

> I was aware that although art historians discussed black culture's influence on the Parisian avant-garde there was no text that looked at the avant-garde's motivations outside of *artistic imperatives*. Redressing this imbalance called for an examination of rarely considered tropes within European art history that reinforced negative stereotypes of blacks, especially in respect to primitivism.[7] (Italics mine)

We need to ask what art historical discourse, especially its Modernist permutations, makes possible and what it suppresses as well as through what logic and apparatus its borders are policed.[8] In other words, we need to examine the historical suppression of issues of race, color, and colonialism within art historical discourse and create a space for post-colonial interventions within cultural practice and analysis. Just as feminist interventions have made it possible to discuss gender and sex issues within the context of patriarchy, a post-colonial intervention within art history would privilege discussions of race, color, and culture within a colonial context. A post-colonial art history also creates a space for the discussion of the production of Native, black, Asian, and other traditionally marginalized artists. This intervention would also fundamentally take up representation as a process of identification and therefore position visual culture as colonial discourse, a site where racial identities are produced and deployed.

Critical theory, especially feminist interventions, has provided clear and effective strategies for cultural transformation of the traditionally patriarchal disciplinarity of art history.[9] However, recent criticism of white feminist practice has contested the extent to which the deployment of an essentializing category of Woman, coupled with the silence around race/color, has re-entrenched the colonial privilege of the white female body. Post-colonial scholarship, particularly its manifestations within cultural studies, is helping to provide the theoretical and material structure for a racial intervention within art history, one that acknowledges culture as a site of colonial discourse and thus as a generative source of racialized identities and racism.[10]

Post-colonial scholarship has also informed the recent racial interventions within the overwhelmingly colonial discourses of anthropology, ethnography, and museology.

Critical contributions to the study of culture have interrogated western colonial histories of exhibition and human display.[11] Within the institutionalized museum practices of ethnographic display, human anatomical and skeletal remains often served as "primitivizing" markers of the racial identification of colonial subjects, evidence of the supposed evolutionary inferiority of colonized populations. Exceeding museum practices in their mass appeal to broad middle and lower class populations, the more socially accessible spectacles of fairs, circuses, and open-air exhibitions often replaced skeletal remains with the living bodies of colonized subjects.[12] As Rosemary Wiss has argued, "European discourse on the perception of difference was partially informed by exhibits of indigenous people brought back to Europe by colonial scientists and entrepreneurs during the eighteenth and especially nineteenth centuries."[13] The colonial subject framed within the Eurocentrically biased and artificially imposed boundaries of reconstructed and anthropologically "authentic primitive" villages were made to perform their cultures and also, significantly, their races, for the entertainment of white audiences.

The colonial practice of human display distanced the white observer, both literally and figuratively, from the primitivized bodies of colonial subjects. Safely behind the carefully demarcated boundaries of the exhibitions and fairgrounds, the space of the colonial "other" was clearly separated from the privileged space of the white viewer/ "self." The deliberately cultivated material and psychic distance was a part of the colonial apparatus which visually objectified the exhibited human subjects and racialized the bodies of the exhibition spectators.

Colonial Exhibition Practices

It is within the colonial space of the West that the "Hottentot Venus" emerged, an iconic sexual and racial identity which resulted from the Trans Atlantic imperialist regimes of global colonization.[14] The term "Hottentot" is present within nineteenth-century western human sciences as a name for a group of people or tribe and sometimes even used to identify a distinct race. Whereas Hottentots were often considered a subcategory of the Negro/Negroid race, the nineteenth-century human scientist James Cowles Prichard went so far as to distinguish them as a race separate from and inferior to Negroes. Appending "Venus" to this term has both general implications in its referencing of ancient mythology and more specific implications in its referencing of nineteenth-century cultural and social ideals of female sexuality and beauty. Since Venus, which in western art has most frequently been represented by white female subjects, has widely been read as an idealization of female beauty, to affix the term "Hottentot" is an ironic or cruelly "humorous" gesture which substitutes a racially "othered" body— the grotesque—for the expected beautiful white female body. Saat-Jee/Saartje/Saartjie or Sarah Bartman was one of several South African women who were displayed naked throughout Europe for the sexual titillation of white audiences.[15] The colonial regime, which transfigured Saat-Jee into the "Hottentot Venus," relied upon the dissolution not merely of her individuality but also of her humanity since, as part of an animal act, Saat-Jee's humanness was fundamentally questioned through her constant juxtaposition with animals.[16] The "Hottentot Venus" was a colonial stereotype which attempted to homogenize representations of black female sexuality as "primitive" and pathological.

Within the practices of colonial ethnographic exhibition, the living Saat-Jee was publicly displayed to curiosity seekers who were "amazed and affrighted by the sight of her naked body with its enlarged buttocks and elongated genital flap."[17] It is critically important to note that it was these corporeal signs, the buttocks and the flap, which were seized and reified as intrinsic signs of a deviant sexuality. As such, these signs of corporeal excess became fundamentally connected with blackness and with the pornographic. It is the visibility of these signs and their legibility as racially specific that provoked the cultural censorship which I will discuss in detail below.

Other Hottentot women suffered similar fates as Saat-Jee. As the entertainment at dinner parties of the social elite, their naked bodies became a sexual spectacle for the titillation and curiosity of white viewers. The sexual exploitation of black women within Western exhibition practices worked to dichotomize the Hottentot body and the ideals of white bourgeois womanhood. This coerced public performance was an integral part of the racial and sexual othering of the black female body within the cultural imagination of the modern West. The sexual and racial objectification of Hottentot women was a matter of life and death. Besides being exhibited as scientific specimens, subhuman examples of racial and sexual difference, Hottentot women had autopsies performed on them by Western scientists in a deliberate search for a source of pathology that would confirm colonial theories of sexual and racial identity as biologically based and thereby fixed and essential.[18]

The "Hottentot Venus" in Canada

Although Hottentot women were never (to my knowledge) "imported" to Canada, the "Hottentot Venus" did make a significant appearance within early twentieth-century Canadian culture—an appearance which, despite the vast geographical distance between Canada and Europe, clearly indexes the prolific circulation and normalcy of colonial ideals of blackness and their saturation within western consciousness. The Hottentot's representation and legibility in Canada is significant not only because of the way this identifiably iconic anatomical type indexed racialized and sexualized conceptions of the body, but for the way it speaks to the social and psychic constitution of difference within the colonial politics of identity. It is the hierarchization of racialized bodies and their cultural policing which must be interrogated if Modernism's investment in coloniality, and indeed blackness, is to be understood.

Within a conservative cultural milieu, Canadians embraced censorship as a means of enforcing the arbitrary social boundaries of artistic production. However, this censorship was not universally applied. Rather, it was practiced within historically Eurocentric hierarchies which racialized concepts of beauty and sexuality. In April 1927 three paintings of female nudes—Max Weber's *Contemplation* (c. 1923) and *Retirement* (ca. 1921) and Alexandre Archipenko's *The Bather* (date unknown)—were secretly removed from the walls of the International Exhibition of Modern Art hosted by the Art Gallery of Toronto (AGT).[19] To acknowledge this censorship as a racially motivated action within a colonial cultural framework calls for an understanding of the conservatism of early twentieth-century Canadian figure painting, the simultaneous politics of representation and censorship, and the historical pathologization of blackness and

black female sexuality. But since colonial stereotypes are not only polarized but parasitic, we must hold these factors in tension with the white female body and its liminality— its proximity to the so-called primitiveness of the black body and the subsequent threat to white male identity. It is within this colonial matrix that the "Hottentot Venus" made an appearance within the Canadian cultural landscape.

Adherence to Traditions

In 1931 the Canadian artist and critic Bertram Brooker called the Canadian art community puritanical and, over fifteen years later, the Montreal-based painter Louis Muhlstock deemed the lack of artistic freedom to be the result of an "excess of prudery."[20] Although these established Canadian artists were most directly concerned with the state of figure painting in Canada, their opinions appropriately described the conservative climate of Canadian artistic production in general.

Early Canadian artists commonly emulated European models to validate their art within the youthful colony. However, this emulation did not extend itself to Modern European trends. Rather, twentieth-century Canadian artists embraced established historical styles of recognized European artistic schools. This colonial dependence was fostered by art patronage and art education which celebrated and rewarded artists who patterned their work after canonized western art. The resulting lack of innovation was evidenced to varying degrees within the different genres of painting.[21] This traditionalism was partially maintained through the practice of museum censorship, which was used to eliminate potentially offensive representations of the human (particularly female) body. Within this realm, the "offensive" paintings were usually those which broke from traditional and idealized visions of the white female body as the nude.[22]

The nude and the naked are two specific art historical terms which have most often been applied to representations of the female body in western art. The nude, which dominated French nineteenth-century academic tradition, has historically needed a *raison d'être*. Generally pandering to a heterosexual male gaze, it has been the more conventional of the two categories and is associated with the Beautiful and with "high art." The naked is aligned with limitless sexuality and impropriety, while the nude is often allegorical or a body which is *always already* unclothed. The naked often points up the process of undressing, as well as the social and biological body, and therefore is generally aligned with the Sublime and the pornographic.

Lack of allegory, contrived womanly innocence, or nature as a veil generally provoked controversy and inevitably censorship. Paintings that represented naked as opposed to nude women were said to pose moral threats to the viewing public. Censorship was used in an effort to monitor and carefully delimit the boundaries of female sexuality. However, this practice was not arbitrary, but directed specifically at representations of the white female body in an effort to protect the idealization of white womanhood through a policing of the arbitrary divide between art and pornography.

Representations of the black female body in Canadian culture have historically received no such paternalistic concern. Overtly sexualized images of black women were condoned, even praised, while comparatively innocuous paintings of white

women were actively censored.[23] Within this colonial practice, the Canadian museum community was enforcing deterministic ideals of race and sexuality by participating in the construction and perpetuation of a Eurocentric womanhood. As such, black women were constituted as "other" by the white artistic community at the center of Canadian artistic practice.

The Canadian museum community, whether sanctioning or censoring female nudes, participated in the construction of whiteness. As Ruth Frankenberg has illustrated, "whiteness refers to a set of locations that are historically, socially, politically, and culturally produced and, moreover, are intrinsically linked to unfolding relations of domination."[24]

The paradigmatic nature of whiteness within colonial discourse provided and continues to provide a protection to white women not historically extended to black women. But within any dichotomous relationship there is an interdependence, and thus the identity of the white woman is constructed not only in her presence but also in her absence: her "other," that which was defined as Black Woman. It is crucial then to examine not only what was representable at any given moment, but what was beyond representation.

Controversy, Censorship, and White Female Nudes in Canadian Painting

During the late 1920s and early 1930s, white female nudes regularly incited controversy and provoked censorship within the Canadian art milieu. Censorship was generally enacted under the guise of a "public service" imposed by museum officials who, as the purveyors of an authoritarian knowledge, acted for the greater benefit and protection of the community. Serving two main agendas, the censorship of white female nudes simultaneously functioned to protect the museum audience from the social threat of pornography while also preserving the ideals of white womanhood and the definitions of femininity and sexuality at its core. Censorship was not limited solely to Canadian art works, but extended to all art works exhibited in Canada.

Censors targeted non-Canadian artists Weber and Archipenko during the first Canadian exhibition of international Modern art at the AGT. The Société Anonyme, largely owing to the efforts of Katherine Dreier, assembled the exhibition (also known as the Brooklyn exhibition for its original U.S. site). As president of the society, Dreier was a vigorous supporter of Modern art and had earlier founded the society with the assistance of Marcel Duchamp and Man Ray.[25] According to Ruth Bohan, "the Brooklyn Exhibition was both the largest and most comprehensive exhibition of modern art shown in this country [United States of America] in the 1920's and the Société Anonyme's grandest achievement."[26]

American audiences had been better prepared than their Canadian neighbors to consume these Modern art works. As Ruth Bohan has noted, the occurrence of several other exhibitions of Modern art had laid the foundation for the International Exhibition. The Armory Show, the Forum Exhibition, and the several smaller exhibitions of modern art held at Alfred Stieglitz's gallery at 291 Fifth Avenue had injected Modernism

into the consciousness of the American audiences, even if those audiences had not yet been ready to embrace it.[27]

Conversely, the International Exhibition of Modern Art marked the first direct exposure of Canadian audiences to the international Modernism of twentieth-century artists. To all but those intimately acquainted with current European artistic trends, these Modernist art works, many of which had begun to embrace abstracting principles, would have seemed "alien." That the exhibition opened in Canada at all is due in large part to the diligent individual efforts of a Canadian familiar with artistic developments in the international art arena: Lawren Harris.[28] After extensive negotiations with officials at the Art Gallery of Toronto, Harris's relentless efforts resulted in the exhibition's showing in Toronto. A successful Canadian artist and patron, Harris, in his nationalist ideology, embraced Modernist art as a vehicle for the articulation of a uniquely Canadian cultural identity. As a member of the Canadian Group of Seven, Harris's painting, though considerably more conservative than his counterparts in the International Exhibition, reflected his belief in the need for Canadian artists to embrace the possibilities of Modernism.

Toronto was the final venue of the International Exhibition. The show had opened at the Brooklyn Museum on November 18, 1926. From there it had traveled to the Anderson Galleries in New York and the Albright Art Gallery in Buffalo before its conclusion in Toronto.[29] The presence of the Weber and Archipenko nudes in the original AGT catalogue is evidence of the original intention to include the pieces and of the hastiness of their withdrawal once in Toronto.

According to a first-hand account, exhibition organizer Dreier had overseen the hanging of the exhibition, but upon returning to the gallery the same evening for the private opening, she found that the Weber and Archipenko works had been removed in the interim.[30] Though a local report noted that "the exclusion of these nudes may not be an instance of prudery,"[31] another explanation located the nexus of sexual and racial motivations which had provoked their censorship. The report stated: "These that the censor has consigned to the coal regions are physical. . . . They are readily identifiable as women. . . . One of Weber's nudes, 'Contemplation' might win a prize in a Hottentot beauty contest."[32] The reference to the Hottentot bodies as the catalyst for censorship exposed the network of racialized anatomical codes which governed the representational practices of the body at this historical moment.

Negrophilia and Modernism: Black Woman as Subject

Throughout the 1920s and 1930s, both Weber's and Archipenko's female nudes possessed the so-called fleshy, excessive, spectacular Hottentot anatomy. Both artists were active within European Modernism, the undisputed capital of which was Paris, at a moment when *les choses africain* pervaded the consciousness of western cultural production. The colonial origins of Modernism must be examined within the context of *negrophilia*, the social and cultural phenomenon of white fear/desire for the black body. Beyond recognizing negrophilia as a phenomenon through which blackness, as sup-

posedly primitive, was revealed and celebrated, we must scrutinize it as a generative force and interrogate it as the very process through which Africanness and blackness were othered and the white body/self located as "civilized," beautiful, rational, and intelligent. As Archer-Straw has commented upon the avant-garde cultural scene of 1920s Paris, "The negrophiles who fraternized with blacks cultivated a shadowy world of nightclubs and bohemianism; their interests were in conflict with mainstream, 'traditional' values. 'Blackness' was a sign of their modernity."[33]

James Clifford situates this Modernist preoccupation with African art and peoples within the framework of the colonial power structure which facilitated the appropriation and fetishization of the colonial subject as "other":

> Picasso, Leger, Appollinaire, and many others came to recognize the elemental, "magical" power of African sculptures in a period of growing *negrophilie,* a context that would see the irruption onto the European scene of other evocative black figures: the jazzman, the boxer (Al Brown), the *sauvage* Josephine Baker. To tell the history of modernism's recognition of African "art" in this broader context would raise ambiguous and disturbing questions about aesthetic appropriation of non-Western others, issues of race, gender, and power.[34]

Modernist practice then, was as much about the West's colonial fascination with African cultural production as it was the racist surveillance, representation, and consumption of African bodies as "primitive" objects themselves.

Early in his career Max Weber spent three formative years in Paris, then the center of western artistic activity. While studying at the Academie Julian, Weber became active in Parisienne contemporary life, socializing with other avant-garde artists, among them Henri Matisse, Robert Delaunay, Henri Rousseau, and Pablo Picasso.[35] The artistic community within which Weber circulated was full of young white male Modernists who actively appropriated so-called primitive art forms, African and otherwise. It was within this context that Weber, as William Gerdts has noted, "also became acquainted with African Negro sculpture, then newly discovered and highly popular with young moderns in Paris."[36]

Alexandre Archipenko's experience with the "primitive" art of Africa parallels that of Weber. Arriving in Paris from Russia in 1908, Archipenko quickly became associated with the Parisienne artistic vanguard.[37] By 1910 Archipenko was exhibiting with the Cubist painters at the Salon des Independants. Although Archipenko did not embrace all of the Cubist idioms, a kinship was forged through a mutual fascination with African art. The following year Archipenko's debt to the "primitive" was directly revealed in the title of his bronze sculpture *Negro Dancer.*[38]

The preoccupation of Modern European artists with African art has been historically rationalized as a purely superficial interest based mainly upon formal aesthetic concerns. This narrow assessment has been perpetuated throughout art historical discourse, attributing the overwhelming influence of African art on twentieth-century western culture to a mere formal reactionism to dominant artistic styles. It is the Eurocentric exclusivity of art historical discourse and its inability to accommodate questions of race, color, and colonialism which has effectively suppressed the colonial context of Western Modernism

within the discipline. Contemporary art historians have continued to replicate these beliefs. According to Katherine Janszky Michaelson:

> In their search for alternatives to impressionism, painters and sculptors alike employed these "primitive" sources to arrive at the new vocabulary of clear massive forms that became the point of departure for cubism. With a new emphasis on formal and structural problems . . . subject matter began to lose the importance it had in the nineteenth century, as is demonstrated by the many generically titled works by Archipenko and others.[39]

Not only does this statement frame Modernism as a superficial search for a new aesthetic vocabulary, it blatantly refuses the obvious colonial context of Modernism's preoccupation, appropriation, and exploitation of African cultures and peoples. Weber, Archipenko, and their contemporaries shared not only a fascination with African art and objects, but with Africanness and blackness as they had been defined in terms of white contact with "primitive" peoples of African descent. This fascination, fueled by white male artists' interaction with African art and their experiences with the "primitive" presence of black people (primarily as artistic performers in nineteenth- and twentieth-century Paris) was largely played out through representations of black women. That Weber and Archipenko were participants within this negrophilia reveals itself in their construction of the female body as Hottentot.

Both Weber's *Contemplation* (c. 1923) and *Retirement* (c. 1921) are compositions which incorporate several female forms represented with thick limbs, rounded stomachs, wide hips, heavy circular breasts, and large buttocks. Similarly, Archipenko's female bathers of this period exhibit sturdy proportions and fleshy bodies which were categorically opposed to more traditional western notions of female beauty. Weber clearly represented the "Hottentot" bodies of his women as white.

While the presence of the four male figures in Weber's *Retirement* (c. 1921) may also be located as a source for the disturbing reception of this painting, the Hottentot anatomy of the women must be understood as a device that could mediate this otherwise unacceptable presence. The bodies of Weber's women marks them as possessing a "primitive" black sexuality and through this inscription normalized the otherwise problematic presence of the men. Weber's painting recalls Manet's *Déjeuner sur l'herbe* (1863), whose representation of a naked white women with two fully clothed white men can be read as a commentary on the role of class in the social construction of female sexuality in nineteenth-century Paris. When Manet painted *Déjeuner sur l'herbe,* Paris was erupting with controversial debates about prostitution, and the human "sciences" were actively engaged in a search for a visual vocabulary of the body that would identify and fix the body of the white prostitute as an essential site of sexual deviance. Class then, as race, would be revealed as predetermined physical markers of sexual behavior and deviance.

Manet's juxtaposition of the black body of the maid with the white body of the prostitute in *Olympia* (1863) located the conflation of race and sexual deviance within the nineteenth-century discourses of female sexuality. As two separate bodies the maid and the prostitute reflect two different sides of the same coin. They were both viewed as sexually deviant in an essential way that implicated their very biology. But whereas

the white woman's sexual deviance allowed for the possibility (however slim) of transcendence or redemption, the black woman, physically marked by the stain/color (and other anatomical and physiognomical signs) of her racial difference, could never transcend her "primitive" sexuality. Part of the problem of *Olympia*'s reception was her elusiveness to easy class categorization, a commentary by Manet on the increased social confusion of prostitutes and "proper" women by men in Paris. The hysteria around the (in)visibility of the prostitute indexed concern for the spread of syphilis and its problematic and sexist alignment with the female bodies of prostitutes as opposed to the male bodies of their clients. But the cool reception of this painting must also be examined in terms of Manet's rupturing of the fantasy of the prostitute as Desire for a heterosexual male gaze, a fantasy dependant upon the suppression of the fact of the economic exchange of money for sex, a fact revealed by the placement of Olympia's hand securely over her genitals and the fixing of her ambiguous gaze outward to the implied john whose position we (the viewer) now occupy.

Through the proximity of the two bodies, Manet clearly referred to a significant trope within the annals of western figure painting through which a "black sexuality" was transferred onto the body of a white female subject or the black female subject acted as a reflective surface to reinforce the unquestioned beauty and racial superiority of the white female subject.[40] As Deborah Willis and Carla Williams have described:

> Exotic but rarely exalted, the black female image frequently functioned as an iconographic device to illustrate some subject believed to be worthier of depiction, often a white female. When she appeared at all, she was a servant in the seraglio, a savage in the landscape, "Sarah" on the display stage, but always merely an adjunct.[41]

However, I would argue that part of the overwhelming rejection of Manet's *Olympia* was based precisely upon its refusal to reinforce this colonial dichotomization of black and white female identity and sexuality. It was the white female body within *Olympia* that was read as naked, dirty, dead, and sexually uncontrollable.[42] Juxtaposed with the fully clothed, demure presence of the black maid, Manet effectively reversed and problematized the stereotypical racial positions to which these two bodies were generally assigned. The rejection of Weber and Archipenko at the AGT in Canada was based on a similar refusal—the destabilization of a presumed colonial racializing of female sexuality.

For Picasso, the bodies of the black woman and the white prostitute became conflated into a single iconic Hottentot anatomy in his drawing *Olympia* (1901) after the earlier painting.[43] Unclothed on a bed, she is ready to service not one (as Manet's *Olympia* implied) but two white men. Black Woman, always already sexually promiscuous, uncontrollable, feral, is represented as a prostitute.[44] The grave irony here is of course that within the colonial history of slavery, black women did not have the privilege of exchanging their sexuality for personal economic benefit as such an exchange was premised upon the legal and material ownership and control of one's body. Disenfranchised by colonial legal discourse, black female slaves were property, and the rights to economic benefit from their labor and procreative capacities were invested with their white owners.

The iconic stature of the Hottentot body as a marker of black sexual deviance and availability was evidenced in Matisse's *Blue Nude (Souvenir of Biskra)* (1907), a work

whose inspiration Archer-Straw traces to the artist's North African trip the previous year.[45] Although the artist chose non-flesh colors to represent the body of the female subject, the arbitrary nature of this selection is undermined by the geometric and Africanized mask-like face, which refutes the otherwise indiscriminate palette by signifying a black body. The thick limbs and full circular breasts are accompanied by deliberately enlarged, over-emphasized buttocks which manage to be revealed to the viewer despite the fact that this blue woman is positioned with her body in a reclining pose frontally aligned with the viewer.

This is the same point at which Weber's and Archipenko's representations of women are inserted into the Modernist dialogue. Unlike Manet's *Olympia* with the separate bodies of the black and white women, or Picasso's *Olympia* which still constituted the represented female body as black, the works of Matisse, Weber, and Archipenko share a moment in which the signification of race at the level of skin color was unnecessary to establish the race of the represented body. The woman could be white, as in Weber's images, or even blue as with Matisse's *Blue Nude (Souvenir of Biskra),* yet the viewer was able to read race into these bodies despite the ambivalence of skin. It is clear then that anatomical and physiognomical signs of the body were as important as color in the identification of race. It is also clear that race was not only visual but that, crucially, what was visible was taken as a sign of what was beyond vision, since regardless of skin color, the Hottentot anatomy signaled that deep down within the body, in the biology and the "essence" of these women, they were all black. And blackness was not only a racial position, but a sexual one.

Conclusion

Weber's and Archipenko's representations of the Hottentot body locate the colonial fascination of western artists with blackness and Africanness, particularly as it has been manifested within representations of black women. By the twentieth century the Hottentot body type was intimately connected with a western artistic consciousness which perceived black women as sexual "primitives." The iconic nature of the Hottentot body provided a concrete visual language for this perception which could then be constituted in a specific, representable physical body.

The censorship of Max Weber's and Alexandre Archipenko's female nudes from the International Exhibition of Modern Art at the AGT was a reaction which perpetuated the dichotomous perception of black and white female sexuality within colonial discourse. The representation of the "Hottentot" body type of itself was not enough to seal the fate of Weber and Archipenko's female subjects. The represented female bodies were not offensive because they depicted the so-called anatomical irregularity of the Hottentot anatomy, but because they dared to construct this body for women that were not definitively identifiable as black. This ambiguity recalled the Freudian preoccupation with white women as the "weak evolutionary link" and their constant danger of backsliding into the "primitive" state of black sexuality, a threat which a patriarchal logic registered mainly in terms of the inevitable danger to the white male body. Although idealized as the paradigm of beauty and sexual purity within the phallocen-

tric West, the impossibility of female sexual difference as anything but "(b)lack" led to white women's precarious and liminal position, which was further destabilized by associations with the "primitive."

Within Freudian psychoanalysis, white female sexuality has been located as a site of "primitive" fear/desire. The inscription of female sexuality as danger has aligned white female sexuality with colonial representations of blackness. Accordingly, white women were seen as the most immediate threat to the imagined "purity" of white men and the heterosocial sanctity of western civilization. It is the liminality of the female body that Weber's and Archipenko's works recalled, breeching the racialized standards of social propriety as they marked the tenuous boundaries between art and pornography.

The Weber and Archipenko works, in representing the iconic Hottentot body, recalled the "primitive" site of a black sexuality. But as white or racially unfixed bodies, they also recalled the instability of white female sexuality and threatened the idealization of white womanhood. While the marks and assigned meanings of the Hottentot body seemed essentially appropriate for the representation of "black sexuality," when applied to the white female subject, they became foreign, offensive, potentially pornographic, and worthy of cultural policing.

Credit: Adapted from Charmaine A. Nelson, "The 'Hottentot Venus' in Canada: Modernism, Censorship and the Racial Limits of Female Sexuality" from *Racism, Eh? A Critical Inter-Disciplinary Anthology of Race and Racism in Canada,* by Camille A. Nelson and Charmaine A. Nelson (Concord, ON: Captus Press Inc., 2004), pp. 366–384. Reprinted with permission of Captus Press Inc., www.captus.com.

1. I am using the term *western* to indicate original European traditions and their colonial permutations in countries like Canada, the United States, and Australia.

2. Lorraine O'Grady, "Olympia's Maid: Reclaiming Black Female Subjectivity," in Joanna Frueh, Cassandra L. Langer, and Arlene Raven, eds., *New Feminist Criticism: Art, Identity, Action* (New York: Icon Editions, Harper Collins Publishers, 1991), 153.

3. For an understanding of Modernism within the visual arts, see Clement Greenberg, "Modernist Painting," in Charles Harrison and Paul Wood, eds., *Art in Theory 1900–1990: An Anthology of Changing Ideas* (Oxford: Blackwell, 1994). For a feminist critique of this tradition, see Griselda Pollock, "Modernity and the Spaces of Femininity," in *Vision and Difference: Femininity, Feminism and the Histories of Art* (London: Routledge, 1988).

4. Clark quoted a nineteenth-century source which perverts the black maid's representation as that of a "hideous negress," uncritically used the "Hottentot Venus" as a barometer of the grotesque, and included contemporaneous "humorous" engravings of *Olympia* which radically burlesqued Manet's demure, even pretty black maid, likening her more to the stereotypical black "mammy." However, he fails to address the core issues of race and racialized sexuality as an obvious theme compelled by the deliberate juxtaposition of the white and the black female bodies. See T. J. Clark, "Olympia's Choice," in *The Painting of Modern Life: Paris in the Art of Manet and His Followers* (London: Thames and Hudson, 1984), 92, 93, 96, 97.

5. See Pollock, "Modernity and the Spaces of Femininity."

6. Griselda Pollock, *Differencing the Canon: Feminist Desire and the Writing of Art's Histories* (London: Routledge, 1999), 187.

7. Petrine Archer-Straw, *Negrophilia: Avant-garde Paris and Black Culture in the 1920s* (New York: Thames and Hudson, 2000), 10.

8. A significant tactic used in the policing of traditional art historical hegemony is to control which questions may or may not be formulated in the face of an art work. A fitting recent and personal example occurred in a review of my art exhibition, "Through An-Other's Eyes: White Canadian Artists—Black

Female Subjects" (1998), in which I employed a post-colonial feminist perspective to explore the three-centuries-long fascination of white Canadian artists with black female subjects. In a review by Henry Lehman in *The Gazette,* rather than critique the exhibition within its own stated thesis and discourse, Lehman belittled the very premise of the show by demonstrating its difference, and implied inferiority and exteriority to, the discourse of Modernist art history and its singular and supposedly universal concerns with formal analysis and "pure" aesthetics. In so doing, Lehman also effectively dismissed the possibility and legitimacy of anything other than a white male viewing perspective. See Henry Lehman, "Artists' Vision Coloured by Prejudice?" *The Gazette* (Montreal), 4 March 2000, J2. See also Charmaine Nelson, "Art Critic Called Misinformed," *The Gazette* (Montreal), 11 March 2000, J5; and Charmaine Nelson, *Through An-Other's Eyes: White Canadian Artists—Black Female Subjects* (Oshawa, Ontario: Robert McLaughlin Gallery, 1998).

9. Griselda Pollock and Roszika Parker, *Old Mistresses: Women, Art and Ideology* (London: Pandora, 1981); and Pollock, *Differencing the Canon.*

10. Two excellent examples of a post-colonial art history are Griselda Pollock's *Differencing the Canon* and Marcus Wood's *Blind Memory: Visual Representations of Slavery in England and America* (London: Routledge, 2000). In the Canadian context, a high standard has been set by Monika Kin Gagnon's *Other Conundrums: Race, Culture, and Canadian Art* (Vancouver: Arsenal Pulp Press, 2000); and Joan Acland's article "Elitekey: The Artistic Production of Mi'Kmaq Women," *Canadian Art Review* 25, 1–2 (1998).

11. See, for example, James Clifford, *Predicament in Culture: Twentieth-Century Ethnography, Literature and Art* (Cambridge: Harvard University Press, 1989); Steven D. Lavine and Ivan Karp, eds., *Exhibiting Culture: The Poetics and Politics of Museum Display* (Washington: Smithsonian Institution Press, 1991); and Annie Coombes, "Museums and the Formation of National and Cultural Identities," *The Oxford Art Journal* 11, 2 (1988).

12. Curtis M. Hinsley, "The World as Marketplace: Commodification of the Exotic at the World's Columbian Exposition, Chicago, 1893," in Ivan Karp and Steven D. Lavine, eds., *Exhibiting Cultures: The Poetics and Politics of Museum Display,* (Washington: Smithsonian Institution Press, 1991), 344–365.

13. Rosemary Wiss, "Lipreading: Remembering Saartjie Baartman," *The Australian Journal of Anthropology* 5, 1–2 (1994): 12.

14. See James Cowles Prichard, *Researches into the Physical History of Mankind,* 4th ed., vol. 1, (London: Houlston and Stoneman, 1851), 109.

15. Michele Wallace, "Modernism, Postmodernism and the Problem of the Visual in Afro-American Culture," in Russell Ferguson, Martha Gever, Trinh T. Minh-ha, and Cornel West, eds., *Out There: Marginalization and Contemporary Cultures* (New York: The New Museum of Contemporary Art, 1990), 45. It is important to note that although the legal status of these women as slaves is in dispute, the nature of their interaction and relationships as African women with European men during a colonial period where slavery and scientific racism were prolific makes it easy to assume at the very least a fundamentally inequitable and exploitative engagement based upon dominant ideals of racial and sex/gender difference.

16. Within the scientific discourse of the body, the Hottentot's increasing viability as a "missing link" between the animal kingdom and human beings, is consistent with Saat-Jee's bestialization and display in Paris as part of a stable of animals.

17. Stephen J. Gould, "The Hottentot Venus," *Natural History* 91 (1982): 20–27.

18. See Mohammed Allie, "Return of 'Hottentot Venus' Unites Bushmen," BBC News, 6 May 2002 (http://news.bbc.co.uk/1/hi/world/africa/1971103.stm); Sander Gilman, "The Hottentot and the Prostitute: Toward an Iconography of Female Sexuality," in Kymberly N. Pinder, ed., *Race-ing Art History: Critical Readings in Race and Art History* (New York: Routledge, 2002), 119–138; Jean-Yves Jounnais, "The Hottentot Venus," *Art Press* 191 (May 1994), 34; Wiss, 11.

19. The Art Gallery of Toronto is today known as the Art Gallery of Ontario.

20. Bertram Brooker, "Nudes and Prudes," *Open House* (Ottawa: Graphic Publishers Limited, 1931); Louis Muhlstock, "An Excess in Prudery," *Canadian Art* 5, 2 (Christmas–New Year, 1947–1948).

21. Twentieth-century Canadian landscape painting, although heavily dependent upon Dutch art, was decidedly more progressive than figure painting. While many landscape artists, including the acclaimed Canadian Group of Seven, aggressively pursued a Modern vision of the vast Canadian wilderness, figure painters adhered more rigidly to nineteenth-century European prototypes.

22. See Kenneth Clark, *The Nude: a Study in Ideal Form* (Princeton: Princeton University Press, 1972); and Lynda Nead, *The Female Nude: Art, Obscenity and Sexuality* (London: Routledge, 1994).

23. Charmaine Nelson, "*Coloured Nude*: Fetishization, Disguise, Dichotomy," *Canadian Art Review* 22, 1–2 (1995): 97–107.

24. Ruth Frankenberg, *White Women, Race Matters: The Social Construction of Whiteness* (Minneapolis: University of Minnesota Press, 1991), 6.

25. Ruth Louise Bohan, *The Société Anonyme's Brooklyn Exhibition, 1926–1927: Katherine Sophie Dreier and the Promotion of Modern Art in America,* Ph.D. Diss., University of Maryland 1980, iii.

26. Bohan, ii.

27. Bohan, ii.

28. Bohan, 140.

29. L. R. Pfaff, "Lawren Harris and the International Exhibition of Modern Art: Rectifications to the Toronto Catalogue (1927), and Some Critical Comments," *Canadian Art Review* 11, 1–2 (1984), 80.

30. Brooker, 94.

31. Brooker, 94.

32. "Paintings of Nudes Consigned to Cellar," *The Toronto Daily Star,* 4 April 1927, 22.

33. Archer-Straw, 19.

34. James Clifford, "Histories of the Tribal and the Modern," *The Predicament in Culture* (Cambridge: Harvard University Press, 1989), 197.

35. William H. Gerdts Jr., *Max Weber: Retrospective Exhibition October 1st–November 15th, 1959* (Newark, NJ: The Newark Museum, 1959), 7.

36. Gerdts, 7.

37. Katherine Janszky Michaelsen, *Alexander Archipenko: A Centennial Tribute* (Washington, DC: National Gallery of Washington and Tel Aviv Museum, 1986), 19.

38. The bronze sculpture *Negro Dancer* (1911) is in the Schueler Collection, Stockholm.

39. Michaelson, 20.

40. See, for example, Dante Gabriel Rossetti, *The Bride or The Beloved* (1865–1866); Jean Léon Gérôme, *Moorish Bath* (c. 1870); Lilly Martin Spencer, *Dixie Land* (1862); and John Lyman, *Sun Bathing 1* (1955).

41. Deborah Willis and Carla Williams, *The Black Female Body: A Photographic History* (Philadelphia: Temple University Press, 2002), 1.

42. Clark, 1984.

43. Pablo Picasso, *Olympia* (1901), pen and colored crayon, private collection, Paris.

44. The institutionalization of breeding practices, which effectively encouraged the rape of black female slaves for the economic benefit of the white plantocracy, must be scrutinized with regard to the de/re-gendering of black bodies within slavery.

45. Archer-Straw, 56.

11 A.K.A. Saartjie

The "Hottentot Venus" in Context (Some Recollections and a Dialogue), 1998/2004

Some Recollections, 2004 (Part 1)

A decade ago I put together a proposal for an exhibition on the image of the Hottentot Venus. Titled "Reclaiming Venus," the show was motivated by numerous African American women cultural practitioners who began to take up the theme in the late twentieth century. My first inspirations were visual artists Renee Green, Tana Hargest, Lorna Simpson, Carla Williams, and Deborah Willis, and writers Elizabeth Alexander, Lisa Jones, and Suzan-Lori Parks. As one version of my prospectus read:

Reclaiming Venus *Curator—Kellie Jones*

In the early 19th century, Saartjie Baartman, a Khoi-San woman of southern African, was displayed publicly throughout Europe as the "Hottentot Venus." Exhibited as a live anthropological specimen, European fascination with her buttocks and genitalia was the cause for such spectacle. Upon her death, Saartjie's labia were dissected and installed in the Musee de l'Homme where the famous "Hottentot Apron" remains to this day.

Since the late 1980s, African American women artists in particular have begun to reclaim Saartjie Baartman as a heroine. They have created work that considers her objectification in light of contemporary ideals of beauty and racial and gender stratifications. This show would explore such work but also more broadly examine issues of female agency, how women claim and control their bodies and sexuality in the 1990s.

In addition to art objects, video plays an important role in the show. In collaboration with scholar Fatimah Tobing Rony, I would like to create a video/film component that looks at misogyny and female objectification in the genre of music video, but also includes video makers who are not afraid to affirm and contemplate the power of the body—sensual, erotic or otherwise.

I am especially interested in addressing young women about feminist aspiration and action, concepts which seem to have been eclipsed in the last 20 years particularly in the realm of popular culture.

Over the years I was unsuccessful in finding a home for the show in the United States. When Okwui Enwezor invited me to contribute an exhibition to the Second

Johannesburg Biennale in 1997, I just knew this was my chance to finally see "Reclaiming Venus" come to fruition. I was wrong. For one thing Okwui was dead set against the idea. I had not yet read his now classic essay, "Reframing the Black Subject: Ideology and Fantasy in Contemporary South African Representation," in which he states:

> The Hottentot Venus, whose supposedly horrendous-looking vagina is now preserved in formaldehyde in a museum in France, and the black man on the auction block, as objects of denigration, become props of . . . ideological fantasy, the degenerative sketch from which whiteness stages its purity. These two historical scenes, in which the black body has been tendered as display, reproduce the abject as a sign of black identification.[1]

Of course I was miffed to have the show rejected once again. But I rallied to produce the exhibition "Life's Little Necessities: Installations by Women in the 1990s."[2] At the Johannesburg Biennale I was able to explore some of the same ideas of women's agency, power, and sexuality for which the Hottentot Venus was an emblematic figure. The context of the Biennale and South Africa also focused the show more centrally around concepts of the global, transnational, and postcolonial. Okwui's action had also saved me from stepping smack into the midst of a controversy in the post-apartheid milieu surrounding race, gender, authority, and nudity, and more specifically the seeming appropriation of the nude black female body by others. The responsibilities of artists, critics, and curators, notions of censorship, issues of historical trace in new images, and themes such as "representational violence" were debated over email, in the press, and on panels, as well as in books and essays printed somewhat later.[3]

Undeterred I decided to stage a dialogue on the subject of the Hottentot Venus as a way to tackle ideas of the body on display, women and agency, creativity and embodiment. What does the body say? Does gesture function as it own language? Are terror and pain inscribed in the body then "written" by the corporeal form? Re-membered there? If Saartjie Baartman's body is initially conceived by the West as a monstrous one, evincing a grotesque and "hyperbolic sexuality"[4] what does that imply about the intersection of race and gender in theories of the monstrous? As Rosi Braidotti has insightfully noted, the cipher of the monster organizes difference. Over time it has located otherness as geographical, theological, anatomical, and cybernetic.

> The monster is neither a total stranger nor completely familiar; s/he exists in an in-between zone. . . . The monstrous body, more than an object, is a shifter, a vehicle that constructs a web of interconnected and yet potentially contradictory discourses about his or her embodied self. Gender and race are primary operators in this process. . . . [T]he monster is a process without a stable object. It makes knowledge happen by circulating sometimes as the most irrational non-object. . . . [I]t will never be known what the next monster is going to look like; nor will it be possible to guess where it will come from. And because we *cannot* know, the monster is always going to get us.[5]

By embracing this body deemed in the West as monstrous, excessive, or as folks say, just "extra," we acknowledge the authority that our physical presence holds. In staging

this dialogue on the Hottentot Venus I wanted to continue discussions on power, diversity, and solidarity among women in the South African context. Perhaps I also assumed it might be the closest I would ever get to bringing my former concept into view.

Some Recollections, 1998

A.K.A. Also Known As. One of Saartjie (now more frequently Sarah[6]) Baartman's aliases (stage names? noms de guerre?) was "Hottentot Venus." We may never know the name she was born with, how she was called by the Khoi or San that identified her as one of their own.[7] Did these words signify beauty, star, quick-wit, lover? Did their sonorous clicks (too difficult for the Dutch to master) wrap her in the safe space of community?

Writing as an African American woman, for me, Saartjie as the Hottentot Venus represented an image of sexualized black femininity. The emotions of disgust/longing that her corporeality raised among some is not unknown to black women, especially those who recognize Saartjie's stunning form as their own.

In that body I did not see the abject, but a sister who thought she would use what she had to get what she wanted (to paraphrase 1970s soul singer Lyn Collins). Showing off your body, which did not carry the same taboo as it did in Western society, might have seemed a bit easier than working the *kraal* of one's *Baas*. In any case it was supposed to be a short gig with a big paycheck. But like most of the misinterpretations advanced under the colonial state, no one mentioned anything about cages, zoo animals, the cold, isolation, groping, stares, or what it meant to be the freak of the week, and even after death, not to be allowed to rest in peace but to be further cut, cast, and displayed for eternity.

Like other African American women, I wanted to recuperate Saartjie: write her the most beautiful poems, make the most exquisite art in her name, tell her centuries later that we dug where she was coming from, let her know that we recognized her beauty *and* her pain, whisper that she had not died in vain. But after visiting South Africa for the first time, I began to question *my* appropriation of Saartjie's black femininity, when I discovered that in her own country the Hottentot Venus was a contested symbol.

First of all "Hottentot"—the misidentification of the Khoi people—was a slur, not a term you would use to anybody's face. The imaging of the Khoi as "others" went back to the eighteenth century. The Hottentot became a vessel of difference, the foil of the natural savage to the colonizer's unwavering civilization. Their itinerant, pastoral lifestyle was equated with instability and vagrancy. They were vilified, much like European gypsies, driven from the land, and even shot at will.[8]

The issue of Saartjie's "consent"—a term most loved by Western women living in the late twentieth century; we know we've got it and we like to think that we would kill any MF who imagines he can take it from us—also became murky. What does "consent" mean for a Khoi-San woman and farmworker, when it is being translated through Dutch documents, "Dutch" language,[9] and patriarchal systems in the early nineteenth century? Do/can we ever hear Saartjie's voice in this decision? And how does the issue of "consent" play out again for South African women in the 1990s, when one of them is physically violated perhaps every other minute?

As in the United States, where the issue of use/misuse of black stereotypes constantly raises its profile, the image of the Hottentot Venus brings out a myriad of questions for cultural producers:

✦ Are artists identifying with racist/sexist imagery?

✦ What roles do myth and fantasy play in South African artmaking?

✦ Can we distinguish the blurry demarcations between appropriation, speaking/creating on behalf of others (and under what circumstances), and "ownership" of images? And if there is differentiation between these positions, how do we recognize it?

✦ How do questions of access to resources make an impact on the discussions of such ideas?

My visits to South Africa during 1997, as part of the curatorial team for the Second Johannesburg Biennale, were my first to the African continent. As an African American child of the 1960s and 1970s, and as a keen observer of the anti-apartheid struggle, this journey represented the fulfillment of many wishes. But as they say, reality bites. As I wrote to some of the artists who would be in the show after returning from my first trip, "South Africa is a truly amazing place, both intense and inspiring at the same time."

Politically, a new country can appear quite rapidly. But the process of developing a fresh civic life is constructed slowly, in fits and starts. That exercise was fascinating as well as painful to observe and to participate in, in some small way. My notion of "service" as a cultural worker (caressing the conflicted edges of the term as it has been described by Bill T. Jones[10]) kept, and keeps me looking forward to returning to the continent to do just that.

In my show for the Biennale, "Life's Little Necessities, Installations by Women in the 1990s," I chose to use women's art and the issues of identity construction as the context for viewing globalism. Five out of the thirteen women included in the exhibition were African. The two from South Africa, Veliswa Gwintsa and Berni Searle, have graciously agreed to participate in this dialogue.

The struggles and joys of putting up that exhibition is a topic I know I will write on in the future. Suffice it to say for now that the obstacles were substantially difficult—three years after the *de jure* fall of apartheid with the first democratic elections—for an American curator who also happened to be a small black, "colored"-looking woman.

The fact that the site of "Life's Little Necessities"—the Castle of Good Hope in Cape Town—was a former fort, built in 1666 and the oldest (Western style) structure in the country, was pretty straightforward. What I only discovered after finishing the project was that a Khoi woman was actually buried on the grounds.

During the seventeenth century Krotoa (a.k.a. Eva) was one of the earliest interpreters for the Dutch settlers. Very much like her Mexican counterpart La Malinche (a.k.a. Malintzin and Marina), she married a settler and eventually was repudiated by both the colonists and the Khoi. Krotoa was banished for a time to Robben Island (used as a prison from the beginning of colonial settlement) before being returned in death and interred under this foundation of the South African republic.

During the installation process, a television interviewer asked me why I thought to put a "women's show" in such a male stratified space. Though I had not ever conceived it in those terms, having seen the galleries months after finalizing the idea, it seemed particularly appropriate, and even more so after finding Krotoa.

A Dialogue, 1998

Given the opportunity to meet many South African women artists in preparation for "Life's Little Necessities," I thought it would be interesting and important to get their input for this project. Saartjie Baartman is after all their ancestor. All of the artists included participated in the Second Johannesburg Biennale. Most exhibited in one of the Biennale's six exhibitions. Bongi Dhlomo-Mautloa, however, was the Director of the Africus Institute for Contemporary Art, the organization that administered the Biennale.

My approach to a discussion of the Hottentot Venus was to create a forum for diverse opinions, something I hoped would illuminate what a variety of women artists were thinking in South Africa today. To this end I staged a transatlantic roundtable, asking for submissions via traditional, telephonic, and electronic mail, rather than setting myself up as the translator of their ideas. The results were wide ranging, touching on the figure and perception of their (in)famous countrywoman, the implications of her image for the performative body and the body on display, and the impact, if any, of Saartjie's history on their own production.

Opinions varied between seeing Saartjie as a truly international figure, embodying the intersection of gender and race on a symbolic level, and considering her as grounded in the South African milieu. She was at once a pawn, the personification of the myth of black women's perversion, a reflection of Europeans' own values, a vessel of women's pain, an emblem of the vulnerability of female sexuality, and a person whose much defiled form could be redeemed as a site of strength.

The following artists participated in the discussion:

+ **BONGI DHLOMO-MAUTLOA** is a painter, printmaker, and respected arts administrator. In addition to being a part of the directorate of both the 1995 and 1997 versions of the Johannesburg Biennale, she has been a pivotal figure in the management of cultural institutions and workshops in South Africa since the 1980s.
+ **PENNY SIOPIS** began her career as a painter and recently has explored photography, installation, and film. (See Figure 19.) She has exhibited prodigiously both inside and outside of South Africa. She is an Associate Professor and Chair of the Department of Fine Arts, University of the Witwatersrand in Johannesburg.
+ As an artist **VELISWA GWINTSA** has worked most recently with multimedia installations. She holds a Master's Degree in History of Art from the University of the Witwatersrand and is currently Curator of the Historical section at the Johannesburg Art Gallery.

+ Multimedia artist **BERNI SEARLE** completed her undergraduate and postgrad-
 uate studies in Fine Art at the University of Cape Town. (See Figure 28.) In
 2001 she participated in the 49th Venice Biennale. She was also the winner of
 South Africa's Standard Bank Young Artist Award in 2002.
+ **MARLAINE TOSONI** primarily works with photography and film. She has
 exhibited throughout South Africa and was included in the Johannesburg
 Biennale in 1995 and 1997.
+ **TRACEY ROSE** is a multimedia artist from Johannesburg whose works
 include video and performance. (See Figure 29.) She also participated in the
 49th Venice Biennale in 2001 and shows regularly with The Project in New
 York.

As a South African and an artist, how do you feel about the attention being paid,
largely by foreign women, to the Hottentot?

PENNY SIOPIS: It seems understandable for foreign women artists to pay attention to
the Hottentot Venus as her image and story are emblematic of concerns beyond the
"local." Saartjie Baartman typifies so many things about racial and gender oppression,
colonialism, Western scientific conceits, and "gaze," etc. In fact she represents the West's
use of Africa. She is almost something legendary, so visualizing her story does not rely
on being South African. Anyway I don't believe cultural images are owned, if this is the
implication of the question. It's a bit like images of slavery or the holocaust. I don't
consider these images the preserve of descendents of slaves or holocaust survivors,
however sensitive these images might be.

Art seems to me to be a good place to explore the complexity of the issues raised by
the Hottentot Venus. As an overdetermined practice, art can elaborate rather than reduce
the issues. Thus the more attention given to Saartjie's story through art, the better.

The way foreign visual artists seem to have referenced Saartjie's story is as "generic
black woman"—as victim or heroine or both. From the little I have seen, the work
seems to have very little reference to the specifics of Saartjie's life—her origin, culture,
location, etc. Since there could be little or no other identification on the part of these
artists with Saartjie's descendants—or her cultural context—her story understand-
ably floats rather without context, or rather, I would suggest, the context becomes
that of the "race" discourse, as articulated for example, within recent black diasporic
culture.

South African artists are of course more likely to be familiar with the actual cultural,
geographical, and political contexts of Saartjie Baartman. This fact might have its own
bearing on race discourses in the future. But interestingly, not many South African art-
ists have referred directly to Saartjie's story. More have explored "Bushmen" culture in
a general sense. But there have been theatrical productions about Saartjie, and quite a
lot of poetry and prose in which very specific reference is made to her time and place
and its relation to present concerns of identity.

BERNI SEARLE: The tendency to use Saartjie Baartman as a rallying point around black
solidarity is comprehensible in the context of theories of anticolonialism and racial

liberation in Africa and the African diaspora. While it is understandable that African American women have claimed Saartjie Baartman as a heroine, there is a tendency on the part of African Americans generally to romanticize Africa and to superficially identify with what they see as being their African brothers and sisters. However, this approach often reinforces romantic and timeless notions of Africa untouched by Western materialism and technology.

MARLAINE TOSONI: I think that the amount of attention being paid to the Hottentot Venus by foreign women is almost expected. During Saartjie Baartman's time, as it is now, the Hottentot Venus is still seen as "foreign." The fact that today foreign women are paying attention to what the Hottentot Venus represents is testimony to that which is familiar to women irrespective of nationality or religion.

VELISWA GWINTSA: The Hottentot Venus will remain present in the history of South Africa for a number of reasons, the most important of these being that she provides an opportunity to talk openly about the reality of the past as far as the history of race and politics in this country are concerned. The matter of Saartjie Baartman became an international issue the moment she was moved from her original context. And therefore no one group, nationally or internationally, can claim to have the exclusive right to this history.

However, in the process Saartjie Baartman has been dehumanized. Moral laws that govern and determine fundamental respect for the body and for human remains—and that are exercised variably by all peoples on earth—have in this case been sidestepped. Hence even today Saartjie Baartman is still being referred to as the Hottentot Venus. Over time she has become not a person but more an object of discussion.

BONGI DHLOMO-MAUTLOA: Issues that surround art production in South Africa now, at the end of the century and the end of the millennium, produce a myriad of unanswered, sometimes unanswerable, questions. The black people involved in art, to start off, enter any of these debates at very different levels than their white counterparts. There are many issues at stake and it is a fact that black women enter these debates and discussions from the most disadvantaged point.

As a South African woman and an artist I react to ways that have been used to display and dehumanize the body and the remains of Saartjie Baartman differently from my black male counterparts. I also react differently from my white female counterparts; I even react differently from my fellow black female counterparts. The reason for this is that we all enter the terrain with different assumptions and levels of understanding.

The reference to the present day depiction and usage of the black female body as a commodity for the "other's" curiosity and enjoyment takes us back to the Hottentot Venus. Saartjie Baartman's displacement from her country and resettlement in Europe could have been done, as we are told, with her consent. Consent in this case could be argued on different levels. But it is the same "consent" that has allowed commercial photographers in this country to include black female subjects as part of the flora and fauna that end up on South African tourist postcards. I don't believe these subjects are made aware of what they are consenting to, that is if any "consent" is ever sought at all. Saartjie Baartman could not have known better. The present day Ndebele women in

traditional attire and the Zulu maidens baring their breasts are not given the "low-down" on what will eventually happen to the photographs.

When foreign women enter the debate around the displacement and eventual display of Saartjie Baartman, the issue ceases to be a South African women's issue. It removes the discussion from national context to gender context first and gender/race context in particular, and opens up a dialogue on the female body and the black female body as icons. In such an inclusive forum, debate revolves around not only who and what determined these images, but what makes them acceptable to some and completely unacceptable to others.

The Hottentot Venus allows us to discuss present day icons, their origins, and their future. It is therefore important to understand the context of the nineteenth century's use/abuse of Saartjie Baartman. Is the use of the black female bodies in present day commercial and artistic representations a formulation of new icons or the perpetuation of the same old stereotype?

TRACEY ROSE: Before I actively engaged with the issues presented in this discussion, I took a mental diary of my experiences over several days:

✦ Yesterday I received an "obscene" cell call. I receive them often and look forward to the attention. The caller, who claimed to be anybody I named, commented on my large arse.

> (*While writing this Michael Bolton howls "can I touch you there?"*)

✦ Within the same time frame I read through what I hoped would be an informative article in a reputable newspaper: entitled "Germany's Shame," dominating the cover page was a large photograph of five Namibian Herero women who, standing in profile (save for one), display their bodies for a 1990s audience one hundred years later. [*Note:* This comment refers to the recent request by the Herero people of Namibia for reparations from Germany as atonement for an "extermination order" given by the colonial power that wiped out close to 80 percent of the population between 1904 and 1907. Many surviving Herero women were made virtual sex slaves following the massacre.]

✦ I recall an interview with South African deejay Mark Gillman and Felicia Mabuza-Suttle (talk-show host, advocate for plastic surgery, local Oprah wannabe, and self-appointed savior). Mark declares white women's envy towards black women as the former unlike the latter get both their arses and their faces done.

On my way out of my sometime job, I stopped and asked a large and beautiful black woman what she thought about Saartjie Baartman/The Hottentot Venus. Confronted by her look of confusion, I explained Saartjie, expanding on the following cues: Hottentot, woman, buttocks, genitalia, London, Paris, jar. "Oh! She is the one with the. . . ." A hand gesture elaborating on her own rather generous buttocks established that she was *au fait* with Saartjie. She then kindly proceeded to jot down the contact numbers of several male colleagues of her husband who have more information on the subject.

*Do you feel the Hottentot Venus is a sign of South African women's artistry,
especially in terms of the performative body?*

ROSE: No.

GWINTSA: Everyone needs to define for themselves what identity as a South African
woman is and stands for, perhaps even to the point of questioning if there is such a
thing. Yes, there are different and individual efforts being made by women in South
Africa that aim toward asserting the power and emancipation of women as such. These
efforts, however, should once again be interpreted as specific, not universal. Oppression,
in other words, must begin to be seen as individually and subjectively felt. In this regard,
then, the use of Saartjie Baartman as a symbol of objectification is a projection of con-
ceived beliefs about what oppression of black women in general stands for.

TOSONI: I don't consider the Hottentot Venus necessarily a sign of South African
women's artistry, though as regards the performative body, she is a sign of the fine line
between predator and prey, the insatiable desire to possess and dispossess.

DHLOMO-MAUTLOA: The assumed consent:

- ✦ by Saartjie Baartman to be displayed as a public spectacle,
- ✦ by female slaves to perform sexual favors for their masters,
- ✦ by rural black women to be used as subjects for touristic postcards and in
 contemporary art production,

and in the many other areas in which black women's subjectivity is at issue, is not a
sign of the women's artistry and cannot be assumed as fully representative of how black
South African women see themselves or want to be seen.

There is a particular way in which we see others and in which we are seen by them.
This is across any divide—it could be language, culture, dress, class, race, etc. When
these perceptions are further supported by a social and political system, it becomes
difficult to undo them without resorting to long debates as to whose perception is right
and whose is wrong. The South African system of government in the past instilled in
the white population the belief that it had the right (by virtue of assumed superiority)
to speak on behalf of the black population. It comes as no surprise to see this belief filter
down generation after generation.

The "Hottentot Venus," "the servant," "the maid," "the prostitute," are all representa-
tions of the black woman not only as subject but also as an object for the "other's" use/
abuse. The body of the subject/object "performs" not for itself, but always outward and
for the satisfaction of the other. All these stereotypes (that exist in the "developed" world
as well) in South Africa tend to be perpetuated under the old guise of talking on behalf
of "our blacks." Of course now everyone is supposedly mumbling in what seems to be
the same voice. But even now, the voices of those who have always believed they have
the right to speak outshout the others with the same authority of "we know what is
good for them." Old habits die hard!

SIOPIS: The Hottentot Venus could be read in this way if performativity entails real or
imagined bodily display. In terms of her representing something for South African
women artists, yes, she would represent the obvious intersection of race and gender.
Her female gender would provide the opportunity for identification to women (black

or white). Saartjie could be seen in some sense to represent, for all African women, a body bearing out desire. Doing this in a sense could be compared to the way Dora signified for European women in relation to the discourse of hysteria. Dora, or Freud's famous case "A Fragment of an Analysis of a Case of Hysteria," was re-read by certain European feminists as a sexual politics of resistance—a challenge to patriarchal domination and to the pathologizing of female sexuality. The phenomenon of the hystericized body—performing or "acting-out," quite literally, in sexually explicit gestures, inner psychic states—is interesting in how it has been reclaimed as woman's (the other's) dis-ease under patriarchy. There is something about this performativity—this spectacle—that, for me, could connect with Saartjie.

The Hottentot Venus raises issues of the female/African body on display. Do you feel such concerns impact you (1) as an artist displaying her work (or the type of work you do), and (2) as a female artist in a male-dominated field?

DHLOMO-MAUTLOA: If I am true to my "calling" as an artist, then issues of the female/African body on display should and do impact me and my work. The question "Who has the right to present the female/African body?" confronts me, and I ask myself if, as a female/African artist, I have the right to present, to talk for or on behalf of these "bodies" through my own work. In a sense, black women artists in South Africa, by their mere entry into the arena of art production, are making statements and are giving voice to the "used" bodies. The voice-giving ritual is performed simply in the act of being an artist, or it can sometimes be found in the subject matter that black women artists produce.

I would not like to see a counterstatement simply for the sake of counterstatement to what we have seen recently from white women artists using black female bodies in their work, where there is further dehumanization and voicelessness of the black subject. I would not like to see the white female body used in a similar degrading manner by anybody. Neither would I like to see black Amazonian icons as homage to struggling and oppressed black women. The Hottentot Venus is that and much more. I would like to draw my strengths from the lived experiences of all members of society and, in the process, be able to give voice to those who need to have it.

SIOPIS: As an artist showing my work, the idea of the female body on display has been fundamental to my practice. It is difficult to comment on the "African body" now in South Africa, as this could mean a white or a black body. This question often arises of late, but I assume in this context, though, you mean a black body. Either way (and I have used images of both black and white bodies), I am interested in the potential of the body on display for positive enactment of desire, rather than the negative cast it receives under patriarchy. I see this [act of] "making positive" what is commonly considered negative as in some way akin to the manner in which hysteria has been read positively from certain feminist perspectives. I have made this connection in many of my works, intertwining the stories of Saartjie and Dora (Freud's famous hysteric). In these and other works I have used my own body, either directly or as a reference for other images. More recently I have made photographs of my own body as kinds of static performances, as well as videos. I have also used body casts of black women as "found" museum objects in some of my installations, as well as having my face cast in the same

"primitive" way human subjects were cast in nineteenth-century scientific endeavors. But in all my works there has always been a very strong personal identification.

This personal aspect has proved to be a double edged phenomenon when it comes to the reception of the work in a male-dominated field. My work is all too often read in reductive terms, the connection with women and biology being typical. There seems little license to explore complex female/sexual subjectivity in this country without being classified in one way or another.

GWINTSA: The female African body on display is a very historically specific concept that has to do with the politics of power and the imposed perversions of a particular white society that are (hopefully) past. This belief in the exaggerated body to be reflective of the African body is something that is a myth and should have no reflection on how individual African women should either see themselves or be seen by others. To see myself as a female artist, and not as an artist and an individual in my own right first and foremost, is to perpetuate and impose perceptions that are not natural. I see, think, create, react as an individual who has a personal past that I consider specific to my place in history.

TOSONI: Regarding the female African body on display: of course it impacts me. These issues often become the references others use when looking at my work simply because I am female, Caucasian, South African. As retaliation, I play with sociology and ethics instead of biology and politics (they're there anyway), and this complicates the way I look at my work. Such generalizations are understandable though not plausible.

ROSE: What fundamentally concerns me about this question is that there appears to be an underlying assumption that Saartjie Baartman—posing as the symbolic Hottentot Venus—is a primary, or rather, an effective model of the manner in which the female/African body is displayed. It assumes that the displayed female is an individual placed (although willingly and consciously, still somehow naively) in a position where she does not or cannot comprehend the broader implications and issues of her context. Surely as artists we should ideally be well aware of the varying dynamics and power plays within the art arena and take these into account when producing and presenting a work of art?

SEARLE: While there is no doubt that Saartjie Baartman is a powerful symbol of our struggle against various forms of oppression, the process of claiming her cannot be a simplistic one. It is understandable that in terms of her suffering and humiliation she has become a symbol of the plight of indigenous people, but it is equally important to consider to what extent she has become a pawn.

Given that there is a strong tendency for various groups to identify with the original inhabitants of southern Africa and the need to be able to claim a particular history which has by and large been ignored, this tendency can be seen as problematic when the links are made superficially to reinforce "ethnic minorities." One has to acknowledge that Cape Aboriginal heritage has been brutally interrupted and broken and that if there is any attempt to identify with that heritage, it has to be by way of enactment/performance/ritual rather than asserting it as part of a lived culture.

The emergence of "colored" political movements with an appropriately ethnic "colored" consciousness has increasingly gained ground in the Western Cape since the 1994

elections. I use the term "colored" in this particular way since it is not a term that I would use to describe myself, unable to see it as anything but an imposed label. Despite my reservations and the fact that it is difficult to speak of any cohesive "colored" identity, i.e., language, class, or religion, there are tendencies within communities previously classified as "colored" under apartheid legislation to foster a kind of ethnic consciousness. This tendency is bound to a number of complex factors and extends beyond the parameters of this discussion. Similar tendencies can be observed in the Inkatha Freedom Party, the far right Afrikaner Weerstands Beweging [Afrikaner Resistance Movement], and the "colored" counterpart, the Kleurling Weerstands Beweging [Colored Resistance Movement], all of which focus on how they are exclusively different from any other groups in the broader South African context.

Such assertions and claims to an exclusive ethnic identity reinforce and perpetuate racism, especially when they become paramount and are protected at any cost. In this context I would support Benedict Anderson's view that all ethnicities are dangerous, breeding the politics of war and xenophobia. The growing pride in having indigenous roots has to be viewed, therefore, both in terms of its benefits and limitations.

Can you discuss some of the issues surrounding the Hottentot Venus in South Africa today or concerns around the female body and its display?

GWINTSA: What is more interesting for me, and that I also try to explore in my productions, is the way in which individuals may choose to represent themselves and others. This reveals a lot more about the person and the surrounding social system. Hence for me the issue of Saartjie Baartman reveals as much about those who portrayed her and their social constructs.

Right now, the issues of equality and power occupy the center of discussion in the new South Africa, i.e., who has the right to represent whom? What might be the agenda in the act of representing the other? How different or genuine is an image from that of the apartheid past? Does a particular representation do justice to the subject, and is it demeaning in any way? Who is the target audience?

SIOPIS: Most of the discussions of the Hottentot Venus in South Africa today are centered on debates around the repatriation of her body, burial rites, and the rights over cultural property. These debates are highly politicized and polarized, with some people feeling that she should remain in Europe as a reminder to the West of the horrific consequences of the colonial enterprise—a kind of symbolic retribution if you like, a bit like the Germans having to look at the victims of Nazi concentration camps. Others feel that Saartjie should be laid to rest in her own country, as a sign of respect for her descendents, and black South Africans more generally. These issues are openly discussed in South Africa today as part of the complex ethos created by the Truth and Reconciliation Commission. In Pippa Skotnes's exhibition, "Miscast: Negotiating the Presence of the Bushmen" (South African National Gallery, Cape Town, 1996), there was some discussion of Saartjie's "sexuality," mostly on account of one of the illustrations (of female "Bushmen" genitalia) reproduced as part of a tiled floor "representing" Bushmen history. But the discussion did not really compare to the intensity raised by other issues of the exhibition. I believe at the opening one of the guests, a "Bushmen" woman, arrived bare-breasted. Whilst this too caused a stir in the press, it was no more sensational than any topless

visitor to the South African National Gallery might be. But what it did do was to raise other issues concerning the female body on display—particularly bare-breastedness—as articulated within local cultural values. Bare-breastedness is often acceptable in traditional rural communities, but in urban metropolitan areas where "Western" values dominate it is considered problematic. There is much debate about this at present in the country, debate which is part of a larger interrogation of questions around gender and rights, whether these concern reproductive rights, polygamy, or whatever.

SEARLE: It is hard in the South African context to ignore the ways in which the African body has been and continues to be displayed. It seems ludicrous that four years after the first democratic elections, the pre-colonial hunter-gatherers of southern Africa are still housed in Cape Town's natural history museum—the South African Museum—while the white colonialists are housed separately in the Cultural History Museum. An article in the *Cape Times* (14 September 1994) quotes K. Hudson as saying the following as early as 1975:

> there is no essential difference between presenting a butterfly and a bushman to the world in this fashion. Both are the white man's specimens, symbols of his power and freedom to collect what pleases him. There are, in South African museums, no dioramas which illustrate the life of white men and women.

The three boxes suspended in front of the window in the installation at the Castle of Good Hope as part of the exhibition "Life's Little Necessities," entitled *Re:Present,* is a comment on this "bones and stones" regard for the country's first inhabitants. When visiting the South African Museum to look at the diorama, I was struck by the reactions of groups of mainly black school children. Some giggled embarrassingly, others mockingly referred to the casts as being each other's uncles or aunts. Aware on the one hand of some connection, this was certainly not a heritage that they identified with. Rather it is a heritage that is associated with the negative connotations of the Afrikaans words "Hotnot" [Hottentot] and "Boesman" [Bushmen], words that they would have grown up with. The diorama remains the museum's biggest attraction.

TOSONI: The female body is displayed in the show window as a "must have" sexual entity, marketed as a "must be" sexual entity, and most women end up selling themselves or being sold simply as sex. As an archetype this does not bode well, though there are women who have made lots of money buying into this market.

ROSE: Page 4 opposite a full frontal pic of two Herero women, "Town lives in fear of child rapist" almost passes my attention.
> "Crime in Chinatown: 'He pulled down his trousers, raped
> the child and sent her off with bananas, sweets & biscuits'"
> "R100,000 Bail!"
> "Two years later
> still no trial."

DHLOMO-MAUTLOA: South Africa carries many problems deep in her bowels and on her shoulders. Just as she recovers from the nightmare of the apartheid government and many others before, she finds herself in the throes of a worse crisis: the use/abuse/discarding of female bodies. South Africa is said to be the "leading" country for rape—

indiscriminate rape of babies, children, teenagers, young mothers, middle-aged mothers, and grandmothers. This represents disregard for the human body, the person who occupies it, and the number of other people who share that person's life.

Hottentot Venus in South Africa today is everywoman. The bodies of women are constantly on display—advertising this or that and looking sometimes more interesting than the product, dead women's bodies found in the veld where a serial killer is lurking in daylight waiting to pounce on unsuspecting women, and especially young and innocent school children. Saartjie Baartman may have left the shores of South Africa during the nineteenth century, but the legacy of her dehumanization in Europe has been brought back to the country of her birth. Young and old women of all races are on their own. Saartjie Baartman was on her own.

Are there any other concerns around your work that intersect with issues raised by the Hottentot Venus?

SIOPIS: A large number of my works have involved the Hottentot Venus directly. These were produced in the late 1980s and early 1990s. Probably the most well known of these are *Dora and the Other Woman* (1988) and *Exhibit: Ex Africa* (1990). (See Figure 19.) In 1988 I took a series of photographs of Saartjie's body cast in the Musee de l'Homme in Paris, which I only exhibited in 1995. I was prompted to show a selection of these photographs, re-presented as juxtaposed with her baptismal and death certificates, in a photographic exhibition on race and representation titled "Black Looks, White Myths" [curated by Octavio Zaya and Tumelo Mosaka for the First Johannesburg Biennale, 1995]. These photos show the whole cast and details of the body presented in a travel crate. I chose the images which revealed something of the artifact quality of the cast and which emphasized the packing materials and museum setting. My interest in the Hottentot Venus was always based on a strong identification. Looking at her cast in the museum and the wax molds of her genitals made me experience a very *contradictory sense of self*. As a woman I identified with her. As a white person, this is more fraught. While African, I am marked by my European descent, whether I like this or not. This connects me—discursively at least—to "the colonizer," the settler position. But I am not easily a settler, a European. I am South African. As a South African, race visibly defines me. But so does being a woman. I thus experience a feeling of being both insider and outsider. Saartjie's image hammered this predicament home to me and this is a large part of why I developed such a deep interest in her. She pictures my ambivalence and challenges my composure.

ROSE: Somewhere throughout these x-periences I became suspicious of the vulnerability projected onto female sexuality both within and outside of the "sisterhood." As I pulled my car into the driveway I picked up the bible which poses in her doorless cubbyhole—it is an act I seldom perform—I open it fingering two sections . . .

+ the 1st titled: second vespers of holy women.
+ the 2nd: the Lord's Prayer with a second version that prays through the intercession of the Virgin Mary.

The vespers being the evening prayers dedicated to specific saints, martyrs, and in this case, holy women and virgin women. Nowhere else within "The Good Book" does it

specify virgin male martyrs/men, etc. Why is it that we do not allow ourselves to cele-brate female sexuality? Perhaps more than a victim and an exploited figure, we should see Saartjie Baartman for what she now is: an icon to the power of the pussy, as we all stand in awe of her well-preserved genitalia. Her relevance is situated not in and among the women that she would or should ideologically represent, for she is a figure specific in time, place, and history, who holds but little significance to many except those who choose to theorize and give pertinence to her issue (whatever that may mean to whom-ever); it is a position which is opportunistic as well as superficial.

In a country with high rape statistics—last time I checked one every 84 seconds—Saartjie Baartman holds no significance, preserved and protected in a sanctified museum space in the confines of a jar. Neither she nor her genitalia can change the position of women nor make a change to the very real problems that confront us today in 1998. Historically she is displaced—time and context have almost nullified her relevance in her native country as we confront here and now more pertinent issues than that of pickled pussy.

As an artist, human being, woman, (classifiably) colored, South African, recovering Catholic, these are thoughts made for a redundant argument/purpose as I reflect on the past (BC–1998).

Some Recollections, 2004 (Part 2)

In 2002, four years after the dialogue above took place, Saartjie Baartman's remains were returned to South Africa with much fanfare.[11] Requests for such action had intensi-fied with the election of Nelson Mandela in 1994, particularly from South Africa's indigenous or First Nations peoples including the Khoi and the Griqua.[12] Introducing his petition with a poem by Khoi descendant Diana Ferrus, in December 2001 Senator Nicholas About brought a bill before the French Senate to have these relics repatriated.[13] After close to two hundred years of languishing in its museums, Saartjie's body parts had become part of France's cultural patrimony thus requiring special legislation for their release. While president François Mitterand had apparently "made a personal promise" to his counterpart Mandela to resolve the issue, it took years for the French parliament to overcome "objections about the precedent it would set for countries seek-ing the return of artifacts."[14] Indeed as recently as 1998 the Musee de l'Homme had even denied that the vestiges of Saartjie Baartman were in its holdings.[15]

Nevertheless, these relics were released with great ceremony and bountiful media attention in April 2002. The "handover" took place at the South African embassy in Paris and was accompanied by music, the singing of a choir, and Ms. Ferrus reading her poem over two wooden coffins, one holding the actual traces of Saartjie's corporeal-ity and the other containing the painted plaster cast of her body. The historic event was attended by French Research Minister Roger-Gerard Schwarzenberg and Bernard Chevassus-au-Louis, director of France's Museum of Natural History, along with South Africa's ambassador to France, Thuthukile E. Skweyiya, as well as the South African Deputy Arts, Culture, Science, and Technology Minister Bridgette Mabandla, who her-alded the occasion as a "'strong symbol' of solidarity between Paris and Pretoria."[16] Media tracked the repatriating plane trip on a South African Airlines Boeing 767 and

its arrival in early May at Cape Town. There Saartjie was received on a "carpet of antelope and zebra skins . . . since officials believed a red carpet would have colonial connotations"[17] and was remembered by a Griqua choir, Khoi and naval bands, and government officials, as well as ordinary people who turned out to welcome a lost ancestor home.[18] After spending three months in a military mortuary, Saartjie's remains were formally buried on 9 August 2002, in rural Hankey, some 470 miles east of Cape Town. The date also marked the celebration of national Women's Day.

Throughout the years-long odyssey of return, the figure of Saartjie Baartman had come to symbolize the fight for the rights of indigenous peoples as well as women. In 1999, three years before the traces of her body came to rest, the Saartjie Baartman Women and Children Centre opened in Manenburg near Cape Town, providing services such as a shelter, rape and HIV counseling, and legal advice. The Centre is perhaps indicative of the will to change the legacy of hardship for and brutality against women that is a specter in South Africa and the rest of the world, and which I alluded to in my initial essay for the "Life's Little Necessities" exhibition. In 2004 rape is still a major issue, and in tandem is now the rising AIDS rate where perhaps three-quarters of its young victims in southern Africa are women.[19] Recognized in almost two hundred countries around the world, this year the international "Sixteen Days of Activism Against Gender Violence" took as its theme "For the Health of Women, For the Health of the World: No More Violence." In South Africa the period was commemorated in such events as marches, plays, religious services, exhibitions of photography, and soccer matches, as well as lectures, acknowledging "gender-based violence as a major global public health issue," particularly the "intersection of violence against women and HIV/AIDS."[20] This campaign also coincided with celebrations marking the tenth year of South African democracy. At Saartjie Baartman's Hankey funeral, President Thabo Mbeki called on South Africans "to work together to build a nonracial society and a land of gender equality. 'When that is done, then it will be possible to say that Sarah Baartman has truly come home.'"[21] Clearly there are still things that Saartjie can tell us about politics, diplomacy, the global and transnational lives of women, and the circulation of bodies in the twenty-first century.

For the artists: Thank you for your poise and patience.

1. This essay first appeared in the exhibition catalogue *Contemporary Art from South Africa,* Riksutstillinger, Oslo, in 1997. I read it when it appeared later that year in *Third Text* 40 (Autumn 1997): 21–40. The piece was subsequently published in Okwui Enwezor and Olu Oguibe, eds., *Reading the Contemporary, African Art from Theory to Marketplace* (Cambridge, MA: MIT Press, 1999), 376–399. The quotation above is from this last version, page 381.

2. The artists were: Zarina Bhimji (Uganda), Maria Magdalena Campos-Pons (Cuba), Silvia Gruner (Mexico), Veliswa Gwintsa (South Africa), Glenda Heyliger (Aruba), Wangechi Mutu (Kenya), Berni Searle (South Africa), Lorna Simpson (U.S.), Melanie Smith (U.K.), Valeska Soares (Brazil), Jocelyn Taylor (U.S.), Fatimah Tuggar (Nigeria), and Pat Ward Williams (U.S.). See Kellie Jones, "Life's Little Necessities: Installations by Women in the 1990s," in Okwui Enwezor, *Trade Routes, History and Geography,* Second Johannesburg Biennale 1997 (Johannesburg and The Hague: Greater Johannesburg Metropolitan Council and the Prince Claus Fund for Culture and Development, 1997), 286–315. Related articles include Kellie Jones, "Life's Little Necessities: Installations by Women in the 1990s," *Atlantica* (Winter 1998): 165–171 (same title as the catalogue essay but a different essay); and "Johannesburg Biennale" (interview with Franklin Sirmans) *Flash Art* 30 (October 1997): 78–82.

3. Briefly, artists such as Candice Breitz, Penny Siopis, Kaolin Thompson, and Minnette Vari, all white South African women, were chastised for the use of the black body in their work. These artists objected primarily to criticism from Okwui Enwezor in the essay cited above and Olu Oguibe, "Beyond Visual Pleasures: A Brief Reflection on the Work of Contemporary African Women Artists," in Salah M. Hassan, ed., *Gendered Visions: The Art of Contemporary Africana Women Artists* (Trenton, NJ, and Asmara, Eritrea: Africa World Press, 1997), although commentary by artist Kendell Geers (in his guise as citric) and deputy speaker of Parliament Baleka Kgositsile (specifically on the Thompson piece—*Useful Objects,* 1996, an ashtray in the shape of a black vagina) also featured in the mix. In 1999 *Grey Areas, Represen-tation, Identity, and Politics in Contemporary South African Art* (Johannesburg: Chalkham Hill Press) was published. Although clearly an attempt by editors Brenda Atkinson and Candice Breitz to consider issues of visuality and power in the post-apartheid world, one cannot help noticing that most of the texts read as attacks on the black male critics (Enwezor and Oguibe). Bongi Dhlomo-Mautloa, Veliswa Gwintsa, Tracey Rose, and Penny Siopis all contributed to this book. Enwezor and Oguibe's *Reading the Contemporary, African Art from Theory to Marketplace* was also published in 1999.

Even earlier the video piece *Uku Hamba 'Ze—To Walk Naked* (1995)—documenting a 1990 incident in which black women, contesting the removal of their dwellings, faced down bulldozers by stripping naked in protest—caused a stir regarding appropriation since it too was made by a collective of white women, including Jacqueline Maingard, Heather Thompson, and Sheila Meintjes. They seemed aware of the concerns the piece would raise. See Jacqueline Maingard's statement in *Panoramas of Passage, Changing Landscapes of South Africa* (Johannesburg and Washington, DC: University of the Witwatersrand and Meridian International Center, 1995), 58.

Two other artworld incidents also speak to the contested visual landscape in the post-apartheid state and to the intersection of race, gender, and power. The exhibition "Miscast: Negotiating the Pres-ence of the Bushmen" (South African National Gallery, Cape Town, 1996), organized by artist Pippa Skotnes as a meditation on the horrors of South African colonial history, seemed to misfire. Besides having no black contributors (out of fifteen) to the exhibition catalogue, Skotnes "neglected to take into account that her voice as the authority of history might indeed be contested by the very people she was attempting to recuperate" (Enwezor, 393). "Bushmen" invitees to the exhibition were apparently disgusted, refusing to recognize any cultural bond with body casts and a linoleum floor printed with their likeness (on which viewers were meant to tread!).

As a bid to prove "reverse" gender and racial discrimination, in 1991 Beezy Bailey, a white man, submitted work to an exhibition under the name Joyce Ntobe. Excitement had built about this new black woman on the scene, when Bailey revealed himself, castigating current art world politics. Amaz-ingly, "he continues to exhibit work by Joyce Ntobe, whom he now claims as his alter ego." Marion Arnold, *Women and Art in South Africa* (New York: St. Martin's Press, 1996), 8.

All of these examples point to the black body, in particular, as a continued site of contention and trauma in the new South Africa. This is surely due in part to its historical role under apartheid and colonialism and the continuing trace of past histories borne by bodily form. There is also the need to develop artists, audiences, and criticism in a place where censorship was the rule for decades. For some interesting discussions of these ideas, see Lola Frost, "Checking One Another's Credentials"; Ernst van Alphen, "Colonialism as Historical Trauma"; and Sue Williamson, "Out of Line: When Do Artists and Critics Go Too Far?" all in Atkinson and Breitz, *Grey Areas.* The figure of the Hottentot Venus is certainly part of this conflicted terrain.

4. Bibi Bakare-Yusuf, "The Economy of Violence: Black Bodies and the Unspeakable Terror," in Janet Price and Margrit Shildrick, eds., *Feminist Theory and the Body* (New York: Routledge, 1999), 313.

5. Rosi Braidotti, "Signs of Wonder and Traces of Doubt: On Teratology and Embodied Differences," in Price and Shildrick, *Feminist Theory,* 292, 300.

6. The name Sarah often replaces Saartjie since the "tjie" suffix, a diminutive, can be deemed patronizing. See the South Africa information site of the International Marketing Council of South Africa: www.southafrica.info/ess_info/sa_glance/history/saartjie.htm (accessed 28 December 2004).

7. The San, the original inhabitants of the Cape of Southern Africa, were nomadic hunter-gatherers. Even before the arrival of the Dutch, they were intermarrying with and being replaced by the Khoi, semi-nomadic pastoralists. Thus the early denizens of this area are sometimes referred to as Khoi-San, as in the case of Saartjie Baartman.

The Dutch colonial designations are, of course, the ones that are most familiar: San became *Boesman* (Bushman); Khoi became *Getotterer,* "which was anglicized into 'Hottentot,'" according to D. R. Morris. This appellation, like so many other colonial monikers, was based on a slur as well as mistaken identity (think "Eskimo," meaning "raw fish eater," for Inuit). As Morris notes, "the Dutch, bewildered by the tongue clicks and a grammatical structure totally alien to the Indo-European languages, initially assumed that all suffered from a hereditary speech impediment and referred to them as *Getotterer* ('hay-totterer' or 'the stutterers')." Donald R. Morris, "South Africa: The Politics of Racial Terminology," *Political Communication* 9 (1992): 112.

However, Khoi and San are somewhat unstable designations as well. These philological terms were applied in the second half of the twentieth century as substitutes for the offensive "Hottentot" and "Bushman" respectively. "Bushman," however, unlike "Hottentot," still seems to have current accepted usage (though often in quotation marks). See Morris, 111–121.

8. Marion Arnold, "My Own and 'the Other,'" Chapter 2 in *Women and Art in South Africa* (New York: St. Martin's Press, 1996), and Obed Zilwa, "South Africa buries remains of indigenous woman who was displayed as oddity in Europe," Reuters, *BC cycle,* 9 August 2002.

9. According to Morris, Afrikaans—a "pidgin Dutch" composed from Khoi, Malay, French, and Dutch—was spoken within a few generations after colonization. It was an oral language known only as *die Taal* (the language) until being written down at the end of the nineteenth century. Morris, "South Africa: The Politics of Racial Terminology," 114.

10. Bill T. Jones has discussed his concept of reinscribing notions of compassion into art as a way of seeing cultural production as "service" (bringing out the preacher in him). However, there was a part of him that rejected the equation of compassion with "service" (that was the slave in him). My notes from a lecture at the Museum of Fine Arts, Boston (31 May 1998).

11. These included her skeleton, labia, brain, and the casts made of her face and body upon her death.

12. John Yeld, "South Africa: Plea to Return 'Hottentot Venus' to South Africa," *Africa News* [online journal], 13 January 1999.

13. Ferrus wrote "A Poem for Sarah Baartman" while studying in Utrecht, Netherlands. Homesick, she began imagining the feelings of her famous ancestor. "Poem the Key to Baartman Return?" *South African Press Association,* 31 January 2002 and 28 December 2004. See www.southafrica.info/ess_info/sa_glance/history/saartjie.htm.

14. David Hearst, "Colonial Shame: African Woman Going Home after 200 Years," *The Guardian* (London), 30 April 2002. All over the world indigenous people are calling for the return and burial of bodies displayed as "specimens" in Western cultural institutions. In 2000 Spain returned to Botswana a Khoisan man who had been exhibited in museums there for a century; see Yeld, "Plea to Return 'Hottentot Venus,'" and Rachel L. Swarns, "Mocked in Europe of Old, African Is Embraced at Home at Last," *The New York Times,* 4 May 2002: A3.

15. Andre Langenay, then head of the museum, made this assertion in Zola Maseko's 1998 documentary, *The Life and Times of Sarah Baartman.* Gail Smith, "Fetching Saartjie," *Mail & Guardian* (South Africa), 17 May 2002.

16. Susan Stumme, "France Returns 'Hottentot Venus' Remains to South African Ambassador" *Agence France Presse* (English), 29 April 2002.

17. Ken Daniels, "Return of South African Woman's Remains Closes Painful Colonial Chapter," Reuters, *BC cycle,* 3 May 2002.

18. Swarns, "Mocked in Europe of Old."

19. BuaNews, "Princess Ann Commends Saartjie Baartman Centre for Its Work," *Africa News* [online journal], 15 July 2003; "The New Face of AIDS; Women and HIV," *The Economist,* 27 November 2004; and "Setting women free from fear," *Sunday Times* (South Africa), 21 November 2004: 36.

20. Quoted at www.capegateway.gov.za/16days (a government information site for the Western Cape; accessed 29 December 2004). See also www.capegateway.gov.za/eng/pubs/public_info/W/91809. For information on U.S. participation in the "16 Days of Activism Against Gender Violence," see the Center for Women's Global Leadership at the State University of New Jersey at Rutgers: www.cwgl.rutgers.edu/16days/home.html.

21. Zilwa, "South Africa Buries Remains."

LINDA SUSAN JACKSON

12 little sarah

in 1810
lured by false promises
of pounds or francs
for her village
she was sold into licentious service
stolen from south africa

exemplifying hottentot virginity
with labia minora
reaching halfway to her thighs
elongated by self-manipulation or weights
solely for prospective husband's pleasure
she was mockingly named/
hideously displayed
as "the hottentot venus"
captivating cultured capitals of europe
where there was an insatiable appetite
for the exotic

her fawn-colored opaque skin
which easily reflected
the ardent african sun
offered no reprieve from
the raw persistent dampness of london town
or dim dank days in gay pareé

imagine her
led out like a bear on a chain
by nefarious showman
into bogus reproduction of her village
twirling on makeshift pedestal
four revolutions per hour
twelve hours per day
legs opened on the drumbeat

fleshy mass
hidden under her hottentot apron
revealing fantastic sexual possibilities
to hot eyed voyeurs
who misunderstood cultural vanity

from a spectator's safe distance
spiral/coarse peppercorn hair
could not hide her rheum-filled eyes
mistaken for provoked tears of pleasure
as "peeping toms" with rimy fingers
touched her genitalia
for an additional fee

far from her pastoral past
with cloudless night skies
homesickness hung heavier
than her tarpaulin tent
she lost her appetite for food
sinking under a pall of despair
how long can a khoikhoi virgin survive
without the natural sweetness
of tsama melons or wild cucumbers?

she lived in paris
no longer than
vegetation on the kalahari
never again to squeeze
the orange river's rich soil
between her toes

heart broken/inflamed
released from this life in 1815
but not from exhibition
her preserved genitalia
still float in a bell jar
in "le muse de l'homme" in paris

Credit: This poem originally appeared in *African Voices,* volume no. 7, issue 9 (Winter 2000/2001): 25.

PART III

Sarah Baartman
and Black Women
as Public Spectacle

NIKKY FINNEY

13 The Greatest Show on Earth

For Saartjie Baartman, Joice Heth,
Anarcha of Alabama, Truuginini, and Us All

Under glass and tent
floating in formaldehyde jelly
curled in a deadman's float
live the split spread
unanesthetized legs
of Black women
broken like the stirrups
of a wishbone

somebody got their wish
and somebody didn't.

The lilac plumage
of our petaled genitalia
in all its royal mauve
and plum rose
with matching eggplant hips
that pull the ocean
across itself each night
boats of peanut skin
folded and rolled
like the new fur
all proof of our pathology
all cut away
by pornographic hands
fascinated with difference

and the spectacle
of being a Black woman

and the normal pay their fifty cents
to see what makes a freak a freak

 Go ahead
 walk around her
 she won't bite
 see her protruding mass
 steatopygia.

We don't have to be dead first
to be cut into a manageable size,
one that fits their measuring rods
their medicine chests will not rest
until we are properly pried
it has always been about
opening us up

experimenting on Black women
but never dissecting their own desires.

The side show
was pitched on our backs
the speculum hammered
out between our legs
modern medicine was founded
on the operation of our hips
we were the standard patterned girth
of every bustle ever made

Black women as spectacle
wanting to but afraid to die
knowing death would never quench
such sterling silver lust.
Bodies quake whole lifetimes
in a national geographic tremble
until the obituary arrives:

Please. Bury me behind the mountains
So they will never find me again.

But they do find us
Do dig us back up,
retrieving the last
swatches of soft skin
the last twig of curved brown bone.

Our opened pirouetting vaginas,
our African music boxes
are whittled down to perfect
change purse size,

For the normal
who will always pay
their fifty cents
to be sure and see
what makes a freak
a freak.

Credit: This poem originally appeared in *The World Is Round,* InnerLight Books, 2003).

MICHELE WALLACE

14 The Imperial Gaze

Venus Hottentot, Human Display, and World's Fairs

> *Few pastimes are more amusing than looking at other people. A study of visitor behavior in public parks shows that people spend more time looking at each other than at the beauties of nature. If the people observed differ in some striking fashion from the observer, interest is further stimulated. For centuries, entrepreneurs and showmen have been charging admission to see human oddities.*
> —Burton Benedict, "Rituals of Representation"

In his important article, "Gramsci's Relevance for the Study of Race and Ethnicity," Stuart Hall makes some significant points regarding the usefulness of Antonio Gramsci's concept of hegemony to any discussion of popular culture. Gramsci defined cultural hegemony, as opposed to the coercive forces of outright domination, as "a very particular, historically specific, and temporary 'moment' in the life of a society. It is rare for this degree of unity to be achieved. . . . Such periods of 'settlement' are unlikely to persist forever. There is nothing automatic about them. They have to be actively constructed and positively maintained."[1]

From his prison cell in Italy in the thirties, Gramsci noted the difficulty of translating a revolutionary strategy that produced success in pre-industrial Russia to the more complicated and variegated conditions of post–World War I Europe. Pre-revolutionary Russia, with its long-delayed modernization, its swollen state apparatus and bureaucracy, its relatively undeveloped civil society and low level of capitalist development, was a much more conducive environment for sparking a government-toppling insurrection than was the industrialized West, with its mass democratic forms and its complex civil societies. In the West, the hegemony of the state is consolidated on a more consensual basis through political democracy.

As Hall writes, in such cases "the State was only an outer ditch, behind which there stood a powerful system of fortresses and earthworks, more or less numerous from one state to another. . . ." In other words, in a non-coercive society, cultural hegemony by the dominant group is not so much an imposition of the values of the ruling class on distinctly different and oppositional values, but rather a fragile and symbiotic process of consensus building. Ironically, these more fragile conditions make the state more resilient and cultural hegemony much more difficult to subvert. In this situation, hegemony becomes "multi-dimensional"—sustained on multiple fronts simultaneously. "Mastery is not simply imposed or dominative in character, and results from winning a great deal of popular consent. Thus it has substantial moral and political authority."[2]

In the context of tracking a genealogy of a race/gender visual at the turn of the century, we need to understand hegemony as a subtle and flexible construction, composed of multiple dialogical currents. Those currents might be viewed concretely as specific pragmatic positions, such as pro- and anti-women's suffrage, anti- and pro-imperialism, pro-nativism and anti-immigration, anti-segregation and lynching versus pro-white supremacy. Or, these currents may be viewed more abstractly, in Foucauldian terms of modern modalities of power/knowledge.

Turn of the (twentieth) century racialism is better understood in the terms of its own time than in our context—though such an understanding is, of course, nearly impossible to achieve. One way to go about our efforts to achieve this understanding of turn of the century racialism's particular hegemony is through a closer examination of its popular forms.

One of the most significant of these popular forms, now all but lost, was human display. Instances of human display ranged from world's fairs and expositions, which were the rage all over the world around the turn of the century, to circuses and freak shows, to ethnographic expositions and life groups in natural history museums, to the staged events of Buffalo Bill's Wild West Show and other such ventures in performance and entertainment.

Human display is a crucial feature of the particular discursive regime of black visual culture herein described. Its race/gender visual circulated internationally, in significant part through the circuitry of world's fairs. The world's fair appears to have been the primary mediator of Western modernity's confrontation with the non-Western world at the turn of the century. To consider world's fairs solely within an American context is to distort the ultimately international and global aspirations of the form. A parallel and overlapping occurrence to Orientalism, such mechanisms of racial hierarchy were an intrinsically international discursive regime, a discourse between Western nations.

Throughout the modern world, when blacks were the focus of human display, there tended to be a special emphasis on what Foucault called "the gaze" as an institutional micro-strategy and on the body as an ideological effect. This "gaze" is crucial to comprehending the peculiar legacy of the race/gender visual as it was formed within the abstract space of the world's fair and as it influenced all manner of racial representations in early cinema. (See Figure 1.)

In one of the earliest known instances of black female display, Saartjie Baartman, a woman of the so-called Hottentots of South Africa, was placed on tour in Britain and France. Her exhibitors admitted a paying audience to view her unusually shaped and large buttocks. In his study of stereotypes of sexuality and race, Sander Gilman reports that Baartman's buttocks were viewed as an indication of the size of her clitoris and her presumably heightened sexual appetite.

French biologist George Léopold Cuvier's dissection of the Venus Hottentot signifies at the level of a specular objectification peculiar to the modern gaze in its apprehension of black or non-white bodies. Modernity's zoos, parks, museums, fair grounds, bazaars, department stores, and shop windows are all designed to display the commodity fetish to its best advantage and to promote its promiscuous and carefree exchange. And yet in this economy of display, the black body always seems to disrupt at a special or intensified level beyond its mere numerical presence or the amount of physical space it occupies in the system.

The Venus Hottentot presents us with a comparatively rare historical object in the form of a black female individual, whom we can identify and study (albeit not adequately) throughout her life, which was used as a human display. Yet there were many others, less well known but like her, who followed her condition. Some fared better, some worse. In that history, most of its record written through the medium of photography (and therefore subsequent to the date of the innovation of photography), Saartjie Baartman occupies a special position in this genealogy of a race/gender visual, as an arbitrary starting point, which precedes photography. The documentation of Baartman's life is through drawings, watercolors, writings, and the preservation of her private organs. Baartman offers us the comparatively rare opportunity to follow the specular examination of one category of objects from the obsolescence of one visual regime to the dawn of another, that of photography. The scopic regime of the peculiarly modern gaze can be identified as formed and ready for employment, through the figure of the Hottentot Venus, even as photography was in its early preparatory stages as daguerreotype, and cinema was yet hardly a notion.

From the Hottentot's private parts, to the skulls of her San and Khoikhoi kinsmen housed in the British Museum, to the African and "primitive" sculptures that populate the galleries of Western museums and transformed the vision of Western avant-gardes, the presence of competing visions of the black body invariably alters the anticipated balance of display; it always tilts the scale to reveal more than it intends about the inherently corrupt intentions of the structure of the gaze.

It is no accident such theorization would suggest that it was a piece of a black body—Sam Hose's knuckles, brutally removed from his hands during his lynching and displayed in a butcher shop window in downtown Atlanta—that revealed to W.E.B. Du Bois the necessity for more aggressive political activism on the part of the "Talented Tenth."[3] And therein lies the trouble with Booker T. Washington's image of blacks and whites in the South as the fingers of a single hand. As Grace Elizabeth Hale reminds us, "black fingers" also "served whites . . . as fetishized objects of entertainment."

> While the gruesome southern practice of lynching actually made black fingers into coveted commodities, lovingly preserved and displayed in jars, northerners practiced a less deadly form of appropriation in which racial images performed as minstrel entertainment and advertisements for the new consumer products.[4]

Indeed, it is hard to imagine that such people, whether entertainers, product-hawkers, or subjects in ethnographic exhibits, might exercise free will on any level, that their participation in such a system of display was in any sense consensual. What manner of freedom could this be? It was much like the kind of provisional freedom visited upon colonized subjects the world over at that time, including the former slaves in much of the Americas. Whereas there was no guarantee that the plight of your descendants would follow your own in perpetuity, as in the case of a slave, on the other hand, someone else's will still entirely dominated your life.

We know very little about the terms of Saartjie Baartman's agreement with the entrepreneurs who exhibited her. But we know that in regard to more recent ethnographic displays, such as the ones featured in world's fairs all over the world in the late nineteenth and early twentieth centuries, there was at least the semblance of a voluntary

arrangement. Such exhibitees were not enslaved or dragged unwillingly to fairgrounds or forcibly bound. A more accurate way to describe their relative position to their keepers is to say that they were coerced. They were not fully apprised of their rights in the situation. They were often promised a great deal more money and comfort than they received. Only a few of these persons were outright entrepreneurs, willingly engaged in the marketing of their own bodies for exhibition.

> The international exhibitions that shaped the cultural geography of the modern world were arenas for making ideas about progress visible. For the designers of international fairs, progress was a universal force that active human intervention could direct toward national benefit.[5]

The fad for world's fairs in decades preceding and following the turn of the century was a peculiar symptom of the changing concerns of the dominant classes and of their preoccupation with having a positive impact on the predilections of the masses. The fascination of the various powers—Britain, France, Belgium and the United States—with the latest technological innovations, the development of foreign markets, the exploration of exotic lands, and their celebration of imperial triumph were paraded for all to examine.

Whatever was new, hot, modern, or futuristic was welcome. The fairs lasted for months and spread over miles, comprising large numbers of newly built and lavishly designed buildings, fountains, and fantastic structures, such as the Eiffel Tower, which was built for Paris's Exposition Universelle Internationale in 1889, or the Ferris Wheel, built for the World's Columbian Exposition in Chicago in 1893.

The fairs were a major influence on the cultural life of their host countries, as they were endlessly memorialized in "songs, books, buildings, public statuary, city parks, urban designs, and photographs" via a variety of commercial media: the illustrated press, lithographs and posters, stereograph sets, and, in later years, newsreels and film, as well as other memorabilia.[6]

Generally, world's fairs are treated by a select group of scholars, usually art and photography historians. They are examined in terms of their exhibitions of art, artifacts, photography, or architecture, and how such innovations were influential in subsequent developments in these fields. Or the fairs are looked at as symptomatic of the imperialist ambitions of the period. Within this latter context, human display has been substantially treated, although commentators are inclined to see the horror of human display, and the racism and imperialism it implied, as a frightening, inexplicable, and anachronistic disjuncture from current issues and concerns. Linking the appetite for human display with equally inexplicable, and presumably distant, practices of early twentieth century imperialism and racism, however, does not provide an adequate explanation for these gargantuan events, much less for the place of human display within them.

Broader consideration of these fairs helps us to understand that minute visual differentiation—via anthropometric measurement, the speculum, photography, and scientific or medical illustration—was the empirical foundation of most thought about race and sexuality (as distinct from gender) during this period.[7] Potentially, the fairs provide a key to all other visual practices, not only because most other visual practices

were actually included in the package of the fair, but also because the fairs themselves were a central feature of a range of visual cultures of the time.

As the first form of industrially produced mass culture designed to promulgate the importance of imperial mission and white supremacy among the masses, the fairs and their deployment of human display served most conspicuously an entertainment function. At the same time, they provided a kind of pedagogical reassurance that would emerge as typical of mass entertainments regarding the safety and security of future progress. Their distractions sought to "dispel anxiety about industrial depression and social unrest."[8]

The presentation of technological and national progress was intertwined with narratives of racial hierarchy. So-called "natives" were imported, paid some nominal fee, dressed in what were imagined to be their "native" costumes, and displayed in what were thought to be characteristic dwellings, where they engaged in typical ceremonies or activities such as cooking and eating. The result was viewed optimistically as a happy marriage of education and entertainment.

A priority at the fairs, as well, was the pursuit of international markets in an increasingly high-pressure and global economy, in which these human displays functioned to verify the savagery and primitiveness of subject colonial populations and to reinforce the superiority of dominant civilizations and nationalistic master-narratives. The effect on the audience must have been a curious combination of loathing and an insatiable desire to know intimately, to experience, even to touch. Re-inscribed by the fairs were all the dominant iconographies of race. Whites were always shown as more beautiful, intelligent, and straighter-standing than blacks or peoples of other "inferior" races, usually though not always demarcated by darker skin.

World's fairs were a laboratory of a race/gender visual regime in which human display and ethnographic exhibitions were prime features, and "invented traditions are always symbolically and emotionally charged."[9] To fully comprehend the effects of the Western gaze, it is necessary to accept and understand this emotional aspect of it. The entertainment values of the gaze in this race/gender visual regime neutralized the capacity of the audience to perceive the military and economic violence the visual regime made possible.

Epigraph: Burton Benedict, "Rituals of Representation: Ethnic Stereotypes and Colonized Peoples at World's Fairs," in Robert W. Rydell and Nancy E. Gwinn, eds., *Fair Representations: World's Fairs and the Modern World* (Amsterdam: VU University Press, 1994), 29.

1. Stuart Hall, "Gramsci's Relevance for the Study of Race and Ethnicity," in David Morley and Kuan-Hsing Chen, eds., *Stuart Hall: Critical Dialogues in Cultural Studies* (New York: Routledge, 1996), 424.

2. Hall, "Gramsci's Relevance," 427; and Antonio Gramsci, *Selections from the Prison Notebooks* (London: Lawrence & Wishart, 1971).

3. David Levering Lewis, *W.E.B. Du Bois: Biography of a Race, 1868–1919* (New York: Henry Holt, 1993), 226.

4. Grace Elizabeth Hale, *Making Whiteness: The Culture of Segregation in the South, 1890–1940* (New York: Vintage, 1998), 150.

5. Robert Rydell, *The Book of the Fairs: Materials about World's Fairs, 1834–1916, in the Smithsonian Institution Libraries* (Chicago: American Library Association, 1992), 9.

6. Rydell, *The Books of the Fairs,* 10; Burton Benedict, *The Anthropology of World's Fairs: San Francisco's Panama Pacific International Exposition of 1915* (Berkeley, CA: Lowie Museum of Anthropology/Scolar Press, 1983), 15–18.

7. Herein I am referring to both race and sexuality in terms of their visually perceivable characteristics on the surface of the body, and gender in terms of its socially and culturally constructed additions to the body. Of course, both sexuality and race can and often are socially and culturally constructed, but this would be irrelevant to anthropometric measurement where both race and sexuality are considered "natural" and continuous with their visual markers.

8. Paul Greenhalgh, *Ephemeral Vistas: The Expositions Universelles, Great Exhibitions and the World's Fairs, 1851–1939* (London: Manchester University Press, 1988), 45.

9. Aram A. Yengoyan, "Culture, Ideology and World's Fairs," in Robert W. Rydell and Nancy E. Gwinn, eds., *Fair Representations: World's Fairs and the Modern World* (Amsterdam: VU University Press, 1994), 66.

CHERYL FINLEY

15 Cinderella Tours Europe

> *West Indian emigrants, such as my parents, traveled [to Europe] with the hope*
> *that both worlds might belong to them, the old and the new. They traveled in*
> *the hope that the mother country would remain true to her promise that she*
> *would protect the children of her empire. However, shortly after disembarkation*
> *the West Indian migrants of the fifties and sixties discovered that the realities of*
> *this new world were likely to be more challenging than they had anticipated. In*
> *fact, much to their dismay, they discovered that the mother country had little, if*
> *any desire to embrace her colonial offspring.*
>
> —Caryl Phillips, *The Atlantic Sound*

With her usual sense of clever wit and passion for historical inquiry, Joy Gregory has created a series of photographs that might forever change the image of Cinderella and the idea of Europe, past and present. In *Cinderella Tours Europe,* Gregory has photographed famous buildings, monuments, and cities associated with the construction of a popular image of Europe, such as the famed Sagrada Familia Church by Antoni Gaudí in Barcelona or the Eiffel Tower in Paris. The places that Gregory has chosen to record on film comprise a list of the classic sites of memory on any tourist's photographic itinerary. Many of these sites have long held a place in the popular imagination of Europe, like the Alhambra in Granada or the city of Venice, itself a magical mirage of twelfth-century buildings floating on water. Other sites are associated with more recent historical and political narratives, such as the United Nations agencies of world peace in Geneva or the 1936 Olympic Park in Berlin. But Gregory's images are anything but your typical tourist photograph. While she employs many of the conventions of tourist photography, from the use of vibrant color film to the conscious choice of the most advantageous angle, the one thing that is missing from each photograph is the tourist body itself, which has been replaced by a pair of very self-conscious golden slippers, both referencing the classic Cinderella fairytale and literally standing in for contemporary Caribbean people for whom the possibility of such a grand tour is becoming more and more difficult. The result is something distinctly of the artist's making, a re-engineered notion of the tourist snap, layered with a twenty-first century sense of diasporic memory.[1]

Cinderella Was Black

Most of us know Cinderella from the children's storybook fairy tale recorded by the Brothers Grimm or from the animated Walt Disney film.[2] The young woman that we picture has fair skin, blond hair, and blue eyes. She is rescued from a life of servitude

by a little bit of magic, a pair of golden slippers, and a handsome prince. Cinderella embodies a child's hopes and dreams, and her literal rags-to-riches story symbolizes the classic battle of good over evil. Gregory's use of this fairy tale expands the possibilities for Cinderella, while helping to make sense of the past and present. In the fairy tale, "The poor child had to do the most difficult work. She had to get up before sunrise, carry water, make the fire, cook, and wash. To add to her misery, her stepsisters ridiculed her and then scattered peas and lentils into the ashes, and she had to spend the whole day sorting them out again. At night when she was tired there was no bed for her to sleep in, but she had to lie down next to the hearth in the ashes. Because she was always dirty with ashes and dust, they gave her the name *Cinderella*."[3] As a young woman forced to slave away for an evil stepmother and two torturous stepsisters, she can also be seen to represent ancestors of contemporary Caribbean people who were enslaved by Europeans and over whose freedom and humanity a battle of good over evil ensued for centuries. The enchanted journey that Gregory documents with Cinderella's golden slippers represents the ability of Caribbean people to transgress the borders of Europe that are now restricted to them.

Caribbean-European (Dis)Connections

The impetus for *Cinderella Tours Europe* grew out of research that the artist was conducting in Europe and her former colonies in the Caribbean for the two critically acclaimed projects *Lost Histories* (1997) and *Memory and Skin* (1998).[4] Over five months, Gregory traveled extensively in Belgium, Holland, France, Spain, Portugal, Cuba, Jamaica, Panama, Trinidad, Guyana, Surinam, and Haiti. Probing for evidence of the contemporary and colonial relationship between Europe and the Caribbean, she conducted interviews with people while collecting artifacts, recording sound, and photographing important sites of memory.

One of the paradoxes Gregory noticed about the people she met in the Caribbean was their strong connection to and affinity for Europe as a motherland, despite the fact that some were the descendants of enslaved Africans who were brought by Europeans against their will to the so-called new world to work the sugar cane, rice, and tobacco plantations. The fruits of their labors helped to build Europe while stripping the Caribbean and Africa of valuable natural and human resources. Today, many of the world's poorest nations are located in these regions, including Haiti and Sierra Leone, to name just two.

Given the effects of the transatlantic slave trade and the subsequent ravages of colonial rule, it should come as no surprise that the familial bond between Europe and the Caribbean is complicated, to say the least. On the one hand, Europe represents the evil stepmother of the Cinderella fairy tale, and on the other it represents the free, happily-ever-after lifestyle that the handsome prince offers. Many Caribbean residents were lured to mother Europe in the period following the second world war, to reach for the promise of employment, better education, and the benefits of being a part of the empire. Gregory's parents emigrated from Jamaica to England more than forty years ago, settling in Britain's Home Counties, near the city of Leeds in Yorkshire,[5] which now boasts a large

Caribbean population, mostly from Jamaica. They represent the West Indian emigrants that Caryl Phillips spoke of in his novel, *The Atlantic Sound,* who "traveled [to Europe] with the hope that both worlds might belong to them, the old and the new. They traveled in the hope that the mother country would remain true to her promise that she would protect the children of her empire."[6]

For those who stayed behind in the Caribbean, Europe still represents a mythical, far away place, a fantasyland and an unattainable dream, according to many of the people that Gregory interviewed. She asked them, "Where would you go, if you could?"[7] Many responded with the name of a European country or city: England, France, Spain, and Portugal were the popular countries, while London, Paris, Venice, and Lisbon were the favored cities. The people that Gregory spoke to were knowledgeable about Europe from the colonial ties that bound them as well as from articles in the press, grade school history classes, and their relatives who emigrated there some fifty years earlier or more recently. One person explained her dream of going to Europe, "My mother left us here and went to England in 1962; she never came home."[8] But today's residents of most Caribbean nations rarely have the means to go overseas to visit family, let alone for a vacation. Not to mention the fact that even if they did book a holiday, access is now restricted: they are required by some mother countries to have a visa. For example, the United Kingdom now requires residents of Jamaica to carry a visa.

As a first-generation Jamaican English woman, Gregory has a special understanding of the complicated relationship between Europe and the Caribbean. She still has familial ties in Jamaica and is acutely aware of how freely she can travel there with her British passport and of how difficult it is for her Jamaican relatives to visit her in the United Kingdom and elsewhere in Europe (and around the world). The artist also noted how painfully ironic it is that the people whose ancestors labored to build Europe are increasingly shut out from her borders and unacknowledged. But their fate seems to be part of a larger trend, or backlash if you will, that is born out of fears stemming from the globalization of labor, commodities, and tourism, on the one hand, and the formalization of the European Union, on the other. Indeed, it is both telling and timely that *Cinderella Tours Europe* was completed at the close of 2001, just months before the European Union introduced the Euro in February 2002, and significant discussions about the consequences of a global economy began in the major news media and in artistic and academic circles.[9]

Many scholars and artists have commented on how the borders of Europe seem to be shrinking, becoming less accessible, and how the nation-states which comprise Europe are becoming smaller and smaller.[10] In turn, identity is becoming more sharply defined both within and outside of these nation-states. For example, the overwhelming majority of people in Basque Country would prefer to be part of the European Union rather than part of Spain. As Gilane Tawadros has pointed out, "The most recent phase in the process of globalization has not dispensed with the categories of race and nation as defining identity within the public and private realms (far from it), but it adds another layer or strand to the intricate construction and experience of individual identity."[11] With globalization comes the fear of shifting populations and homogeneity. But as Tawadros continues, "the reality is that many of us now occupy the grey expanse that is inter-national, inter-racial, and inter-linguistic."[12]

Cinderella Wore Prada

The shoes that have a starring role in Gregory's *Cinderella Tours Europe* caught the artist's eye in a shop window in Panama City. Hardly the design of Prada, Manolo Blahnik, or Pedro Garcia, they are flashy, gaudy, and sexy nevertheless. An obvious allusion to wealth, the shimmering faux snake skin shoes reference the contemporary yet age-old style of many Caribbean people who proudly don showy gold jewelry and ornamentation as a status symbol.[13] This fashion stems from pre-Columbian times when gold was abundant and worn in elaborate designs as part of headdresses and clothing accessories as well as body adornment. Indeed it was this overstated opulence that attracted early European explorers such as Christopher Columbus and Sir John Hawkins, who first made it big in the Caribbean after finding vast resources of gold there in the fifteenth and sixteen centuries. The exploitation of native Indian and later imported African labor made it possible for countries like Spain, Portugal, and England to reap vast amounts of wealth, while stimulating a demand for enslaved African labor.

Gregory made three separate journeys to complete *Cinderella Tours Europe,* and these took their toll on the shoes she took as her companions. "Each time I came back, I had to re-gild the shoes. I poured glitter over them and let them dry and shook them and then took them on the next journey in the same shoe box that I brought from Panama."[14] The performative nature of the artist's process demands consideration here. Gregory's tour of Europe, involving several trips and re-gildings of the shoes, on the one hand recalls the multiple trips of the colonial explorers mentioned earlier and on the other hand suggests the impracticality of (real) golden shoes and highlights their artifice.

Yet, Gregory's golden high-heeled pumps are not ashamed to be desirable. They are sexy and self-conscious, posing and acutely aware. On the steps of the gardens of Versailles, they seem to pause, as if waiting for someone to notice them, before running off, disappearing to catch a carriage that is destined to turn into a pumpkin. Like other artists before her, Gregory is also playing on the fetish quality of women's shoes, which stand in for/allude to sexuality and genitalia.[15] In Lorna Simpson's homage to Saartjie Baartman (*Unavailable for Comment, 1993*), the ghost of the famed Hottentot Venus breaks into the Musée de l'Homme and takes back her labia, leaving behind her shoes in their place. (See Figure 35.) Simpson's black and white photograph shows a pair of suede pumps amid the remnants of a shattered glass jar that had contained Baartman's private parts.[16] In *Cinderella Tours Europe,* the golden shoes remain empty and Cinderella is effectively disembodied. The act of disembodying her allows viewers to imagine the body (part) of another in her place and tempts their desire to see themselves in her shoes. For example, in Zaanse Schans, Netherlands, Gregory's golden shoes, photographed in the extreme foreground, appear to straddle three classic Dutch windmills barely visible across the water. (See Figure 33.)

For Gregory, the golden shoes symbolized the sum total of her experience in the Caribbean, as she put it, "becoming a personification of all the relationships and conversations struck up during four months of traveling."[17] They became her muse, and with them she entered the world of make believe, embarking on a post-colonial grand tour around Europe to familiar landmarks that also were significant to the people she

got to know in the Caribbean. She took them, among other places, to the city of love and lights, Paris, and to the Olympiadstaad in Berlin, where in 1936 the black American athlete Jesse Owens won a record-breaking four gold medals.[18]

Cinderella, a Woman on the Go!

Gregory is a consummate traveler. She has set foot on nearly every continent and is aware of how deeply tourism affects the global economy. For *Cinderella Tours Europe* she traveled as a tourist herself, photographing cliché sites of memory in a style reminiscent of nineteenth-century European travelers on the Grand Tour, who brought back photographs of the exotic, the native, and the Other. Instead of pyramids, colorful markets, and grinning natives, her golden slippers are posed in front of the docks at Antwerp, the Reichstag in Berlin, and the geyser at Lake Geneva. With this strategy, she shrewdly asks the questions: What is foreign? Who is other? And from whose perspective are these attributes determined? Exercising a bit of role reversal, she took the workers/servants of the tourist economies of the Caribbean on a tour of Europe and gave them a taste of what it might be like to be photographed as a tourist in the presence of monuments, sites, and cities that have deep, albeit complicated, significance to their past. Gregory has stated that in *Cinderella Tours Europe,* "Tourism is turned on its head as the viewed becomes the viewer, and the feared are rendered harmless."[19] Thus she posed her subjects in such a way as to refer to this complicated relationship, using distance and blurring to suggest their sense of belonging or disorientation.

The artist studied post cards, street maps, and city guides to determine the best view, angle, or location from which to take each photograph. She is as calculating in her method as the people at Kodak, who designed a series of Kodak Photo Spots at Disney World and other amusement parks directing tourists to the best vantage points from which to take pictures of loved ones that are guaranteed to be flawless, perfect mementos. But Gregory uses this methodology to different design and effect. Aside from having a pair of golden shoes take center stage in the place of a person or a family group, there is often something slightly off, different, or out of place in this series of photographs.

For example, in the image of Cristo Rei taken in Lisbon, the famous towering statue of Christ is shrouded in scaffolding, only recognizable by the small head which peers out from the top. (See Figure 34.) Virtually eclipsed by the construction, the statue's block-like appearance with long, rectangular legs brings to mind a stiff robot or a small toy figure that a child might build from Lego toys. Placed in the extreme foreground, as if walking out of the left corner of the image, is the pair of golden shoes—confident, alluring, taking a stand. In fact, if one were to imagine the figure of a Caribbean woman standing in them from that point of view, she would overshadow the imposing statue of Cristo Rei, perhaps asserting her right to be there. In another photograph, also from Lisbon, the pair of golden shoes is barely visible in front of the blinding, white marble monument to Vasco de Gama on the shores of the Atlantic.[20] That monument, in the shape of a stylized ship, celebrates the achievements of the sixteenth-century explorer, which heralded Portugal's entry into the slave trade and pre-eminence as a world colonial power. During that period, a tenth of the people living in Lisbon came from Africa.

Both the Cristo Rei statue and the Vasco de Gama monument are sited so as to be in conversation with her former colonies in the new world, facing out across the Atlantic, pointing and looking westward. Together, Gregory's photographs pay homage to the African presence in Portugal while recognizing the power of Christianity as a medium of faith as well as a colonizing force.

There are a few photographs in the series in which the golden shoes are placed in front of, behind, or hanging from wrought iron fences.[21] The wrought iron brings to mind historical associations of black people with being kept out or kept in: slavery, imprisonment, and denial of entry. In Gregory's photograph of the Palace of Westminster, the golden shoes are positioned on a granite pillar between wrought iron spikes, which were placed there to keep unwanted people (and pigeons) from sitting, loitering, or sleeping. The Palace of Westminster appears as a foggy mirage in the distance across the Thames, perhaps suggesting the outsider status of Caribbean people traveling to and within the United Kingdom.

Gregory's photographs of the Alhambra in Granada and the Plaza de España in Seville are reminders that at one time North Africa conquered Spain. Al Tariq invaded Spain in the eighth century C.E., calling it Al-Andalus. The Moors remained in power, especially in the south, until about the fourteenth century, when they were forced back into North Africa. The ways in which they influenced art and culture in southern Europe can still be felt today. Gregory's golden shoes stand outside of an iron fence that encloses the garden of the Orangery at the Alhambra. Once the headquarters of the Caliph during the Arab rule of Spain, the ornate palace is the finest example of Moorish architecture in Europe. Perched on a ledge of the Plaza de España, the golden shoes seem to interrogate that monument to national pride and accomplishment. Constructed primarily out of colorful mosaic tiles, themselves a symbol of Spanish identity, it is rarely noted how their origin and design was influenced by North Africa. Both images reflect the aesthetic contributions of the Moors to Spanish art and architecture.

Rewriting, Reclaiming History

Gregory often takes children's fairy tales, such as Cinderella, or popular historical narratives and updates them with diasporic African figures, women, and others who are frequently left out of the picture. With such a gesture, she asks, why can't a Caribbean woman occupy the happily-ever-after fantasy life of Cinderella? And why can't Gregory rewrite Cinderella's fantasy to include a tour of Europe and the places that have significance for Caribbean people? This is not Gregory's first foray into rewriting popular narratives; rather, that contemporary art practice is central to her manner of working. In 1999, in a similar fashion, Gregory reinterpreted the Amberley Panels, a group of eight sixteenth-century paintings at Pallant House in Chichester, England, which depict the Amazon queens, noted historical figures, warriors, and scholars. Gregory used contemporary women from diverse economic, social, and ethnic backgrounds as her (role) models and added text in order to make the narratives of the queens relevant and accessible to today's audiences. In the resulting series of portraits, called the *Amberley Queens*, Gregory photographed contemporary women in the roles traditionally portrayed with the image of white European women. Like photographers and installation artists

Carrie Mae Weems, Renée Cox, Fred Wilson, and Terry Adkins, Gregory can be counted among a group of artists working today who regularly create works of redemptive memory as part of their aesthetic practice.

Epigraph: Caryl Phillips, *The Atlantic Sound* (New York: Alfred A. Knopf, 2000), 20–21.

1. Gregory's interest in tourism has been shared by other contemporary artists of note, including the late photographer Tseng Kwong Chi, who from 1979 until 1990 made the *Expeditionary Series* (also known as *East Meets West),* the acclaimed body of self-portraits in front of famous monuments and sites of the world, calling attention to the fleeting nature of his physical self in the face of AIDS and the seeming permanence of the monuments; the conceptual artist Ken Lum, who took the famous words spoken by Dorothy in the *Wizard of Oz* to confront the plight of immigrants and asylum seekers in Europe in the billboard project *There's No Place Like Home,* installed at the Kunsthalle in Vienna in 2000 and at the Museum Boijmans Van Beuningen in Rotterdam in 2001; and the multimedia artist Keith Piper, who followed the comings and goings of a make believe post-colonial tourist in the urban centers of Europe in 2001's *A Fictional Tourist in Europe.*

2. Brothers Grimm, *Grimm's Complete Fairy Tales* (New York: Barnes and Nobel Books, 1993), 80–86. The original Walt Disney animated version of *Cinderella* was produced in 1950 and a sequel, *Cinderella II: Dreams Come True,* appeared in 2002. Another film version was released in 1964 with a score by Rogers and Hammerstein, starring Lesley Anne Warren as Cinderella and Ginger Rogers as the Queen. It is interesting to note that in this version Cinderella has brown hair and brown eyes.

3. Brothers Grimm, 80.

4. *Lost Histories* was first exhibited at the National Gallery of South Africa in Cape Town in 1997 and later traveled to the Johannesburg Biennale in the same year. *Memory and Skin,* Gregory's first installation of photographs, sound, video, sculpture, and artifacts, has been shown widely in the United Kingdom, appearing at the Huddersfield Art Gallery (1998), the Fruit Market Gallery in Edinburgh (1998), and at the Royal Photographic Society in Bath (1999). See Joy Gregory, *Memory and Skin* (Edinburgh: Fruitmarket Gallery, 1998); *Continental Drift: Europe Approaching the Millennium* (Edinburgh: Fruitmarket Gallery and Edinburgh College of Art/Edinburgh Projects, 1998), 16–23.

5. The Leeds city center is approximately 25 minutes from Harewood House, an opulent English stately home built on 4,000 acres of rolling countryside in the late eighteenth century by the Lascelles family, who had considerable interests in sugar plantations in the Caribbean. Harewood House is one of the most popular national tourist destinations in the Midlands, where a sense of Englishness (read European-ness) and national pride are bestowed upon the visitor with little mention of its historical and contemporary ties to the Caribbean. Recent efforts supported by the Heritage Lottery Fund and implemented by scholars, activists, and cultural workers try to make connections between the intertwined histories of Harewood House and the Caribbean more integral to public history.

6. Phillips, *The Atlantic Sound,* 20–21.

7. Interview with Joy Gregory, London, 9 June 2003.

8. Joy Gregory, *Objects of Beauty* (London: Autograph, 2004), 78. This scenario was not uncommon. Many Caribbean immigrants to the United Kingdom and European nations still find it challenging to return to the Caribbean, either to pick up the lives they left behind or to bring children and relatives to join them in Europe. After postwar Europe met its needs with the new workforce it had beckoned from the Caribbean, immigration laws were tightened, foreclosing the possibility of return for many.

9. *Cinderella Tours Europe* was commissioned by the Organization of Visual Arts (OVA), London, in 2001 and first exhibited as *Cinderella Stories* at the Pitshanger Manor Gallery in London the same year. In 2003, *Cinderella Tours Europe* was exhibited at Archivo del Territoria Histórico de Álava, Vitoria-Gasteiz, Spain.

10. See, for example, the critically acclaimed exhibition and book, *Unpacking Europe,* which questioned the historical and contemporary meaning of Europe in light of the introduction of the Euro, stricter immigration policies, increasing xenophobia, and the program of globalization. Salah Hassan and Iftikhar Dadi, eds., *Unpacking Europe* (Rotterdam: Museum Boijmans Van Beuningen and NAi Publishers, 2001).

11. Ibid., 10.

12. Ibid.

13. This fashion is not exclusive to Caribbean people, rather it is highly prevalent in hip hop culture and urbanized global culture as well as in parts of Africa, such as Ghana, where gold production is still a primary economic industry. In some poorer parts of the world, including the Caribbean, many people wear imitation gold, gold plate, and hollow gold jewelry, an indication that the resources that their lands once had have been all but depleted.

14. Gregory, *Objects of Beauty,* 124–125.

15. In her extensive essay on the work of Lorna Simpson, Kellie Jones has written about the relationship between the shoe, the body, and sexuality. She has called the shoe "the ultimate fetish, the ultimate substitute for the missing sexual organ." See Kellie Jones, "(Un) Seen and Overheard: Pictures by Lorna Simpson," in *Lorna Simpson* (London: Phaidon Press, 2002), 26–103.

16. Ibid., 52–53.

17. Gregory, *Objects of Beauty.*

18. Jesse Owens was the first American in the history of Olympic Track and Field to win four gold medals in a single Olympic games. His victory also symbolized a triumph over racism at home and in Hitler's fascist Germany.

19. Gregory, *Objects of Beauty.*

20. The 25th of April Bridge, celebrating the 1974 Carnation Revolution, is in the background.

21. See, for example, *Palace of Westminster, The Orangery, The Geyser,* and *The Docks at Antwerp.*

MICHAEL D. HARRIS

16 *Mirror Sisters*

*Aunt Jemima as the Antonym/Extension
of Saartjie Bartmann*

Aunt Jemima began her public career as a spectacle in minstrelsy. She was a white
man for much of the early part of her career and the "knowledge that the black woman
was really a white man was an integral part of the pageant."[1] She began a second stage
in her career at the 1893 Columbian World's Exposition in Chicago where a black
woman portrayed and personified her. She was a product shill but she became the
prototypical mammy figure in American culture. In many ways Aunt Jemima was the
mirrored counterpart for the sexualized black woman in Europe, emblematized by
Saartjie (Sarah) Bartmann roughly eighty years earlier and characterized as a wanton
Jezebel in the United States. Both figures, one actual woman and one constructed one,
came to symbolize for many people the essential nature and characteristics of black
women. The sexualized black woman and the asexual mammy servant are mirror sisters
born from the same seed of white male patriarchy and the desire to maintain a certain
social order.

Bartmann and Jemima were imagined and imaged to help define visually those
paradigmatic qualities of black women that justified the prescribed social stratification,
which layered white men at the top followed by white women, black men, and then
black women on the bottom. Their sexuality was a threat because it defied the conven-
tions of the day, and it encouraged sexual liaisons across restricted boundaries. Looking
at some of the images of both black and white women can uncover the logic behind
them and provide insight into the context that produced them.

In "Black Bodies, White Bodies: Toward an Iconography of Female Sexuality in Late
Nineteenth-Century Art, Medicine, and Literature,"[2] Sander Gilman surmised that black
femaleness and sexuality became synonymous and "the perception of the prostitute in
the late nineteenth century thus merged with the perception of the black." He also
pointed out that the skin color which marked blacks as different from whites had been
associated with medical pathologies for centuries.[3] In the late nineteenth century syphi-
lis, a sexually transmitted scourge brought to Europe by Christopher Columbus's sail-
ors, was thought to be a form of leprosy from Africa and was associated with black
women in a conflation of primitive sexuality and the pathology of blackness.[4]

In Europe, the conceptual link of the black female to the sexually available white
woman or prostitute played out visually in art works, such as Manet's 1863 painting
Olympia. (See Figure 3.) The painting builds upon a long tradition of sexually consumable
reclining nudes in European art and reinterprets one of the first of these, *Venus of Urbino*
(1538) by Titian.[5] The black servant attending the reclining nude white woman in the

painting stands as a cipher for the discourse around the supposed characteristics of primitive women. She heightens the sexuality of the scene by her presence while also signifying warnings about the disease to be found in primitive sexuality. Notions about the sexuality of black women, as represented by Bartmann, provided the language to define the nature of prostitutes and any woman with a primitive sexuality: they were lascivious, diseased threats to white social order and morality. Hammond and Jablow, writing about Europe's confrontation with the disruptive potential of African sexuality, tell us that:

> According to the literature, sexuality is a disruptive force, one which must be either repressed or else safely channeled into inconsequential affairs, or even more safely into marriage. Marriage, of course, provides the socially sanctioned outlet. Ideally, it should be a union between members of the same class who share the same values.[6]

In the United States, the sexual primitive embodied by Bartmann was conceived as a wanton Jezebel. Manring argues that "the chief image of black women was the lustful Jezebel," and she supposedly lured white men into interracial sex. She represented the "nightmarish consequences of lascivious black women free to tempt white men" and therefore justified the legal and social strategies to contain her.[7] A number of laws and codes were devised to institutionalize slavery in the American colonies and simultaneously maintain the social order by regulating sexual conduct. John Hope Franklin details that in Virginia the statutory recognition of slavery came in 1661, and the following year "Virginia took another step toward slavery by indicating in its laws that children born in the colony would be held bond or free according to the condition of the mother."[8] This was inspired, in part, because of the complications developing in the colony as whites and blacks had children, people of mixed heritage had children with whites or others with mixed backgrounds, and people with these diverse backgrounds began to move fluidly back and forth across the color line. The laws did not prevent or punish white males in their aggressive liaisons with black women, but they helped suppress categorical escapes by mixed race children seeking to end the hardships that the experience of being black produced.

Many slave narratives speak about the sexual impositions made by white men upon black women. These sexual liaisons most often were violent abuses of power. Darlene Clark Hine writes that "virtually every known nineteenth-century female slave narrative contains a reference to, at some juncture, the ever present threat and reality of rape."[9] Melton McLaurin documents a case in Missouri where Robert Newsome purchased a female named Celia in 1850 when she was approximately fourteen years old. "On his return to Callaway County, Newsom raped Celia, and by that act at once established and defined the nature of the relationship between the master and his newly acquired slave."[10]

Former slave James Green recalled: "One slave had four chillun right after de other, with a white moster. Deir chillun was brown, but one of 'em was white as you is."[11] Another former slave, Mary Peters, told about her mother's harrowing experience:

> Mother always worked in the house; she didn't work on the farm, in Missouri. While she was alone, the [mistress's sons] came in and threw her down on the

floor and tied her down so she couldn't struggle, and one after the other used her as long as they wanted, for the whole afternoon. Mother was sick when her mistress came home. When Old Mistress wanted to know what was the matter with her, she told her what the boys had done. She whipped them, and that's the way I came to be here.[12]

It would be unfair to suggest that all the sexual liaisons between white men and women of African descent were brutal, though they did reflect the prerogatives of power. An Englishman traveled through the South in the early 1840s and detailed some of the intricacies of the sexual arrangements. He wrote of the liaisons at the *Bal de Société* in New Orleans between quadroons—women who were one-quarter black—and white men. He recalled:

> if it can be proved that she has one drop of negro blood in her veins, the laws do not permit her to contract a marriage with a white man; and as her children would be illegitimate, the men do not contract marriages with them. Such a woman being over-educated for the males of her own caste, is therefore destined from her birth to be a mistress, and great pains are lavished upon her education, not to enable her to aspire to be a wife, but to give her those attractions which a keeper requires.[13]

At these social affairs, white males went alone and if "one of them attracts the attention of an admirer, and he is desirous of forming a liaison with her," the man then makes an agreement with the mother and pays her a sum of money "in proportion to [the daughter's] merits."[14] Such arrangements had resonances of the auction block and were consummated at the instigation of the white male.

Even former president Thomas Jefferson had a long affair with Sally Hemings, a slave in his charge who was twenty-eight years his junior. Hemings and Jefferson represent the most notorious story of black-white coupling, and it may have been more similar to the New Orleans arrangements than to the violent abuse described above. During an 1873 interview Madison Hemings, son of Hemings and Jefferson, spoke of his African great-grandmother who was the mistress of the Captain Hemings, the white sea captain of an English trading vessel. She was the property of John Wayles, who refused to sell her and her child Elizabeth to Hemings. Eventually Elizabeth became Wayles's mistress after the death of his third wife and he fathered six children by her, one of whom was Sally. Wayles also was the father of Martha, Thomas Jefferson's wife. When Wayles died, Martha brought Elizabeth Hemings and her children to Monticello, where Sally encountered Jefferson. After Martha died, Jefferson is alleged to have impregnated Sally when she was around sixteen years of age in France, where she had gone in 1787 to be the body servant of Jefferson's youngest daughter Maria.[15] Sally lost that child but Jefferson later fathered four others with her back in the United States, including Madison. Annette Gordon-Reed convincingly supports Madison Hemings's claim that Jefferson induced Sally to return from Paris to Monticello with the promise that he would free all of her children when they reached the age of twenty-one, which, in fact, he did.

In this case we have an African woman who was given a child by a white man, and that daughter, Elizabeth, was given six more children by her slavemaster. One of those

children, Sally, was given four children by her slavemaster, the second president of the United States. Sally's half sister was Jefferson's wife. In Paris, Sally was the servant protector of Maria, the daughter of her half-sister, whose father would also father her children. No wonder the Jefferson-Hemings affair has generated so much interest and controversy during the past 190 years.

With this history of sexual exploitation by both the high and the obscure showing the raw exercise of power, the sexualized black woman had no place in polite society, especially as symbolized in visual expression. The renegade sexual liaisons of white males with slave women presented moral, ethical, and legal conundrums and contradictions for a social order dependent upon the exploitation of black social inferiority and the containment of sex within marriage. These conflicts were irresolvable, though well understood by all. The presence of half-caste children on a plantation or in northern cities made it obvious that much philandering was occurring. Perhaps the mammy image, grafted atop that of the Jezebel, would mask the harsh realities of interracial sexuality and provide a protected space for the white woman.

Mammy, the Asexual Cipher and Servant

> The mammy was a peculiar tool created by white supremacists to nurture young white supremacists and run white supremacist households, and allow white men access to Jezebel's household, too.[16]

After the Civil War, the raw power of white males in the South had been eroded and the mammy was constructed as a safe, emblematic black woman. She could continue to be controlled as a servant, and her demeanor was made to embody many of the stereotypical characteristics assigned to black women. This paradigmatic black woman, so as not to threaten the white woman of the house, was imagined in ways to undermine any perception of her as a sexual rival. This was done by creating an antonym to the prevailing notions of the idealized white woman of the period, and by making the mammy a menopausal, grandmotherly figure. She was large, dark skinned, usually smiling, and covered from neck to ankle with clothing. In no way did she resemble the women of mixed race who so fascinated the New Orleans dandies and the males who fathered several generations of Hemings children. She wore a scarf and an apron, both of which signified that she was a domestic worker. The black female body was reclaimed and controlled, and her enthusiastic service to the whites employing her renewed the myth of happy slaves on the plantation and assuaged white guilt about slavery. She also "revived an image of the plantation South as a symbol of white leisure, abundance, and sexual order."[17]

The mammy became a comfort to white women rather than a rival. The mammy relieved the white woman of kitchen work, watched her children as a nanny, and kept order in the house by supervising other house slaves. During slavery there were women who did these things, but usually more than one woman shared this work, and many of them were young. Not only did the mammy relieve white women of work, but she also helped create status.

In the second half of the nineteenth century the mammy, and black service to whites in general, came to be associated with wealth, leisure, and luxury. The idea of a black

servant as an indicator of luxury and status was linked to British precedents. Elizabeth O'Leary writes that new prosperity and a growing cosmopolitan outlook in the latter part of the nineteenth century "inspired many Gilded Age Americans to look to Europe for standards in manners and tastes."[18] Wealthy eighteenth-century Europeans had been especially interested in the services of African children, to the point where possessing them became a fashion, and advertisements for them being for sale in London, Liverpool, and elsewhere were printed in newspapers.[19] According to O'Leary, "As it became fashionable in the eighteenth century for aristocratic British families to own black servants, particularly houseboys, the number of Africans brought to England from the West Indies steadily increased. . . . Bought and sold at inns and coffeehouses, boys and girls were trained as house servants and groomed as domestic pets."[20] Therefore, O'Leary argues, "the portrayal of black servants in American art was built on British traditions of representing slaves as docile attendants, figures who functioned primarily to elevate the importance of white subjects."[21] By the end of the nineteenth century these notions were firmly in place in the United States, especially in the South.

Black mammies were revered in the South to the point that a movement developed after the turn of the century to establish monuments to old black mammies, and in Athens, Georgia, a Black Mammy Memorial Association was formed in 1910 to charter a Black Mammy Memorial Institute, which would train young blacks in domestic skills and "moral attitudes that were generally associated with 'old black mammy' in the south."[22] In 1923 the Daughters of the Confederacy raised money and asked Congress to set aside a site in the Capitol for the erection of a bronze monument in recognition of the black mammy.[23]

Many African American women were dark skinned, large, and worked as domestic servants. Many wore headscarves to keep dust and dirt out of their hair, but these characteristics were exaggerated or overemphasized in visualizations of the mammy figure, and they were given social and symbolic values to represent most, if not all, black women in ways useful to whites. To have seen these women at their best in church or on a special occasion would render the mammy unrecognizable because black women often wore elaborate hats and lovely dresses on such occasions. Their hair was done, make-up and perfume were probably worn (particularly in twentieth-century urban settings), and their interactions with family and friends were quite different than with white employers. When Hattie McDaniel accepted her Oscar in 1940 for playing a mammy in *Gone with the Wind,* she hardly resembled that character as she gave a thoughtful, articulate acceptance speech in an outfit suitable for the occasion.

The mammy construction persisted into the second half of the twentieth century. George Carroll in 1958 opened a memoir praising his mammy and presenting some of her stories in her "own inimitable voice" [read: dialect].

> In an effort to keep alive in the memory of all who claim the South as home, this essay is dedicated to that greatest of home institutions throughout the South; the old black Mammy. . . .
>
> Mammy was an institution on the farm or in plantation homes throughout the southern part of the United States. She occupied a position in the family that was peculiarly her own, disputed by no one and shared by none. In this position, recognized and respected by all, she reigned supreme.[24]

It is possible that the love of the mammy stated so emphatically by Carroll was also nostalgia, but one for the carefree period of childhood when this surrogate mother/grandmother figure cared for him and bestowed an overarching humanity upon white children. It must be nostalgia for a time of black servitude, mythologized as willing and enthusiastic devotion to white needs. Carroll wrote that her "loyalty to her 'white folks' was a thing of beauty. She never spoke disparagingly nor would she permit any one to 'knock' any member of her 'family'" at any time. She considered the whites her family but was quite content to live in a cabin behind their big house.[25] Such fantasy of black devotion was strangely similar to what might be described of a pet, but it is not replicated in African American expression, as the texts of black minstrel songs, poetry, and literature confirm. One former slave recalled the true feelings behind the mask of devotion whites perceived.

> When the white folks would die, the slaves would all stand around and 'tend like they was crying, but after they would get outside, they would say, "They going to hell like a damn barrel full of nails."[26]

The headscarf worn by the typical mammy may have been the ultimate denouement of African American ethnicity in the contrived caricature. Hair has been a significant item of concern and beautification for African and African American women for centuries, and the scarf negated any beauty potential to be found in an elaborate coiffure and its decoration with beads or thread. Also, black women shared beauty rites in grooming each other's hair. The headscarf/bandanna literally covered up these potentials and soon became a demeaning sign of racial and social status.

Hairstyles can be a means for women to express their individuality and assert their location within a social class. Hair itself was associated with meaning and metaphysical potentials. Black folklore suggests that hair can carry a person's essence. Hair cut from men in barbershops was to be swept up and burned so no one could pick up a sample and work roots on the man. One admonition women might hear would be not to let hair cuttings get out of one's control because a bird finding it and making a nest using a woman's hair might cause madness.

Judith Wilson argues that, along with "a preference for *abundance,* . . . both African and African American hairstyles frequently exhibit a high degree of *artifice.*"[27] Wilson also indicates that the curly texture of many black women's hair required strategies to manage and maintain it, and in the New World—separated from the resources and practices which had developed in African settings—new methods and materials were devised by women for their hair care. Madam C. J. Walker developed a new method of relaxing and promoting healthier hair and then formed a company to sell hair care products to African American women. Walker invented the hotcombing method in 1905 and, subsequently, a formula for hair pomade, thereby creating the essentials of the "Walker method" of hair care.[28] The rapid growth of Walker's company during its first decade of operation into one selling products across the United States and in the Caribbean and Panama indicates the attention black women gave to their hair at this time.

The headscarf worn by Aunt Jemima, the paradigmatic mammy/servant, and seen in so many mammy images, suppressed her individuality and effectively separated her

from the African American ethnic discourse about hair. Instead, it located her within the derogatory racial discourse that objectified her. How many women represent themselves publicly or in photos by wearing the clothing or the hair treatment they use when cleaning house?

Stereotypes clearly affected the self-perceptions of African Americans in complicated and persistent ways and represented threats to their dignity. Hair and treatment of the head with hats or scarves signified a variety of meanings or social codes. The representation of black women as mammies wearing bandannas tied up and contained the whole cultural discourse about hair within a stereotypical image. Aunt Jemima was the most well known and stereotypical incarnation of the mammy, but who was she? From where did she come?

Reflection Upon the Mirror Sister: Aunt Jemima

The idea for Aunt Jemima as a living product trademark emerged from the visit to a minstrel show in St. Joseph, Missouri, in the fall of 1889, by Chris L. Rutt, one of the owners of the Pearl Milling Company, developers of the ready-mix pancake flour.[29] He saw a renowned performance of a cakewalk to the song "Old Aunt Jemima" written by Billy Kersands, a black blackface minstrel who was one of the most prominent performers of his day.[30] Many white minstrels performed the popular song and modified the lyrics, and the performer Rutt saw was in blackface and in drag. He wore an apron and a bandanna around his head pretending to be a black woman cook.[31] According to Arthur Marquette's history of the Quaker Oats company (present owners of the Aunt Jemima brand name), "Here was the image Rutt sought! Here was southern hospitality personified."[32]

Kersands, the song's author, was born in New York in 1842. He improvised upon the song during his many performances and one set of lyrics suggests the song to be a slave lament.

> My old missus promise me
> Old Aunt Jemima, oh, oh, oh
>
> When she died she'd set me free
> Old Aunt Jemima, oh, oh, oh
>
> She lived so long her head got bald
> Old Aunt Jemima, oh, oh, oh
>
> She swore she would not die at all
> Old Aunt Jemima, oh, oh, oh[33]

The lyrics of "Old Aunt Jemima" reveal a glimpse of the real desire for self-control and freedom behind the mammy mask. Robert Toll speculates that the song's "lack of even a face-saving comic 'victory' for the black character" and its protest message differ from the black tradition in minstrelsy, which most often used "symbolic indirection" and some sort of victory, however small, for the black characters.[34] In minstrel

performance, blacks frequently expressed their resistance to and displeasure with the social order, often with allusion or coded references that white audiences usually missed. Toll writes that black culture sensitized people "to hear and enjoy . . . surreptitious barbs, while most whites might not even notice them."[35] Direct protest and confrontation by blacks was not common and could be dangerous to the protester.

The fact that the song was popular with black audiences suggests that something else may have been going on in this particular case; the displeasure with the social order may have been layered within the song. Stuckey confirms this by revealing a slave song that apparently was the source for the minstrel version.

> My ole missus promise me
> W'en she died, sh'd set me free,
> She lived so long dat 'er head got bal'
> An' she give out'n de notion a-dying' at all.[36]

The fact that *Old Aunt Jemima* was performed to a cakewalk complicates things while providing the key for decoding the performance. The cakewalk was a dance devised by African Americans to spoof the formal promenades of whites through exaggerated gestures. The dance and the lyrics suggest that Kersands had modified the song and layered it with messages that did provide a small victory for blacks. It seems that there was a level of signifying going on spoofing white folks' ways. The old "missus" was so mean, so committed to keeping black folks in captivity, that she would not die, even after her *hair* fell out! Hair is a woman's crown, the source of great energy and vanity, and this woman kept on despite losing it. Also, whites consistently broke their promises to blacks. These lyrics floated atop the signifying dance—the cakewalk. A black audience would get it. Beneath the physical and cultural transvestitism that Rutt saw as authentic was the kernel of African American authenticity and sentiment that he did not see.

Another minstrel song, "Jemima Susianna Lee" by George L. Rousseau, presents a younger Jemima who is desirable and has interracial coupling in her lineage.

> Twas on de ribber, o de old Tennessee
> Dat I first met Jemima Susianna Lee
> Black eyed yeller gal, lubly as de moon
> Golly I did lub her, dat same Octaroon
>
> (*chorus*)
> Oh Jemima Susianna Lee
> Sweet as de sugar cane
> Busy as de bee
> Lublier dan any on the Mississip to see
> de Rappaban, de Potomac, or de Tennessee . . .
>
> One night in her cabin on de ribber side
> I asked de lubly Jemima would she be my bride
> Dat she would, case she lub'd no oder
> So I took de yeller belle and happy we libed togedder[37]

This Jemima was young enough to be a bride, a "yellow" skinned octaroon, and was not called Aunt as were many older black women. This Jemima would not serve the purposes of the mammy Jemima.

Where did the name Jemima come from? It could have roots in African languages because it is not a common English name. From the Yoruba language we can find the name *Jémílá* from an Ijebu song about the complaint of a man who paid a dowry to Jémílá's parents only to be denied her hand anyway. There also is the name *Yémàmá*, a term used to address one's maternal grandmother. There are Wolof words such as *gĕmma* (to close one's eyes), *gĕmmi* (to open one's eyes), *jamma* (peace), *jĕmma* (prestige, presence, appearance), and the name *Maama*.[38] While these and likely other names or terms from West African languages hold some promise, it seems most probable that the name comes from an obscure bible verse naming the daughters of Job after his restoration by God.

The restoration of Job after his long travails is described in Job 42:12–14:

> 12 So the LORD blessed the latter end of Job more than his beginning: for he had fourteen thousand sheep, and six thousand camels, and a thousand yoke of oxen, and a thousand she asses.
> 13 He had also seven sons and three daughters.
> 14 And he called the name of the first, Jemima; and the name of the second, Kezia; and the name of the third, Kerenhappuch.

Jemima, a variant spelling of Yemima, is a name possibly related to an Arabic term meaning "dove." According to the Targum (an ancient translation of Hebrew scripture into Aramaic that often included commentary), "Job named his daughters in accordance with their attractiveness: Jemimah means 'day,' for her beauty shone forth like the sunlight. . . ."[39] Because slaves often identified with the plight of biblical Hebrews enslaved in Egypt, and many folk learned to read by studying the bible (notably Frederick Douglass), it is possible that the name Jemima came to someone's attention and it was bestowed upon a daughter. It also is possible that the Hebrew "Jemima" sonically resembled certain African language forms enough to be comfortable to some slaves.[40] Unfortunately, whatever the origins of the name Jemima and the protest sentiments at the root of the original song, its ubiquitous presence in association with the pancake mammy has suppressed its usage in African American communities in the twentieth century.

In 1889, when Rutt was searching for a symbol for his self-rising pancake flour, whites intimately identified black cooks with southern cooking. Undercapitalized, Rutt and his partner, Charles Underwood, sold the company to R. T. Davis in 1890. After Davis purchased the company, he initiated a search for a black woman to embody his perception of Aunt Jemima as "a Negro woman who might exemplify southern hospitality."[41] That woman, Nancy Green, was found working as a domestic for a Judge Walker in Chicago, and she was hired to personify Aunt Jemima. Subsequently a mythical plantation past was invented for the character, a narrative showing her loyalty to the South and to her master, and Green traveled the United States promoting the product as the fictional character.

Green was a former slave born in Kentucky in 1834. She made her first appearance as Aunt Jemima in 1893 at the World's Columbian Exposition in Chicago. Green worked

in front of a flour barrel that was 24 feet high, 16 feet in diameter, and had an interior fitted as a reception parlor to entertain visitors. There, as Aunt Jemima, she "sang songs, and told stories of the Old South while greeting fair visitors." She also cooked thousands of pancakes.[42] The important shift that was taking place was that the comic spoof of blacks in minstrelsy, where a white male masqueraded as a black woman, was giving way to a supposedly authentic black slave woman endorsing a product. Manring indicates that "Aunt Jemima's largest and most important audience would be white women, and her claim to be an authentic black woman—not a white actor—would be the key to her success."[43]

As Aunt Jemima, Green masqueraded as a former slave with a love for the old South and devotion to the whites she served. As a human trademark, she became an advertising icon and the latest twist in the complex history of blacks and commerce in the Americas: from advertisements announcing the arrival of slave ships, to ads for runaway slaves, to an entertainment industry of minstrel performance based upon the appropriated representation of black culture, to product icons. That black women worked as cooks and domestics is unquestioned, but it is unlikely that many of them enjoyed the fact that such jobs were the primary employment/career alternatives for themselves and their daughters.

Ironically Marquette claims that Nancy Green's demonstrations in grocery stores "taught an entire generation of housewives that some forms of cooking could be simple and made them clamor for others," and this started the "procession toward ready-mixes and other prepared food products" ushering in the era of convenience foods.[44] The woman who supposedly cooked to relieve a white woman of the responsibility was the brand logo for the first product to make cooking easier for those who did their own cooking.

Green's appearance at the fair firmly established Aunt Jemima in the public mind. People gathered at her display for pancakes, folklore, and conversation in a script drawn in part from the minstrel song, memories of her own plantation days, and her imagination. Purd Wright, the original advertising manager for Aunt Jemima products, devised a souvenir lapel button to pass out to the visitors jamming the aisles. It showed a likeness of her and the caption "I'se in town, honey." According to Marquette:

> Her audience took up the phrase and it became the catchline of the Fair. Special police had to be recruited to monitor the exhibit. Davis claimed later that more than 50,000 orders for his pancake flour were placed at the fair by merchants from all over the world.[45]

Soon thereafter, Davis and Wright published a souvenir booklet, *The Life of Aunt Jemima, the Most Famous Colored Woman in the World*. The company prepared a narrative about her plantation life in the Old South along with factual material about her triumph at the Fair—she was named Pancake Queen—and the medals and certificates she received.[46] Among the plantation myths wrapped around Aunt Jemima was one showing her devotion to her plantation "employer," Colonel Higbee. When the Union Army arrived at his plantation on the banks of the Mississippi, they were about to tear Higbee's mustache out by the roots when Aunt Jemima saved him by offering the troops her pancakes, and in their excitement the Colonel was able to escape. A more important

myth was that Aunt Jemima shared her secret recipe with her beloved white family and now they were making it available to everyone.

The legendary mammy provided "impeccable service, loyalty, cheerfulness, and asexuality" which "combined, in white minds, to bolster white planter values, just as Jezebel's wantonness excused miscegenation."[47] Aunt Jemima was the appropriate black servant for the new urban era emerging in the United States with improved rail transportation and the growth of industrial practices in food production and delivery. She symbolically provided the luxury of plantation wealth to average households. Yet she also served as a sexual cipher carrying a subtle message into millions of homes.

One of the more successful marketing ploys promoting Aunt Jemima Pancake Mix was used in 1905 when customers could send in a boxtop from a carton and twenty-five cents to receive an Aunt Jemima rag doll. This expanded upon an 1895 stunt of printing cutout paper dolls of Aunt Jemima on the new packaging cartons that were replacing the old one-pound sacks of mix. The rag doll offer was so successful that it was claimed that "almost every city child owned one." Eventually a whole family was created including Uncle Mose and two "moppets," Diana and Wade.[48]

By 1918, after Quaker Oats had acquired the Aunt Jemima product, an advertising series describing the legend of Aunt Jemima began to appear, starting in the October issue of *Ladies Home Journal,* with images drawn by N. C. Wyeth.[49] This same ad estimated that more than 120 million Aunt Jemima breakfasts were served annually. Marquette tells of other promotions that distributed the name and myth of Aunt Jemima as widely as possible.

> Latter-day promotions have distributed four million sets of Aunt Jemima–Uncle Mose salt and pepper shakers in polystyrene, and 200,000 dolls in vinyl plastic. A cookie-jar premium shaped like Aunt Jemima sold 150,000. Another premium sought by more than a million housewives was a plastic syrup pitcher.[50]

Aunt Jemima, as the exemplar mammy, became ubiquitous in American culture and carried with her a message, a valuation, about the nature and characteristics of black women. Like Bartmann, she entered public life as a spectacle, a popular curiosity, and she served as a text for the delivery of certain sexual politics and definitions. Her own thoughts were no more important to those who placed her on display than were those of Bartmann. Both figures continued in service posthumously. Bartmann's genitalia remained on display until the 1980s in the Musée de l'Homme in Paris, and Aunt Jemima pancake products continue to populate grocery stores in the United States long after Nancy Green's death in 1923, long after the death of minstrelsy where her name first found an audience, and long after the first two companies to use her as a product icon disappeared by folding or through acquisition by a subsequent corporate owner.

The Signified Respond: Oxidizing the Quicksilver

In 1932 Paul Edwards published *The Southern Urban Negro as a Consumer* and polled consumers in major southern cities about various topics and products. He found that African Americans strongly disliked Aunt Jemima for all the things that the advertiser

emphasized to link her to slavery.[51] Eventually the NAACP mounted attacks upon the image associated with the product, and during an eleven-year span from 1963 to 1974 at least five important African American artists created works seeking to undermine Aunt Jemima. Jeff Donaldson (1963), Joe Overstreet (1964), Murry DePillars (1968), Betye Saar (1972), and Jon Lockart (1974) turned Aunt Jemima around. Overstreet and Saar gave her automatic weapons, and all of them made her a black militant. Donaldson, working in Chicago, imagined Jemima in a physical struggle with white male authority in the form of a policeman in his work *Aunt Jemima and the Pillsbury Doughboy.*

Donaldson was in Chicago watching the March on Washington and Martin Luther King, Jr.'s famous speech on television but he felt disappointed that King gave no marching orders; he gave no charge to African Americans for specific actions after the March. In addition, Donaldson was not enamored with nonviolent tactics. So a year before the first Watts uprising in Los Angeles he visually predicted that the struggle for rights would move to the streets with the "minions" of the black community in confrontation with the representatives of white oppression: the police. Moreover, what figure embodied the everyday working people of the community more than Aunt Jemima did?[52] The sixties were a time when African American artists began to represent themselves visually in aggressive ways that challenged misrepresentations or invisibility. Donaldson stated that the "one word that is seldom used to describe our struggles in those days is heroism. We talk about peaceful marches and stuff, but that was also supported by some very, very heroic actions. And only that made sense to a militant state such as ours."[53]

Donaldson took the American flag and abstracted the stripes into a chevron pattern that might seem at first as though the flag is furled in the wind. This rhythmic pattern would become quite prominent in the art of Africobra, the important artists' group that Donaldson helped found in 1968, and has antecedents in Kuba cloth and other African decorative traditions. Interestingly, the two combatants are product icons, a fact alluding to the economic concerns at the root of a great deal of race conflict, and signifying the complicity of corporations in slavery and black oppression.[54] Also, many of the most well known mythical black characters in the twentieth century—like Aunt Jemima, Uncle Ben (1940), the Gold Dust Twins (who appeared at the 1904 World's Fair in St. Louis), and Rastus (1890)—were put forth to the public as product trademarks to produce white wealth. The policeman as a corporate front man suggested that the struggle in the street would be between the working folk and the agents of corporate interests.

Donaldson's Aunt Jemima is a large, powerful woman, but her size suggests strength and vigor; she is not overweight or elderly. (Nancy Green was 59 when she appeared at the Chicago Fair.) Her apron and scarf locate her in the working world of domestic or food service, but she has been humanized and cannot be beaten back into myth and fantasy. Here it is the policeman who is faceless, frozen in anonymity. Donaldson's Aunt Jemima is no smiling servant. She was the first wave of the resistance and protests to come.

One of the most notable images of the black woman as sexual primitive in the twentieth century was that of Josephine Baker who, in the late 1920s in Paris, opened her career as a modern sexual spectacle inciting a voyeurism and fascination not unlike that surrounding Bartmann. Andrea Barnwell, in an essay emphasizing Baker's agency

and transformation, opens with a description of her acting out the ultimate colonial fantasy in her most notorious stage role:

> Fatou, a native girl, bare-breasted and clad in a skirt of rubber bananas, slithers down the limb of a jungle tree and encounters a white explorer who lies asleep and dreaming under his mosquito net. Scantily dressed black men provide the ambience for this setting by singing softly and beating drums. As Fatou shimmies, the bananas jiggle, as if imitating the erect phallus of the explorer, who is awoken by her call to the wild.[55]

Baker in time was able to reclaim control of her image and escape the cage of primitivist fantasy, but she rose to stardom on the strength of the sexual fantasies she manipulated. The "call" of the pristine wild state of humankind that awakens the explorer in this scene was a part of the lure of Tahiti to an artist like Paul Gauguin. The black men residing in the margins as "ambience" also symbolize the dominance of the white explorer who has access to the native woman while the native men provide the theme music rather than protective resistance, which is itself a patriarchal assumption. The explorer has sexual prerogatives for any woman he chooses and the power to subvert any challenges that might arise when his desires are transgressive. Baker as Fatou enables and makes visual this fantasy of potency and liberated libido.

More than a century after Bartmann's death, the sexual tension and fantasy surrounding the primitivized black woman pervaded France and reappeared as strong as ever, evoked by Baker's appearance on stage in Paris. Just over sixty years later, Lorna Simpson felt compelled to dispel this same sexual mythology about black women through her art. The repulsion/fascination, the push/pull of the black woman for the white male persisted and repeatedly surfaced in different guises or incarnations.

In the 1970s and 1980s African American women artists began to challenge sexist assumptions in their work, and a brilliant work by Simpson inverted the implications of Edouard Manet's *Olympia* and used them as their own critique. Simpson has conflated the black maid and the reclining white prostitute in her 1988 work, *You're Fine,* but she has done so to liberate both from the sexist, primitivist critique. This work challenges the male gaze and its gendered assumptions from the perspective of the black woman who has been objectified through a focus upon her physicality and sexual potential. (See Figure 16.) By turning the subject's back to the viewer and covering her with a gown, Simpson has resisted the accessibility associated with the reclining nudes of the past. Gone is the returned gaze, openly available body, and any hint of dominated compliance. Simpson's work confronts the viewer with an active female subjectivity that subverts male control.

The anonymous woman in this work becomes a signifier for women, especially black women, rather than an individual personality. The text around the image suggests that she is being assessed for her female physicality rather than for her skills or internal qualities. On the right is the text, "Secretarial Position," which indicates that the examination is for a clerical job, but also implied is the sexual harassment that often came with such jobs—the *position* is lying down. This emphasis upon the body echoes the slave auction block and the humiliating physical examinations Africans endured there. The sexual implication of the work is heightened by the woman's pose, replicating all

the reclining, sexually available women found in art over the centuries. However, the fragmentation of the image into panels begins to deconstruct the sexual iconography, and the vertical parts of the frame form a barrier, disrupting the image while separating it from the viewer.

By having a black woman at the center of this work, Simpson has directly addressed the issues around *Olympia* (as well as the sexual objectification of black women by black men), and she has given the woman a voice—it is Simpson's voice, the sign for her subversive intentions. The objectified black woman here expresses her disdain for the male viewer/voyeur through this image. No longer will she be compliant or complicit in such display.

Donaldson and other male artists have stood in defense of objectified black women, but there is a masculinist quality to their responses. Perhaps the futility and fatality of such defenses in the antebellum period (continuing through the era of segregation) demanded that African American men step forward as an act of self-empowerment; the heroism of defending one's wife/mother/daughters contributes to a feeling of manhood. The physical aggression to be found in Donaldson's painting of Aunt Jemima is a masculine strategy, whereas Simpson's feminist approach depends more upon subtlety, irony, and signification. She is signifying in the African American tradition rather than in that of postmodernist critical theory with its *signifier* + *signified* = *sign* formula. Taken together, Donaldson and Simpson represent a collective resistance to the impositions of male power which the mammy and primitivized black woman were constructed to facilitate. These mirror sisters were aspects of related objectives and reflections of something outside of the real women they were assumed to represent.

Perhaps it is an oversimplification to suggest that the sexuality at the root of Bartmann's mistreatment and public spectacle is behind the spectacle of the mammy servant, Aunt Jemima. However, the history of sexual exploitation of black women by white males in the antebellum period, combined with the fact that the ownership of slaves reflected and generated wealth, makes the construction of the mammy explainable. Unlike European nations, the United States had within its borders a large black population in need of social containment, yet the barriers around them needed to be permeable enough to allow white males to pass in and out of the contained social space without penalty. Miscegenation was rampant before the Civil War, and the children of those liaisons threatened a social and economic order dependent upon a clear separation of blacks and whites into groupings with distinct, identifiable differences.

Aunt Jemima also served the purpose of symbolically reclaiming control of the black female body that had been freed from the absolute control of slavery, and she helped to re-establish the categorical difference between whites and blacks. Bartmann personified sexual excess and its disruptive potential and she became the conceptual foundation of the Jezebel. The Aunt Jemima of advertising turned attention away from black sexuality by her construction, but she provided other satisfactions. As Manring argues, "Her blackness still reminds white consumers that they are white, and that whiteness is a good thing."[56] She accented white femininity by her conceptual and physical opposition to it. They, too, were mirror sisters, inverted images of each other fathered by the same patriarchal phenomenon. Bartmann was the moral and sexual antonym to paradigmatic white womanhood, and Aunt Jemima was its physical and social antonym.

Bartmann explained black sexuality scientifically because her sexual parts were seen as physically different from those of white women. Aunt Jemima (and the mammy generally) was the dénouement of that sexuality, its containment and exploitation through service. In actuality, the perceptions of Bartmann were evidence of her invisibility, the blindness induced by hallucinations of the primitive. Her humanity disappeared behind the stereotyping. Jemima was evidence of myopia, a blurred vision providing only a shadowy recognition of misperceived African American women. She was a reflection more than a real person.

Both images, in the end, are mirror reflections of the consciousness of whites more than they are black women. They personify some of the perceptions, desires, fantasies, and fascination white males had about black women. Bartmann's mistreatment reflects the moral character of men with a certain consciousness toward Africans. Aunt Jemima reflects the denial of the sexual abuse and exploitation of black women. These are the daughters of white imagination, inspired by real women perhaps, but as perceived they are not real women. They live in quicksilver.

Aunt Jemima and Sartjie Bartmann are reflections and the personifications of concepts, notions that persisted well into the twentieth century. The imagery has been so powerful, the concepts so influential, that artists still seek to darken the quicksilver, to oxidize it with the oxygen of their own understanding. They have tried to bring attention to the mirror and to the reflection to undermine the perception of the image and turn our attention to the source. Then we might see the transvestitism. The mirror sisters are white male fantasies in drag.

1. M. M. Manring, *Slave in a Box: The Strange Career of Aunt Jemima* (Charlottesville: University of Virginia Press, 1998), 70.

2. Sander L. Gilman, "Black Bodies, White Bodies: Toward an Iconography of Female Sexuality in Late Nineteenth-Century Art, Medicine, and Literature," in Henry Louis Gates Jr. and Kwame Anthony Appiah, eds., *"Race," Writing, and Difference* (Chicago: University of Chicago Press, 1986).

3. Ibid., 248–250.

4. Ibid., 250.

5. Among the classics in the lineage of reclining female nudes with sexual implications are Titian's *Venus of Urbino* (1538), Ingres's *Grand Odalisque* (1815), Manet's *Olympia* (1863), and Gauguin's *Spirit of the Dead Watching* (1892). In 1907 Picasso's *Les Demoiselles D'Avignon* merged the black sexual primitive with the prostitute in one body by the use of African masks as faces on two of the women.

6. Dorothy Hammond and Alta Jablow, *The Africa that Never Was: Four Centuries of British Writing about Africa* (New York: Twayne Publishers, Inc., 1970), 154.

7. Manring, 20–21.

8. John Hope Franklin, *From Slavery to Freedom: A History of African Americans,* 7th ed. (New York: Alfred A. Knopf, 1994), 56–58.

9. Darlene Clark Hine, "Rape and the Inner Lives of Black Women in the Middle West," *Signs* 14 (Summer 1989), 912. Cited in Melton A. McLaurin, *Celia, A Slave* (New York: Avon Books, 1991), 24.

10. McLaurin, 24.

11. James Mellon, ed., *Bullwhip Days: The Slaves Remember, An Oral History* (New York: Avon Books, 1990 [1988]), 296. Mellon has edited a number of interviews conducted between 1934 and 1941 by interviewers from the Federal Writers' Project, an adjunct of the Works Progress Administration.

12. Mellon, 297.

13. G. W. Featherstonhaugh, *Excursion through the Slave States* (London: John Murray, 1844), 267–268.

14. Ibid., 268.

15. Hemings was in France from 1787 to 1789. See Annette Gordon-Reed, *Thomas Jefferson and Sally Hemings: An American Controversy* (Charlottesville: University of Virginia Press, 1997), 23.

16. Manring, 43.

17. Ibid., 11.

18. Elizabeth O'Leary, *At Beck and Call: The Representations of Domestic Servants in Nineteenth-Century American Painting* (Washington, DC: Smithsonian Institution Press, 1996), 5.

19. Jan Pieterse, *White on Black: Images of Africa in Western Popular Culture* (New Haven, CT: Yale University Press, 1992), 126.

20. O'Leary, 18.

21. Ibid., 34.

22. June O. Patton, "Moonlight and Magnolias in Southern Education: The Black Mammy Memorial Institute," *Journal of Negro History* 65 (Spring 1980), 150. Cited in Marilyn Kern-Foxworth, *Aunt Jemima, Uncle Ben, and Rastus: Blacks in Advertising, Yesterday, Today, and Tomorrow* (Westport, CT: Greenwood Press, 1994), 89.

23. Kenneth W. Goings, *Mammy and Uncle Mose: Black Collectibles and American Stereotyping* (Bloomington: Indiana University Press, 1994), 64.

24. George F. Carroll, *Mammy and Her Chillun* (New York: Comet Press Books, 1958), 1.

25. Carroll, 4.

26. Anonymous narrative. Mellon, 301.

27. Judith Wilson, "Beauty Rites: Towards an Anatomy of Culture in African American Women's Art," *The International Review of African American Art,* Vol. 11, No. 3 (1994): 13.

28. Wilson, 14–15.

29. For extensive documentation on Aunt Jemima, see Goings; Kern-Foxworth; Manring; Arthur F. Marquette, *Brands, Trademarks and Good Will: The Story of the Quaker Oats Company* (New York: McGraw-Hill, 1967); and Diane Roberts, *The Myth of Aunt Jemima: Representations of Race and Region* (London: Routledge, 1994).

30. "The show stopper of the Baker & Farrell act was a jazzy, rhythmic New Orleans style cakewalk to a tune called 'Aunt Jemima' which Baker performed in the apron and red-bandanna headband of the traditional southern cook." Marquette, 143. This account differs slightly from Kern-Foxworth's detailed account which lists the black minstrel, Billy Kersands, as the performer. Black minstrel performance was a black renovation of white performance caricaturing black performance. It was not, on its face, black performance.

31. Manring, 61.

32. Marquette, 143.

33. "Old Aunt Jemima," 1875. Kern-Foxworth writes that "By 1877 Kersands had performed the song more than 3,000 times and had developed three different improvisational texts for his audiences." Kern-Foxworth, 64–65.

34. Robert C. Toll, *Blacking Up: The Minstrel Show in Nineteenth-Century America* (New York: Oxford University Press, 1974), 260.

35. Ibid., 246.

36. Sterling Stuckey, "Through the Prism of Folklore," *Massachusetts Review* (1968), 424. Cited from Manring, 70.

37. Geo. L. Rousseau, "Jemima Susianna Lee" (Saint Paul: John A. Weide, 1876).

38. David P. Gamble, *Gambian Wolof–English Dictionary* (Brisbane, CA, 1991), 58, 74, 78, 100. Wyatt MacGaffey indicates that KiKongo does not yield standard names but names are compound words expressing a specific meaning.

39. *The Stone Edition Tanach* (Mesorah Publication, 1996), 1678, footnote 42. Thanks to Jewish scholar and historian Rabbi Sholomo Levy for providing this reference.

40. The bible proved to be a prominent resource for the names of slaves. Beyond the commonly used David, John, Joseph, and Mary, one can find a variety of less common biblical names including: Amos, Beulah, Ebeneezer (Ebenezer), Elijah, Enoch, Enos, Ephraim, Gabriel, Gamaliel, Hezekiah, Israel, Isaac, Jeremiah, Josiah, Nehemiah, Solomon, and one Job Ben Solomon. See John Blassingame, ed., *Slave Testimony: Two Centuries of Letters, Speeches, Interviews, and Autobiographies* (Baton Rouge: Louisiana State University Press, 1977).

41. Marquette, 144.

42. Kern-Foxworth, 63–67.

43. Manring, 71–75

44. Marquette, 147–148.

45. Ibid., 146.

46. Ibid., 146–147.

47. Manring, 54.

48. Marquette, 148. Kern-Foxworth claims only five cents was required to redeem the doll with a boxtop. Kern-Foxworth, 73.

49. Kern-Foxworth, 72–76.

50. Marquette, 148–149.

51. Paul K. Edwards, *The Southern Urban Negro as a Consumer* (New York, 1932), 228–229, 234. Cited in Manring, 155–157.

52. Jeff Donaldson, telephone conversation, December 17, 1997.

53. Moyo Okediji, interview with Jeff Donaldson, January 7, 1999.

54. It should be remembered that the Atlantic slave trade was run by large corporations. John Hope Franklin writes: "At a time when the other countries were granting monopolies to powerful government-supported trading companies, Portugal elected to leave her trade in the hands of merchants who proved ineffective matches for their competitors from other countries. Not until 1692 did Portugal license the Portuguese Company of Cacheo. By that time several strong companies from other countries had so monopolized the slave trade. . . ." Franklin, 33. John Thornton concurs by writing, "In the case of the northern Europeans after 1600, the state's role was vested in the hands of parastatal chartered companies, such as the Dutch West India Company, the English Royal Africa Company, or the French Senegal Company, which made their own arrangements with private traders." John Thornton, *Africa and Africans in the Making of the Atlantic World, 1400–1680* (Cambridge: Cambridge University Press, 1992), 55. The Spanish were excluded from Africa by the papal arbitration of 1493 but were granted rights to carry slaves to her colonies by the system of *asientos*.

55. Andrea Barnwell, "Like the Gypsy's Daughter, or Beyond the Potency of Josephine Baker's Eroticism," *Rhapsodies in Black: Art of the Harlem Renaissance* (Berkeley: University of California Press, London: Hayward Gallery, 1997), 84.

56. Manring, 178.

17 My Wife as Venus

Those feet of yours—
pint-sized,
no bigger
than bees,
how
they
eat up
the shoe leather!
 —Pablo Neruda, "You Flame-Foot"

Shortly after my daughter Jasmine-Simone was born at George Washington University Medical Hospital, I had an interesting conversation with my wife Denise. I recall her holding our first-born child against her chest and mentioning how beautiful she was and how blessed we were. My wife, still beaming, then said, "And she has all her toes." In many ways this remark told me how deeply my wife had been affected by the shape of her feet. My wife was born with stunted toes on both feet. A very small "fourth" toe created a significant "deformity" which is obvious to anyone who looks at her feet.

What attracts a man to a woman the first time they meet? How do you know you have met your wife? Your Venus? One of my mother's favorite expressions is, "God works in mysterious ways." My father, when he was alive, always spoke about how there was always someone out there for everyone. One just had to look. . . .

Denise claims she knew immediately I would become her husband.

We were sitting in my office at Howard University and she was a woman with a poem. If she were an actress maybe this would have been an audition. A chance to stand before someone and try to make an impression. The job interview, the first date, the stepping into a restaurant or bar in a new neighborhood. These are all trips of exploration, a journey into the unknown. It is here where we meet the "other," the person behind a counter or desk.

We try to make a good first impression, maybe we pose, holding our head or hands a certain way. We gesture and laugh. We relax and try to put an end to the staring.

So what if it were the Venus Hottentot in front of me instead of Denise?

When my wife was born in Des Moines, Iowa, in 1950, her parents already had two girls. Doctors informed them that an operation on their new daughter's feet could correct how they looked. Unfortunately, my wife's parents could not afford the cost of

an operation. They were also told by doctors that the physical shape of their daughter's feet would not affect her ability to walk. Maybe no one at that time considered the psychological hurdles my wife would have to overcome. The teasing and staring which is often a part of childhood and growing up.

When a man loves a woman he embraces her past and promises her a future. In our society couples like to look good when they are out. Many times things are hidden from public view, or we try to hide them. The issue of the twenty-first century is the issue of privacy.

What a person's toes look like is a private matter. Or is it? What is the border separating the private from the public? A pair of shoes?

How has my relationship with my wife been affected by her toes? Do I look at them when we undress? Do I make a conscious attempt not to notice? Was I worried about my daughter's feet before my wife made her comment?

As a poet I try to look beyond the physical. I rely on metaphors, a different way to see things. So an image of a woman opens a door to an idea or feeling, an emotion with color. In my poems I have written about women's breasts, legs, eyes, and hands. Why the absence of feet? It was Langston Hughes in one of his Simple stories who wrote about the history of black feet. Feet as witness. What about my wife's feet? What have they witnessed?

We imagine what we love. Our eyes shape the physical. Things that are different can easily be ostracized or made marginal. Best to look at something offensive from behind bars or a curtain. We have a tendency to cover, to dress, even to make believe. It is language, however, art, which undresses and challenges our beliefs and values. How do I describe something different? Where are my words? Language?

How long did it take us to love our blackness? I think about my wife growing up in Iowa. We are the same age and so there was a point in both our lives when we wore Afros and African garments. Now in our middle age, after the revolution, which only left us with Kwanzaa, I wonder what my wife felt looking down at her toes. Does this black beauty extend to her toes? And what if she wanted to take her shoes off and relax, rest her weary feet? Would they attract the attention of someone walking by? Once at a nearby beach in Maryland I noticed that there were few people of color sitting in the sand. A young white kid who sold my wife and me an umbrella casually mentioned something about a Ku Klux Klan rally taking place not far from where the sun kisses the water. What year is this I thought? How far South have I come?

I lay on the blanket thinking about how the segregation of beaches made no sense. Why draw a line in the water? But what if a white person suddenly saw my wife's toes? Would this not be the evidence needed to prove blacks were different from whites? Would my wife suddenly become the Venus Hottentot pulled out of the water and placed on display on the local boardwalk?

How would she explain her toes to someone who already believed she was different?

Is this not the type of physical proof racist scientists looked for at the turn of the century?

Maybe we are always "putting our foot in our mouth." An attempt to explain where we have been. The distance traveled by a writer is measured not with words but instead by small moments of enlightenment passing for faith and a belief in the unseen. It should be the function of art to show us what lies beyond the physical. So maybe I should write an ode to my wife's feet, something which captures the tone of Neruda, but embraces the journey my wife has made toward self-love. How would it begin?

I see my wife sitting on the edge of the bed, painting her toenails. She is unaware that I am beginning to write about this. . . .

Epigraph: Pablo Neruda, "You Flame-Foot," in *Selected Poems of Pablo Neruda,* ed. and trans. Ben Belitt (New York: Grove Press, 1961), 221.

Gallery

Figure

1 Léon de Wailly, *Saartjie Baartman, the "Hottentot Venus,"* 1815 g3

2 Transformation [Playing] Cards, *The Five of Clubs* [*The Hottentot Venus*], 1811 g4

3 Edouard Manet, *Olympia,* 1863 g5

4 Artist unknown, *Love and Beauty—Sartjee the Hottentot Venus,* ca. 1810 g5

5 Sexual anomalies in the Hottentot and in the European woman, 1893 g6

6 Steatopygia in black females, 1893 g7

7 Photographer unknown, *Bushwoman, So. Africa,* n.d. g8

8 Carrie Mae Weems, *Untitled,* from the *Sea Islands* series, 1992 g9

9 J. T. Zealy, *Drana, country born, daughter of Jack, Guinea,* 1850 g9

10 Hank Willis Thomas, *When Harriet Met Saartje,* 2009 g10

11 Roshini Kempadoo, *Colonised 1,* from the *Banking on the Image* series, 1994 g11

12 Roshini Kempadoo, *Sweetness and Light: Great House 4,* from the *Banking on the Image* series, 1997 g11

13 Roshini Kempadoo, *Sweetness and Light: Head People 1 & 2,* from the *Banking on the Image* series, 1997 g12

14 Roshini Kempadoo, *Colonised 3,* from the *Banking on the Image* series, 1994 g13

15 Lorna Simpson, *Three Seated Figures,* 1989 g14

16 Lorna Simpson, *You're Fine,* 1988 g14

17 Carla Williams, *Untitled,* from *How to Read Character,* 1990–1991 g15

18 Carrie Mae Weems, *The Hottentot Venus* (diptych), 1997 g16

19 Penny Siopis, *Exhibit: Ex Africa,* 1990 g17

20 Renée Green, *Sa Main Charmante,* 1989 — g18

21 Renée Green, *Seen,* 1990 — g18

22 Renée Green, *Permitted,* 1989 — g19

23 Kara Walker, *Untitled,* 1990s — g20

24 Kara Walker, *Untitled,* 1990s — g21

25 Deborah Willis, *Hottentot/Bustle,* 1995 — g22

26 Deborah Willis, *Tribute to the Hottentot Venus,* 1992 — g22

27 Simone Leigh, *Untitled #1,* from the *Venus* series, 1994 — g23

28 Berni Searle, image from *Still,* 2001 — g24

29 Tracey Rose, *Venus Baartman,* 2001 — g25

30 Lyle Ashton Harris with Renée Cox, *Venus Hottentot 2000,* 1994 — g26

31 Carla Williams, *Venus,* 1994/2009 — g27

32 Roshini Kempadoo, *Lapping It Up 2,* from the *Banking on the Image* series, 1997 — g28

33 Joy Gregory, *Zaanse Schans,* from the *Cinderella Tours Europe* series, 1998–2001 — g29

34 Joy Gregory, *Cristo Rei,* from the *Cinderella Tours Europe* series, 1998–2001 — g29

35 Lorna Simpson, *Unavailable for Comment,* 1993 — g30

36 Petrushka A. Bazin, *Jabba Strikes Back,* 2003 — g31

37 Petrushka A. Bazin, *Bashment Link Up Red and White Affair,* 2004 — g31

38 Radcliffe Roye, *Dancehall #8,* 2008 — g31

39 *Josephine Baker,* ca. 1938 — g32

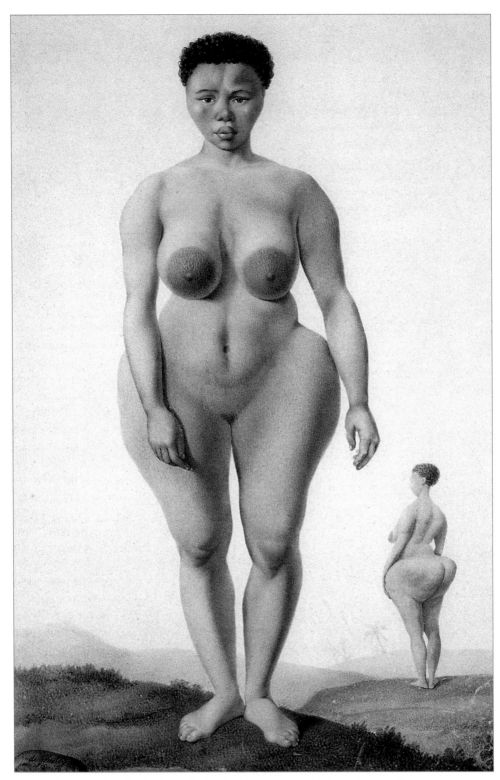

1 Léon de Wailly, *Saartjie Baartman, the "Hottentot Venus,"* 1815. Watercolor on vellum. Paris: Muséum national d'Histoire naturelle, Bibliothèque centrale. Reproduced in Geoffrey Saint-Hilaire and Frédéric Cuvier, *Histoire naturelle des mammifères avec des figures originales* (Paris: A. Belin, 1824). [Chapters 1, 6, 14]

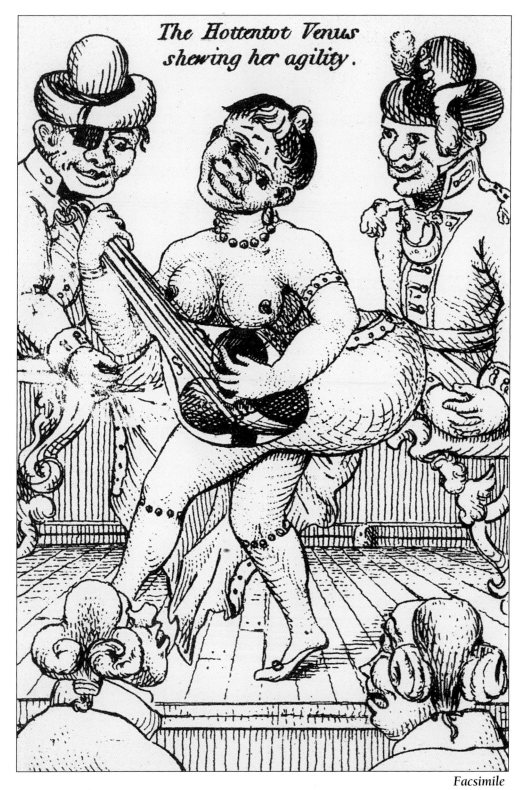

Facsimile

2 Transformation [Playing] Cards, *The Five of Clubs* [*The Hottentot Venus*], 1811. Guildhall Library, London, and The Worshipful Company of Makers of Playing Cards (published in 1978 by Harry Margery, Limpne Castle, Kent, in association with Guildhall Library, London). [Introduction]

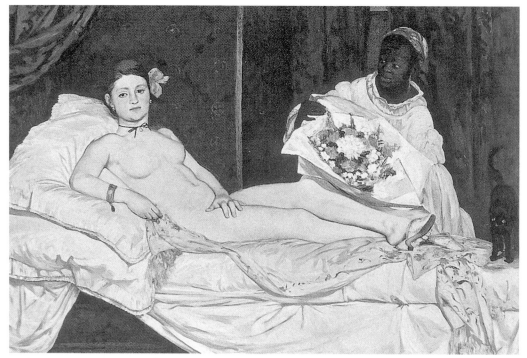

3 Édouard Manet, *Olympia,* 1863. Oil on canvas.
Orsay © Photo RMN—Herve Lewandowski.
[Chapters 1, 10, 16]

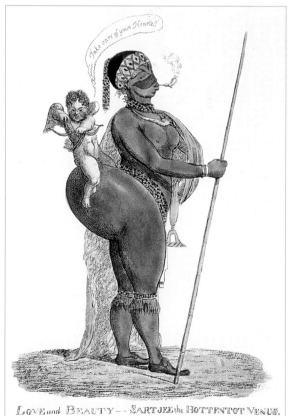

4 Artist unknown, *Love and Beauty—
Sartjee the Hottentot Venus,* ca. 1810.
Cartoon.

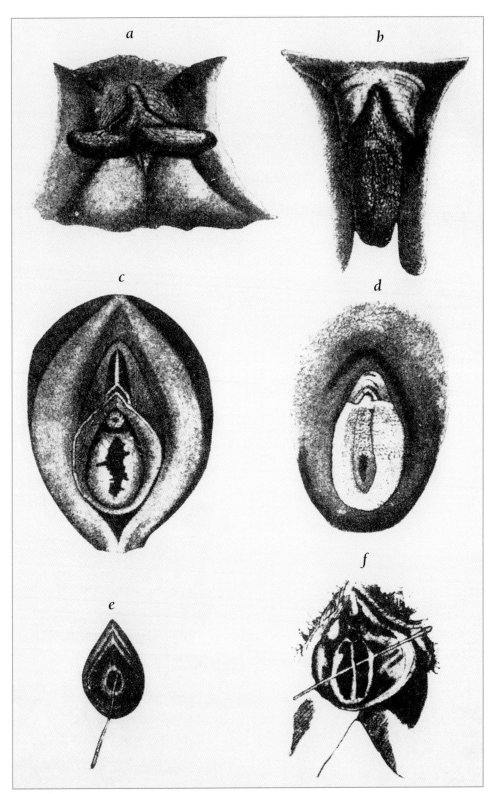

5 Sexual anomalies in the Hottentot (a, b) and in the European woman (c, d, e, f). From Cesare Lombroso and Guglielmo Ferrero, *La donna delinquente: La prostituta e la donna normale* (Turin: L. Roux, 1893), pl. 1. [Chapter 1, 8]

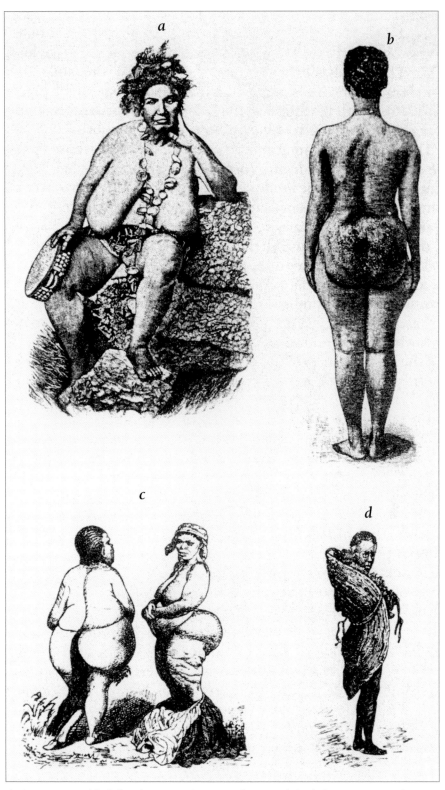

6 Steatopygia in black females. From Cesare Lombroso and Guglielmo Ferrero, *La donna delinquente: La prostituta e la donna normale* (Turin: L. Roux, 1893), pl. 2. [Chapter 1]

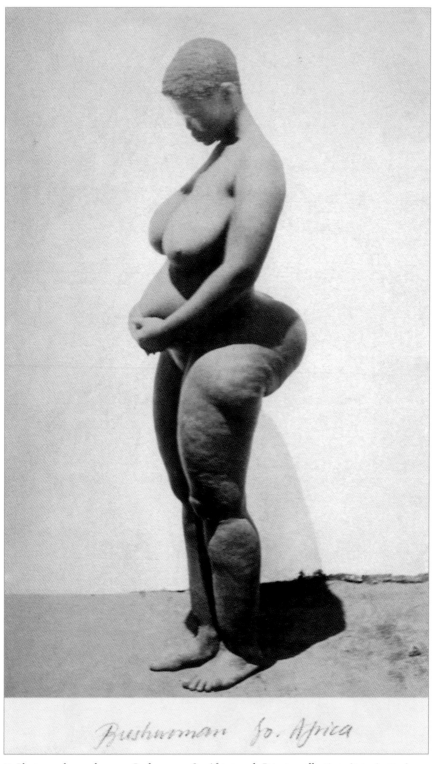

7 Photographer unknown, *Bushwoman, So. Africa,* n.d. Private collection. [Introduction]

8 Carrie Mae Weems, *Untitled* from the *Sea Islands* series, 1992. This triptych is based on several daguerreotypes taken by J. T. Zealy in 1850. Ms. Weems photographed reproductions of the daguerreotypes that were provided to her by the Peabody Museum at Harvard University. Certain of Ms. Weems's photographs of the reproductions have been toned or reversed. The copyrights to the daguerreotypes were registered with the Library of Congress in the name of the President and Fellows of Harvard College in 1977. [Chapter 6]

9 J. T. Zealy, *Drana, country born, daughter of Jack, Guinea. Plantation of B. F. Taylor*, 1850. Daguerreotype. Peabody Museum, Harvard University. [Chapter 6]

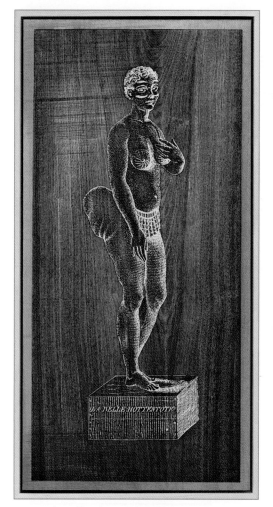 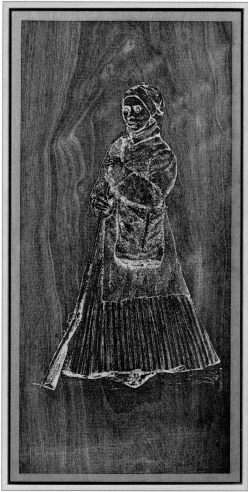

10 Hank Willis Thomas, *When Harriet Met Saartje,* 2009. Mahogany. Courtesy of the artist. [Introduction]

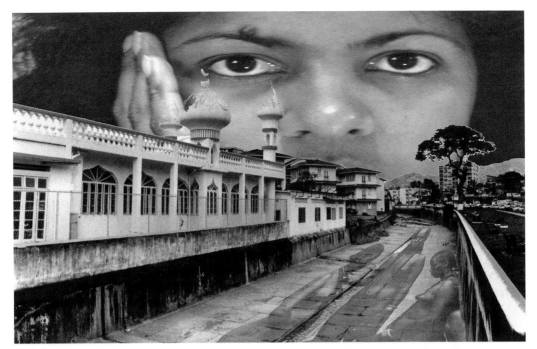

11 Roshini Kempadoo, *Colonised 1,* from *Banking on the Image* series, 1994. Fine art giclée inkjet print. [Introduction]

12 Roshini Kempadoo, *Sweetness and Light: Great House 4,* from *Banking on the Image* series, 1997. Fine art giclée inkjet print. [Introduction]

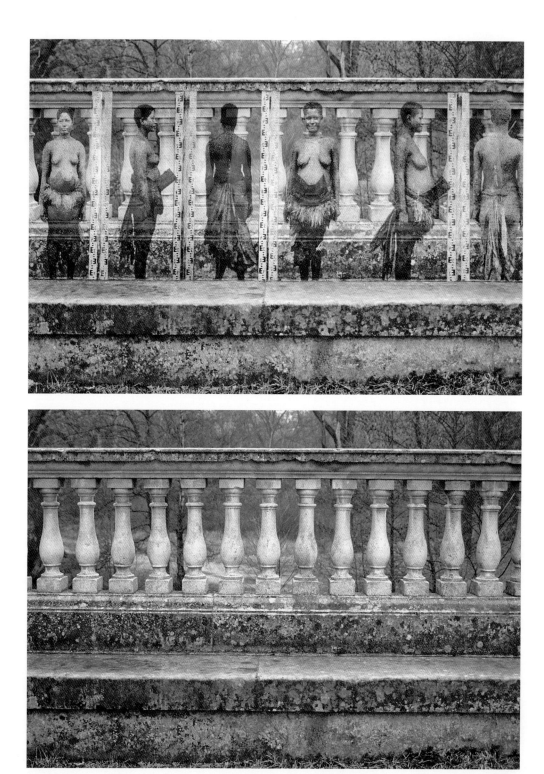

13 Roshini Kempadoo, *Sweetness and Light: Head People 1 & 2,* from *Banking on the Image* series, 1997. Fine art giclée inkjet prints. [Introduction]

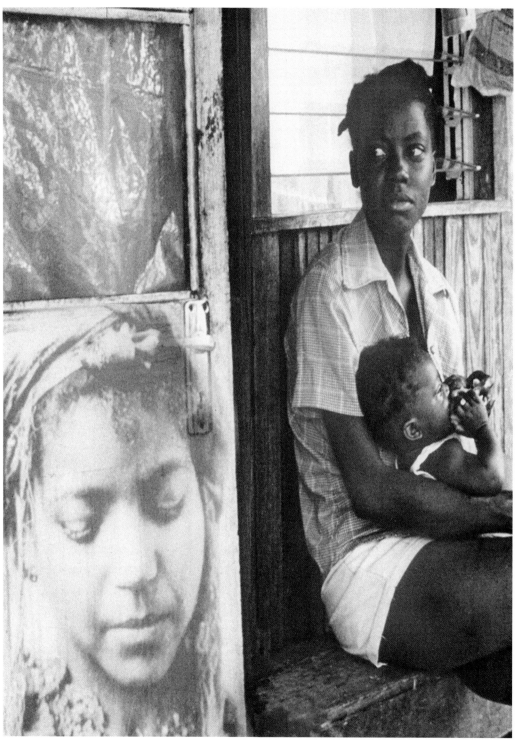

14 Roshini Kempadoo, *Colonised 3,* from *Banking on the Image* series, 1994. Fine art giclée inkjet print.
[Introduction]

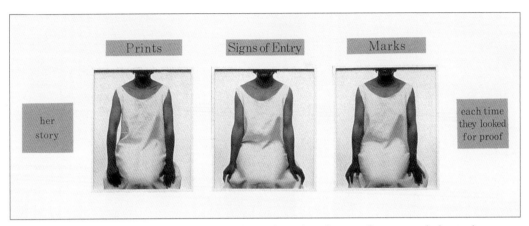

15 Lorna Simpson, *Three Seated Figures,* 1989. Three color Polaroid prints, five engraved plastic plaques. Copyright Lorna Simpson. [Chapter 6]

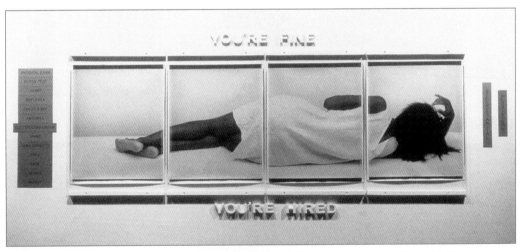

16 Lorna Simpson, *You're Fine,* 1988. Four Polaroids, wood plates, ceramic letters. Copyright Lorna Simpson. [Chapter 16]

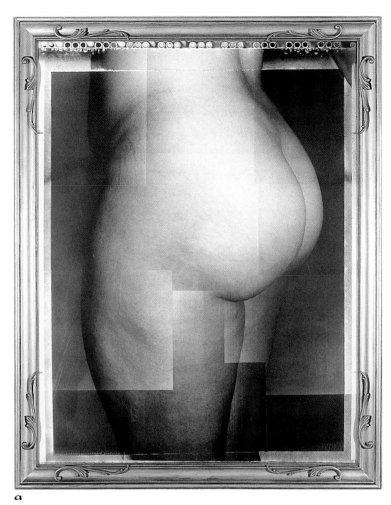

a

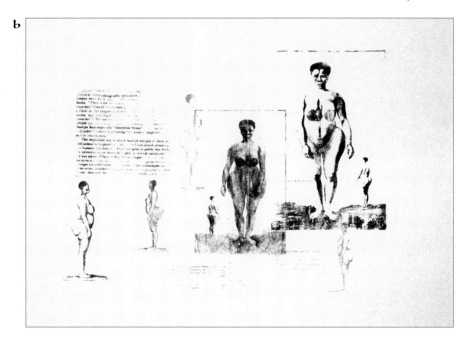

b

17 Carla Williams, *Untitled* from *How to Read Character*, 1990–1991. Gelatin silver print (a) and photocopy transfer (b). Courtesy of the artist, collection of The Art Museum, University of New Mexico. [Chapter 6]

In a 19th century zoological garden,
I passed Monsieur Cuvier;
he fixed his gaze onto me;
a sudden chill rose and
the hairs on the nape
of my neck
stood on end,
in defense,
I touched myself,
& fled.

I've heard that after the King
sat eyes upon you,
the bustle became
all the rage
with ladies of
the court

18 Carrie Mae Weems, *The Hottentot Venus* (diptych), 1997. [Chapter 7]

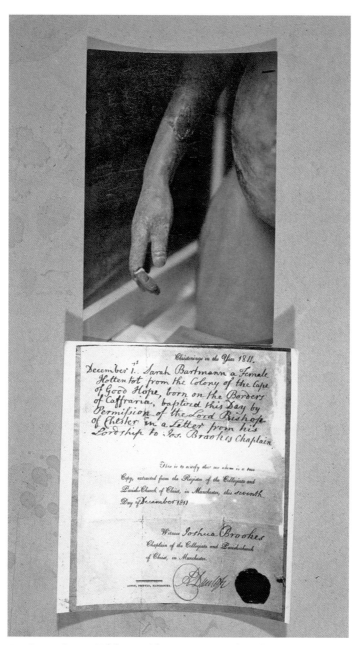

19 Penny Siopis, *Exhibit: Ex Africa*, 1990. Mixed media. [Chapter 11]

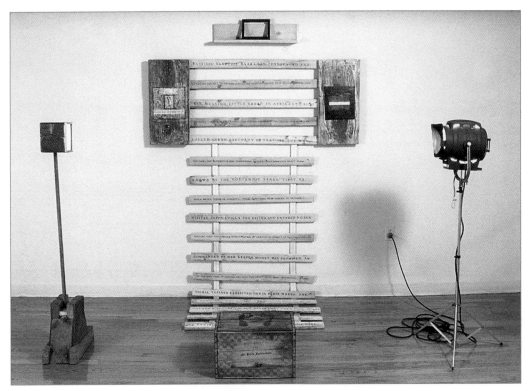

20 Renée Green, *Sa Main Charmante,* 1989. Mixed media installation, RG 89 04. Courtesy of Pat Hearn Gallery, New York. [Chapter 7]

21 Renée Green, *Seen,* 1990. Mixed media installation, from *Anatomies of Escape* exhibition at Clocktower Gallery, New York City. Courtesy of Pat Hearn Gallery, New York. [Chapters 6, 7]

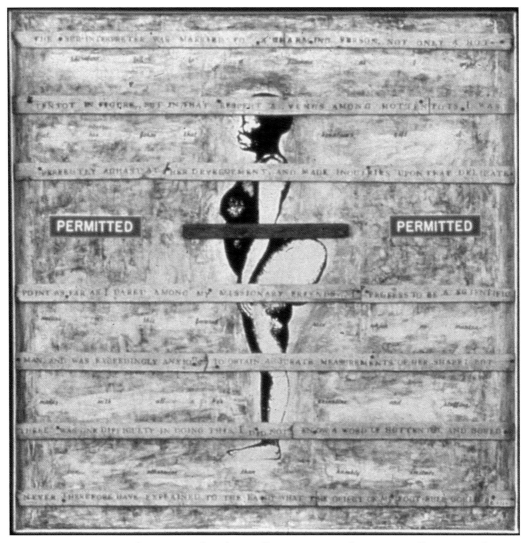

22 Renée Green, *Permitted*, 1989. Mixed media installation. Courtesy of Pat Hearn Gallery, New York. [Chapter 7]

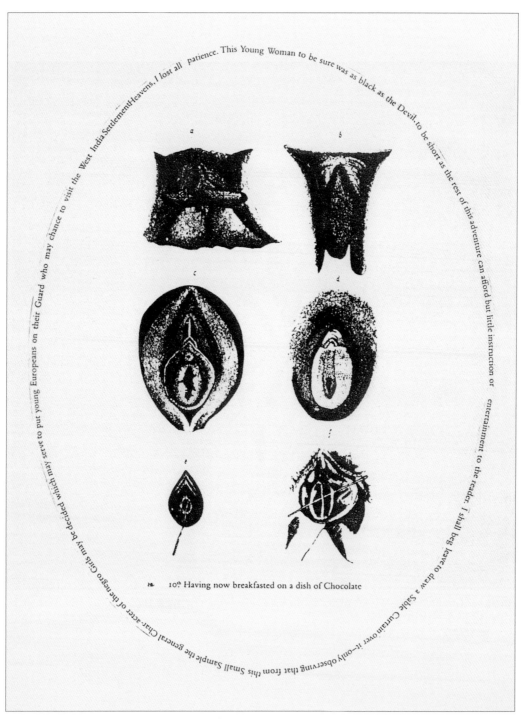

23 Kara Walker, *Untitled,* 1990s. Courtesy of the artist and the Renaissance Society, University of Chicago. [Chapter 8]

The ~~~~ lies limp, her ~~~~ ~~~~ pose,
Such as ~~~~ VENUS ~~~~ , ,
 In F~~~~ENCE, where she's seen;
Both just ~~~~, except the ~~~~,
~~~~ differ ~~~~—gone ~~~~ night,
     The bea~~~~s ~~~~ between. [22]

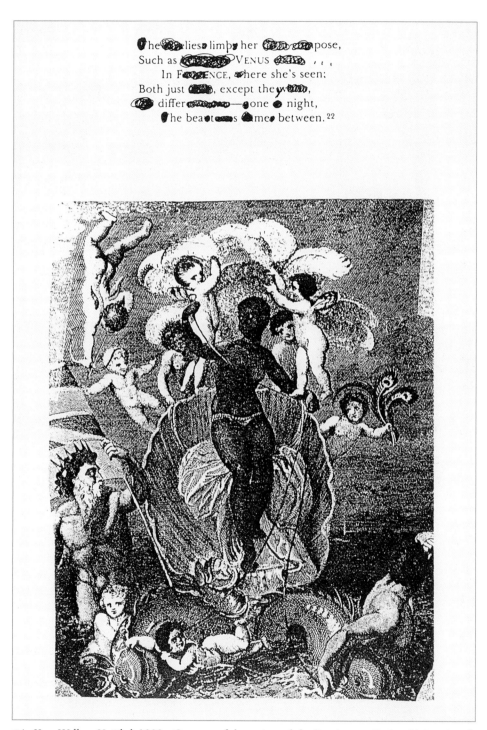

**24** Kara Walker, *Untitled*, 1990s. Courtesy of the artist and the Renaissance Society, University of Chicago. [Chapter 8]

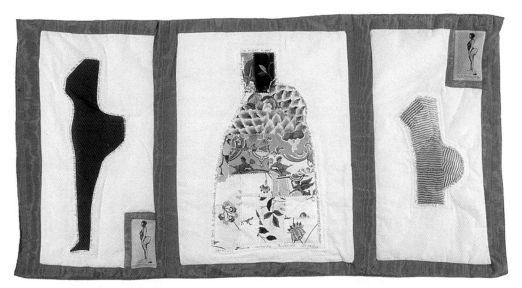

**25** Deborah Willis, *Hottentot/Bustle*, 1995. Fabric, photo linen. Courtesy of the artist. [Chapter 7]

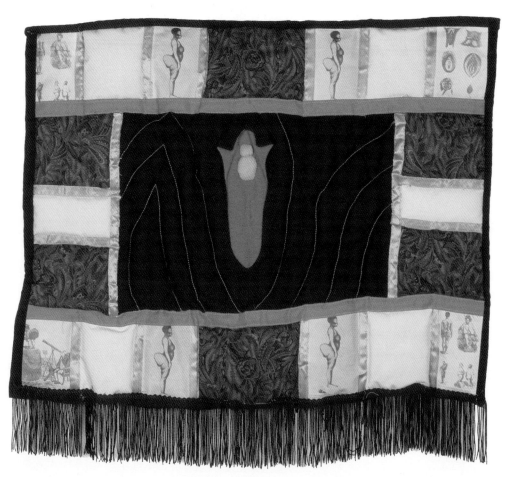

**26** Deborah Willis, *Tribute to the Hottentot Venus*, 1992. Fabric, photo linen. Courtesy of the artist. [Chapter 7]

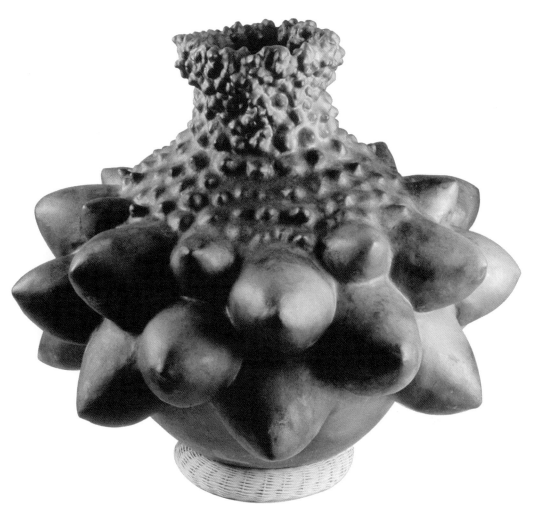

**27** Simone Leigh, *Untitled #1*, from the *Venus* series, 1994. Pit-fired terracotta. From the collection of Danny Simmons. [Introduction]

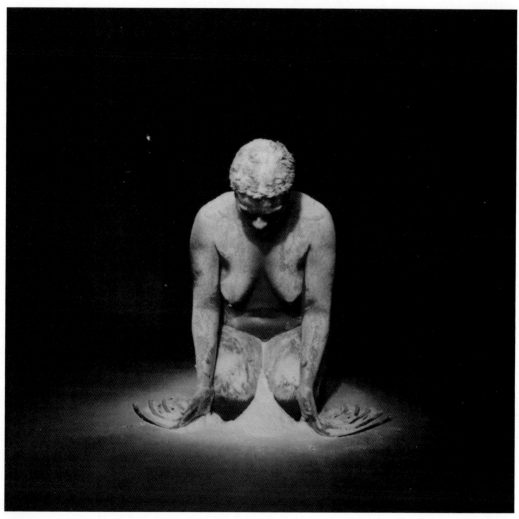

**28** Berni Searle, image from *Still*, 2001. One of eight digital prints on backlit paper, suspended, with flour. Photo courtesy of Jean Brundrit. [Chapter 11]

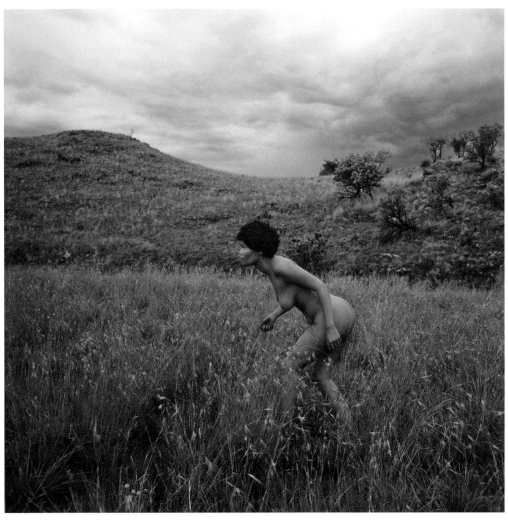

**29** Tracey Rose, *Venus Baartman*, 2001. Lambda print, edition of 6+2 AP. Courtesy of the artist and The Project, New York. [Chapter 11]

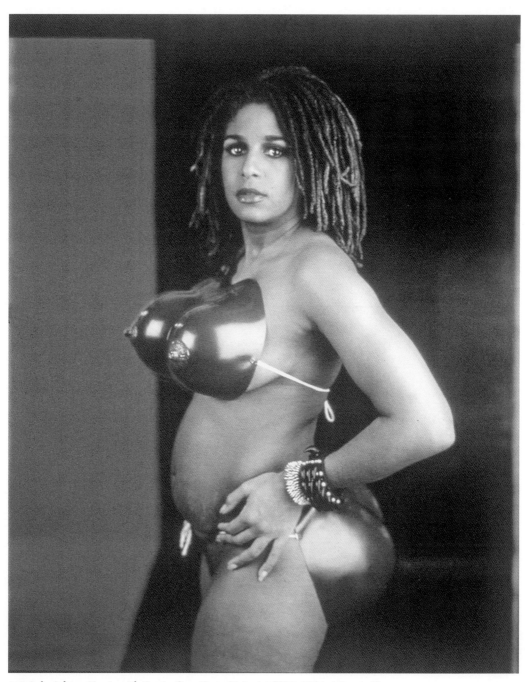

**30** Lyle Ashton Harris with Renée Cox, *Venus Hottentot 2000,* 1994. [Chapter 7]

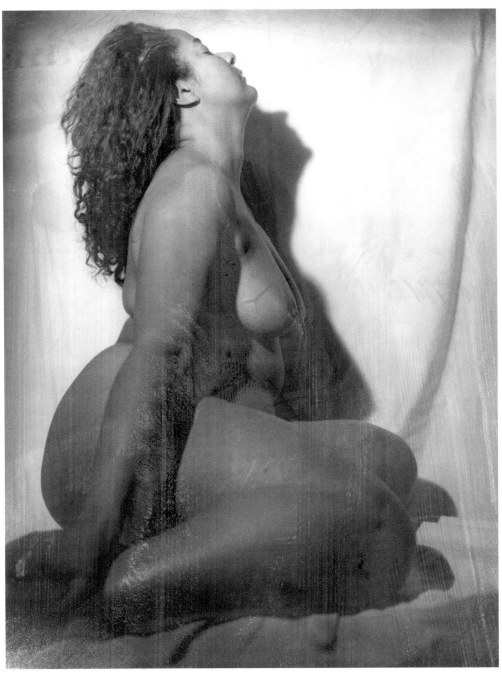

**31** Carla Williams, *Venus*, 1994/2009. Archival ink jet print. Courtesy of the artist.

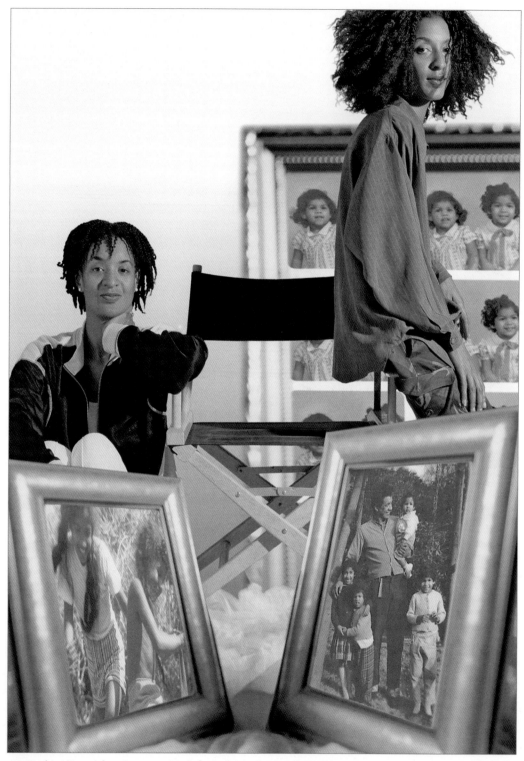

**32** Roshini Kempadoo, *Lapping it Up 2,* from the *Banking on the Image* series, 1997. Fine art giclée inkjet print. [Introduction]

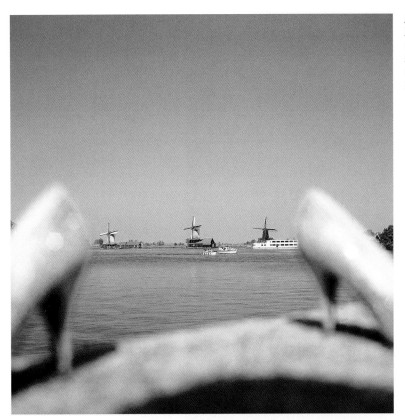

**33** Joy Gregory, *Zaanse Schans*, from the *Cinderella Tours Europe* series, 1998–2001. Color photographs. [Chapter 15]

**34** Joy Gregory, *Cristo Rei*, from the *Cinderella Tours Europe* series, 1998–2001. Color photographs. [Chapter 15]

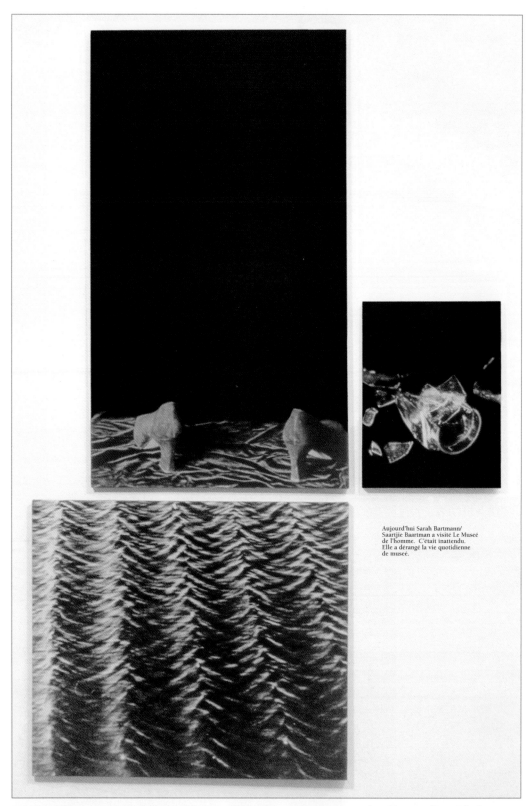

Aujourd'hui Sarah Bartmann/
Saartjie Baartman a visité Le Museé
de l'homme.  C'était inattendu.
Elle a dérangé la vie quotidienne
de museé.

**35** Lorna Simpson, *Unavailable for Comment,* 1993. Three photo linen panels with text. Copyright Lorna Simpson. [Chapters 7, 15]

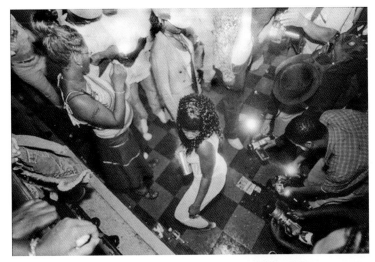

36 Petrushka A. Bazin, *Jabba Strikes Back,* Emerald Lounge, Bronx, New York, 2003. Gelatin silver print. [Introduction]

37 Petrushka A. Bazin, *Bashment Link Up Red and White Affair,* GFS Ballroom, Hyattsville, Maryland, 2004. Lambda print. [Introduction]

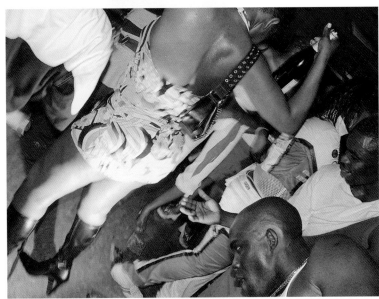

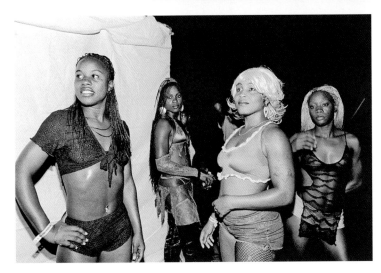

38 Radcliffe Roye, *Dancehall #8,* Kingston, Jamaica, 2008. Gelatin silver print. Courtesy of the artist. [Introduction]

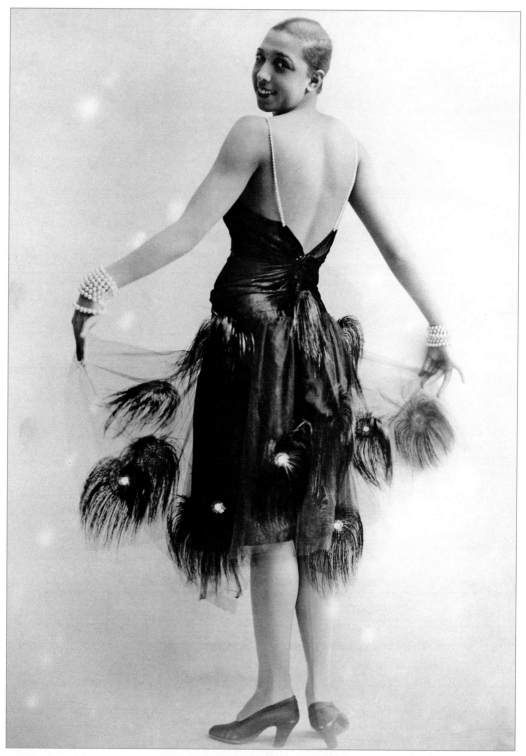

**39** *Josephine Baker,* ca. 1938. © Hulton-Deutsch Collection/CORBIS Historical Standard RM, HU042100.

PART IV

# Iconic Women in the Twentieth Century

HOLLY BASS

## 18   agape

agape: her knees grew, wide open, eyed, mouth

only christ could love
a child so
night black and tender
rib meat falling
off the bones into
a saucy mouth
slick with salivation
the rendering of her
image cast in
Victorian silhouette
onto a perfect ivory
brooch was also
cause for concern
"he don't love me no more!"
she was said to have shouted
from her pinned position
causing consternated looks
from those nearby the bearer
of her object beauty
whatch'all lookin' at!?
he snapped back
dandy as ever, his
grayed-in blue striped
seer sucker suit

it was plain to see:
the hard attention
was gettin to 'em
when she divulged
her greatest asset yet—silence
and it was into this
weak wet gaze of
bowlegs and jelly legs

and gaping double jointed
knees she regressed
slipping back into his mind's
recesses to redress herself

pure white cotton lace panties
the moist black loam of his need
filtering through her Tara'd fingers
oh tara taray he whistled, stepping jauntily
irish soda bread jig and
whiskey singing
toorah loorah loorah
under his breath like
incantation
devils have a magicness when they
make that heathen noise
that unh grunt aah help me
so help me
she knew this too
would pull back her
lips for him and let out
the sounds, mouth
open wide like a
hyena, legs and heels
kicked high
topsying tommying
curtsying, even
she knew
how to treat a man like royalty
a high horse a giddyup
a go round good ole good ole

these days don't nothing come cheap
or easy. you work for your sweat
you work for your time.

Credit: "agape: her knees grew, wide open, eyed, mouth" first appeared in nocturnes (re)view of the literary arts, Spring 2004.

CAROLE BOYCE DAVIES

## 19  Black/Female/Bodies Carnivalized in Spectacle and Space

> *Bodily memory should [therefore] be understood as narratives expressing beliefs about the content (as well as the form) of white violence. . . . Bodily memory has very powerful emotional resonances in that it is the medium through [which] are constructed the affirmations of black people.*
> —Alrick Cambridge, "Black Body Politics"

**The need to think through** the black female body obtains significance given the location, in the semiotic field, of black bodies and female bodies historically. Even so, the black female body carries its own set of resonances, also historically locatable, which demand independent articulation. The epigrammatic quote which leads this paper is taken from "Black Body Politics" by Afro-Caribbean scholar/activist Alrick Cambridge, who makes some arguments that I find helpful. Speaking in the context of police violence on the black body in England, the context in which he works, he asserts:

> The black body is a surface of traces. Outwardly it bears the mark of exclusion upon the skin. But the black skin which bounds the body is an enclosure of a special kind for it is not only what differentiates. It is also what identifies. The black body is thus a mark of exclusive difference and also the basis upon which identification—and the claims to identity—can be formed. . . . In fact, what black skin denotes is already more than that, because it is already an outcome of traumatic histories of racialist transgressions. The black body is not only a natural, physical body, but a political and cultural body upon the surface of which are already imprinted multiple historic subjections.[1]

In speaking of the black female body, then, the particular contexts of representation have to be historical as much as they have to be culturally located. So it is with the resonances of the historical and the cultural simultaneously that this essay is concerned. And the meaning of body memory in both of these processes is also centrally important. One of the most obvious representations and commodifications of the black female body takes place within the context of carnivals and as a result allows a series of questions about representation and the carnivalesque.

The discussion which follows is organized, therefore, around four central formulations: (1) the carnivalized female body; (2) the commodified female body; (3) the taking of space, freedom, movement, and resistance; and (4) triangular representations.

The particular originating moments for the raising of some of these questions have been, in a larger sense, the re-interpretation of African Diaspora and, more directly,

Caribbean culture in a variety of locations. The re-creation of Caribbean carnivals in a variety of U.S. and European cities, in frameworks and locations very different from Caribbean island space, gives rise to a larger consideration of the very meaning of Diaspora, culture, and migration. The genesis of these carnivals carries the intent of resisting on some level the otherwise alienating conditions of life in North American/Puritan–based culture or European culture, and therefore to carnivalize in "post-colonial" intent imbues these landscapes with some of the joy and space commensurate with Caribbean Carnival.

Being from Trinidad, and having done (and still doing) my own share of carnivalizing, I found myself in a very strange position when witnessing some of the Caribbean festivals as a spectator. But I was often also a participant, enjoying the joy of free movement, the body for itself outside of circumscribing controls, and often experiencing the two (witnessing and participating) simultaneously.

For me, the issue moves contradictorily around the location of the Caribbean woman's body, at once existing as the object of voyeuristic gaze; at once taking control in carnivalized space: the do-what-you-want-to-do, this-is-my-body-not-yours. So I want to locate this paper in the midst of this contradictory context without necessarily offering any neat resolution, but rather highlighting questions about these contradictory implications in the context of a series of hierarchies and asymmetrical relationships located in dominant patriarchal and imperialistic contexts. Additionally, the highly misogynistic representations of women in the lyrical articulations of female bodies in some versions of calypso, reggae, rap, dancehall, and toasting are also implicated.

In this latter context (patriarchal/imperialistic), female genitalia are pornographically exposed, identified in ways so detailed and objectified that no amount of women's reversing the terms of pornography by exposing male sexuality could be equivalent. To attain such a level, women would have to actually engage beyond the discourses of "how do real men measure up?" or some of the other versions that women have tried in rap and toasting, to discourses of dismemberment. For, given the politics of power and dominance in terms of gender, the exposure of male and female body parts cannot be equivalent or symmetrical.

In pornography, one of the standard tropes is that women's bodies are dismembered, reduced to parts for easy consumption. Judith Wilson, taking it to the limit, would actually define pornography as "the entire spectrum of representations that fetishize the body and objectify desire for public consumption."[2] She would also identify the replication of pornographic standard tropes in Afro-U.S. works such as Romare Bearden's, even as he "participated in an important recuperative project of twentieth century African-American art."[3] And in some extreme versions of black male popular culture, women were reduced to chained-up "bitches" and were pornographically located as body parts in the most culturally referenced misogynistic contexts.[4]

Central to the issue of the representation of the black female body in this particular discussion is the question of space in the meanings of carnival. The implications of the controlled, inside, and staged notion of carnival and the woman's location in these inner spaces, as opposed to the outside, street-based carnival, are significant. Marlene Nourbese Philip in "Dis Place: The Space Between," is very clear about the meaning of Caribbean *jamette* culture and the taking back of the street as radical space.[5] So, the question of female agency and resistance, even as it is attempted to be controlled, is as significant for me as is the critique of certain modes of black female representation.

Carolyn Cooper makes a very strong case for the positive identification of "slack-ness," highly relevant in the midst of Jamaican bourgeois representations that often consign the "vulgar body" to working class women.[6] For her, "slackness culture" resists pretensions of "(high) culture" as expressed by bourgeois classes and therefore occupies a plane of resistance.

A further related context has to be the freedom that African women exercise in terms of their bodies and their physical/sensual possibilities and pleasures in move-ment, which exist outside of Western, restricted, Puritanical modes of perceiving the body as sinful and which under colonialism began to be misread and located under the Western/male gaze.

For me, what precisely makes these representations of the body not symmetrical are the dynamics of gender, race, and position, the power relations between men and women, between white and black, and the ways that these relations enhance the con-tinued commodification of black female bodies. Further, located within white suprema-cist, imperialistic dynamics, the female body has been trained to function for the benefit of and in the service of others.

## The Carnivalized Body

In "Nudity in Brazilian Carnival," Monica Rector speaks about the visual and verbal codes that displace the carnival event to nakedness and shift erotic nakedness to por-nography.[7] Primary among these representations is that it is the women who are most often reduced to nakedness, making them objects for male consumption and reinforcing the central messages of female subordination encoded in carnival.

> In Carnival, then, nudity is transformed into a series of metonymic images of the woman as an object of desire. Her physical charms are presented (ranging from the parts of her body)—face, legs, arms, bust, buttocks—to her representa-tion as an erotic object as a whole.[8]

Still, even as we pursue questions of female nudity and carnival, we may want to follow Mikhail Bakhtin in his analysis of carnival as the interruption of dominant dis-courses, the refusing "to surrender the critical and cultural tools to the dominant class, and in this sense, carnival can be seen above all as a site of insurgency."[9] For Bakhtin, carnival and the carnivalesque occupy that space outside of the centralizations of moder-nity as these (carnival and the carnivalesque) resist and subvert hierarchies and other societal normatives. Robert Stam identifies in Bakhtin a "constellation of interrelated tropes and ideas, not all of which are attractive to the same constituencies." Still he asserts that carnivals can be "politically ambiguous affairs that can be egalitarian and emancipatory or oppressive and hierarchical."[10]

Inserting gender into the dynamic of carnival, Mary Russo's reading of Bakhtin for women sees that the notion of the "grotesque body," on which Bakhtin bases much of his analysis, ends up, for feminist readings, in positions of ambivalence. Thus Bakhtin, in Russo's words, "fails to acknowledge or incorporate the social relations of gender in

his semiotic model of the body politic, and thus his notion of the Female Grotesques remains in all directions, repressed and undeveloped."[11]

In Stam's reading, Bakhtin's notion of carnival as one of the "decentralizing forces that militate against official power and ideology" is a category that Brazilian artists and cultural critics have used to a certain degree.[12] Still "carnival in Brazil, as elsewhere, is both a release for popular resentment *and* a locus of popular resistance; it is the constant site of struggle between the two tendencies, between official power and popular imagination, hegemony and resistance, co-optation and subversion."[13]

In my view, then, if we are to account for the representation of the carnivalized female body, then carnival itself also has to be complicated in terms of historical period, class, gender, sexuality, and so on. And therefore, in the same way, it can be the site of struggle between dominance and resistance on issues of representation of the black female body, which embodies at least gender, sexual, and racial tropes historically located in subordination.

My own reading of Caribbean and Brazilian carnival makes distinctions between the *"carnival of resistance,"* which began in resistance to oppression and which occupies that same pole as slave rebellions, uprisings, *cannes brulees (canboulay,* or burning-of-cane events for crop destruction), and maroon communities; and the *"carnival of cooptation and tourism,"* which has more to do with selling the Caribbean and Brazil and the female body as sites of pleasure for both insiders and outsiders. It is an important distinction which allows us to read carnivals in complicated ways to uncover and decode the functions of carnival that have been appropriated by dominant discourses. In that way, carnival is not at every level and always a site of complete liberation; it may in fact function as a site of containment. For in some cases, the attraction to the carnival is the possibility of seeing female bodies, naked and prostituted and willfully performing for the pleasure of the voyeur. In many locations, men have become spectators and not performers.

It is precisely here where the female body can become part of a series of pornographic representations, dismembered and reduced to its parts often via photography and other forms of camera work. The female body then becomes part of the saleability of carnival. Thus, black female bodies, which at times adopt dance postures with their backs on the ground, or hands on the ground and buttocks in the air, mime that very struggle and therefore mark the distinctions I want to make between asserting resistance and being caught, between the horizontal and the vertical in terms of the use of space, gaze, and position. The ways these distinctions relate to conquest and domination remain overarching considerations.

The Caribbean female body displayed with her back on the ground replays, in distinct ways, the imperialist entry into the land, "the lay of the land" as feminist critics would say. The Caribbean, in all its tourist manifestations, gets re-presented as exotic space, with its primary mode of existence as the provision of sexual/erotic pleasure for a series of visitors, in the "we are here just to serve you" mode of the tourist representations. Philip traces this history well when she identifies that "the black woman comes into the New World with only the body. And the space between. The European buys her not only for her strength, but also to service the black man sexually."[14]

The island/female body becomes, then, another tempestuous site of male/colonial ownership. The absent black woman of *The Tempest,* which Sylvia Wynter identifies, is in fact not absent at all but becomes transferred to the land itself.[15]

The enforced heterosexual coupling in the land and in the representation of the woman's body mimed in tourism, as Jamaica Kincaid identifies well in *A Small Place* (1998), and that later appears as the lead-in to the 2001 documentary film *Life and Debt* by Stephanie Black, captures many of the identifications of tourism with exploitation that repeat themselves incessantly. Women are the visual and the captured in these exercises in voyeurism and erotic pleasure. As Rector notes, in eroticized versions of Rio carnival, all women are represented as prostitutes as they are all represented as the "guests of men," the sexualized objects of male gaze.[16] In other words, the sexuality, as it is presented, is made equivalent to enforced heterosexuality, that is, women performing the dance of intercourse at the level of desire. For black female bodies, the link between the violence of slavery and rape are mapped onto the historical meanings of the voyeuristic gaze. Significant as well is that in some narratives on the Middle Passage, black women are identified as chained on their backs, in the supine position, ready for entry by white slavers as they felt inclined. Citing Barker-Benfield, Lemuel Johnson recounts the horrific uses of African slave women for gynecological experimentation and repeated surgeries in his aptly named "Speculum in a New World," which identifies the various ways in which the female body serves the male text.[17]

The black female subject in the New World is born within the context of commodification and has only been able to resist it when deliberately reclaiming herself outside of the terms of and in resistance to this commodification.

## The Commodified Body

The commodified body of women in horizontal positions ("prone" and supine) aligns with the commodification of the Caribbean in tourism. I have been trying to think of ways to re-present the Caribbean other than through fragmentation and commodification and also to allow some female agency. One therefore has to make some distinctions between questions of spectatorship, location, and the male gaze on the one hand and the ability of women to transform their own spaces on the other. Rector's position is that female freedom signifies less liberation and instead indicates the transformation of the woman into consumable object.[18]

This concern for the reclamation of female space has been expressed in Marlene Nourbese Philip's essay,[19] which deliberately re-creates the dramatic through *jamette* culture and the theatrical. In her example, the legendary Trinidadian calypso singer/ stick fighter who carried the sobriquet Boadicea and the other *jamettes* challenge a series of authorities—bourgeois culture, their men, the state through its police and court system—and thus liberate themselves back into the streets.

But in Caribbean popular culture as it exists today, the question of the body and its cash equivalent still must be located in this contemporary moment of late capitalism. For example, in the popular dance-calypso, "Dollar Wine," some clever calypsonian gave an ascending value to each of the gestures of wining (the popular sensual Caribbean dance), with the lowest equivalents assigned to side-to-side motions, the rear being ascribed a bit more value, and the full frontal assigned the most value, moving from cents to dollar, with each thrust of the body emphasized by the word "dollar." Again,

as someone who gleefully participated and mastered these movements, the assignment of cash value to wining has to be temporarily suspended analytically in order to facilitate full enjoyment. But therein lies the primary contradiction for women, for Caribbean feminists, for intellectuals, and for Caribbean subjects attempting to discuss these matters. For in the end, all gets subsumed under the carnivalized demands of entertainment, thus not to be analyzed or discussed, and thus paradoxically containing the freedom to enforce dominant discourses, continuously and without challenge. For who wants to stop the carnival?

Still, the allying of the Caribbean with prostrate female bodies masks the agency and enjoyment in terms of body and desire, which women simultaneously exercise in carnivals. Again, within the contradiction of carnival, this is the one time that women are able to take space, to assert the sexuality which includes women wining on and with each other, and which also includes women at home in their bodies expressing the very same sexuality that men simultaneously desire and fear they cannot control. Thus taking space also becomes women's version of a carnival of resistance.

Pursuing the ritual of dance and sexuality, the butterfly, an early nineties dance which mimed with the legs the movements of the butterfly's wings, revealed the female body opening and closing, allowing possibilities for entry and simultaneously barring entry, giving life and also taking it in all its gestures. Pearl Primus and later Katrina Hazzard-Gordon would see dance as carrying its own language and vocabulary and African dance, both in the continent and in the New World, as specifically carrying many unread messages of resistance.[20] Significantly, as with any language which one does not know, there always exists the possibility of being misinterpreted or misread by the viewer/listener. One of the mistakes often made by viewer/spectators from other cultural locations in apprehending carnival behavior is the reading of Caribbean female physical movement as equivalent to heterosexual access or the "cash equivalent." Therefore, the body read as sexual object does not exist necessarily in the same way for the viewer as for the viewed, which always historically has been the racist/rapist/colonizer's mistake. Further, it does not necessarily follow that the phallus, as signifier for the Law of the father, has to be represented in Lacanian context as the sole object of lack or desire. Rather, it may be power and pleasure in the presence/absence of men that may be operative, but which the voyeur seeks necessarily to contain. Dionne Brand, for example, identifies that Boadicea and several of the other *jamettes* existed in a cultural space in which "indications of lesbianism" can be found.[21] Embedded in the very formulation of *jamette* is the notion of transgressive identity or transgressive space, a space both within and outside of the confines of men, a "taking space" of location.

The unanswered/unanswerable question which arises from all of this is: Can one avoid all those interpellations by dominant culture? In a March 1994 *National Geographic* piece on Trinidad titled "The Wild Mix of Trinidad and Tobago," frontal, painted, gyrating black bodies come across as engaged in orgiastic ritual, juxtaposed in succeeding pages with more orderly images including, significantly, a neatly clad baby boy in red, white, and blue jumpers born "accidentally" in New York City and therefore an "American."[22]

The ongoing work on sex tourism[23] also has to be considered as it details a much wider marketing of the Caribbean body linked to tourism for both men and women

that is camouflaged by the natural warmth and sensuality of Caribbean culture. The historical specificity of the black body as commodity and its contemporary representation as a site for Euro/U.S. social and political constructions have to be factored in, particularly given the fact that the black female body became that doubled sign of commodification and reproduction.[24]

## Taking Space: Freedom and Self-Articulation

If, as Pearl Primus would assert, "dance is a language," then it is not so much the physicality and sexuality of the dance itself but what it communicates that is most critical.[25] The problem, then, may reside in the voyeur and the colonizer of the Caribbean/female body. Understanding the concept of "taking space" in Afro-Caribbean dance allows us some further understanding and allows some agency for Caribbean women, particularly when dance is aligned with personal freedom. "Taking space" is best understood not simply as taking physical space, but also as taking "mental or spiritual space."[26]

"Wining" can therefore be identified as the basic verb form of Caribbean dance. It is as well the deliberate using of the body in a certain physical public or private space. A range of other erotic African Diaspora dance movements that occupy a plane outside of European definitions of obscenity also have to be accounted for.

Taking space, then, means moving out into areas not allowed. It is also the transgressing of restricted spaces, particularly the racialized/gendered space confinements. A few important parallels can be made at this point. The first can be called the basic sentence of Carnival parading that one sees versions of in New Orleans, Trinidad, and Brazil, in which the dancer negotiates the road, creating space, as in the Trinidad-verbalized "give me room," which sometimes accompanies desire for space in the execution of physical movements.[27] In this particular context, the dancer is able to negotiate among a variety of other dancers his or her own particular dance space. Another example is *limbo,* in which the space metaphor is graphically expressed in terms of a before-and-after, with either side of the limbo bar or pole representing a space of physical freedom. The pole, which has to be negotiated in the language of dance, represents slavery and the slave ship, and the physical gesture of Middle Passage, piled on with fire, lowered to the ultimate, necessitates physical dexterity and finally transcendence.

The bizarre parallel of space in a transoceanic vessel and the maximizing of exploitation of this space by oppressors becomes the historical background against which all of these dynamics operate. The calculations of use of space by gender, size, and age for slave ship passage, and the use of the black female body as space to maximize profit through reproduction are also significant. The maximizing of space by oppression for material gain meant the constricting of space for black women. The semiotics of "taking space/making space" references, therefore, become clear in each of these dance formats, as do the various modalities.

So, in that context, the butterfly—itself already a sexual symbol—is simultaneously a movement of limiting space and making space. In this particular case, the space that is being referred to is the space made between women's legs and the space between islands.[28] But this is also a present/absent, misrecognized space. As this space is not

necessarily and automatically a space for men, it is not terminally an empty space for the discoverer, navigator, colonizer to enter.

This ability to represent the Caribbean in terms of space offers some possibilities for the way in which we see and use the space. Benitez Rojo's formulation of the "repeating island" is helpful in the sense that each island is both a repetition and a transformation.[29] But important for me as well are the spaces between, which can be seen not necessarily as open spaces with dotted islands but as spaces in which the islands themselves can be seen in the reverse, as visual representations of what is hidden, what is submerged, what is both visually accessible and not.

Perhaps it is that ability to navigate the space of the unseen which hides all of these histories.[30] For it is how the woman, the body, commands fluidity which makes the dance live. The Caribbean in this formulation *is* that very economical use of space, as it is that sense of the possibility of "taking space." "Making space," on the other hand, refers to creating space for the other and is less a position of empowerment.

The island space can be seen in this context as "small spaces" or spaces of freedom and extension.[31] The butterfly, in its scissor-like manipulations, may not so much suggest the desire to perform actual physical castrations as the desire to be left alone. It is that sexual play with pleasure, danger, life, and death which is perhaps the basis of the seduction in butterflying. But viewed another way, the butterfly in its beauty has a short-lived and delicate existence which is subject to commodification and destruction.

One final aspect of this representation that has to be addressed is staging. The staged format for dance inside a structure, for spectatorship, aligns well with the raised float in, for example, the province of the commodified Brazilian *mulatta* of Rio Carnival. The staged versions occupy the pole of the Carnival of tourism and voyeurism and "making space," as opposed to the grounded carnival of resistance with people "taking space" or controlling their own space, taking over the streets and making their own movements, as in Bahia carnival or in Trinidad *j'ouvert*. The staged Carnival becomes more and more a site of containment with the distinctions between vertical and horizontal intact. In the end, subject to both vertical and horizontal gaze,[32] the prostrate butterfly immobilized as art and staged for colonizing gazes is not a figure of resistance.

## Triangular Representations

The problems of representing black female bodies are amplified in regard to the use of black women's bodies in history. Hortense Spillers's article "Mama's Baby, Papa's Maybe" and Alrick Cambridge's "Black Body Politics," with their black flesh/black skin/black body references, identify some of these questions.[33] All of the discourses on the representation of the female body in western culture assert "the female body as the site of patriarchy's construction of the feminine,"[34] but also identify it to be "figured as absence, silence and nonrepresentability in the phallocentric discourses of Western metaphysics."[35]

For black female bodies, this sense of multiplied absence/presence has centrally manifested as commodification and distortion. The black female body in Western culture has existed in the context of either exoticization or abjection. Finding those who,

in the last five hundred years, have really loved our bodies has been difficult. Rather, our bodies have been chained, sold, transported, paraded, flayed, pried open, discarded, and possessed.[36]

So, how does one reclaim that female body now in the context of recent history? On the one hand it is possible to see the physical control that women take in attempting to do with their bodies as they please. But *is* it what they please? Or is the female body still not doing what it is trained to do? PLEASE!

Some recent re-articulations of prior forms of representations of the female body as well as newly emerging expressions that are taking place in dance and other cultural forms are attempting to work through this reclamation of the body.[37] Further, pursuing representations of the black female body in African contexts reveals some interesting "taking space" constructs and oppositional gazes outside of Western formulations of the contained body.[38] Dionne Brand says in reference to the response to a public reading of her story "Madame Alaird's Breasts," and to the heterosexism involved in most representations of Caribbean women's literature, "to write this body for itself feels like grappling for it, like trying to take it away from some force."[39] Clearly "Madame Alaird's Breasts"—a story of adolescence in which a teacher of ample size has breasts that cannot be avoided by her students, but are celebrated—is one of those reclamations of the body, a body objectified in a way by the gaze of the young women who desire, but nevertheless a gaze outside of male prescriptions, reveling in the body's excesses for the sheer female joy of it.

In *Lazy Thoughts of a Lazy Woman,* Grace Nichols offers a series of reflections on the black woman's body, herself. In fact, the general premise on which the book operates, the notion of laziness for black women, occupies an existence on the semiotic plain that both challenges colonialist/racist critiques of blacks as lazy and redirects the political implications of laziness for both women and black people, on whose backs and with whose labor capitalist erections took place. Thus, when black women's labor is that consumable, laziness becomes a resistance to her exploitation, unless it is labor in her own benefit and of her choice.

In her poems "Dust" and "Grease," which begin Nichols's collection, the assertion is that these elements, which have in recent history been the assumption of black women's work, are allowed to be, to exist unimpeded. Thus

> Dust has a right to settle
> Milk the right to curdle
> Cheese the right to turn green
> Scum and fungi are rich words[40]

Likewise,

> Grease steals in like a lover
> over the body of my oven.
> Grease kisses the knobs
> of my stove.
> Grease plays with the small
> hands of my spoons.

> Grease caresses the skin
> of my table-cloth,
> Getting into my every crease.
> Grease reassures me that life
> is naturally sticky.
> Grease is obviously having an affair with me.[41]

Dust and grease for Nichols are distanced elements which exist outside of her identity as a black woman, with no direct relation to her in terms of getting up and cleaning. For her, then, grease becomes a teasing playfulness which can be responded to in like manner. As a writer and as a black woman, she chooses to "sing the body reclining," that is, take space in a way which is directly counter to the expectations for black women:

> I sing the body reclining
> I sing the throwing back of self
> I sing the cushioned head
> The fallen arm
> The lolling breast
> I sing the body reclining.[42]

The images Nichols uses to articulate this reclining female body become "an indolent continent," "sluggish as a river," "as a wayward tree"—all representations of resistance in freedom and being.[43] Still there is a different intent in this reclining body in the sense of its own definition; it is not the body reclining as it waits for something/someone else (the phallus), but the body existing in its own right, as Brand also describes it, not in order to serve.

But Nichols is similarly clear about the representations of black female sexuality in all its triangulated implications as well as in terms of reveling in excess, as the "fat black woman poems" suggest. The black female body for her is expressed in the language of a certain geography and history which has been denied, as black woman's control over her own sexuality has been denied. Thus the links are made deliberately in terms of resistance to control in her "Black Triangle" poem, which recognizes its historical marking as it claims itself:

> And though it spares a thought for history
> my black triangle
> has spread beyond his story
> . . . carries the seal of approval
> of my deepest self.[44]

For Nichols, the triangular representations of the Middle Passage get re-presented as (reduced to) female sexual space, pubic, vulvic, and localized, but also historicized in resistance to patriarchal, misogynistic, imperialistic, and colonizing imperatives. The social construction of space between women's legs, or of always making space for something/someone else, as space to be filled by a baby or a man, has to be overturned.

Island space and women's space are imagined spaces of absence/presence. Caribbean seas extending to the Atlantic Ocean cover the unfathomable existences, unknown except by the daring, but nevertheless still with their own palpable existences and histories. The sea/the ocean is nevertheless a place of escape when island spaces become too confining, as the Haitian or Cuban refugees' existence reveals.

It may be that we still do not have the ability to fully imagine resisting women. In other words, the shock to men is that none of this may be about them at all. Black female space becomes a space of life and rich moisture, a delta of fertility, creativity, life. The open and the closed then refer to that sense of play, mystery, access to—but also the barring of entry to—these troubling locations.[45] The play between presence and absence, open and closed (for whom?), the social constructions of independence (political) and its opposite (old and new colonizations), the erased sexuality of women in their own right, and a variety of imaginary spaces permit us to eschew closure in any of these discussions.

*Credit:* A version of this paper previously appeared as "Black Bodies/Carnivalised Bodies," in *Border/Lines* 34/36 (1994): 53–57. The version appearing here has been revised for inclusion in this collection.

*Epigraph:* Alrick Cambridge, "Black Body Politics," in Alrick Cambridge, Stephan Feuchtwang, J. Clarke, and J. Eade, *Where You Belong: Government and Black Culture* (Aldershot, UK, and Brookfield, VT: Avebury, 1992), 117.

1. Cambridge, 110.
2. Judith Wilson, "Getting Down to Get Over: Romare Bearden's Use of Pornography and the Problem of the Black Female Body in Afro-U.S. Art," in Gina Dent and Michele Wallace, eds., *Black Popular Culture* (Seattle: Bay Press, 1992), 113.
3. Wilson, 118.
4. Snoop Doggy Dog, *Doggy Style,* Death Row/Interscope Records, 1993. See also bell hooks, "Sexism and Misogyny: Who Takes the Rap?" *Z Magazine* (February 1994): 26–29, for discussion of some of the related issues.
5. M. Nourbese Philip, "Dis Place: The Space Between," in Lynne Keller and Cristanne Miller, eds., *Feminist Measures: Soundings in Poetry and Theory* (Ann Arbor: University of Michigan Press, 1994), 287–316. This paper was completed before reading Marlene Philip's essay, and in some ways is in response to hearing her beginning to identify the "space between woman's legs" as worthy of a certain kind of discussion. I try to go beyond her formulations, however, in exploring the distinctions that can be made even as we talk about the black female body in public space.
6. Carolyn Cooper, *Noises in the Blood: Orality, Gender and the 'Vulgar' Body of Jamaican Popular Culture* (London: Macmillan, 1993). See also essays in *Small Axe* 11 (1; 2006). such as Idara Hippolyte, "Un-Theory," 186–192, and Bibi Bakare-yusuf, "Clashing Interpretations in Jamaican Dance Hall Culture," 161–173, in response to Cooper's subsequent work *Sound Clash: Jamaican Dancehall Culture at Large* (New York: Palgrave Macmillan, 2004).
7. Monica Rector, "Nudity in Brazilian Carnival," *American Journal of Semiotics* 6 (4; 1989): 67–77.
8. Rector, 70.
9. Analysis of Bakhtin in Mary Russo, "Female Grotesques: Carnival and Theory," Teresa de Lauretis, ed., *Feminist Studies/Critical Studies* (Indianapolis: Indiana University Press, 1986), 218.
10. Robert Stam, *Subversive Pleasures: Bakhtin, Cultural Criticism, and Film* (Baltimore and London: Johns Hopkins University Press, 1989), 93–94, 95.
11. Russo, 219.
12. Stam, 122.
13. Stam, 131.
14. Philip, 289.

15. Sylvia Wynter, "Beyond Miranda's Meanings: Un/Silencing the Demonic Ground of Caliban's Woman," afterword in Carole Boyce Davies and Elaine Savory Fido, eds., *Out of the Kumbla: Caribbean Women and Literature* (Trenton, NJ: Africa World Press, 1990), 355–372.

16. Rector.

17. Lemuel Johnson, "A-beng: (Re) Calling the Body In(To) Question," in Davies and Fido, eds., *Out of the Kumbla*, 111–142.

18. Rector, 70.

19. Philip, 287–316.

20. Katrina Hazzard-Gordon, *Jookin': The Rise of Social Dance Formations in African-American Culture* (Philadelphia: Temple University Press, 1990).

21. Dionne Brand, "This Body for Itself," in *Bread Out of Stone: Recollections on Sex, Recognitions, Race, Dreaming and Politics* (Toronto: Coach House Press, 1998), 47–49.

22. A. R. Williams, "The Wild Mix of Trinidad and Tobago," *National Geographic*, 185 (3; March 1994): 66–88. All of the other representations in the article juxtapose bourgeois culture (of art galleries) and working class black and Indian cultures for their exotic implications.

23. See the work of Kamala Kempadoo and others in the sex tourism research group.

24. See, for example, Robin Wiegman, "Black Bodies/American Commodities: Gender, Race and the Bourgeois Ideal in Contemporary Film," in Lester D. Friedman, ed., *Unspeakable Images: Ethnicity and the American Cinema* (Urbana and Chicago: University of Illinois Press, 1991), 308–328.

25. Pearl Primus Master Class, State University of New York–Binghamton, May 1993.

26. Pearl Primus Master Class, May 1993, and interview with Valeria Thompson, her student, November 1993.

27. The phrase is also used as verbal exclamation within the text of calypso and even as title in various calypsos; it is perhaps more significantly present within the performative aspects of carnival street dancing and "jumping up."

28. M. Nourbese Philip in "Dis Place" writes in a wonderfully creative and thoughtful way about the dialectic between inner and outer space in the representation of the black female body.

29. Antonio Benitez-Rojo, *The Repeating Island: The Caribbean and the Postmodern Perspective*, James E. Maraniss, trans. (Durham, NC, and London: Duke University Press), 1992.

30. One way of reading the text of the Haitian "boat people" fleeing tyranny in their island space is to see the sea as space and the boats as temporary island space, constrained, at times treacherous, subject to capture and the like. An alternative reading is to see the tremendous navigation and boating skills in which, almost out of nothing, workmen are able to create movable vessels which successfully take their passengers to their intended destination.

31. Jamaica Kincaid, *A Small Place* (New York: Farrar, Strauss and Giroux, 1988).

32. See Michel Foucault's work on the "gaze" in *The Birth of the Clinic: An Archaeology of Medical Perception* (New York: Vintage, 1994 [translation]) as it relates to the development of medical technology and the field of medicine itself; and Luce Irigaray's *Speculum of the Other Woman* (Ithaca, NY: Cornell University Press, 1985).

33. Hortense Spillers, "Mama's Baby, Papa's Maybe," *Diacritics* 17 (Summer 1987): 65–81.

34. E. Jane Burns, *Body Talk* (Philadelphia: University of Pennsylvania Press, 1993); and Zillah R. Eisenstein, *The Female Body and the Law* (Berkeley: University of California Press, 1988).

35. Luce Irigaray, *The Sex Which Is Not One*, Catherine Porter and Carolyn Burke, trans. (Ithaca, NY: Cornell University Press, 1985). Also see a portion of Chapter One, "Of Bodies, Secrets, and the Making of Histories," in Leslie A. Adelson, *Making Bodies, Making History: Feminism and German Identity* (Lincoln and London: University of Nebraska Press, 1993), 13–22, which develops issues of cultural representations and inscriptions and the exterior and interior of women's bodies.

36. Toni Morrison has one of her characters, Baby Suggs, make this point in the sermon in "The Clearing" in *Beloved* (New York: Knopf, 1987), when she dramatically challenges people who had left slavery behind to relearn how to love the various parts of their bodies.

37. See Judith Lynne Hanna, "New Moves for Women," in *Dance, Sex and Gender: Signs of Identity, Dominance, Defiance, and Desire* (Chicago: University of Chicago Press, 1988), 201–216. A great deal of new work re-reads dance, movement, the body within the context of women's pleasure.

38. See Molly Ahye, *Golden Heritage: The Dance in Trinidad and Tobago* (Petit Valley, Trinidad and Tobago: Heritage Cultures Ltd., 1978).

39. Brand, "This Body for Itself," 31. Dionne Brand, "Madame Alaird's Breasts," in *Sans Souci and Other Stories* (Toronto: Williams-Wallace, 1988), 79–84. Brand, in *Bread Out of Stone,* also cautions against avoiding the heterosexist trap in a reading of Caribbean gender.

40. Grace Nichols, *Lazy Thoughts of a Lazy Woman* (London: Virago, 1989), 3.

41. Nichols, 3.

42. Nichols, 3–4.

43. Nichols, 4.

44. Nichols, 25.

45. A chapter by Renee Hirschon, "Open Body/Closed Space: The Transformation of Female Sexuality," in Shirley Ardener, ed., *Defining Females: The Nature of Women in Society* (Oxford: Berg Publishers, Ltd., 1993), 51–72, looks at Greek society and the way in which "closing" is associated with misfortune, whereas "opening" is associated with the positive in sociability and life. Her point, though, is that "opening" in (hetero)sexuality is "effected for the woman through the man . . ." (p. 63). She notes further that the road and open space are associated with women who have "lost their reputations," and thus seclusion is the desired location for women. I find Hirschon's points interesting, but she is not using the formulations in the same ways that I am, and there are some clear distinctions in the meaning of these concepts in Caribbean society. For example, the "road" in Caribbean culture is associated with mobility as my own work shows in *Migrations of the Subject: Black Women, Writing and Identity* (London and New York: Routledge, 1994).

TERRI FRANCIS

## 20 Sighting the "Real" Josephine Baker
### Methods and Issues of Black Star Studies

> Because stars have an existence in the world independent of their screen/
> "fiction" appearances, it is possible to believe (with for instance ideas about
> the close-up revealing the soul, etc.) that as people they are more real than
> characters in stories. This means that they serve to disguise the fact that they
> are just as much produced images, constructed personalities as "characters"
> are. Thus the value embodied by a star is as it were harder to reject as
> "impossible" or "false", because the star's existence guarantees the existence
> of the value he or she embodies.
>
> —Richard Dyer, *Stars*

**When conducting research** on a celebrity such as Josephine Baker, the essential work is not separating fact from rumor, but understanding the ways in which intertwined strands of rumors and facts about her circulate and gain meaning among a variety of believing audiences, constituting what Dyer refers to in the epigraph as the constructed existence or public persona, which is independent of her screen fiction. Baker's real voice is almost a holy grail and I would not argue for abandoning its pursuit, but the reality is more complicated than any notion of basic authenticity would imply because her expressivity is far from a discrete split between the public and private. Certainly, Baker had a private life, but what emerges in her performances and papers is a prismatic construction that contains facets of her many iterations in the world, on the screen, and in written texts. And yet Baker's reality—her private thoughts and struggles, which are often tied to a notion of her agency—remains a natural, ethical, and perfectly legitimate scholarly and personal concern. Many audiences typically hope that artists who work in nonverbal forms will interpret the work and give a sense of authorial intentions. A routine convention in celebrity interviews is asking controversial artists to clear up misunderstandings. The more audiences are aware of the degree to which a star is constructed, the more they may crave a sense of that star's realness and even normalcy. However, given the particularly poignant vulnerability, exposure, and double jeopardy as a black woman that Baker endured in early twentieth-century colonialist and masculinist contexts, it falls to a feminist ethics, among others, to take up the question of Baker's agency carefully. Baker's real agency, however, resides refracted in a prism of complexity.

Baker authored her own stardom, characterized by combinations of reality and fiction, with the help of the press, particularly those journalists such as Marcel Sauvage, who wrote her memoirs with her, and most significantly through her films. In the short film *Le Pompier des Folies Bergères* (anon. 1928) and the features *Siren of the Tropics* (Henri

Étiévant, 1927), *Zou Zou* (Marc Allégret, 1934), and *Princesse Tam Tam* (Edmond T. Gréville, 1935) she re-enacted the rise to fame that made her such a powerful symbol of African American success in Paris. Yet narratology of Baker's films reveals more than her biography. Baker used her stardom at turns as a shield, a cage, and a window for her personal dreams and ambitions, such as love and family life at her home Les Milandes and the adopted children of her Rainbow Tribe. How do researchers begin to develop a method for handling such a contradictory and complicated subject? What then does it mean to do a history of Josephine Baker's film career? How to move beyond Baker's compelling biography? Can such a project be about more than only Baker? Part of the research I have done involved French periodicals as well as scrapbooks and scattered letters, her novel, and her co-authored autobiographies. There exists what I think of as Baker's museum of documents, which includes images and written material. My history of the figure of Baker is grounded in the films themselves because they metaphorically reference her career. The images are themselves a museum about the history and construction of Baker's stardom. They record and reveal the conceptualization of the figure of Baker. In Baker's films she plays characters that are very similar to her music hall persona: "exotic," naïve, and seemingly given to spontaneous singing and dancing. These movies' narratives are structured around the transformation of Baker's character from a naïve, exotic, talented, and anonymous person to an acclaimed music hall star. Baker's films tend to retell her own transformation from dance novelty to recording artist and film star. Whereas her biographers have looked to Baker's life and times to contextualize and explain Baker in a nearly empirical way, I contend that the fiction of Baker, or her persona, has yet to be properly understood. Baker is quoted in Phyllis Rose's biography as saying "In all the shows I've done, films included, I've insisted that the different stages of my life be represented. Each time. . . . There is just a hint of a reminder of the past, for the sake of contrast."[1] Thus the basis of the kind of textual history I am pursuing is the idea that the narratives, performances, mise-en-scène, and images of Baker's films encode an account of Baker's stardom. Precisely because of the ways in which Baker's authorship is fractured by the participation of screenwriters, directors, co-authors, reports, and the cultural milieu that shaped how audiences would interpret her, the imperative becomes to look carefully at what Baker does, what her film stories are, how she delivers her lines, and what settings she inhabits—in other words, close textual analysis promises to illuminate new frameworks for thinking about Baker's performances.

But the tendency to biographize rather than theorize remains. As existing Baker scholarship has demonstrated, Baker received significant attention in the general French press in the form of promotions, publicity, and reviews of her music hall performances, products she advertised, and activities and appearances around town. These are documented in the written press, for example *Le Monde,* and *Midi-Soir,* as well as in newsreels. The gap between Baker's on and off-stage personas is ever present. For instance, a fascinating newsreel in the collection of the Forum des Images in Paris shows Baker trying on wigs. In it, we see an aspect of her construction. But in showing Baker the entertainer trying on wigs—as a spectacle itself—the duality of the real Baker and the performative Baker is fractured, although they remain whole in the prism of Baker's persona. Doing a film history of Baker involves seeing whether and how film journals and magazines of the 1920s and 1930s registered Baker. But the most crucial issue to be resolved is

figuring out a framework and a vocabulary for thinking about the structures of Baker's performance style. Understanding Baker's particular condensation of race and film, performance and authorship, as a black American woman in France opens up new perspectives on black Diaspora cinemas and cultures.

Film periodicals that date from Baker's zenith, the 1920s and 1930s, that specialized in cinema, while not being aimed exclusively at film technicians and filmmakers, represent an area of research that could potentially lead the way to new questions about Baker's reception and presence in France because they venture beyond the scope of the generalist reading and reception that previous Baker scholarship has analyzed. European film journals such as *Cinemagazine, Mon Cine,* and *Close-Up* were aimed at readers who had an artistic or intellectual interest in films. Selecting from among extant issues from the 1920s and 1930s, I looked for mentions of Baker's career in order to see whether and how movie-ologists registered or perceived the popular phenomenon "La Venus Noire" amid articles in which writers sought to institutionalize and celebrate aesthetics, techniques, and theories of cinema. Such sources would lend themselves to understanding Baker's role as an actress in film culture, which can only add to what we know about her status as a personality in popular culture. Later, I also expanded my search to include periodicals that were more for cinephiles and that would focus on movie stars, such as *Vedettes de Cinéma* and *Cinéma.*

I found that a limited number of figures of African American cinema and performance were noted across the collection of journals. These include Paul Robeson, Daniel L. Haynes, Nina Mae McKinney, and other performers in King Vidor's *Hallelujah* (1929), as well as Clarence Muse (mistakenly cited as Charles Muse), who plays "A Blind Negro" in *Cabin in the Cotton* (Michael Curtiz, 1932). I saw one feature article in *Cinéma* (August–September 1927) that served as advance publicity for *Siren of the Tropics.* Baker does occasionally appear in these film-oriented periodicals through advertisements of her films, but she received less publicity than other stars and her celebrity somewhat unsurprisingly tended toward an exoticism that capitalized on fantasies about black female Others. Based only on this group of sources, one would be led to conclude that while Baker was a phenomenon of some import to French popular culture, her film career was somewhat marginal to the intellectual institutionalization of cinema and also to the popular conception of the film starlet. Such conclusions are not incorrect, however, Baker's signification in the French star system resonates widely, but particularly in Europe and the United States. As a black American French movie celebrity, Baker's stardom, while limited in scope from one angle, appears from another to be the gateway to understanding both the unconscious and the overt cinematic racializations of nonwhites in early film history—and not only in European or Hollywood cinema but in African American independent films most significantly—which underpin mythologies of whiteness and womanhood.

There is, however, an important caution regarding an analysis of Baker through the paradigm of identity. When we ask what is required to account for Baker's ideological/cultural functioning as a star, we look for materials of promotion, publicity, films, and criticism and commentaries. However, a traditional film studies analysis of Baker's star signification provides an inadequate method for understanding the role of cultural specificity, which is essential in Baker's stardom—beyond symptomatic terms. Baker is far more than a symptom of colonialist, masculinist contexts. Further, it seems important

to go beyond celebrating talent, magic, or charisma—although audiences' attraction to a performer through their perception of these qualities is absolutely important. At the point of such a potential impasse, a close reading of the film's surface, a textual analysis potentially yields a balance that integrates the power of Baker's creativity within the limitations of the entertainment industry in Paris. Analyzing black stars in cultural context necessitates empathy with the ambition and imperative within African American film cultures toward identification and the density of the term *representation* in which political representation is easily conflated with cultural representation.

African American cinema abounds with reflexive references to the black image on film and in the wider cultural landscape. For example, race films were created for segregated black moviegoing audiences. These films addressed issues and featured story lines and characters involving the black community that were absent from mainstream or Hollywood cinema. They were created partly in response to both the dearth of black representation and the predominance of misrepresentation of black people. Think back to Spike Lee's *Do the Right Thing* (1989): When "Buggin Out" (Giancarlo Esposito) demands that Sal put some "brothas" on the wall (pictures of famous black people) at Sal's Famous Pizzeria, based on the idea that the restaurant is located in a black neighborhood and has a 100 percent black customer base, he is asking for cultural (masculinist) representation and recognition through stardom. Identification, representation, and recognition are all bundled together in the metaphor of "brothas on the wall" for Buggin Out. Despite the gains made through protest and decision making in social institutions, in the politics of the 1960s and 1970s, Buggin Out views the realm of culture, particularly celebrity or stardom in popular media, as a meaningful realm in which to gain some recognition. With this sequence in *Do the Right Thing*, Lee is picking up on a long-standing urgency on the part of black people as a collective—a desire that has been expressed in a variety of ways—to be seen as a community with cultural structures and a meaningful existence, often through exemplary folk. As an international celebrity and as the rare black woman to star in feature films in the 1920s and 1930s, Baker seems marginal to stateside black American concerns by virtue of her phenomenal success in Paris. However, through film and live performance Baker resonated with issues of representation and the visual dimensions of what W.E.B. Du Bois described as "double-consciousness," or seeing oneself through the eyes of others. In Baker's case, these eyes were contemptuous, envious, and fascinated. Both Du Bois and Baker, in very different ways, responded to transnational formations of blackness in visual and performative frameworks.

The figure of Baker was a flashpoint of African American ambitions for representation in media and culture. In many ways, she went beyond Du Bois, creating what I would call an embodied understanding of a range of dilemmas of black identity and culture. Not just looked at, Baker saw, beyond the eyes of others, under the heat of a black gaze the visual problem with which Du Bois grappled through his writings but even more concretely through the photographs in the Negro Exhibit.[2] For example, in *Zou Zou*, Baker plays the title character, who is a laundress who is drawn to the glamour of the music hall. Following the conventions of backstage musicals, she finally, somewhat reluctantly, takes the stage for a purpose. In this case it was partly to earn money to get her love interest Jean, who was wrongly imprisoned, out of jail. In the film's denouement, Zou Zou sees Jean released from prison, but he is embracing her friend

Claire. Distraught, tears streaming down her face, Zou Zou runs along a street plastered with posters announcing her music hall show. The posters resemble the ones Baker used for her own stage shows, so there is a significant correspondence between the diegesis and the still-fictional life constructed for an audience beyond the film. As the camera tracks Zou Zou running, at times she seems to run toward the viewer. She has no other reference point except the reproductions of her painted likeness. It is a moment of profound invisibility and rejection, for it is the climax or anti-climax of Baker's longing for love and domesticity through a union with Jean. Instead of intimacy, she gets stardom. Zou Zou wins acclaim and transcends reality into stardom but is left no other society, culture, or family than her posters and performances can offer. This sequence in *Zou Zou* offers an example of how Baker's nondiegetic persona and her diegetic character double-exposes or are layered in the film's fictional world.

Baker was singular but she contained multitudes. There were certainly other black performers and other black women performers. Baker was part of the phenomenon of black success among entertainers in Paris and other European cities. However, there is an element of peerlessness, of being the only one at the core of her particular success. Given her success, it seems critical to ask what becomes of the cultural specificity that in many ways accounts for the fact that she is a star to begin with? Her blackness is the basis of her status and persona as exotic Venus Noire. Baker is neither totally of St. Louis, Missouri, nor totally Parisian. The crux of Baker's persona is her performance of transition, of identity as change. Further, identity and stardom are complex for Baker because she performed what I would call an elastic ethnicity, and her characters were by turns Caribbean, African, and American. Baker intervened in a history of black stereotyping in Hollywood by establishing her career outside of it. Like so many African Americans who established their entertainment or artistic careers outside of the United States, she provided a point of recognition and representation. Studying Baker's stardom requires more culturally specific attention to concepts of recognition and invisibility than what Dyer may provide, although his attention to whiteness in subsequent work has marked a paradigm shift.

Although film history is often understood in fairly concrete terms—the circulation and condition of film prints, venues of exhibition, screening history, production/reception histories, and locating outtakes—Baker's documents are incomplete at the moment in this regard. It is necessary then to account for Baker by theorizing and analyzing her stardom through the idea of presence. By working in an entanglement of sexuality, ethnicity, and comedy, the expected gap between the persona and the person becomes less interesting, in a way, than the production and conceptualization of the persona.

I am as torn as anyone between the allure of Baker's "bananas" comic-erotic persona and our duties to identify Baker the person, and this tension is perhaps nowhere more fundamental than on the question of sexuality. Baker's celebrity was both racialized and sexualized, particularly in the French entertainment periodicals that covered her. For example, when journalist Dany Gérard interviewed Baker for *Paris Music-Hall* in 1933, he asked the world's most famous black woman and the first international modern star this scintillating question: "Do you prefer white men or black men as lovers?" Baker responded by asking why he bothers with such "banal questions." Further on, Gérard comments, "The more I looked at her, the more I felt vaguely that she doesn't tell me

what she thinks."[3] In this brief interaction Baker can be seen as either guarded or coy. We can see that while Baker was a star and received some of the rewards that come with that status, "she was simultaneously locked into a derogatory and objectified essence of black femaleness."[4] In turn, she was subjected to objectifying forms of extra-performance publicity. Gérard's question reflects the significance of sex and sexuality in Baker's reception, to the point where this accomplished woman was reduced to referee-ing the fascination of others with her. Not that attention to Baker's erotics is entirely out of line, since pleasure was Baker's product as an entertainer. Still, Gérard's question provides an opportunity to think generally about the ways sex is used in the discourse around Baker; his question about Baker's sexual preferences shed light on the aspect of her persona that sees her as a figment of sexual competition between men.

What might also be at work here is the way in which Baker was taken as a represen-tative of her race and gender, here problematically stereotyped as hyper-sexually aware and available, but not as a serious performer. For instance, the French music hall per-former Mistinguett, who was Baker's closest rival, was certainly portrayed as sexy and objectified, but articles about her tend to emphasize her work on the stage rather than her sexual preferences in "real" life. Pictures of white women stars in the French peri-odicals of the day tended to be notably more demure, even if they are also nudes. Baker's nudity, by contrast, is presented with a uniquely exoticizing kinesis, through her cos-tumes, which shimmer and involve moving parts, while her body seems more exposed in ways related to the fact that, even in a still photograph, her persona is associated with bursts of seemingly spontaneous and uncontrolled movements rather than poses—at least in the earlier years of her career. Baker's reception history in France is character-ized therefore by two features: collapse of persona and person as well as a conflation of gossip and ethnography. The first, according to Dyer's explication of stardom cited in the epigraph, is a normal part of Baker's celebrity formation. Baker's interviews and co-authored autobiographies constitute secondary spheres of not much less fictional performances that complement (for her contemporary audiences) and complicate (for today's scholars) her primary fictional performances on the stage and screen.

Two newspaper articles, respectively from the middle and later years of Baker's career, offer two more examples of how slippery the notion of realness can be in Baker's star-dom. In an article he wrote for the *Chicago Defender* in 1944, Langston Hughes relates a story about how Baker had received him in her dressing room in 1938 at the Folies Bergère.[5] He writes that she spoke to him mostly in French, and when she spoke in English she did so with a French accent. He said he found it charming, but this impor-tant tale in the folklore of Josephine Baker has greater significance. This story and Hughes's telling of it is an example of what Michel Fabre has called "a site of recogni-tion,"[6] but in a strange way that raises questions such as: What is being recognized? Is it Baker's ability to transform her persona? Is it Hughes's veiled envy, springing from his own ambivalent desire about his own possibilities of self-remaking in Paris? The history of African American migrations and sojourns to Paris is well documented. Europe, particularly Paris, often functioned largely as a utopian space, free of racial prejudice and the violence associated with Jim Crow. However, apart from the political liberties Paris offered, the city as it was personified in Baker's career especially, appealed to a collective black fantasy life in which a person could play out and play with personal and racial identities in ways that were less accessible in America. In Paris, freedom could

be cast as modernity, consumable as stylish, urban clothing and posed as a certain self-possessed attitude conveyed through gestures and body stance.[7] For a price, Paris offered Hughes, Baker, and so many others an education in life and place to discover their artistry.[8]

The main points of Hughes's article are, however, ostensibly the fact that Baker's obituary had been printed while she was very much alive and that at that moment in 1944 she had received honors for her efforts on behalf of the Resistance. The comeback again star was also touring as well. Hughes describes with pride the way that Baker came to be meaningful to Parisians and others after the war, saying "she has made of her song, *j'ai deux amours,* a kind of prayer that brings tears streaming down the faces of men, women and children who remember Paris." In many ways Baker was a symbol of Paris's glamour and carefree attitudes—or at least the imagination of it as having been such before the war. Hughes's article demonstrates the way that the career of Baker circulates as a concept, fusing fact and gossip into myths that aggrandize and abstract the star apart from the real woman entertainer.

In 1974, an interviewer for a Cape Town newspaper talks with Baker about rumors:[8]

"Yes, the bananas were true," she chuckles. But she insists some of the wilder legends are sheer imagination. Like the one that she stripped in the corridor of the Orient Express while the chef made her coffee. And one in a local paper which claimed she started singing in Harlem nightclubs at 8 years old. "Now what could I do in a Harlem nightclub at 8 years old? I ask you. Newspapers are quite extraordinary."

The next paragraph reads:

Josephine was born in St. Louis of Martinique parentage. But Paris soon became her home—the Paris of Picasso, Matisse and Hemingway. She danced with the Tiller Girls in *L'Art Negre.* With bundles of fruit and flowers which glowed when the lights went out.

It is ironic that the article mobilizes a bundle of fantasies about Baker's origins as well as a nostalgic recalling of her luminous performances, while claiming to clear up mistakes. The phrase, "With bundles of fruit and flowers which glowed when the lights went out," sounds like a fragment of a remembered dream, an image that captures reviewers' efforts to embody Baker's ephemeral music hall performances on paper. Baker was born in St. Louis, Missouri, and none of her biographers have documented any familial links of hers in Martinique. Paris certainly was her home, but as the capital city of a colonial power, the city of light was more than a stage for glamorous luminaries. Baker's stardom brings together idealizations of the city of Paris, which obscure its gruesome imperial realities with nostalgia for both the city and Baker.

Baker's stardom was reflected in and constructed through particular moments in her multimedia film, stage, and recording career. Baker acted in four feature films and appeared in a variety of newsreels, television specials, and concert footage. She co-authored five autobiographies, and there are scrapbooks, documentaries, and numerous newspaper articles that comprise her published and unpublished papers. In my research,

one of my clearest agendas has been to distinguish and understand the issue of Baker's authorship—which goes to agency. Since most accounts of women (particularly black women) in film convincingly describe their being controlled in many ways by the apparatus of the film industry, the gaze, and the pleasures of the spectator, a feminist ethic asks: What role did Baker play in the choreography of her dancing? How did she contribute to her films other than through acting? These are some of the questions that address Baker's agency through textual specificity.

At least three French avant-garde filmmakers of the 1920s took notice of Baker's dancing, especially her Charleston, and referenced it in their films: Man Ray, Jean Renoir, and an anonymous artist. My analysis below will focus on a sequence from each of the following: *Emak Bakia* (Man Ray, 1926), in which a medium shot shows legs framed from the knees down performing the dance known as the Charleston dance; *Charleston* (Jean Renoir, 1927), in which a classic blackface minstrel and a white woman character, costumed as an exotic or primitive, dance the Charleston and other moves, which are enhanced by camera tricks; and *Le Pompier des Folies Bergères,* in which Baker appears first as a subway attendant then is transformed into her recognizable stage persona through dancing and camerawork.

These films, oriented by a character's subjective viewpoint, are marked by mental images such as dreams, hallucinations, memories, point-of-view shots, superimpositions, blurring, distorting features through close-ups, framing, and a moving camera. They emphasize a personal vision. While some conventional Impressionist films used these devices sparingly as punctuation in the narrative, experimental short films featured them continuously. *Emak Bakia, Charleston,* and *Pompier* all show a kind of imaginary world that is simultaneously sci-fi yet technologically simple, futuristic yet past. Baker's performance is presented as iconic of this primitivist modern world. However, I am not saying that Baker is literally referenced in these films and that this is the only way to understand the films. I am saying that because of the references to black performance that circulated in a context that Baker shared, these films enable us to view Baker's performances more closely and with greater insight, as part of a wider range of aesthetics that resonated with the avant garde.

Renoir's *Charleston* is a narrative avant-garde film that plays with the dual heritage of black performers, particularly Baker's in Paris. In this short sequence a white woman, figured as primitive through her body language and costume, dances the Charleston with a black minstrel figure played by vaudevillian Johnny Hudgins. He is dressed in blackface, floppy hat, tattered dark clothing, and walks with a slow drag reminiscent of Bert Williams's stage character. She is dressed in a costume reminiscent of Baker except for the hairstyle—she is wearing beads, large earrings, and a raffia-style skirt. She appears to teach him the dance, in a spoof about updating minstrelsy. Baker's persona is taken apart. Her dual heritage of late nineteenth-century minstrelsy and of the flapper's fashionable physicality with high kicks and arms thrown out away from the body is made apparent.

Man Ray's *Emak Bakia* was conceived following surrealist principles: "automation, improvisation, irrationality, psychological sequences and an absence of logic in the narrative."[10] Man Ray's cinepoem essentializes cinema to its basic elements of light and dark, movement and image. The film is a spectacle of moving light, such as when blurred spheres of light revolve on a black background. Without any further context,

the moving lights exist as the "story." Many sequences feature ordinary objects animated or brought to life through cinematic means. In one sequence, he uses images to project the idea of visualized sound. The brief Charleston sequence brings together this concept with that of celebrity.

In Jean-Michel Bouhours's account, "The driver gets out of the car. We only see her legs. . . . The same legs dance the Charleston accompanied by music and the image of a banjo."[11] But in fact there is a cut between the sequence in which the viewer sees legs, possibly those of the driver, stepping out of a car and the Charleston sequence. There are several women stepping out of a car but they are only filmed from the knees down. The legs appear to belong to different women dressed similarly and of a similar skin tone. At the cut, the viewer sees a pair of legs dance the Charleston on what might be a sidewalk. The Charleston sequence is composed of a shot that frames the legs up to the knees intercut with shots of a banjo. The hands playing the banjo are blurred. This shot is high contrast, with the banjo appearing very white against a background that is black, possibly the player's costume. The shots of the Charleston are in a different visual mode. It is in grayscale, resembling newsreel footage. The film's nonlinear, fragmentary form suggests that it is composed of pieces of either previously existing film or scenarios created especially for the cinepoem. Man Ray deliberately creates confusion as to the identity of the dancer, though the dancing feet combined with the banjo are clearly suggestive of Baker and American jazz music in the French context. Though the shot of the legs getting out of the car and those dancing the Charleston appear to be in a different space, there is an association because of the similarity of the composition. Since the point of view is scattered, it is unclear who is dancing in the sequence and who is seeing it. The question of whether it was Baker in the film emerges. So far documentation has not supported this. What is perhaps more important is that Baker is quoted. This means that her distinctive aesthetics were recognized and that she was seen as embodying and authoring a unique aesthetic that lent itself to translation in film. Ray evoked the sound and jazz form of black music through images of dance performance, namely the Charleston and the banjo, which the French tended to associate with jazz. The Charleston is pared down to feet, and one could even argue that black culture is pared down to this particular pair of dancing feet. The film cannot be said to have a center, and it is difficult to name themes. However, the anonymity of the dancer creates an interesting tension with the recognizable figures in the film, such as Kiki. Are those dancing legs the equivalent of Kiki's famous face? In this abstract film, widely known celebrities are abstracted or reduced to essential components of their persona or performance.

*Le Pompier des Folies Bergères* deals with Baker's recognizability as well. The film features the Charleston and its most well known performer, Baker, in an extended sequence. The film's humor is based on the hallucinations suffered by a supposedly inebriated fireman whose drunken subjectivity constitutes the film's point of view as well as the pretext for the superimpositions, blurring, extreme close-ups, diagonal camera angles, dissolves, and a sense of fragmentation that all serve to make the viewer aware of the camera's role in shaping the story. The narrative's use of these modernist cinematic devices aligns avant-garde visions with subjective disorientation, all connected to Baker's screen performance.

Baker figures in the film as a psychological and visual phenomenon—she is part of the diegesis as a character and as mise-en-scène. Baker, who is filmed theatrically, is

folded into the film's visual circus of avant-garde techniques, making it clear that her high-speed, disjointed, and angular movements were an inspiration for the film, and the fireman's unexpected encounter with her in the subway is the film's narrative as well as its visual core. By filming her theatrically the filmmakers appear to be taking her stage show whole and inserting it into this disorienting experience. Through the story of the film, it becomes apparent that Baker's performance is an aesthetic cause, a stable center, and that her aesthetics are equivalent to the fireman's wine. Baker's dancing does not need weird angles because it contains them.

In these films, Baker's dance was cited as a pretext for employing camera tricks that manipulated the temporality of natural motion in these movies. These three films are examples of the fact that some of the most compelling responses to or studies of Baker have been through other performers' or filmmakers' quotations and revisions of her work. They quote her performance style through poses, dances, voice, and costume. Josephine Baker is a museum. Calling Baker a museum is also an intervention on the side of her authorship, for Baker's personal energy, her presence, was at the center of her persona. She is a body-museum in that her dance is an assemblage of exotic dances, emphasizing her conceptual influence rather than contradicting it.

As a star, she was not only famous but she functioned as a figure of recognition. She was a cultural institution, a museum that represented cultural structures of the black Diaspora community. Baker seemed always aware of her performance of a social type— the outsider woman desirous of assimilation and domesticity. She was a collective, and she achieved this configuration by playing virtually the same character several times and claiming each time that the character represented her own life—then in other moments blending her biography with the collective history of black Americans. For instance, the prefatory titles of one her costume films celebrates Baker's rise from the cotton fields of the South. Her authorship did entail providing ideas for her films—she wanted them to represent her life. But it was also relevant to her history in the film industry, and not just the film/character. Regarding Baker as a museum invokes a way of envisioning her cultural specificity, despite her wide-ranging importance to European and American film, media, and performance cultures. The museum is not only all the materials, which here would mean the sum of Baker's performances on film as well as other recordings and texts, but also the interpretation—how we come to understand Baker's protean place in culture and the arts.

I have discussed several filmmakers' quotations of Josephine Baker's presence in their work. Baker is evoked or quoted in French experimental short films in the ways that they reveal an understanding of Baker's aesthetics and their relevance to a filmmaking practice. Man Ray's *Emak Bakia: A Cinepoem,* Jean Renoir's *Charleston,* and the anonymous *Le Pompier des Folies Bergères,* in which she quotes herself, all point to the essential elements of her dance: principally, its angularity, speed, and multiple sources. Sighting the real Josephine Baker—analysis of her film presence, not just the production history of her films—yields the clearest and most fruitful understanding of Baker's stardom. In these and other films, the narratives, the mise-en-scènes, and her performances provide an understanding of Baker that is in many ways absent from the written record.

While Baker may have been marginal to the textual institutionalization of film aesthetics in journals, the films I have discussed represent the ways in which filmmakers sought inspiration in the formal qualities of her performances, in contrast to the popular

fascination with her sexuality I referenced earlier. Seeking to express the era's concern with fragmentation and multifaceted views in form, movement, and perspective in their work, several filmmakers seized upon black American dance as expressed in Paris by Josephine Baker. Both dance and film are spectacles of motion and disjuncture that thrive on creating a feeling of spontaneity by playing with rhythm. It is in many ways natural that filmmakers, whose own art is one of assemblage, time, and motion, would draw upon Baker's disjointed dancing, its syncretic heritage, and its collage presentation. Evocations of Baker in these films are not mere cameos or offhand references to a famous figure of the era; they bring Baker's body language into the film as an aesthetic force—with the codes of race, gender, and power that she brings with her, as well as the American and French performance histories and theoretical issues in which she was entangled.

*Epigraph:* Richard Dyer, *Stars* (London: BFI Publishing, 1982), 22.

1. Phyllis Rose, "Queen of the Colonies," in *Jazz Cleopatra: Josephine Baker in Her Time* (New York: Vintage, 1991 edition; published 1989), 165. See also Marcel Sauvage and Josephine Baker, *Les Mémoires de Joséphine Baker,* illustrations by Paul Colin (Paris: Éditions Kra, 1927), 213.

2. This is a collection of photographs Du Bois curated and displayed at the 1900 Paris Exposition. For more on this project, called the "Negro Exhibit," see Shawn Michelle Smith, *Photography on the Color Line: W.E.B. Du Bois, Race and Visual Culture* (Durham, NC: Duke University Press, 2004).

3. He writes, "Plus je la regarde, plus je sens confusément qu'elle ne me dit pas ce qu'elle pense." Dany Gérard, "Joséphine noircie par ses soeurs," *Paris Music-Hall* (January 4, 1933), 23–24 [reproduced in Arsenal Pressbook].

4. T. Denean Sharpley-Whiting, *Black Venus: Sexualized Savages, Primal Fears, and Primitive Narratives in French* (Durham, NC: Duke University Press, 1999), 107.

5. Langston Hughes, "Capt. Josephine Baker," *Chicago Defender* (August 5, 1944).

6. Michel Fabre, "International Beacons of African-American Memory: Alexandre Dumas père, Henry O. Tanner, and Josephine Baker as Examples of Recognition," *History and Memory in African-American Culture,* ed. Geneviève Fabre and Robert O'Meally (New York: Oxford University Press, 1994), 122–129.

7. In the musical-comedy short *Rufus Jones for President,* Ethel Waters sings "Underneath a Harlem Moon," which contains the following lines:

*We just live for dancing / We're never blue or forlorn / Cause it ain't no sin to laugh and grin. / Once we wore bandanas* (actor makes tying motion about the head) */ Now we wear Parisian hats* (actor puts hands on hips and turns head to make a profile shot) */ Once we were barefoot / Now we're sporting shoes and spats. / Once we were Republicans / Now we're Democrats.*

"Underneath a Harlem Moon," sung by "Mrs. Jones" (Ethel Waters) in *Rufus Jones for President,* dir. Roy Mack, perf. Sammy Davis Jr. and Ethel Waters, 1933. In these lines, the imagined, idealized versions of Harlem and Paris are referenced. Style becomes a mode for expressing self-assertion, creativity, and making a break with the rural South, figured as past. In a curious way, the song is about migration and the possibilities of transformation.

8. Josephine Baker is such a potent signifier of freedom to self-construct in Europe that Stew cites her in rousing tribute in his musical *Passing Strange,* now adapted to film by Spike Lee (*Passing Strange,* Spike Lee, 2009).

9. *Radio Times* (Capetown, South Africa), November 21, 1974.

10. Jean-Michel Bouhours, "Fichez-moi la paix! Essai de reconstitution d'*Emak Bakia,*" in *Man Ray, directeurs du mauvais movies,* ed. Jean-Michel Bouhours and Patrick de Haas (Paris: Centre Georges Pompidou, 1997).

11. Bouhours, 49.

WILLIAM JELANI COBB

## 21  The Hoodrat Theory

**The flyers posted in Cosby Hall** said it all: "We Care About Your Sister, But You Have To Care About Ours, Too." The slogan explained the position of the student-activists at Spelman College whose protests over Nelly's 2004 "Tip Drill" video led the artist to cancel his scheduled appearance for a bone marrow drive on the campus. But in a real sense, their point went beyond any single rapper or any single video and went to the center of a longstanding conflict in the heart of the black community.

We have, by now, been drowned by the cliché defenses and half-explanations for "Tip Drill," most of which fall into a formulaic defense of Nelly's "artistic freedom" while casting hellfire on the unpaid women who participated in the creation of the video. The slightly more complex responses point to the pressing need for bone marrow donors in the black community, saying that saving the lives of leukemia patients outweighs the issue of a single soft-porn music video. But rarely do we hear the point that these students were bringing home: that this single video is part of a centuries-long debasement of black women's bodies. And the sad truth is that hip-hop artists' verbal and visual renderings of black women are now virtually indistinguishable from those of 19th century white slave owners.

History is full of tragic irony.

Full Disclosure: I am a history professor at Spelman College. I've also taught several of the students involved in the protests over the video. I don't pretend to be unbiased in my support for their actions. I openly supported the students, who—and this is important—never uninvited Nelly or canceled the marrow drive. They did however request that he participate in a campus-wide forum on the problematic images and stated that if he did not, the marrow drive could continue, but his presence on campus would be protested. That Nelly's organization decided to cancel the drive rather than listen to the views of women who were literally being asked to give up bone and blood is tantamount to saying, "Shut up and give me your bone marrow."

This is the truth: hip-hop has all but devolved into a brand of neo-minstrelsy, advertising a one-dimensional rendering of black life. But stereotypes serve to justify not only individual prejudices, but also oppressive power relationships. In the 1890s, the prevailing depiction of black men as sex-crazed rapists who were obsessed with white women served as a social rationalization for the insanity of lynching. Nor should we forget that Jim Crow took root and evolved in tandem with the growing obsession with blackface caricature of African Americans as senseless children too simpleminded to participate in an allegedly democratic society. It is no coincidence that the newborn

NAACP made its first national headlines for protesting D. W. Griffith's white suprema-cist epic, *Birth of a Nation.*

In short, stereotypes are the public relations campaign for injustice.

In the case of black women, the body of myths surrounding their sexuality served to justify the sexual exploitation they experienced during and after slavery. And in so doing, the blame for adulterous relationships that produced biracial offspring shifted from married white slaveholders to insatiable black temptresses who led them astray. The historian Deborah White has written of the prevailing images of enslaved black women:

> One of the most prevalent images of black women in antebellum America was of a person governed almost entirely by libido, a Jezebel character. In every way, Jezebel was the counter-image of the mid-nineteenth-century ideal of the Victo-rian lady. She did not lead men and children to God; piety was foreign to her. She saw no advantage in prudery, indeed domesticity paled in importance before matters of the flesh.[1]

As long as black women could be understood to be sexually lascivious, it was impos-sible to view them as victims of sexual exploitation. Some went so far as to argue that black women did not experience pain during childbirth—evidence, in their minds, that black women were not descendants of Eve, and therefore not human.

In 1895, when Ida B. Wells-Barnett began traveling abroad to publicize the horrors of American racism and highlight the recreational homicide of lynching, this same set of ideas was employed to discredit her. One editor charged that she was not to be believed because it was a known fact that black women were inclined toward prosti-tution, among an array of other immoral pastimes. During the 1930s, this image of the black Jezebel was dusted off to justify the forced sterilization of black women who, it was believed, were sexually insatiable and prone to produce far too many offspring. Half a century later, Ronald Reagan's rhetoric about punishing "welfare queens"—basically Jezebels who traveled to the big city and moved into the projects—helped him solidify support among white voters who perceived welfare as a subsidy for reck-less black sex and reproduction.

It would be easy to assume that sexist music videos are simple entertainment rather than the equivalent of a body of myths that have been used to oppress black women, were it not for the fact that the lines between culture and politics are not always that easily distinguishable. Hip-hop is now the prevailing global youth culture and, in many instances, the only vision people have of African American life. In a twisted testament to the ubiquity of black culture, a student who spent a semester in China reported back that some of the town residents were fearful of the black male exchange students, having met very few black people, but having viewed a great many black-thug music videos.

Regardless of Nelly's intentions, videos like "Tip Drill" are viewed as yet another confirmation of the longstanding ideas about black women. On one level, the consistent stream of near-naked sisters gyrating their way through one video after the next and the glossary of hip-hop epithets directed at women—chickenheads, tip-drills, hoodrats, etc.—highlight a serious breach between young black men and women. But on another

level, it was affirming to see young men from Morehouse and Clark-Atlanta Universities involved in the protests.

All told, the students who organized the protests were not hating on a successful black man or ignoring the pressing need for bone marrow. They were highlighting a truth that is almost forgotten in hip hop these days—a truth so basic that I wish I did not have to state it: anything that harms black women harms black people.

*Credit:* This essay originally appeared in *The Devil and Dave Chappelle and Other Essays*, Basic Books, 2007.

1. Deborah Gray White. *Ar'n't I a Woman? Female Slaves in the Plantation South* (New York: W. W. Norton & Co., Inc., 1985), 28–29.

DIANA FERRUS

## Epilogue

### I've Come to Take You Home
(Tribute to Sarah Bartmann
Written in Holland, June 1998)

I have come to take you home
Home! Remember the veld
and the lush green grass beneath the big oak trees?
The air is cool there and the sun does not burn.
I have made your bed at the foot of the hill,
your blankets are covered in buchu and mint,
the proteas stand in yellow and white
and the water in the stream chuckles sing-songs
as it hobbles along over little stones.

I have come to wrench you away
away from the poking eyes of the man-made monster
who lives in the dark with his clutches of imperialism
who dissects your body bit by bit,
who likens your soul to that of satan
and declares himself the ultimate God!

I have come to soothe your heavy heart,
I offer my bosom to your weary soul.
I will cover your face with the palms of my hands,
I will run my lips over the lines in your neck,
I will feast my eyes on the beauty of you
and I will sing for you,
for I have come to bring you peace.

I have come to take you home
where the ancient mountains shout your name.
I have made your bed at the foot of the hill.
Your blankets are covered in buchu and mint.
The proteas stand in yellow and white—
I have come to take you home
where I will sing for you,
for you have brought me peace,
for you have brought us peace.

**GLOSSARY:**    *buchu:* an herb used by Khoi-khoi people for medicinal purposes
*mint:* an herb used for medicinal and cooking purposes
*proteas:* the national flower of South Africa
*veld:* wide open space/landscape

*Credit:* This poem originally appeared in the book *Ink @ Boiling Point—A Selection of 21st Century Black Women's Writing from the Southern Tip of Africa,* edited by Shelley Barry, Malika Ndlovu, and Deela Kahn (WEAVE, 2000).

# Bibliography

This list includes works cited in Chapter 3 as well as recommended general reading on the subjects covered in this volume.

Abrahams, Yvette. 1997. "The Great Long National Insult: 'Science', Sexuality and the Khoisan in the 18th and Early 19th Century." *Agenda* 32:34–48.

———. 1998. "Images of Sara Bartman: Sexuality, Race, and Gender in Early-Nineteenth-Century Britain." In *Nation, Empire, Colony: Historicizing Gender and Race*, ed. Ruth Roach Pierson and Nupur Chaudhuri, 220–236. Bloomington and Indianapolis: Indiana University Press.

Adelson, Leslie. 1993. *Making Bodies, Making History: Feminism and German Identity*. Lincoln: University of Nebraska Press.

Ahye, Molly. 1978. *Golden Heritage: The Dance in Trinidad and Tobago*. Petit Valley, Trinidad and Tobago: Heritage Cultures Ltd.

Aletti, Vince. 1992. "Dark Passage." *Village Voice* (22 December): 102.

Alexander, Elizabeth. 1990. *The Venus Hottentot*. Charlottesville: University Press of Virginia.

Alexander, M. Jacqui, and Chandra Talpade Mohanty, eds. 1997. *Feminist Genealogies, Colonial Legacies, Democratic Futures*. New York: Routledge.

Altick, Richard D. 1978. "The Noble Savage Reconsidered." In *The Shows of London*, 268–273. Cambridge, MA: Belknap.

Appel, Tony. 1987. *The Cuvier-Geoffroy Debate*. Oxford: Oxford University Press.

Archer-Straw, Petrine. 2000. *Negrophilia: Avant-Garde Paris and Black Culture in the 1920s*. New York: Thames and Hudson.

Arnold, Marion. 1996. *Women and Art in South Africa*. New York: St. Martin's Press.

Asantewaa, Eva Yaa. 1998. "Upbeat Program Shakes Its 'Batty': Urban Bush Women, Aaron Davis Hall, NYC," February 12–14. Retrieved October 19, 2002, from Dance Online Web site, http://www.danceonline.com/rev/bush.html. [Cited in Hobson, 2003.]

Avalon, Jean. 1926. "Sarah, la Venus hottentote." *L'Aesculape* 16.

Badou, Gérard. 2000. "Sur les traces de la Vénus Hottentote." *Gradhiva* 27.

Bakhtin, Mikhail. 1981. *The Dialogic Imagination: Four Essays*. Austin: University of Texas Press.

Banta, Melissa, and Curtis M. Hinsley, eds. 1986. *From Site to Sight: Anthropology, Photography, and the Power of Imagery*. Cambridge: Peabody Museum Press.

Barnes, Natasha. 1997. "Face of the Nation: Race, Nationalisms, and Identities in Jamaican Beauty Pageants." In *Daughters of Caliban: Caribbean Women in the Twentieth Century*, ed. Consuelo López Springfield, 285–306. Bloomington: Indiana University Press.

Barnwell, Andrea. 1997. "Like the Gypsy's Daughter, or Beyond the Potency of Josephine Baker's Eroticism." In *Rhapsodies in Black: Art of the Harlem Renaissance*, Richard J. Powell, David A. Bailey, and others. Berkeley: University of California Press; London: Hayward Gallery.

Barrow, John. 1801. *Travels in the Interior of Southern Africa*. London.

Bartra, Roger. 1997. *The Artificial Savage: Modern Myths of the Wild Man*, 254, 256. Ann Arbor: University of Michigan Press.

Benitez-Rojo, Antonio. 1992. *The Repeating Island: The Caribbean and the Postmodern Perspective*, trans. James E. Maraniss. London: Duke University Press.

Benner, Susan. 1992. "A Conversation with Carrie Mae Weems." *Artweek* 23 (15; May 7): 4–5.

Bentham, William. 1834. *The Gael and the Cymbri*. London.

Bogdan, Robert. 1988. *Freak Show*. Chicago: University of Chicago Press.

Brand, Dionne. 1994. "This Body for Itself." In *Bread Out of Stone: Recollections on Sex, Recognitions, Race, Dreaming and Politics*, 31, 47–49. Toronto: Coach House Press.

Braxton, Joanne M., and Andree Nicola McLaughlin, eds. 1990. *Wild Women in the Whirlwind: Afra-American Culture and the Contemporary Literary Renaissance.* New Brunswick, NJ: Rutgers University Press.

Burchell, William. 1822. *Travels in the Interior of Southern Africa.* London.

Burns, E. Jane. 1993. *Body Talk.* Philadelphia: University of Pennsylvania Press.

Burnside, Madeleine. 1997. *Spirits of the Passage: The Transatlantic Slave Trade in the Seventeenth Century,* ed. Rosemarie Robotham. New York: Simon & Schuster.

Cambridge, Alrick. 1992. "Black Body Politics." In *Where You Belong: Government and Black Culture,* by Alrick Cambridge and Stephan Feuchtwang, 108–126. Aldershot: Avebury.

Carby, Hazel V. 1999. *Cultures in Babylon: Black Britain and African America.* London: Verso.

Carroll, George F. 1958. *Mammy and Her Chillun.* New York: Comet Press Books.

Carroll, Noël. 2000. "Ethnicity, Race, and Monstrosity: The Rhetorics of Horror and Humor." In *Beauty Matters,* ed. Peggy Zeglin Brand, 140–150. Bloomington: Indiana University Press.

Chambers, Robert, ed. 1863. *The Book of Days: A Miscellany of Popular Antiquities in Connection with the Calendar,* Vol. 2, 621–622. London.

Chase-Riboud, Barbara. 2003. *Hottentot Venus: A Novel.* New York: Doubleday.

Cheng, William. 1995. *Joyce, Race, Empire.* Cambridge: Cambridge University Press.

Clark, T. J. 1984. "Olympia's Choice." In *The Painting of Modern Life: Paris in the Art of Manet and His Followers.* London: Thames and Hudson.

Clifford, James. 1989. "Histories of the Tribal and the Modern." In *The Predicament in Culture: Twentieth-Century Ethnography, Literature, and Art.* Cambridge, MA: Harvard University Press.

Cohen, William B. 1980. *The French Encounter with Africans: White Response to Blacks, 1530–1880.* Bloomington: Indiana University Press.

Collins, Patricia Hill. 2000. *Black Feminist Thought: Knowledge, Consciousness, and the Politics of Empowerment,* Revised, 10th Anniv., 2nd Edition. New York: Routledge.

Cooper, Carolyn. 1993. *Noises in the Blood: The Vulgar Body of Caribbean Oral Discourse.* London: Macmillan.

Cooper, Frederick, and Ann Stoler. 1997. "Between Metropole and Colony: Rethinking a Research Agenda." *Tensions of Empire: Colonial Culture in a Bourgeois World,* ed. Frederick Cooper and Ann Laura Stoler. Berkeley, Los Angeles, and London: University of California Press.

Corbey, Raymond. 1993. "Ethnographic Showcases, 1870–1930." *Cultural Anthropology* 8 (3): 338–369.

Crais, Clifton C. 1992. *White Supremacy and Black Resistance in Pre-industrial South Africa: The Making of the Colonial Order in the Eastern Cape, 1770–1865.* Cambridge: Cambridge University Press.

Crais, Clifton, and Pamela Scully. 2008. *Sara Baartman and the Hottentot Venus: A Ghost Story and a Biography.* Princeton, NJ: Princeton University Press.

Curtis, L. Perry, Jr. 1968. *Anglo-Saxons and Celts: A Study of Anti-Irish Prejudice in Victorian England.* Bridgeport, CT: University of Bridgeport.

———. 1997. *Apes and Angels: The Irishman in Victorian Caricature,* rev. ed. Washington, DC: Smithsonian Institution Press.

Cuvier, Frédéric, and Etienne Geoffroy Saint-Hilaire. 1824. "Femme de race bochismann." In *Histoire naturelle des mammifères.* Paris.

Cuvier, Georges. 1817. "Extrait d'observations faites sur le cadavre d'une femme connue à Paris et à Londres sous le nom de Vénus Hottentotte." *Mémoires de Muséum d'Histoire naturelle* 3:259–274. [The autopsy report.]

———. 1864. "Extrait d'observations faites sur le cadavre d'une femme connue à Paris et à Londres sous le nom de Vénus Hottentote." In *Discours sur les révolutions du globe.* Paris: Passard.

de Blainville, Henri. 1816. "Sur une femme de la race hottentote." *Bulletin des sciences par la société philomatique de Paris,* 183–190.

Debrunner, Hans Werner. 1979. *Presence to Prestige: A History of Africans in Europe before 1918.* Switzerland: Baster Afrika Bibliographen.

Di Filippo, Paul. 1995. *The Steampunk Trilogy: Victoria, Hottentots, Walt and Emily.* New York: Four Walls Eight Windows.

Doy, Gen. 1998. *Women and Visual Culture in Nineteenth-Century France, 1800–1852.* London and New York: Leicester University Press.

Du Bois, W.E.B. [1896] 1973. *The Suppression of the African Slave-Trade to the United States of America, 1638–1870.* Cambridge: Harvard Historical Studies Series 1; reprint, Millwood, NY: Kraus-Thomson Organization Ltd.

Duff, George. 1852. "The South African Exhibition in London" [song lyrics]. In *A South African Miscellany of History, Narration and Descriptive Sketches, Tales, Poetry, et,* Part I, 79–80. Johannesburg, South Africa: Africana Society, City of Johannesburg Africana Museum.

Duke, Lynne. 1996. "S. Africans Seek to Bring Home Bones of a Bitter Past." *Washington Post* (February 7): A1, A15.

Durkheim, Emile. 1982. *The Rules of Sociological Method.* New York: Free Press.

Easton, Kai. 2002. "Travelling through History, 'New' South African Icons: The Narratives of Saartje Baartman and Krotoä-Eva in Zoe Wicomb's David's Story." *Kunapipi: Journal of Postcolonial Writing* 24 (1–2): 237–250.

Edwards, Paul, and James Walvin. 1983. *Black Personalities in the Era of the Slave Trade,* 171–185. Baton Rouge: Louisiana State University Press.

Eisenstein, Zillah R. 1988. *The Female Body and the Law.* Los Angeles: University of California Press.

Eze, Emmanuel Chukwedi, ed. 1997. *Race and the Enlightenment: A Reader.* Cambridge, UK: Blackwell.

Fabre, Michel. 1991. *From Harlem to Paris: Black American Writers in France, 1840–1980.* Urbana and Chicago: University of Illinois Press.

Fairbrother, Trevor. 1988. "Interview with Lorna Simpson." In *The Binational: American Art of the Late 80's.* Boston: Institute of Contemporary Art.

Fanon, Frantz. 1963. *The Wretched of the Earth,* trans. Constance Farrington. New York: Grove Press.

———. 1967. *Black Skin, White Masks,* trans. Charles Lam Markmann. New York: Grove Press.

Fausto-Sterling, Anne. 1995. "Gender, Race and Nation: The Comparative Anatomy of 'Hottentot' Women in Europe: 1815–1817." In *Deviant Bodies: Critical Perspectives on Difference in Science and Popular Culture,* ed. Jennifer Terry and Jacqueline Urla. Bloomington and Indianapolis: Indiana University Press.

Featherstonhaugh, G. W. 1844. *Excursion through the Slave States.* London: John Murray.

Ferguson, Russell, ed. 1993. *World Tour: Renée Green.* Los Angeles: Museum of Contemporary Art.

Fields, Barbara J. 1982. "Slavery, Race, and Ideology in American History." In *Region, Race and Reconstruction: Essays in Honor of C. Vann Woodward,* ed. J. Morgan Kousser and James M. McPherson, 143–177. New York: Oxford University Press.

———. 1990. "Slavery, Race, and Ideology in the United States of America." *New Left Review* 181: 95–118.

Fisher, Richard Barnard. 1814. *The Importance of the Cape of Good Hope.* London.

Foucault, Michel. [1978] 1990. *The History of Sexuality,* Vol. 1, *An Introduction.* Trans. Robert Hurley. New York: Random House; reprint, New York: Vintage.

———. 1994. *The Birth of the Clinic: An Archeology of Medical Perception.* New York: Vintage Books.

Franklin, John Hope. 1994. *From Slavery to Freedom: A History of African Americans,* 7th ed. New York: Knopf.

Fredrickson, George M. [1971] 1987. *The Black Image in the White Mind: The Debate on Afro-American Character and Destiny, 1817–1914.* New York: Harper and Row; reprint, Hanover: Wesleyan University Press.

Freud, Sigmund. [1953] 1965. *The Interpretation of Dreams,* trans. James Strachey. Reprint, New York: Avon Books.

Fusco, Coco. 1995. *English Is Broken Here: Notes on Cultural Fusion in the Americas.* New York: New Press.

Gates, Henry Louis, Jr., and Kwame Anthony Appiah, eds. 1986. *"Race," Writing, and Difference.* Chicago: University of Chicago Press.

Gemie, Sharif. 1999. *French Revolutions, 1815–1914, An Introduction.* Edinburgh: Edinburgh University Press.

George, Mary Dorothy. 1947. *Catalogue of Political and Personal Satires Preserved in the Department of Prints and Drawings at the British Museum,* Vol. 7, entry 11578, 948; entry 11577, 949; Vol. 9, entry 12749, 655. London: British Museum.

Gerzina, Gretchen Holbrook. 1995. *Black London: Life before Emancipation.* New Brunswick, NJ: Rutgers University Press.

Giddings, Paula. 1984. *When and Where I Enter: The Impact of Black Women on Race and Sex in America.* New York: William Morrow.

Gilman, Sander L. 1985a. "Black Bodies, White Bodies: Toward an Iconography of Female Sexuality in Late Nineteenth-Century Art, Medicine, and Literature." *Critical Inquiry* 12 (1; Autumn): 204–242.

———. 1985b. *Difference and Pathology: Stereotypes of Sexuality, Race and Madness.* Ithaca, NY: Cornell University Press.

———. 1986. "Black Bodies, White Bodies: Toward an Iconography of Female Sexuality in Late Nineteenth-Century Art, Medicine, and Literature." In *"Race," Writing, and Difference,* eds. Henry Louis Gates Jr. and Kwame Anthony Appiah. Chicago: University of Chicago Press.

———. 1989. *Sexuality: An Illustrated History, Representing the Sexual in Medicine and Culture from the Middle Ages to the Age of AIDS.* New York: Wiley.

Gilroy, Paul. 1993. *The Black Atlantic: Modernity and Double Consciousness*. Cambridge, MA: Harvard University Press.

Goings, Kenneth W. 1994. *Mammy and Uncle Mose: Black Collectibles and American Stereotyping*. Bloomington: Indiana University Press.

Gordon, Robert. 1992. "The Venal Hottentot Venus and the Great Chain of Being." *African Studies* 51 (2): 185–201.

Gordon-Reed, Annette. 1997. *Thomas Jefferson and Sally Hemings: An American Controversy*. Charlottesville: University of Virginia Press.

Goude, Jean-Paul. 1981. *Jungle Fever*. New York: Xavier Moreau.

Gould, Stephen Jay. 1982. "The Hottentot Venus." *Natural History* 91 (10; October): 20–27.

———. 1987. *The Flamingo's Smile: Reflections in Natural History*. New York: W. W. Norton.

———. 1996. *The Mismeasure of Man*. New York: W. W. Norton.

Gramsci, Antonio. 1971. *Selections from the Prison Notebooks*. London: Lawrence & Wishart.

Gray, Stephen. 1979. *Hottentot Venus and Other Poems*. Cape Town: David Philip.

Greenberg, Clement. 1994. "Modernist Painting." In *Art in Theory 1900–1990: An Anthology of Changing Ideas,* ed. Charles Harrison and Paul Wood. Oxford: Blackwell.

Grigsby, Darcy Grimaldo. 2002. *Extremities: Painting Empire in Post-Revolutionary France*. London: Yale University Press.

Hall, Stuart. 1996. "The After-Life of Frantz Fanon: Why Fanon? Why Now? Why Black Skin, White Masks?" In *The Fact of Blackness: Frantz Fanon and Visual Representation,* ed. Alan Read, 12–37. Seattle: Bay Press.

Hammond, Dorothy, and Alta Jablow. 1970. *The Africa That Never Was: Four Centuries of British Writing about Africa*. New York: Twayne Publishers, Inc.

Hammonds, Evelynn M. 1997. "Toward a Genealogy of Black Female Sexuality: The Problematic of Silence." In *Feminist Genealogies, Colonial Legacies, Democratic Futures,* ed. M. Jacqui Alexander and Chandra Talpade Mohanty. New York and London: Routledge.

Hanna, Judith Lynne. 1988. *Dance, Sex and Gender: Signs of Identity to Dominance, Defiance and Desire*. Chicago and London: University of Chicago Press.

Haraway, Donna. 1989. *Primate Visions*. London: Routledge.

Hartman, Saidiya V. 1992. "Excisions of the Flesh." In *Lorna Simpson: For the Sake of the Viewer,* ed. Beryl J. Wright and Saidiya V. Hartman, 55–67. Chicago: Museum of Contemporary Art.

Hassan, Salah, and Iftikhar Dadi, eds. 2001. *Unpacking Europe*. Rotterdam: Museum Boijmans Van Beuningen and NAi Publishers.

Hays, J. N. 1983. "The London Lecturing Empire, 1800–50." In *Metropolis and Province: Science in British Culture, 1780–1850,* ed. Ian Inkster and Jack Morrell. Philadelphia: University of Pennsylvania Press.

Hazzard-Gordon, Katrina. 1990. *Jookin': The Rise of Social Dance Formations in African-American Culture*. Philadelphia: Temple University Press, 1990.

Hirschon, Renee. 1993. "Open Body/Closed Space: The Transformation of Female Sexuality." In *Defining Females: The Nature of Women in Society,* ed. Shirley Ardener, 51–72. Oxford: Berg Publishers.

Hobson, Janell. 2003. "The 'Batty' Politic: Toward an Aesthetics of the Black Female Body." *Hypatia* 18 (4): 87–105.

———. 2005. *Venus in the Dark: Blackness and Beauty in Popular Culture*. New York: Routledge.

Holloway, Camara Dia. 1999. *Portraiture and the Harlem Renaissance: The Photographs of James L. Allen*. New Haven: Yale University Art Gallery.

Holmes, Rachel. 2007. *African Queen: The Real Life of the Hottentot Venus*. New York: Random House.

Homans, Margaret. 1994. "Women of Color, Writers, and Feminist Theory." *New Literary History* 25 (1994): 73–94.

Honour, Hugh. 1989. *The Image of the Black in Western Art*, Vol. 4: *From the American Revolution to World War I*, Part 2: *Black Models and White Myths,* ed. Ladislas Bugner. Houston: Menil Foundation; distributed by Harvard University Press.

hooks, bell. 1992. *Black Looks: Race and Representation*. Boston: South End Press.

———. 1994a. "Postmodern Blackness." In *Colonial Discourse and Postcolonial Theory: A Reader,* ed. Patrick Williams and Laura Chrisman, 421–427. New York: Columbia University Press.

———. 1994b. "Sexism and Misogyny: Who Takes the Rap?" *Z Magazine,* February 1994:26–29.

"'Hottentot Venus': A Ballad, The." 1962. In *Circus and Allied Arts,* ed. R. Toole, 333–336. Derby, UK: Harper and Sons.

"Hottentot Venus and the Grenvilles, The." 1810. *The Satirist, or Monthly Meteor* (November 1): 424–427.

"Hottentot Venus and the Grenvilles (Further Particulars), The." 1810. *The Satirist, or Monthly Meteor* (December 1): 550–554.

"Humours of Bartlemy Fair, The" [song lyrics]. n.d. *The Universal Songster,* Vol. 1, 118–119. London.

Johnson, James. 1995. *Listening in Paris: A Cultural History.* Berkeley, Los Angeles, London: University of California Press, 1995.

Jones, Kellie. 1990a. "A Contemporary Portfolio." *Exposure* 27 (4; Fall): 27–31.

———. 1990b. "In Their Own Image." *Artforum* 29 (3; November): 132–138.

Jones, Lisa. 1991. "Venus Envy." *The Village Voice* 36 (28; July 9): 36.

Jordan, Glenn, and Chris Weedon. 1995. *Cultural Politics: Class, Gender, Race and the Postmodern World.* Oxford, UK, and Cambridge, MA: Blackwell.

Joseph, Regina. 1990. "Lorna Simpson Interview." *Balcon* 5 (6): 35–39.

"Journal des Dames et des Modes, 12 February 1815." 1876. In *Le Costume historique,* ed. M. Racinet, tome ii, 255 bis. Paris.

Keegan, Timothy. 1996. *Colonial South Africa and the Origins of the Racial Order.* Cape Town: David Philip.

Kellner, Bruce, ed. 1984. *The Harlem Renaissance: A Historical Dictionary for the Era.* Westport, CT: Greenwood Press.

———, ed. 1987. *The Letters of Carl Van Vechten.* New Haven, CT: Yale University Press.

Kern-Foxworth, Marilyn. 1994. *Aunt Jemima, Uncle Ben, and Rastus: Blacks in Advertising, Yesterday, Today and Tomorrow.* New York: Greenwood Publishing Group.

Kincaid, Jamaica. 1994. *A Small Place.* New York: Farrar, Strauss and Giroux.

Kirby, Percival R. 1949. "The Hottentot Venus." *Africana Notes and News* (Johannesburg, South Africa) 6 (3; June): 55–62.

———. 1953. "More about the Hottentot Venus." *Africana Notes and News* (Johannesburg, South Africa) 10 (4; September): 124–134.

———. 1954a. "The 'Hottentot Venus' of the Musée de l'Homme, Paris." *South African Journal of Science,* vol. 50, no. (12; (July): 1954), 319–322.

———. 1954b. "A Further Note on the 'Hottentot Venus.'" *Africana Notes and News* (Johannesburg, South Africa) 11 (5; December): 165–166.

Klein, Martin. 1998. *Slavery and Colonial Rule in French West Africa.* Cambridge: Cambridge University Press.

Koch, Eddie. 1995. "Bring Back the Hottentot Venus." 1995. *Weekly Mail & Guardian* (Johannesburg, South Africa), June 15–22, 13.

Kushner, Tony. 1999. "Selling Racism: History, Heritage, Gender and the (Re)production of Prejudice." *Patterns of Prejudice* 33 (4): 67–86.

Leppert, Richard. 1996. *Art and the Committed Eye: The Cultural Functions of Imagery.* Boulder: Westview Press.

Lichtenstein, Henry. 1812. *Travels in Southern Africa in the Years 1803, 1804, 1805, and 1806.* London.

Lindfors, Bernth. 1983. "'The Hottentot Venus' and Other African Attractions in Nineteenth-Century England." *Australasian Drama Studies* 1.

———. 1984. "The Bottom Line: African Caricature in Georgian England." *World Literature Written in English* 24 (1): 43–51.

———. 1985. "Courting the Hottentot Venus." *Africa: Rivista trimestrale di studi e documentazione dell'Istituto Italo-Africano* 40 (1; March): 133–148.

———. 1996. "Ethnological Show Business: Footlighting the Dark Continent." In *Freakery: Cultural Spectacles of the Extraordinary Body,* ed. Rosemarie Garland Thomson, 207–218. New York: New York University Press.

———, ed. 1999. *Africans on Stage: Studies in Ethnological Show Business.* Bloomington: Indiana University Press.

Loomba, Ania. 1996. *Colonialism/Postcolonialism.* New York: Routledge.

Loveman, Mara. 1999. "Is Race Essential?" *American Sociological Review* 64:891–898.

Lurie, Edward. 1960. *Louis Agassiz: A Life in Science.* Chicago: University of Chicago Press.

Lysons, Daniel. n.d. *Collectanea; or a Collection of Advertisements and Paragraphs from the Newspapers, Relating to Various Subjects,* Vol. 2. Unpublished scrapbook in the British Library, London.

Malik, Keenan. 1996. *The Meaning of Race.* New York: New York University Press.

Mann, Sylvia. 1978. *Introductory Note.* Facsimile of Transformation [Playing] Cards, 1811. Kent, UK: Harry Margary, Lympne Castle, in association with Guildhall Library, London.

Mannheim, Karl. 1936. *Ideology and Utopia.* New York: Harcourt.

Manring, M. M. 1998. *Slave in a Box: The Strange Career of Aunt Jemima.* Charlottesville: University of Virginia Press.

Mapplethorpe, Robert. 1986. *The Black Book.* New York: St. Martin's Press.

Maseko, Zola, dir. 1998. *The Life and Times of Sara Baartman.* First Run/Icarus Films.

Mathews, Mrs. Charles. 1839. *Memoirs of Charles Mathews, Comedian,* Vol. 4, 136–139. London: Richard Bentley.

McClintock, Anne. 1995. *Imperial Leather: Race, Gender and Sexuality in the Colonial Contest.* New York and London: Routledge.

McLaurin, Melton A. 1991. *Celia, a Slave.* New York: Avon Books.

Mellon, James, ed. 1988. *Bullwhip Days: The Slaves Remember, an Oral History.* New York: Avon Books.

Morgan, Jennifer L. 1997. "'Some Could Suckle Over Their Shoulder': Male Travelers, Female Bodies, and the Gendering of Racial Ideology, 1500–1770." *William and Mary Quarterly* 54:167–192.

Morley, David, and Kuan-Hsing Chen, eds. 1996. *Stuart Hall: Critical Dialogues in Cultural Studies.* New York: Routledge.

Moss, Thylias. 1999. *Last Chance for the Tarzan Holler: Poems.* New York: Persea Books.

*Musée de l'Homme en relief par les anaglyphes.* 1939. [Stereographs featuring the body cast of the Hottentot Venus.] Paris: Musée de l'Homme.

Nichols, Grace. 1989. *Lazy Thoughts of a Lazy Woman.* London: Virago.

*No Place (Like Home).* 1998. Minneapolis: Walker Art Center.

O'Grady, Lorraine. 1991. "Olympia's Maid: Reclaiming Black Female Subjectivity." In *New Feminist Criticism: Art, Identity, Action,* ed. Joanna Frueh, Cassandra L. Langer, and Arlene Raven. New York: Icon Editions, Harper Collins.

O'Leary, Elizabeth. 1996. *At Beck and Call: The Representations of Domestic Servants in Nineteenth-Century American Painting.* Washington, DC: Smithsonian Institution Press.

Pacteau, Francette. 1994. *The Symptom of Beauty, Essays in Art and Culture.* London: Reaktion Books.

Parks, Suzan Lori. 1997. *Venus: A Play.* New York: Theatre Communications Group.

Philip, John. 1828. *Researches in South Africa.* London.

Philip, Marlene Nourbese. 1994. "Dis Place: The Space Between." In *Feminist Measures,* ed. Lynn Keller and Cristanne Miller, 287–316. Ann Arbor: University of Michigan Press.

Phillips, Caryl. 2000. *The Atlantic Sound.* New York: Knopf.

Pick, Daniel. 1989. *Faces of Degeneration: A European Disorder, c. 1848–c. 1918.* Cambridge: Cambridge University Press.

Pieterse, Jan Nederveen. 1992. *White on Black: Images of Africa and Blacks in Western Popular Culture.* New Haven, CT: Yale University Press.

Pollock, Griselda. 1988. "Modernity and the Spaces of Femininity." In *Vision and Difference: Femininity, Feminism and the Histories of Art.* London: Routledge.

———. 1999. *Differencing the Canon: Feminist Desire and the Writing of Art's Histories.* London: Routledge.

Pollock, Griselda, and Roszika Parker. 1981. *Old Mistresses: Women, Art and Ideology.* London: Pandora.

Price, Thomas. 1829. *An Essay on the Physiognomy and Physiology of the Present Inhabitants of Britain.* London.

Prichard, James C. 1857. *The Eastern Origin of the Celtic Nations.* London.

Pringle, Thomas. 1834. *African Sketches.* London.

Prior, James. 1811. *Narrative of a Voyage in the Indian Seas.* London.

Rattansi, Ali, and James Donald. 1992. *'Race,' Culture and Difference.* London: Sage.

Read, Alan, ed. 1996. *The Fact of Blackness: Franz Fanon and Visual Representation.* Seattle: Bay Press.

Rector, Monica. 1989. "Nudity in Brazilian Carnival." *American Journal of Semiotics* 6 (4): 69–77.

Reichlin, Elinor. 1977. "Faces of Slavery." *American Heritage* 28 (4; June): 4–10.

"Review of *Lichtenstein's Travels in Southern Africa in the Years 1803–1806.*" 1812. *The Quarterly Review* 7 (16; December): 374–395.

Roger, J. A. 1952. *Nature Knows No Color-Line: Research into the Negro Ancestry in the White Race.* St. Petersburg, FL: Helga M. Rogers.

Roquebert, Anne, et al. 1994. *La sculpture ethnographique de la Vénus hottentote à la Tehura de Gauguin.* Paris: Réunion des Musées Nationaux.

Russo, Mary. 1986. "Female Grotesques. Carnival and Theory." In *Feminist Studies/Critical Studies,* ed. Teresa De Lauretis. Indianapolis: Indiana University Press.

Rydell, Robert W. 1993. *World of Fairs: The Century of Progress Expositions.* Chicago: University of Chicago Press.

Rydell, Robert W., and Nancy E. Gwinn. 1994. *Fair Representations: World's Fairs and the Modern World.* Amsterdam: VU University Press.

Saint-Hilaire, Etienne Geoffroy. 1815. Untitled, unpublished manuscript. Paris: Musée de l'Homme, Paris.

Saint-Hilaire, Etienne Geoffroy, and Frédéric Cuvier. 1824. "Femme de Race Bochismann." In *Histoire Naturelle des Mammifères*. Paris.

Sala-Molins, Louis. 1987. *Le Code Noir ou le calvaire de Canaan*. Paris: Quadrige/PUF.

Schiebinger, Londa. 1993. *Nature's Body: Gender in the Making of Modern Science*, 156–171. Boston: Beacon Press.

Sekula, Allan. 1989. "The Body and the Archive." In *The Contest of Meaning: Critical Histories of Photography*, ed. Richard Bolton, 342–389. Cambridge: MIT Press.

Sharpley-Whiting, T. Denean. 1996. "The Dawning of Racial-Sexual Science: A One Woman Showing, A One Man Telling, Sarah and Cuvier." In *FLS: Ethnography in French Literature*, vol. 23. Amsterdam: Editions Rodopi.

———. 1999. *Black Venus: Sexualized Savages, Primal Fears, and Primitive Narratives in French*. Durham, NC: Duke University Press.

Shohat, Ella. 1997. "Post-Third-Worldist Culture: Gender, Nation, and the Cinema." In *Feminist Genealogies, Colonial Legacies, Democratic Futures*, ed. M. Jacqui Alexander and Chandra Talpade Mohanty. New York and London: Routledge.

Skotnes, Pippa, ed. 1996. *Miscast: Negotiating the Presence of the Bushmen*. Cape Town, South Africa: University of Cape Town.

Smith, Anna H. 1984. "Still More about the Hottentot Venus." *Africana Notes and News* (Johannesburg, South Africa) 26 (3; September): 95–98.

Snoop Doggy Dog. 1993. *Doggy Style*. Death Row/Interscope Records.

Solomon-Godeau, Abigail. 1996. "Representing Women: The Politics of Self-Representation." In *Reframings: New American Feminist Photographies*, ed. Diane Neumaier, 305–310. Philadelphia: Temple University Press.

Sontag, Susan. [1977] 1990. *On Photography*. New York: Farrar, Straus and Giroux; reprint, New York: Anchor.

Spillers, Hortense. 1987. "Mama's Baby, Papa's Maybe: An American Grammar Book." *Diacritics* 17 (Summer): 65–81.

Stallybrass, Peter, and Allen White. 1986. *The Politics and Poetics of Transgression*. London, Methuen.

Stam, Robert. 1989. *Subversive Pleasures: Bakhtin, Cultural Criticism and Film*. Baltimore and London: Johns Hopkins Press.

Stamp, Kenneth M. [1956] 1989. *The Peculiar Institution: Slavery in the Ante-Bellum South*. New York: Knopf; reprint, New York: Vintage.

Stepan, Nancy. 1990. "Race and Gender: The Role of Analogy in Science." In *Anatomy of Racism*, ed. David Theo Goldberg. Minnesota: University of Minnesota.

"Stereotypes Subverted? Or for Sale?" *International Review of African American Art* 14 (3). [Special issue on the use of racial stereotypes in the visual arts. Includes images by many of the artists represented in this volume.]

Stoler, Anne. 1995. *Race and the Education of Desire*. Durham, NC: Duke University Press.

Stovall, Tyler. 2000. "Race and the Making of the Nation: Blacks in Modern France." Paper presented at the conference "Crossing Boundaries: The African Diaspora in the New Millennium," New York University/Schomburg Center for Black Culture, September 2000.

Strother, Z. S. 1999. "Display of the Body Hottentot." In *Africans on Stage: Studies in Ethnological Show Business*, ed. Berth Lindfors, 1–61. Bloomington: University of Indiana Press. [Includes transcripts of Sarah Baartman's trial.]

Terry, Jennifer, and Jacqueline Urla, eds. 1995. *Deviant Bodies: Critical Perspectives on Difference in Science and Popular Culture*. Bloomington and Indianapolis: Indiana University Press.

Théaulon, Marie-Emmanuel-Guillaume-Marguerite, Armand Dartois, and Brasier. 1814. *La Vénus hottentote, ou haine aux Françaises* [*The Hottentot Venus; or the Hatred of Frenchwomen*, a one-act "vaudeville"]. Premiered in Paris on November 19; length of run unknown. Script (in French) in the Bibliothèque Nationale de France, Paris, Department of Printed Matter, Microfilm, call #* Yth 18862. [An English translation of the play in its entirety appears in T. Denean Sharpley-Whiting, *Black Venus: Sexualized Savages, Primal Fears, and Primitive Narratives in French*, 127–164 (Durham, NC: Duke University Press, 1999).]

Thompson, George. 1827. *Travels and Adventures in Southern Africa*. London.

Thomson, Rosemarie Garland. 1997. *Extraordinary Bodies: Figuring Physical Disability in American Culture and Literature*. New York: Columbia University Press.

Toll, Robert C. 1974. *Blacking Up: The Minstrel Show in Nineteenth-Century America*. New York: Oxford University Press.

Toole-Stott, Raymond. 1962. *Circus and Allied Arts: A World Bibliography 1500–1962*, Vol. 3, 333–336. Derby, UK: Harpur & Sons.

Topinard, Paul. 1894. "Of the Races of Mankind," in *Anthropology,* 193–263. London: Chapman and Hall.

Trachtenberg, Alan. 1989. *Reading American Photographs: Images as History, Mathew Brady to Walker Evans.* New York: Hill and Wang.

———. 1990. *American Daguerreotypes from the Matthew R. Isenburg Collection.* New Haven, CT: Yale University Art Gallery.

Van Vechten, Carl. 1926. *Nigger Heaven.* New York: Knopf.

Vaughan, Megan. 1991. *Curing Their Ills: Colonial Power and African Illness.* Cambridge, UK: Polity.

Wacquant, Loic. 1997. "Towards an Analytic of Racial Domination." *Political Power and Social Theory* 11:221–234.

Wallis, Brian. 1988. "Questioning Documentary." *Aperture* 112 (Fall): 60–71.

———. 1995. "Black Bodies, White Science: Louis Agassiz's Slave Daguerreotypes." *American Art* 9 (2; Summer): 38–61.

Watson, Steven. 1995. *Harlem Renaissance: Hub of African-American Culture, 1920–1930.* New York: Pantheon Books.

Weber, Eugen. 1976. *Peasants Into Frenchmen: The Modernization of Rural France, 1870–1914.* Palo Alto, CA: Stanford University Press.

White, Deborah Gray. 1985. *Ar'n't I A Woman? Female Slaves in the Plantation South.* New York: W. W. Norton.

Whitten, Norman E., Jr. [1973] 1990. "Contemporary Patterns of Malign Occultism among Negroes in North Carolina." In *Mother Wit from the Laughing Barrel: Readings in the Interpretation of Afro-American Folklore,* ed. Alan Dundes, 402–418. Englewood Cliffs, NJ: Prentice-Hall; reprint, Jackson: University Press of Mississippi.

Wiegman, Robin. 1991. "Black Bodies/American Commodities. Gender, Race and the Bourgeois Ideal in Contemporary Film." In *Unspeakable Images: Ethnicity and the American Cinema,* ed. Lester D. Friedman, 308–328. Urbana and Chicago: University of Illinois Press.

Williams, Carla. 1994. "The Erotic is Naked and Dark." In *Picturing Us: African American Identity in Photography,* ed. Deborah Willis, 128–134. New York: New Press.

———. 2002. "Artist's Statement," September 2002. Carlagirl Photo Web site, http://www.carlagirl.net.

Williams, Carla, and Deborah Willis. 2002. *The Black Female Body: A Photographic History.* Philadelphia: Temple University Press.

Willis, Deborah. 1995. "Women's Stories/Women's Photobiographies." In *Reframings: New American Feminist Photographers,* ed. Diane Neumaier, 84–92. Philadelphia: Temple University Press.

Wilson, Judith. 1989. "Stereotypes, or a Picture Is Worth a Thousand Lies." In *Prisoners of Image: Ethnic and Gender Stereotypes,* 20–21. New York: The Alternative Museum.

———. 1992. "Getting Down to Get Over. Romare Bearden's Use of Pornography and the Problem of the Black Female Body in Afro. U.S. Art." *Black Popular Culture,* ed. Gina Dent and Michelle Wallace, 112–122. Seattle: Bay Press.

———. 1994. "Beauty Rites: Towards an Anatomy of Culture in African American Women's Art." *International Review of African American Art* 11 (3).

Wiss, Rosemary. 1994. "Lipreading: Remembering Saartjie Baartman (Kung Tribeswoman Put on Display in England in 1810). Women's Difference: Sexuality and Maternity in Colonial and Postcolonial Discourses." *Australian Journal of Anthropology* 5 (1–2; Winter–Spring): 11–40.

*Women's Work.* 1996. Dance performance by Urban Bush Women [VHS], dir. Jawole Willa Jo Zollar, Marianne Henderson, and Bruce Berryhill. Charlottesville: University of Virginia, Virginia Museum of Fine Arts.

Wynter, Sylvia. 1990. "Beyond Miranda's Meanings: Un/Silencing the 'Demonic Ground' of Caliban's 'Woman.'" In *Out of the Kumbla: Caribbean Women and Literature,* ed. Carole Boyce Davies and Elaine Savory Fido, 111–142. Trenton, NJ: Africa World Press.

Young, Jean. 1997. "The Re-Objectification and Re-Commodification of Saartjie Baartman in Suzan Lori Parks's *Venus.*" *African American Review* 31:699–708.

# Contributors

**ELIZABETH ALEXANDER** is a poet, essayist, playwright, and teacher. She is professor of African American studies and American studies and chair of the Department of African American Studies at Yale University. She holds a B.A. from Yale University, an M.A. from Boston University, and a Ph.D. in English from the University of Pennsylvania. She has published five books of poems and two collections of essays, including *The Venus Hottentot* (1990), *American Sublime* (2005, a finalist for the Pulitzer Prize and an American Library Association "Notable Book of the Year"), and *Power and Possibility* (2007). Her play "Diva Studies" was produced at the Yale School of Drama. Her many awards and prizes include the first Alphonse Fletcher, Sr. Fellowship, Guggenheim, and the first Jackson Prize for Poetry in 2007. In 2009, she was Inaugural Poet, reading an original poem at the inauguration of President Barack Obama.

**HOLLY BASS** is a writer and multidisciplinary performer. Her poems have appeared in *Callalou, nocturnes (re)view, Role Call,* and *The Ringing Ear.* Her work has been presented at esteemed art spaces such as the Kennedy Center, the Whitney Museum, and the Experience Music Project. She curated the NYC Hip Hop Theater Festival for three years and was the first journalist to put the term "hip hop theater" into print (*American Theatre*). She is one of twenty artists nationwide to receive the 2008 Future Aesthetics grant from the Ford Foundation/Hip Hop Theater Festival. She is a Cave Canem fellow. Her current dance theater work maps the endless allure of booty—from Venus Hottentots to video vixens.

**PETRUSHKA A. BAZIN** is an independent curator and artist based in New York. She holds an M.A. in curatorial practice from California College of Arts and a B.F.A. in photography and imaging from New York University's Tisch School of the Arts. Her curatorial projects have included working as assistant curator of the traveling photography exhibition "Reclaiming Midwives: Stills from All My Babies" and as co-curator of "Self-Storage" and of "Learning to Love You More," a project of Miranda July and Harrell Fletcher. Bazin's photographic work has been included in exhibitions in New York and abroad and in such publications as *Black: A Celebration of a Culture* and *exposure*, the journal of the Society for Photographic Education.

**WILLIAM JELANI COBB** is associate professor of history at Spelman College. He holds a Ph.D. in American history from Rutgers University. He is the author of *To the Break of Dawn: A Freestyle on the Hip Hop Aesthetic* and *The Devil & Dave Chappelle and Other Essays.* His book *In Our Lifetimes: Barack Obama and the New Black America* is forthcoming. He blogs at www.americanexception.com.

**LISA GAIL COLLINS** is associate professor of art history and Africana studies at Vassar College. She holds a B.A. in art history from Dartmouth College and a Ph.D. in American studies from the University of Minnesota. Collins is author of *The Art of History: African American Women Artists Engage the Past* (2002) and *Art by African-American Artists: Selections from the 20th Century* (2003). She is coauthor, with Lisa Mintz Messinger, of *African-American Artists, 1929–1945: Prints, Drawings, and Paintings in the Metropolitan Museum of Art* (2003) and coeditor, with Margo Natalie Crawford, of *New Thoughts on the Black Arts Movement* (2006). She has taught at Barnard College and Princeton University and has received grants from the Ford, Mellon, and Anyone Can Fly foundations.

**RENÉE COX** was born in Colgate, Jamaica, and grew up in Scarsdale, New York. She holds an M.F.A. in photography from the School of Visual Arts. A photographer and mixed media artist, she produced her first individual show, "Raje," in 1988. She has since displayed her work in exhibits around the world. Her photograph *Yo Mama's Last Supper* (1996) met with controversy in 2001 when it was shown at the Brooklyn Museum of Art. Her most recent series is *The Discreet Charm of the Bougies* (2008).

**J. YOLANDE DANIELS** is an architect and assistant professor of architecture at Columbia University. Her collaboration with Sunil Bald as studioSUMO received a 2006 Design Vanguard Award from *Architectural Record* magazine and a 1999 Young Architects Award from the Architectural League of New York, as well as a 2002 Architecture/Environmental Structures fellowship from the New York Foundation for the Arts. From 2003 to 2004 Daniels was a Rome Prize Fellow, and from 2005 to 2006 she was a MacDowell Colony Fellow.

**CAROLE BOYCE DAVIES**, an African diaspora studies scholar, was born in Trinidad and Tobago. She is professor of Africana studies and English at Cornell University. Her publications include *Left of Karl Marx: The Political Life of Black Communist Claudia Jones* (2008), which won the Association of Black Women Historians' Letitia Woods Best Book Prize for 2008. Her book *Black Women, Writing and Identity: Migrations of the Subject* (1994) is considered a theoretical base for many related studies in the field. In addition to numerous scholarly articles, Boyce Davies has also published several anthologies in African diaspora studies and African and Caribbean literature, as well as a two-volume collection of critical and creative writing entitled *Moving Beyond Boundaries* (1995). She is general editor of the three-volume *Encyclopedia of the African Diaspora* (2008). Currently, she is writing a series of personal reflections called *Caribbean Spaces: Between the Twilight Zone and the Underground Railroad,* dealing with the issue of transnational Caribbean/American black identity, and is preparing an edition of the writings of Claudia Jones, *Beyond Containment: Claudia Jones, Activism, Political Clarity and Vision.*

**MANTHIA DIAWARA** is professor of comparative literature and cinema studies at New York University. He is also director of NYU's Institute of Afro-American Affairs and a University Professor. A native of Mali, Diawara received his education in France and later traveled to the United States for his university studies. He is the author of *We Won't Budge: An African Exile in the World* (2003), *Black-American Cinema: Aesthetics and Spectatorship* (1993), *African Cinema: Politics and Culture* (1992), and *In Search of Africa* (1998). He has published widely on the topic of film and literature of the black diaspora. Diawara also collaborated with Ngũgĩ wa Thiong'o in making the documentary *Sembene Ousmane: The Making of the African Cinema,* and directed a number of films, including the German-produced documentary *Rouch in Reverse* and *Maison Tropicale.* He has received grants from the Ford Foundation, the Rockefeller Foundation, ARTE/ZDF, and the Andy Warhol Foundation for the Arts. He has also served as distinguished lecturer at Princeton University, Harvard, Cornell, Stanford University, and the École des Hautes Études en Sciences Sociales (Paris). He has published articles on literature, film, and art in scholarly and popular magazines.

**DIANA FERRUS** is a critically acclaimed South African poet and writer of Khoisan descent who writes in both English and Afrikaans. She has published several collections of poetry and is a founding member of the Afrikaans Writers Association. In addition to writing and lecturing, she serves as an administrator at the University of the Western Cape. Ferrus wrote "A Poem for Sarah Baartman" while studying at the University of Utrecht, Netherlands, in 1998. Her words helped to convince the French government to return Sarah Baartman's remains to South Africa.

**CHERYL FINLEY** is an assistant professor in the History of Art Department at Cornell University. She received her Ph.D. in African American studies and history of art from Yale University. She is the author of many books, articles, and essays, including most recently *Diaspora, Memory, Place: David Hammons, Maria Magdalena Campos-Pons, Pamela Z* (2008), a collection of essays from the 2004 exhibition "3×3: Three Artists/Three Projects," which she co-curated with Salah Hassan for Dak'Art, the Biennial of Contemporary African Art in Dakar, Senegal. Finley's research has been supported by

the Ford Foundation, the Center for Advanced Study in the Visual Arts, an Alphonse Fletcher, Sr. Fellowship, and the American Academy of Arts and Sciences, among others. She is completing a manuscript on the cultural memory of the slave ship icon, *Committed to Memory: The Slave Ship Icon in the Black Atlantic Imagination,* and a monograph on the artist Maria Magdalena Campos-Pons.

**NIKKY FINNEY** is professor of creative writing at the University of Kentucky. She has written numerous books of poems and short stories. *Rice* (1995), a collection of stories, poems, and photographs, won the 1999 PEN American Open Book Award. Finney's 1998 volume of short stories, *Heartwood,* was written to assist adult literacy students. Her poetry collection *The World Is Round* won the 2004 Benjamin Franklin Award for Poetry. She is editor of the anthology *The Ringing Ear* (2007), a contemporary collection of one hundred poetic black voices. During the 2007–2008 academic year she was the Grace Hazard Conkling Writer-in-Residence at Smith College.

**KIANGA K. FORD** is an assistant professor of New Genres/Fine Arts in the School of Art, Media, and Technology at Parsons, The New School for Design in New York. Her work is in visual culture, with a focus on the dynamics of contemporary social identity, proximity, intimacy, and relationship. She brings to this work a background in photography and film production, as well as a B.A. in literature from Georgetown University and an M.F.A. from the University of California, Los Angeles. She is a doctoral candidate in the History of Consciousness program at the University of California, Santa Cruz, where she is completing a dissertation on articulations of race and identity in contemporary exhibition. Ford's work has been exhibited nationally and internationally; in the field of sound art, she has worked collaboratively with a range of international composers, from Toronto to Bergen, Norway. She is a current Creative Capital grantee and a recipient of the California Community Foundation fellowship for emerging artists and the LEF Foundation grant. She has recently been awarded a grant by the Asian Cultural Council to pursue a new project in Japan.

**TERRI FRANCIS** is assistant professor in the film studies program and the Department of African American Studies at Yale University. She holds a Ph.D. in English from the University of Chicago, with a specialty in African diaspora cinema, literature, and culture. Her current book, *The Josephine Baker Body-Museum: Blackness, Power and Visual Pleasure,* is forthcoming. Research in progress includes histories of Jamaican film culture and African American home movies.

**SANDER GILMAN** is a distinguished professor of the liberal arts and sciences as well as professor of psychiatry at Emory University, where he is the director of the Program in Psychoanalysis and the Health Sciences Humanities Initiative. A cultural and literary historian, he is the author or editor of over eighty books, including *Creating Beauty to Cure the Soul: Race and Psychology in the Shaping of Aesthetic Surgery* (1998) and *Making the Body Beautiful: A Cultural History of Aesthetic Surgery* (1999). Gilman's *Fat: A Cultural History of Obesity* appeared in 2008; his most recent edited volume, *Race and Contemporary Medicine: Biological Facts and Fictions,* was published that same year. He has held distinguished professorships at Cornell University, the University of Chicago, and the University of Illinois, Chicago. He was president of the Modern Language Association in 1995.

**RENÉE GREEN**, dean of graduate programs at the San Francisco Art Institute, is an artist, filmmaker, and writer. She has had one-person exhibitions in numerous international locations including Berlin, Milan, Lisbon, and Paris. Her books include *Between and Including* (2001) and *Shadows and Signals* (2000), as well as *Negotiations in the Contact Zone* (2003), which she edited.

**JOY GREGORY** was born in England to Jamaican parents and grew up in Buckinghamshire, studying at Buckinghamshire College of Higher Education, Manchester Polytechnic, and the Royal College of Art. Her work has been exhibited all over the world and featured in many biennales and festivals. One of her many awards was a 2002 fellowship from the National Endowment for Science Technology and the Arts. Her usual medium is photography but her work has evolved from self-portraiture to include articles and accessories of dress, landscape, portraits of others, and wildflowers. Examples of her work are featured in the collections of the Victoria and Albert Museum, London; Institute of Modern Art, Brisbane, Australia; and Yale University. She lives and works in London.

**LYLE ASHTON HARRIS** grew up in New York City and Dar Es Salaam, Tanzania, and currently lives and works in New York City and Accra, Ghana. He is assistant professor of art at New York University. During 2000 and 2001, he was a fellow at the American Academy in Rome. His work has been exhibited nationally and internationally. Harris participated in the 2nd International Biennial of Contemporary Art of Seville and the 52nd Venice Biennale. His work is in numerous public collections and is regularly commissioned for a wide range of publications, including *The New York Times Magazine, Vibe,* and *New York.* Publications of and about his work include the recent retrospective monograph *Lyle Ashton Harris: Blow Up* (2008) and *Lyle Ashton Harris, Excessive Exposure: The Complete Chocolate Portraits* (forthcoming).

**MICHAEL D. HARRIS** is an associate professor of art history in the Department of African American Studies at Emory University. He earned his Ph.D. in the history of art at Yale University. Harris also has been a practicing artist and a member of the artist collective AfriCOBRA since 1979. He authored *Colored Pictures: Race and Visual Representation* (2003), coauthored *Astonishment and Power* (1993) and *A History of Art in Africa* (2000, 2007), and was a contributing editor of *TransAtlantic Dialogues: Contemporary Art In and Out of Africa* (1999). Books, exhibition catalogs, and journals containing his contributions include *Third Text; Nka: Journal of Contemporary African Art; Landscape of Slavery: The Plantation in American Art* (2008); *Art from Start to Finish: Jazz, Painting, Writing, and Other Improvisations* (2006); *Picturing the Banjo* (2005); *Walls of Heritage, Walls of Pride* (2000); *African Arts;* and the *International Review of African American Art.*

**LINDA SUSAN JACKSON** is associate professor of English and currently serves as associate provost at Medgar Evers College of the City University of New York. Her first book of poetry, *What Yellow Sounds Like* (2007), was a finalist for the Patterson Poetry Prize (2009) and the National Poetry Series Competition (2006). She is also the author of two chap books: *Vitelline Blues* (2002) and *A History of Beauty* (2001). She has received fellowships from The New York Foundation for the Arts, Frost Place, Soul Mountain Writers Retreat, and Cave Canem. Her work has appeared in anthologies and journals, including *Ringing Ear: Black Poets Lean South, Gathering Ground, Crab Orchard Review, Rivendell, Brilliant Corners: A Journal of Jazz & Literature,* and *Heliotrope* and was featured on the *From the Fishouse* audio archive.

**KELLIE JONES** is associate professor in the Department of Art History and Archaeology at Columbia University. She holds a Ph.D. from Yale University. An art historian and curator, she pursues interests in African American and African diaspora artists, Latino/a and Latin American artists, and issues in contemporary art and museum theory. She has published widely and holds awards from The Ford Foundation, The Rockefeller Foundation, and The High Museum of Art, among others. She was named an Alphonse Fletcher, Sr. Fellow for 2008–2009. Jones has two books forthcoming: one on African American artists in Los Angeles in the 1960s and 1970s, and the other a book of collected essays and family collaborations.

**ROSHINI KEMPADOO** is a London-based photographer, media artist, and reader in media practice at the School of Social Sciences, Media, and Cultural Studies, University of East London. She has exhibited internationally in solo and group shows, writes for art and academic journals, and presents work to international lectures and events. Recent shows include "Liminal: A Question of Position" (2009), Rivington Place, London, and "Art & Emancipation in Jamaica: Isaac Mendes Belisario and His Worlds" (2007), Yale Center for British Art, New Haven, Connecticut. Her retrospective "Roshini Kempadoo Work: 1990–2004" (2004) was shown at Pitzhanger Manor and Gallery, London. Kempadoo holds postdoctorate degrees from Goldsmiths College, University of London, and from the University of Derby. Her writing has appeared in the *Journal of Media Practice* and in *Projecting Migration: Transcultural Documentary Practice* (2007).

**SIMONE LEIGH** is an artist living and working in Brooklyn, New York. Her work has been exhibited nationally and internationally at venues in locations such as New York; Rabbat, Morocco; and Cape Town, South Africa. Among the residencies and grants she has been awarded are the Hunter College artist-in-residence (AIR) program, Lower Manhattan Cultural Council's Workspace grant, and the Bronx Museum's Artist in the Marketplace (AIM).

**ZINE MAGUBANE** is associate professor and chair of the Department of Sociology at Boston College. She is author of *Bringing the Empire Home: Race, Class, and Gender in Britain and Colonial South Africa* (2004) and editor of *Postmodernism, Postcolonialism, and African Studies* (2005). She is currently working on a book titled *Brand the Beloved Country: Africa in Celebrity Culture.*

**E. ETHELBERT MILLER** is a literary activist. He chairs the board of the Institute for Policy Studies (IPS) and is a board member of The Writer's Center and editor of *Poet Lore* magazine. Since 1974 he has been the director of the African American Resource Center at Howard University. He is the author of numerous books, including *Fathering Words: The Making of an African American Writer* (2000), *How We Sleep on the Nights We Don't Make Love* (2004), and *The 5th Inning* (2009). His poems are included in such anthologies as *In Search of Color Everywhere* (1994) and *Beyond the Frontier* (2002). *Fathering Words* was selected by "DC We Read" in 2003 for the One Book, One City program sponsored by the District of Columbia Public Libraries. In 2004, Miller received a Fulbright Program award to visit Israel.

**ROBIN MITCHELL** is a Ph.D. candidate in late modern European history at the University of California, Berkeley, specializing in nineteenth-century France. Her dissertation, "The Black Mariannes: Race and Gender in France's First Post-Colonial Crisis, 1802–1848," explores the correlation between representations of black women and the aftermath of the Haitian revolution in French society.

**CHARMAINE NELSON** is an associate professor of art history at McGill University in Montreal, Canada. She teaches in the areas of critical theory, postcolonial studies, black diaspora studies, and nineteenth-century Canadian, American, and European art. Most of her research is in the areas of race and representation and the visual culture of slavery, particularly the representation of black female subjects. She is also coeditor and contributor to the anthology *Racism Eh? A Critical Inter-Disciplinary Anthology of Race and Racism in Canada* (2004) and author of *The Color of Stone: Sculpting Black Female Subjects in Nineteenth-Century America* (2007). Two forthcoming books include her edited volume *Ebony Roots, Northern Soil: Perspectives on Blackness in Canada* and the single-authored book *Representing the Black Female Subject in Western Art.*

**TRACEY ROSE** is a multimedia artist from Johannesburg, South Africa, whose works include video and performance. She participated in the 49th Venice Biennale in 2001 and exhibits regularly with The Project in New York and Los Angeles.

**RADCLIFFE ROYE** is an editorial and documentary photographer. His work focuses on dancehall culture and most recently has documented black life in Chicago, New York, New Orleans after Katrina, and Bahia, Brazil. His work has been published in magazines and books, and he is the recipient of a grant from the Open Society Institute and a member of the Kaimonge Workshop, Inc.

**BERNI SEARLE** is a photographer and multimedia installation artist who completed her undergraduate and postgraduate studies at the University of Cape Town. Her work has been exhibited across Africa and Europe and in the United States. In 2001 she participated in the 49th Venice Biennale. She was the winner of South Africa's Standard Bank Young Artist Award in 2002.

**LORNA SIMPSON** received degrees from the School of Visual Arts, New York, and the University of California, San Diego. She was considered a pioneer of conceptual photography and became well known in the mid-1980s for her large-scale photograph-and-text works. With the African American woman as a visual point of departure, Simpson uses the figure to examine the ways in which gender and culture shape the interactions, relationships, and experiences of our lives in contemporary multiracial America. Her work has been exhibited widely in the United States and internationally. She has participated in such major international exhibitions as the "Hugo Boss Prize" at the Guggenheim Museum, New York, and "Documenta XI" in Kassel, Germany. In 2009, she exhibited her work in group shows in San Francisco, New York, and Rio de Janeiro, and is planning a solo show of new drawings in Paris.

**DEBRA S. SINGER** is executive director and chief curator of The Kitchen, an experimental, interdisciplinary performance space in New York City. Singer came to The Kitchen in 2004 after

a seven-year tenure at the Whitney Museum of American Art, where she was associate curator of contemporary art and the museum's primary performance curator. A graduate of the Whitney Independent Study Program, Singer earned an M.A. in art history from the University of California, Santa Barbara, and a B.A. in political science from Princeton University.

**PENNY SIOPIS** is an associate professor and chair of the Department of Fine Arts, University of the Witwatersrand in Johannesburg, South Africa. She began her career as a painter and recently has explored photography, installation, and film. She has exhibited in South Africa and in Europe.

**HANK WILLIS THOMAS**, winner of the first Aperture West Book Prize for his monograph *Pitch Blackness* (2008), received a B.F.A. from New York University's Tisch School of the Arts and an M.F.A. in photography, as well as an M.A. in visual criticism, from the California College of the Arts, San Francisco. His work was featured in the exhibition and accompanying catalog *25 under 25: Up-and-Coming American Photographers* (2003). He has exhibited in galleries and museums throughout the United States and abroad.

**KARA WALKER** is a visual artist and serves on the faculty of the M.F.A. program at Columbia University. She earned an M.F.A. in painting/printmaking at Rhode Island School of Design, and a B.F.A. in painting/printmaking at Atlanta College of Art. In 1997, she was the youngest person (then 28) to be awarded a MacArthur Foundation Achievement Award. In 2002 she represented the United States in the São Paulo Biennial. Her work has been exhibited nationally and internationally.

**MICHELE WALLACE** is professor of English, women's studies, and film studies at the City College of New York and the CUNY Graduate Center. She holds a Ph.D. in cinema studies from New York University's Tisch School of the Arts. She is the author of *Black Macho and the Myth of the Super-woman* (1979), *Invisibility Blues* (1990), *Black Popular Culture* (edited by Gina Dent, 1991), and *Dark Designs and Visual Culture* (2004). She is currently working on two books about photographs: *Soul Pictures: Black Feminist Generations* (about her family archive) and *Talking in Pictures: Race and American Photography*.

**CARRIE MAE WEEMS** began her career as a documentary photographer in the late 1970s and early 1980s in California. Her work has been exhibited across the United States and internationally. The recipient of honorary degrees and numerous awards, she was honored in 2005 with the Distinguished Photographers Award by Women in Photography International. Weems earned a B.A. from the California Institute of the Arts and an M.F.A. from the University of California at San Diego, and she studied folklore at the University of California, Berkeley. She is the recipient of the 2005/2006 Joseph H. Hazen Rome Prize Fellowship, and was awarded a Pollock-Krasner Foundation Grant in Photography and a Visual Arts Grant from the National Endowment for the Arts. Her work has been represented at DAK'ART, the Biennale of Contemporary Art in Dakar, Senegal, and the Johannesburg Biennale in Johannesburg, South Africa. In addition, she has had solo and group shows at a number of museums.

**CARLA WILLIAMS** is a writer and photographer. She has published numerous essays and books, including *The Black Female Body: A Photographic History* (coauthored with Deborah Willis; Temple University Press, 2002), and her photographic work has been widely exhibited. Selections from her writings, images, and research can be viewed at www.carlagirl.net.

**DEBORAH WILLIS** is professor and chair of the Department of Photography and Imaging at Tisch School of the Arts and University Professor at New York University. Willis is a 2005 Guggenheim and Fletcher Fellow, a 2000 MacArthur Fellow, 1996 Recipient of the Anonymous Was a Woman Foundation Award, and is an exhibiting photographer. She has published widely, including *Reflections in Black: A History of Black Photographers—1840 to the Present* (2000), *The Black Female Body: A Photographic History* (coauthored with Carla Williams; Temple University Press, 2002), and *Posing Beauty: African American Images from the 1890s to the Present* (2009). She received a B.F.A. in photography from the University of the Arts, an M.F.A. in photography from Pratt Institute, an M.A. in art history/museum studies from City College of New York, and a Ph.D. in cultural studies from George Mason University.

# Index

Page numbers preceded by "g" refer to pages in the photo gallery, which begins after page 182.

abolitionists, attempt to end Baartman's display, 34–35, 44n20, 57–58
About, Nicholas, 140
Adkins, Terry, 161
African American. *See* black
African art, modern European artists' fascination with, 118–120
African Association for Promoting the Discovery of the Interior of Africa, 57–59
African continent, contours of, Willis's use of, 91
African people, myths regarding, 72
*African Queen: The Real Life of the Hottentot Venus* (book by Rachel Holmes), 3, 4
African women, photographed naked, 6, 87
Africobra, 174
Afrikaans, 143n9; "-tjie" diminutive, 4
"agape" (poem by Holly Bass), 8, 185
Agassiz, Louis, 7, 89; on difference of enslaved Africans, 71; first significant contact with black people, 74; on human "types," 75; scientific methods of, 74–75, 84n11; study of African bodies, 74–75
Alexander, Elizabeth, 126, 223; "The Venus Hottentot (1825)" (poem), 1–2, 5
Alhambra, Gregory's photograph of, 160
Amberley Panels, Gregory's reinterpretation of, 160
*Amberley Queens* (portraits by Joy Gregory), 160
*Anatomies of Escape* (installation by Renée Green), 78–79, 92–93
anatomy of African slaves, Agassiz's study of, 74–75. *See also* dissection
ape(s): Baartman likened to, by Cuvier, 42, 51, 63, 73; blacks and, 19th-century notions of, 16; prostitute likened to, 23
Archer-Straw, Petrine, 119; *Negrophilia: Avant-Garde Paris and Black Culture in the 1920s* (book), 113
Archipenko, Alexandre, 117, 122–123; *The Bather* (painting), 115; *Negro Dancer* (sculpture), 119; and negrophilia, 119–120
Art Gallery of Toronto, censorship of paintings of female nudes, 115–116, 117
art history, 7; canonical, 113; Eurocentricity of, 119–120; post-colonial, 113, 124n10; race issues and, 112–113, 123n8
art-in-service-to-science, 6; Agassiz and, 72–73; Williams's challenge to, 79–80
artists: Baartman as model for, 72–73; contemporary, images of Baartman, 7; South African women artists' thoughts on Baartman, 131–133

Association for the Advancement of American Science, Agassiz's lecture to (1850), 75
atavistic subclass: prostitutes as, 23; Victorian invention of, African woman as prototype for, 49–50
Atkinson, Brenda, 142n3
*Atlantic Sound, The* (novel by Caryl Phillips), 155, 157
Aunt Jemima, 8, 99; African Americans' dislike of, 173–174; as asexual, 163, 173; as living product trademark, 169, 171–173; in minstrelsy, 163, 169; as mirror sister of Baartman, 176–177; rag doll and rag doll family of, 173, 179n48; as white male fantasy, 177; white man in blackface as, 163
*Aunt Jemima and the Pillsbury Doughboy* (work by Jeff Donaldson), 174, 176
autopsy(ies): of Baartman, 17–18, 29n17; of blacks, in 19th century, 18–19. *See also* dissection

Baartman, Sarah: as "antithesis of European sexual mores and beauty," 72, 91; as antithesis of white French identity, 33; autopsy of, 17–18, 29n17; baptism in Manchester, England, 4, 34, 44n13, 65; birth, 34; burial in South Africa, 3, 141; contract/agreement with her exhibitors, 34–35, 58–59; death of, 40, 45n55, 65, 73; as desirable, Weems's evocation of, 92; display of, 4–5; images of, 9, 10; late 20th-century artwork addressing, 126; as mirror sister of Aunt Jemima, 176–177; name, 4, 128; physical coercion of, 32; refusal to display her genitalia, 45n55; return of her remains to South Africa, 140–141, 143n11; sale of images at Brighton Pavilion, in 1996, 10; South African women artists' thoughts on, 130–133; touching of, by public, 32; voyage to England, 34–35; as white male fantasy, 177
*Babylonian Marriage Market, The* (painting by Edwin Long), 20
*Baby's Got Back* (rap song by Sir Mix-A-Lot), 91
Bachofen, J. J., 23, 31n46
Bailey, Beezy, 142n3
Baker, Josephine, 43n3, 78–79, 103; agency in public arena, 8, 199, 205–206; authorship, 206, 208; avante-garde filmmakers' references to, 206–208; biographies of, 199–200, 205; birthplace, 205; as cultural institution, 202; and double-consciousness, 202; as Fatou, 175; as figure of recognition, 208; film career, 199–201; in French popular culture, 201–202; in Green's work, 78–79, 93, 95n21, 95n23; *Josephine Baker* (photograph), g32; multimedia career of, 205–206; as person versus persona, 203–204;

Baker, Josephine (*continued*)
post-war career, 205; press attention to, 200–201; in reality versus fiction, 199–200, 204; sexual fantasies manipulated by, 174–175; sexuality of, 203–204; *Siren of the Tropics* (film), 199, 201; stardom, 199–200, 203, 204, 205; *Zou Zou* (film), 200, 202–203
Bakhtin, Mikhail, notion of Female Grotesques, 188–189
Bamako, Mali, Keïta's work on, 107–111
*Banking on the Image* series (Roshini Kempadoo), 9, g11, g12, g13, g28
Barnwell, Andrea, 174–175
Barrow, John, 17
*Bashment Link Up Red and White Affair* (photograph by Petrushka A. Bazin), g31
Bass, Holly, 223; "agape" (poem), 8, 185; "crucifix" (poem), 6, 68
Bataille, Georges, 15
*Bather, The* (painting by Alexandre Archipenko), 115
Baudelaire, "Vénus noire" (poem), 15
Bayros, Franz von, *The Servant* (print), 16
Bazin, Petrushka A., 9, 223; *Bashment Link Up Red and White Affair* (photograph), g31; *Jabba Strikes Back* (photograph), g31
Bearden, Romare, 187
beauty: of Bamakoise, Keïta's photographs of, 107–109; European, Baartman as antithesis of, 72, 91
Beddoe, John, 53
Bellanger, Marguerite, 25
*Beloved, The, or The Bride* (Dante Gabriel Rossetti), 16
Benedict, Burton, "Rituals of Representation," 149
Benjamin of Tudela, 16
Berré, J.-B., 6
Bible, as resource for slave names, 171, 178n40
Billroth, Theodor, 18–19, 22
Black, Stephanie, *Life and Debt* (documentary), 190
"Black Bodies, White Bodies: Toward an Iconography of Female Sexuality in Late Nineteenth-Century Art, Medicine, and Literature" (Sander L. Gilman), 5–6, 47, 51, 163
"Black Body Politics" (Alrick Cambridge), 186, 193
black diasporic culture, 186–187; Carrie Mae Weems's reflection on, 81
*Black Female Body in Photography, The: A Photographic History* (book by Deborah Willis and Carla Williams), 3–4
black females: contemporary conceptions of, 101–103, 106n14; objectification of, in contemporary popular culture, 91; 19th-century representations of, 87; sexuality of, 19th-century views on, 17. *See also* black women; body(ies)
black males: misogyny, 187; stereotypes of, 210–211
Black Mammy Memorial Association (Athens, Georgia), 167
Black Mammy Memorial Institute, 167
black mythical characters, as product trademarks, 174
black narcissus, 89
blackness: Baartman as representation of, 28n7, 52; as historically determined ideology, 6, 40, 52, 53; pathology of, 163
black servant(s): functions in arts of 18th and 19th centuries, 15–16, 20. *See also* mammy
"Black Triangle" (poem by Grace Nichols), 195
black women: asexual, Aunt Jemima (mammy) as, 163, 173; Canadian artistic practice and, 116–117; as desirable, Weems's evocation of, 92; images of, in hip-hop culture, 210–212; myths about, 71; objectifica-

tion, artists' challenges to, 175–176; representations of, in French culture, 33, 43n3; sexuality, myths about, 71, 211; sexualized, Baartman as, 163. *See also* black females
*Blue Nude (Souvenir of Biskra)* (Henri Matisse), 121–122
Blumenbach, Johann Friedrich, 16, 40
Boadicea (Trinidadian calypso singer/stick fighter), 190, 191
body(ies). *See also* carnival and carnivalized body
—African, Agassiz's study of, 74–75
—Baartman's: dissection by Cuvier, 73, 76–77; as monstrous in Western view, 127; plaster cast of, 10, 41, 88, 140; storage at Musée de l'Homme, 73
—black, 186; as evidence of deviance and inferiority, 81; in human display, 150–151
—black artists' use of, 89
—black female, 186; appropriation by others, 127, 142n3; in art, 121, 127, 142n3; in contemporary Western culture, 87, 94; 19th-century visualizations of, modern artists' retorts to, 84; objectification of, contemporary artists' response to, 87–88; overvisibility of, 78; as site of contention and trauma in late 20th-century South Africa, 127, 142n3; Williams and, 79–80
—Caribbean female, display of, 189
—commodified, 190–192
—female: in horizontal positions, 189, 190; modern reclamation of, 193–196; pornographic representations of, 189; representation in modern Western culture, 193–196; as "vessel," Simpson's imagery of, 91
—"othering," form of, Cox's and Harris's exploration of, 90
—reclining, Nichols' imagery of, 195. *See also* Manet, Edouard; nude(s)
—site of struggle, Cox's and Harris's exploration of, 90
Bohan, Ruth, 117
bourgeoisie, in 19th-century Paris, 36–37, 44n31
Boutet, Anne Françoise Hyppolyte, 37–38
brain, Baartman's, preservation of, 99
Brand, Dionne, 191; "Madame Alaird's Breasts" (story), 194
Breitz, Candice, 142n3
Brighton Pavilion, image of Baartman for sale in 1996, 10
Broca, Paul, 30n23
Brooker, Bertram, 116
Brookes, Joshua, 34
Brooklyn Exhibition (Société Anonyme), 117
Buffon, 16
Bumbray, Rashida, 4
Burchell, William, 55
"Bushman" [term], 142n7
Bushman tribe, 53; artworld incident regarding, 142n3; Baartman as member of, 19th-century beliefs about, 50
*Bushwoman, So. Africa* (photograph), g8
bustle, 64, 90–91, 95n12; Weems's evocation of, 92
butterfly (dance), 191, 192–193
buttocks
—Baartman's, 5, 17–18, 150; artists' depictions of, 72–73; plaster cast of, 99; public fascination with, 64, 72; scientific community's interest in, 72; 19th-century perception of, 95n12
—bustle as exaggerated simulation of, 90–91, 95n12
—of "Hottentot" woman, Galton's measurement of, 92–93
—19th-century fascination with, 19–20
Bynum, William, 17

cakewalk, 169–170
Callipygian Venus, 37
Cambridge, Alrick, "Black Body Politics," 186, 193
camera, as instrument of dissection, for Agassiz, 76–77
Campbell, John, 65
Canada: censorship of female nude in art (early 20th century), 7, 115–116, 117–118, 122–123; figure painting in, traditionalism and, 116; "Hottentot Venus" in, 115–116; landscape painting in, Modernism and, 124n21
Caribbean culture, carnivals in, 186–187
Caribbean-European connection, Gregory's exploration of, 156–157
carnival and carnivalized body, 8, 186–187, 188–190; dancing as language of, 192; external versus internal space and, 187–188; as interruption of dominant discourses, 188–189; as site of containment, 189; as site of struggle between dominance and resistance, 189; staging of, 193
carnival of coaptation and tourism, 189–193
carnival of resistance, 189–193
Carroll, George, 167–168
cartoon representations of Baartman, g4, g5
Castle of Good Hope (Cape Town), 129
censorship: artistic, in Canada, 7, 115–116, 117–118, 122–123; condensation and, 102
Cezar, Hendrik, 34, 56, 57–59
Cezar, Peter, 34
Charles, Michael Ray, 96, 98
Charleston (dance), 206–207
Charleston (film by Jean Renoir), 206, 208
Charpy, Adrian, 23
Chase-Riboud, Barbara, 3
Chi, Tseng Kwong, 161n1
children: Baartman's, 65; black, as servants in 19th-century Europe, 167; of slaves, as slaves, 24, 121, 164
chimpanzee. See ape(s)
Cinderella: Disney versions, 155, 161n2; Gregory's use of, 155–156; Grimm's fairy tale, 155–156, 161n2
Cinderella Tours Europe (series of photographs by Joy Gregory), 155–161, g29; exhibitions, 161n9
Citron, 24
civil rights movement, and contemporary art, 97–98
Clark, T. J., 7; "Olympia's Choice," 112, 123n4
Clifford, James, 119
Cobb, William Jelani, 8–9, 210–212, 223
Code Noir (1685), 35
Cohen, William, 35–36
Colescott, Robert, 97
Collins, Lisa Gail, 7, 71–86, 223
colonialism, French, 33, 42
Colonised 1 (Roshini Kempadoo), g11
Colonised 3 (Roshini Kempadoo), g13
condensation: and censorship, 102; functions of, 101–103; psychoanalytic definition of, 101, 106nn13–14
conjurers, 81, 86n32
consent: Baartman's, 128; Dhlomo-Mautloa on, 134
Contemplation (painting by Max Weber), 115, 118, 120
control: of Baartman, 32, 33; need for, and Other/othering, 27, 49. See also power
Cooper, Carolyn, 188
Cooper, Frederick, 36, 44n30
Courbet, Gustave, 15

Cox, Renée, 7, 87–88, 98, 100, 105, 161, 224; Hottentot (photographic self-portrait), 89; in Venus Hottentot 2000 (Polaroid), 89–90, g26
craniometry, of Irish, 60, 61n2
Cristo Rei (photograph by Joy Gregory), 159–160, g29
"crucifix" (poem, Holly Bass), 6, 68
Cubism, 119, 120
Cuvier, Georges, 5, 6, 17, 40, 63; account of Baartman's autopsy, 17–18; attempts to document Sarah Baartman's body as inferior, 71; dissection of Baartman's body, 73, 150; employs artists to depict Baartman, 72; fears about political equality, 51; obsession with Baartman's sexuality, 42, 46n58; stance on great chain of being, 50–51; Weems's evocation of, 92

daguerreotypes, of enslaved Africans, 75–76; names accompanying, 76; publication of, 85n20; Weems's reworking of, 80–82, g9
dance: as language, 191, 192; and messages of resistance, 191; staging, in carnival, 193
Dancehall #8 (photograph by Radcliffe Roye), g31
Daniel Deronda (novel by George Eliot), 28n16
Daniels, J. Yolande, 5, 6, 62–67, 224
Darwin, Charles, 20
Darwin's ear, 22, 25
Davies, Carole Boyce, 8, 9, 186–198, 224
Davis, R. T., 171
de Blainville, Henri Ducrotay, 17–18, 63
De Blasio, Abele, 23
Degas, Edgar, The Madam's Birthday, 25
degeneracy, 19th-century science of, 50. See also deviance
Déjeuner sur l'herbe (painting by Edouard Manet), 120
Delacroix, Odalique, 15
Dent, Gina, 105n10
DePillars, Murray, 174
Der Rosenkavalier (Richard Strauss), 15–16
desirability, issues of: Green's evocation of, 92; Weems's evocation of, 92
deviance: black as icon for, 16, 48; Hottentot Venus as image of, 100, 114–115; models of, 19th-century linkage of, 22; white prostitute as image of, in 19th-century Paris, 120–121
Dhlomo-Mautloa, Bongi, 7, 130, 142n3; discussion of the Hottentot Venus among South African women artists, 132–133, 134, 135, 138–139
diaspora. See black diasporic culture
Diawara, Manthia, 7, 107–111, 224
Diderot, on sexuality of blacks, 23, 31n46
difference: display of, in preservation of Baartman's genitals, 77; European perceptions of, public exhibitions and, 114; human perception of, Gilman on, 49, 52; visual documentation of, by Agassiz/Zealy, 77
Difference and Pathology: Stereotypes of Sexuality, Race: and Madness (book by Sander Gilman), 87; and Madness (book by Sander L. Gilman), 5, 87
displacement, 101, 106n13
display(s), human: Baartman as, 64; of black body, 8, 150; of Caribbean female body, 189; of commodity fetish, 150; and objectification of exhibited subject, 114; and race issues, 114; subjects' agreement with, 151–152; venues for, in late 19th and early 20th century, 150; in world's fairs, 8, 150–153
dissection: of Bushman females, in 19th century, 18; camera as instrument of, for Agassiz, 76–77; Cuvier's, of Baartman, 41, 49, 73, 76–77, 150; of Hottentot females, in 19th century, 18; spiritual, of Baartman, 63

"Dollar Wine" (calypso dance), 190
Donaldson, Jeff, *Aunt Jemima and the Pillsbury Doughboy* (painting), 174, 176
*Do the Right Thing* (film by Spike Lee), 202
*Drana, country born, daughter of Jack, Guinea* (photograph by J. T. Zealy), g9
dream(s): condensation and, 101, 106n13; displacement and, 101, 106n13; latent content of, 101; manifest content of, 101
Dreier, Katherine, 117, 118
Du Bois, W.E.B., 151; on double-consciousness, 202
Dunlop, Alexander, 34–35, 44n10
Durkheim, Emile, 48–49
"Dust" (poem by Grace Nichols), 194–196
Dyer, Richard, 203, 204; *Stars,* 199

Edwards, Paul, *The Southern Urban Negro as a Consumer* (book), 173–174
Eliot, George, *Daniel Deronda* (novel), 28n16
Ellis, Havelock, 23, 27; *Studies in the Psychology of Sex,* 19–20
*Emak Bakia* (film by Man Ray), 206–208
Enwezor, Okwui, 142n3
England: black servants in, in 19th century, 167; national identity in 19th century, Baartman's role in, 44n20
Enwezor, Okwui, 126–127; "Reframing the Black Subject: Ideology and Fantasy in Contemporary South African Representation" (essay), 127
ethnographic specimen(s): Baartman as, 72, 73; black female body as; Renée Green on, 78; colonized subjects as, 114; enslaved Africans and African Americans as, for Agassiz, 76; Hottentot as, for Europeans, 99; images of, as substitute pornography, 93
Europe: black children as servants in, in 19th century, 167; and Caribbean, relationship between, 157; Caribbean emigrants in, post-WW II, 156–157, 161n8; class dynamics, in 19th century, 50–51; globalization and, 157; national identities in, 157
European society, Baartman's effect on, 5
evil eye, 86n32
*Exhibit: Ex Africa* (mixed media by Penny Siopis), g17
exhibition(s), of colonized subjects, 114. *See also* display(s)
exploitation: of island/female body, 189–190; of physically mature black female, 4

Fabre, Michel, 204
face(s), Simpson's denial of access to, 82–83
Fanon, Frantz, 96–97
fatness, as stigma of prostitute, 21, 23, 24–25
Fausto-Sterling, Anne, 5, 42, 49, 56, 66, 91
feet: a husband's meditation on, 8, 180–182; of prostitutes, 19th-century study of, 23
female, versus feminine, 62
female sexuality: black, 19th-century notions of, 16, 100, 114–115, 122–123; colonial racializing of, 121; "mystery" of, 87; pathology of, 19th-century views on, 18; white, Freudian notions of, 122–123; white, 19th-century notions of, 16
feminine, versus female, 62
feminist theory, 60
Ferrero, Guglielmo, 22–23, g6, g7
Ferrus, Diana, 224; "A Poem for Sarah Baartman," 9, 140, 143n13; "I've Come to Take You Home" (poem), 213–214
*Fictional Tourist in Europe, A* (multimedia project by Keith Piper), 161n1

Fields, Barbara, 51
film(s): avante-garde, references to Josephine Baker, 206–208; Josephine Baker's, 199–201; journals, blacks in, 201; for segregated black audiences, 202
fingers, black, as fetishized objects, 151
Finley, Cheryl, 8, 155–162, 224–225
Finney, Nikky, 225; "The Greatest Show on Earth: For Saartjie Baartman, Joice Heth, Anarcha of Alabama, Truuginini, and Us All" (poem), 8, 147–148
first-person voice, Baartman's, 35; conferred by Alexander, 1–2, 5; conferred by Weems, 92; in "crucifix" (poem by Holly Bass), 68; lack of, Simpson's comment on, 91
Fisher, Barnard, 53, 55
Flower, W. H., 18
Ford, Kianga K., 7, 96–106, 225
Fort, C. H., 19
Foucault, Michel, 150; on gaze, 150; on power, 84n9
France: blacks in, historiography of, 35–37, 43n6; national identity in 19th century, Baartman's role in, 6, 32–33; and slave trade, 35
Francis, Terri, 8, 199–209, 225
Frankenberg, Ruth, 117
Franklin, John Hope, 164, 179n54
*Frau Welt* (Madam World), 26
Freud, Sigmund: on female genitalia, 20; on female sexuality, 27; on prostitutes, 22

Galton, Francis, 92–93
Garamsci, Antonio, 149
Gates, Henry Louis, Jr., and Kwame Anthony Appiah, eds., *"Race," Writing, and Difference* (book), 6, 51
Gauguin, *Spirit of the Dead Watching,* 177n5
gaze: Baartman's, in Wailly's painting, 73, g3; blacks as victim of, Carrie Mae Weems on, 80–82; colonialist, and spiritual dissection of Baartman, 63; construction of, hegemony in, 8; Cox's use of, 89–90; Cuvier's, on Baartman, 42; Foucault's notion of, 150; of Manet's *Olympia,* 121; public, Baartman as object of, Green's work on, 93; and race/gender visual, 150–153; of slaves in Zealy's daguerreotypes, 76, g9; voyeuristic, and carnivalized body, 187, 190. *See also* looking
Geers, Kendell, 142n3
gender: in dynamic of carnival, 188–189; iconographies, and world's fairs, 152–153; scientific constructs of, in 19th-century, 41
genitalia. *See also* Hottentot apron; labia
—Baartman's, 5, 17–18; Cuvier's examination of, 41–42, 73; her refusal to display, 105n8; preservation of, 18, 65, 73, 77, 99; Willis's commentary on, 90
—female: Freud on, 20; pornographic exposure of, 187
—Hottentot female's, Virey's discussion of, 17
—of prostitutes, 19th-century studies of, 21–23
—women's shoes as stand in for, 158, 162n15
Gérard, Dany, 203–204
Gerdts, William, 119
Gibbes, Robert, 75
Gilman, Sander L., 15–31, 49–50, 53, 54, 62, 67n12, 100, 150, 225; "Black Bodies, White Bodies: Toward an Iconography of Female Sexuality in Late Nineteenth-Century Art, Medicine, and Literature," 5–6, 47, 51, 163; *Difference and Pathology: Stereotypes of Sexuality, Race, and Madness* (book), 5, 87; discussions of race, 51–54; on icons, 45n66
"give me room," 192, 197n27
globalization, 157

gold as status symbol: in Africa, 162n13; in Caribbean, 158; in hip hop culture, 162n13

*Good Life, The* (series of portraits by Lyle Ashton Harris), 89–90

Gordon-Reed, Annette, 165

Goya, *Naked Maja,* 15

Grainger, W., *The Voyage of the Sable Venus, from Angola to the West Indies* (engraving), 104, 106n16; incorporated into artwork by Kara Walker, g21

"Gramsci's Relevance for the Study of Race and Ethnicity" (essay by Stuart Hall), 149

*Grand Odalisque* (Ingres), 177n5

"Grease" (poem by Grace Nichols), 194–196

great chain of being, 16–17; applied to perception of sexualized Other, 19–20; blacks as lowest rung on, 72; Cuvier's stance on, 50–51

"Greatest Show on Earth, The: For Saartjie Baartman, Joice Heth, Anarcha of Alabama, Truuginini, and Us All" (poem by Nikky Finney), 8, 147–148

Green, Nancy (as Aunt Jemima), 171–172, 173, 174

Green, Renée, 7, 87–88, 100, 126, 225; *Anatomies of Escape* (installation), 78–79, 92–93; *Permitted* (installation), 92–93, g19; *Revue,* 95n18, 95n21; *Sa Main Charmante* (installation), 92–93, g18; *Seen* (installation), 78–79, 92–93, g18

Gregory, Joy, 8, 225; *Amberley Queens* (portraits), 160; *Cristo Rei* (photograph), g29; *Cinderella Tours Europe* (series of photographs), 155–161, 161n9, g29; *Lost Histories,* 156, 161n4; *Memory and Skin* (multimedia project), 156, 161n4; popular narratives reinterpreted by, 160; reinterpretation of Amberley Panels, 160; *Zaanse Schans* (photograph), g29

Guitard, A. J., 35

Guys, Constantin, 25

Gwintsa, Veliswa, 7, 129, 130, 142n3; discussion of the Hottentot Venus among South African women artists, 132, 134, 136, 137

hair/hairstyles: meaning of, 168–169, 170; Walker method of care for, 168

Haiti, Negro State of, 35–36

Haitian Revolution (1791–1803), 35

Hale, Grace Elizabeth, 151

Hall, Rosie Lee Moore, 99

Hall, Stuart, 89, 97; "Gramsci's Relevance for the Study of Race and Ethnicity" (essay), 149

Haraway, Donna, 52

Harewood House, 161n5

Hargest, Tana, 126

Harris, Lawren, 118

Harris, Lyle Ashton, 7, 98, 226; *The Good Life* (series of portraits), 89–90; *Venus Hottentot 2000* (Polaroid), 89–90, g26

Harris, Michael D., 8, 163–179, 226

Hauser, Henriette, 24

Hazzard-Gordon, Katrina, 191

headscarf/bandanna, symbolism of, 168–169

hegemony, cultural, 149–150; and construction of gaze, 8

Hemings, Elizabeth, 165

Hemings, Madison, 165

Hemings, Sally, 165–166, 178n15

Hermant, Abel, 27

Hildebrandt, H., 19

hip-hop culture: gold as status symbol in, 162n13; representations of black women in, 210–212; and stereotypes, 210–212

historical character(s), black: condensation and re-presentation, 101–103; misuse and manipulation of, outrage at, 96, 105n1; recycling and re-presentation, 103; re-presentation of, in contemporary art, 96–97; residual ideologies and re-presentation, 98; response to re-presentation, 96–98

history: reclamation and rewriting of, contemporary artists' work and, 160–161; in *Three Seated Figures* (photo-text work by Lorna Simpson), 83–84, g14

HIV/AIDS, in South Africa, 141

Hobson, Janell, *Venus in the Dark: Blackness and Beauty in Popular Culture* (book), 3

Hofmannsthal, Hugo von, 15–16

Hogarth, William: *A Harlot's Progress,* 16; *A Rake's Progress,* 16

Holmes, Rachel, *African Queen: The Real Life of the Hottentot Venus* (book), 3, 4

hooks, bell, 54–55

Hose, Sam, 151

Hottentot: as antithesis of European sexual mores and beauty, 16, 47; as black female in essence, 28n7, 52; female, iconographic function in 19th century, 28n7; re-presentation of, in contemporary art, 96; term, 5, 114, 128

*Hottentot* (photographic self-portrait of Renée Cox), 89

"Hottentot and the Prostitute, The: Toward an Iconography of Female Sexuality" (Sander L. Gilman), 5–6, 15–31, 62

Hottentot apron, 17, 19, 23, 41, 52–53, 64, 67n10, 99, 100, 105n8; Lombroso and Ferrero plate, 106n15, g6. *See also* genitalia; labia

Hottentot body: in Archipenko's work, 120, 122; iconic status of, 122–123; in Matisse's painting, 121–122; in Weber's paintings, 120, 122

*Hottentot/Bustle* (photo-quilt by Deborah Willis), 90–91, g22

Hottentot Venus: Baartman exhibited as, 34, 44n16, 63; caricatures of, 20, 44n20, g4, g5; as colonial stereotype, 114; as contemporary signpost, 99–100; images conjured by, 72; and issues of female/African body on display, 135–137; issues surrounding, in new South Africa, 134–135, 137–139; re-presentation of, in contemporary art, 99–100, 103; woman other than Baartman exhibited as, 6, 18, 63, 64, 87, 99

*Hottentot Venus, The* (photo-text diptych by Carrie Mae Weems), 92, g16

*Hottentot Venus, The, or Hatred of Frenchwomen* (French play, 1814), 38–40, 45n43, 64

Hottentot women, racial and sexual othering of, 114–115

*How to Read Character* (photo-text installation by Carla Williams), 79–80, g15

Hudgins, Johnny, 206

Huet le Jeune, Nicolas, 6; painting of Baartman, 72

Hughes, Langston, newspaper article about Josephine Baker, 204–205

hymen, of black women, 19th-century accounts of, 18–19

icon(s): Baartman as, 47–48; Gilman on, 45n66

ideology, 55; racialist, and 19th-century political programs, 59

*Ideology and Utopia* (Mannheim), 55

imagery, as colonizing tool, 87

images, and racist claims, 71

Ingres, *Grand Odalisque,* 177n5

International Exhibition of Modern Art (Toronto, 1927), 115, 117–118

Irish Celts: craniometric studies of, 60, 61n2; purported Negroid ancestry of, 53–54, 61n2
iron fences, in Gregory's photographs, 160
island(s), repeating, 193
island/female body: exploitation of, 189–190; space of, 192–193, 195–196
"I've Come to Take You Home" (poem by Diana Ferrus), 213–214

Jabba Strikes Back (photograph by Petrushka A. Bazin), g31
Jackson, Linda Susan, 226; "little sarah" (poem), 7, 144
jamettes, 190, 191
Jardin du Roi (Paris), display of Baartman in, 42, 63, 92
Jefferson, Maria, 165–166
Jefferson, Martha, 165
Jefferson, Thomas: affair with Sally Hemings, 165; on sexuality of blacks, 23, 31n46
Jemima (name), origin of, 171
"Jemima Susianna Lee" (song by George L. Rousseau), 170–171
Jezebel: black sexual primitive as embodiment of, 164, 211; myth of, 71–72, 211
Jim Crow, 210–211
Johannesburg Biennale (1997), 126–127, 129
Johnson, Lemuel, "Speculum in a New World," 190
Jones, Bill T., notion of "service," 129, 143n10
Jones, Grace, 103
Jones, Kellie, 7, 126–143, 226
Jones, Lisa, 126; "Venus Envy" (Village Voice article), 3
Josephine Baker (photograph), g32
Julien, L., 23

Keïta, Seydou, 7, 107–111
Kempadoo, Roshini, 226; Banking on the Image series, 9, g11, g12, g13, g28; Colonised 1, g11; Colonised 3, g13; Lapping It Up 2, g28; Sweetness and Light: Great House 4, g11; Sweetness and Light: Head People 1 & 2, g12
Kersands, Billy, 169–170, 178n30, 178n33
Kgositsile, Baleka, 142n3
Khoi, 128, 142n7
Khoikhoi: as representative Africans, 52–53; travelers' descriptions of, 55–56
Khoi-khoip, 5
Khoisan language, 5
Kincaid, Jamaica, A Small Place, 190
King's Garden (Paris), display of Baartman in, 42, 63, 92
Kirby, Percival, 34, 43n7
Krotoa (a.k.a. Eva), 129–130
Kushner, Tony, 10

labia: deliberate elongation of, among Khoikhoi, 105n8; of Hottentot and Bushman females, 19th-century descriptions of, 18. See also genitalia; Hottentot apron
La donna delinquente (Cesare Lombroso and Guglielmo Ferrero), 22–23, g6, g7, g20
L'assommoir (novel by Emile Zola), 25
Lapping It Up 2 (Roshini Kempadoo), g28
Lawal, Kay, 88
Lazy Thoughts of a Lazy Woman (poetry by Grace Nichols), 194–196
Lee, Spike: Do the Right Thing (film), 202; Passing Strange (film), 209n8
Leeds, England, 156–157, 161n5
Leigh, Simone, 226; Venus vessels, 9–10, g23
Le Pompier des Folies Bergères (film), 206, 207–208
leprosy, congenital, and skin color, 24

lesbianism: Hottentots and, 19, 22; jamettes and, 191; prostitutes and, 22
Les Desmoiselles D'Avignon (Pablo Picasso), 25, 177n5
Levaillant, François, 17
Life and Debt (documentary by Stephanie Black), 190
Life and Times of Sara Baartman, The (film by Zola Maseko), 3
"Life's Little Necessities: Installations by Women in the 1990s" (exhibition, Kellie Jones curator), 127, 129–130
Lil' Kim, 103
limbo (dance), 192
Lisbon, Portugal: Gregory's photographs of, 159–160, 162n20; slaves in, 159
"little sarah" (poem by Linda Susan Jackson), 7, 144
Lockart, Jon, 174
Lombroso, Cesare, and Guglielmo Ferrero, La donna delinquente, 22–23, g6, g7; plate incorporated into artwork by Kara Walker, g20
London, England: display of Baartman in, 18, 32, 34, 63, 64, 72; Saartjie-mania in, 4
Long, Edwin, The Babylonian Marriage Market (painting), 20
looking: dynamics of, Green's work on, 93; power of, 7, 78–79. See also gaze
Lost Histories (project by Joy Gregory), 156, 161n4
Love and Beauty—Sartjee the Hottentot Venus (cartoon), g5
Lum, Ken, 161n1
lynching, 210, 211

Mabandla, Bridgette, 140
Macaulay, Zachary, 34, 58
"Madame Alaird's Breasts" (story by Dionne Brand), 194
Madam's Birthday, The (painting by Degas), 25
Mademoiselle Mars, 37–38
Magubane, Zine, 6, 47–61, 227
Maingard, Jacqueline, 142n3
"Mama's Baby, Papa's Maybe" (Hortense Spiller), 193
mammy, 8; characteristics of, in visual images, 167; as comfort to white woman, 166; as emblematic black woman, 166; headscarf worn by, 168; monuments to, 167; as status symbol, 166–167; training of young blacks to become, 167. See also Aunt Jemima
Manet, Edouard: Déjeuner sur l'herbe (painting), 120; Nana, 15, 24–27; Olympia (painting), 7, 15, 20, 24, 25, 67n12, 112–113, 120–121, 122, 163–164, 175–176, 177n5, g5
Mannheim, Ideology and Utopia, 55
Man Ray, Emak Bakia (film), 206–208
Manring, M. M., 164, 172, 176
Marquette, Arthur, 172, 173
Maseko, Zola: The Life and Times of Sara Baartman (film), 3; The Return of Sara Baartman (film), 3
Mathews, Charles, 32
Matisse, Henri, Blue Nude (Souvenir of Biskra), 121–122
Mbeki, Thabo, 141
McClintock, Anne, 41–42, 45n54, 49
McDaniel, Hattie, 167
medical model: of black female sexuality, 17, 24; of female sexuality, prostitutes and, 21–24, 30n32
medical specimens, people exhibited as, in 19th century, 59–60
Meintjes, Sheila, 142n3
Memory and Skin (multimedia project by Joy Gregory), 156, 161n4
Mercer, Kobena, 94

Meurend, Victorine, 15
Michaelson, Katherine Janszky, 120
middle class, in 19th-century France, 36–37, 44n31;
    and French national identity, 42
Middle Passage, 192, 195–196
Miller, Christopher, 35
Miller, E. Ethelbert, 8, 180–182, 227
minstrel(s), black: blackface, 169, 178n30; surreptitious
    barbs used by, 169–170
minstrelsy: Aunt Jemima in, 163, 169; spoof of, in
    Renoir film, 206
"Miscast: Negotiating the Presence of the Bushmen"
    (exhibition, Pippa Skotnes organizer), 137, 142n3
miscegenation, 27, 33, 38, 176
misogyny: in black male popular culture, 187; and
    Caribbean lyrical articulations, 187
Mistinguett, 204
Mitchell, Robin, 6, 10, 32–46, 227
Modernism: in art, American audiences' introduction to,
    117–118; art history and, 112–113, 123n8; colonial
    origins of, 118–122; International Exhibition of Mod-
    ern Art in Toronto (1927), 117–118; negrophilia,
    118–122; in visual arts, 112, 123n3
modernity, Keïta's photographs of Bamakois and, 107–111
monkey. See ape(s)
monster/monstrosity, 127
Monti, Nicolas, 91
Morel, Augustine Benedict, 50
Morrison, Toni, Playing in the Dark, 62
movies. See film(s)
Muhlstock, Louis, 116
Müller, Johannes, 18
Murie, James, 18
Musee de l'Homme: denial that vestiges of Sarah Baart-
    man were among its holdings (1998), 140, 143n15;
    display of Baartman's genitalia and buttocks, 18;
    remains of Sarah Baartman kept at, 10
museum displays: censorship of paintings, 116, 117;
    colonized subjects as, 114
myth(s): about Aunt Jemima, 172–173; about black
    women, 71; about black women's sexuality, 100, 211;
    definition of, 84n1; Jezebel, 71–72, 211; supporting
    slavery, 71; and trademarks, 174; visualizing, 71–73

naked female, in art: association with Sublime and por-
    nographic, 116; versus nude female, 15
Naked Maja (Goya), 15
Nana (novel by Emile Zola), 25–27
Nana (painting by Edouard Manet), 15, 24–27
National Geographic, piece on Trinidad, 191
Needham, George, 15
Negress, as character in Walker's work, 100, 104, 105n9
Negro Dancer (sculpture by Alexandre Archipenko), 119
Negro Exhibit, 202, 209n2
negrophilia, 118–122
Negrophilia: Avant-Garde Paris and Black Culture in the
    1920s (book by Petrine Archer-Straw), 113
Nelly (rapper), 8–9, 210
Nelson, Charmaine, 7, 112–125, 227
Neruda, Pablo, "You Flame-Foot" (poem), 180, 182
New Orleans, Louisiana, Bal de Sociètè, 165
Nichols, Grace: "Black Triangle" (poem), 195; "Dust"
    (poem), 194–196; "Grease" (poem), 194–196; Lazy
    Thoughts of a Lazy Woman (book), 194–196
not-us, in Keïta's photographs of Bamakois, 110. See also
    Other/othering

Ntobe, Joyce, 142n3
nude(s), female: in art, 15, 177n5; association with
    Beauty and "high art," 116; censorship in early 20th-
    century Canada, 115–116, 117–118, 122–123
nudity: Baartman's, in Cuvier's art-in-service-to-science,
    72; and Baartman's status as exotic specimen, 93;
    black female, Williams and, 79–80; female, in Brazil-
    ian carnival, 188; in Hottentot (photographic self-
    portrait of Renée Cox), 89; of slaves in Zealy's
    daguerreotypes, 76, g9

objectification, sexual, of black female, 4
Odalique (painting by Delacroix), 15
O'Grady, Lorraine, 112
Oguibe, olu, 142n3
"Old Aunt Jemima" (song), 169–170, 178n30, 178n33
O'Leary, Elizabeth, 167
Olympia (drawing by Pablo Picasso), 25, 121–122
Olympia (painting by Edouard Manet), 7, 25, 67n12,
    163–164, 177n5, g5; black maid in, 15, 20, 24, 112–
    113, 120–121, 122, 163–164; composition, Gilman
    on, 15; Keïta's allusion to/images of, 109; Simpson's
    subversion of, 175–176
"Olympia's Choice" (T. J. Clark), 112, 123n4
orangutan. See ape(s)
origin of man, Agassiz's theory of, 75
othered other, 62, 67n5
Other/othering: of Baartman, by Cuvier, 42; of black
    female, 62, 67n5; black maid in Manet's Olympia as,
    112–113; of blacks, in 19th-century France, 33–34,
    37; of black women, in Canadian artistic practice,
    117; of colonial subject, 119; Cox's and Harris's
    exploration of, 90; of exhibited human subjects, 114;
    Hottentot Venus as representative of, 99–100; and
    need for control, 27; pathologizing of, 49; in photog-
    raphy, 9; process of, Baartman as emblematic of, 47;
    racial and sexual, of black female body, 114–115;
    sexualized, Hottentot as, 28n16; sexualized, 19th-
    century perception of, 19–20; and social and cultural
    distinctions, Foucault on, 84n9; systems of, Green
    on, 78–79; undermining of, by contemporary
    artists, 94
Otto, A. W., 18
Overstreet, Joe, 174
Owens, Jesse, 159, 162n18

Pacteau, Francette, 104–105
Palace of Westminster, Gregory's photograph of, 160
Parent-Duchatelet, A.J.B., 24; physical description of
    prostitutes, 21–22
Paris, France: artistic community in, in early 20th-cen-
    tury, 119; Baartman abandoned in, 56; display of
    Baartman in, 32, 37, 72; idealized in black fantasy,
    204–205, 209n7; as personified in Josephine Baker's
    career, 204–205
Parks, Suzan-Lori, 3, 94, 126; "The Rear End Exists,"
    87, 94; Venus (play), 8
Passing Strange (film by Spike Lee), 209n8
Passing Strange (musical by Stew), 209n8
patriarchy, and pornography, 187
peephole, Green's use of, 93
pelvis, female, as sign of racial superiority, 19–20
Permitted (installation by Renée Green), 92–93, g19
Philip, John, 58
Philip, Marlene Nourbese, 187, 189, 190
Phillips, Caryl, The Atlantic Sound (novel), 155, 157

photography: documentary, Simpson's work and, 82–84; documentary, Weems on, 80–82; and documentation of African people's difference, 73–76; as evidence and proof, undermining, 82–84; and history, 77–78; and human display, 151; and pornography, 189; purported democratic properties, 77, 85n23; as revealing truth, and Keïta's work on Bamako, 107–111; "socially concerned," as revealing "truth," 82, 86n34; social power of, 77–78, 85n24; studio (*see* studio); tourist, Gregory's re-engineering of, 155–161

photo-quilts, paying homage to Baartman, by Willis, 90–91, g22

phrenology, Williams's challenge to, 79–80

physical anthropology, 40–41; of prostitutes, in 19th century, 21; use of photographs of non-Western individuals, 89

physiognomy, 62; of black, association with pathology, 24; Williams's challenge to, 79–80

Picasso, Pablo, 121; *Les Desmoiselles D'Avignon,* 25, 177n5; *Olympia* (drawing), 25, 121–122

pickanniny, re-presentation of, in contemporary art, 96

Pieterse, Jan, 93

Pindell, Howardena, 105n1

Piper, Keith, 161n1

play, French, about Baartman, 38–40, 45n43, 64

play [term], 99

playing card, Baartman's image on, 6, g4

*Playing in the Dark* (Toni Morrison), 62

Plaza de España (Seville), Gregory's photograph of, 160

"Poem for Sarah Baartman, A" (Diana Ferrus), 9, 140, 143n13

politics, of black signifier, 97

Pollock, Griselda, 112–113, 123n3

polygenesis, 16–17, 18, 23, 28n16; Agassiz's theory of, 75

popular entertainment, Baartman as, 72, 73

popular preconscious, 106n14

portrait(s): collaborative photographic, Harris's, 89, g26; formal photographic, manipulation and critique by Williams and Weems, 81; formal photographic, Sekula on, 81; by Keïta, and Bamako identity, 107–111

Portugal, involvement in slave trade, 179n54

power: Foucault's notion of, 84n9, 150; of seeing and naming, 78–79; and 19th-century sexual liaisons between white men and black women, 165–166; uncertainty of, and documentation of differences, 77. *See also* control

Prichard, James Cowles, 114

Primus, Pearl, 191, 192

Pringle, Thomas, 53

Prior, James, 53

prostitute(s)/prostitution: associated with blackness, 23, 163; fatness of, 21, 23, 24–25; genitalia of, 19th-century studies of, 21–23; iconography of, in 19th century, 21–24, 28n7, 30n32; as image of sexual deviance, in 19th-century Paris, 120–121; medical model of female sexuality and, 21–24, 30n32; physiognomy and pathology, 21, 22–23

public health, prostitutes and, 19th-century views on, 21–23, 24

quadroons, 165

quilts, Willis on, 90. *See also* photo-quilts

race: characterization as trope, by Gates, 51–54; Gilman's discussions of, 51–54; iconographies, and world's fairs, 152–153; as ideology, 53–54; as issue of art historical inquiry, 112; psychic representations of, 97; scientific constructs of, in 19th-century, 41

*"Race," Writing, and Difference* (book edited by Henry Louis Gates Jr. and Kwame Anthony Appiah), 6, 51

racial tropes, 51–54; contemporary artists' challenges to, 94

racism: and black signifier, 97; in use of term "Hottentot," 5; visual "proof" for, Cox's challenge to, 89; visual "proof" for, Williams's challenge to, 79–80

rape: of black women by white men, Jezebel myth and, 71–72, 211; imagery of, in *Three Seated Figures* (photo-text work by Lorna Simpson), 83–84, g14; of slaves, 164, 190; in South Africa, 138–141

Raynal, Guillaume Thomas, 17

Réaux (Baartman's Parisian handler), 37, 45n36

"Reclaiming Venus" (proposed exhibition, Kellie Jones curator), 126–127

Rector, Monica, 188, 190

recycling: definition of, 103; functions of, 103; of premise of Hottentot Venus, 103

"Reframing the Black Subject: Ideology and Fantasy in Contemporary South African Representation" (essay by Okwui Enwezor), 127

Renoir, Jean, *Charleston* (film), 206, 208

representation(s): and carnivalesque, 186; political versus cultural, 202; as social facts, Durkheim on, 48–49; triangular, 193–196

resignification, 97

*Retirement* (painting by Max Weber), 115, 120

*Return of Sara Baartman, The* (film by Zola Maseko), 3

*Revue* (Renée Green), 95n18, 95n21

"Rituals of Representation" (Burton Benedict), 149

road, in Caribbean culture, 198n45

Rojo, Benitez, 193

Rony, Fatimah Tobing, 126

Rose, Tracey, 7, 131, 142n3, 227; discussion of the Hottentot Venus among South African women artists, 133, 134, 136, 138, 139–140; *Venus Baartman,* g25

Rossetti, Dante Gabriel, *The Beloved, or The Bride,* 16

Rousseau, George L., "Jemima Susianna Lee" (song), 170–171

Roye, Radcliffe, 9, 227; *Dancehall #8* (photograph), g31

*Rufus Jones for President* (musical-comedy short), 209n7

Russia, pre-revolutionary, 149

Russo, Mary, 188–189

Rutt, Chris L., 169–170, 171

Saar, Betye, 105n1, 174

*Saartjie Baartman, the "Hottentot Venus"* (watercolor by Léon de Wailly), g3

Saartjie Baartman Women and Children Centre (Manenburg, South Africa), 141

Saint Domingue, French involvement in, 35

*Sa Main Charmante* (installation by Renée Green), 92–93, g18

sambo, re-presentation of, in contemporary art, 96

San, 53, 128, 142n7

Sauvage, Marcel, 199

savage land/woman, distinguished from civilized female of Europe, 91

Schiebinger, Londa, 54, 60

Schrank, Josef, 22

scientific specimen: Baartman as, 33, 56–57, 72, 73; buttocks of "Hottentot" woman as, and Galton's measurement of, 92–93

Scott, Jill, "Thickness" (poem/song), 4

Scott, Joyce, 7, 87–88; exploration of Baartman's life, 88–89; *Women of Substance* (performance piece), 88

*Sea Islands* series (Carrie Mae Weems), g9

Searle, Berni, 7, 129, 131, 227; discussion of the Hottentot Venus among South African women artists, 131–132, 136–137, 138; image from *Still*, g24

*Seen* (installation by Renée Green), 78–79, 92–93, g18

Sekula, Allan, on photographic portrait, 81

self-representation, "hybrid forms" of, 88

*Servant, The* (print by Franz von Bayros), 16

sex tourism, 191–192

sexual anomalies in the Hottentot and in the European woman (plate from Lombroso and Ferrero, *La donna delinquente*), g6, g20

sexual intercourse, with black women, by white men: Jezebel myth and, 71–72, 211; in slave narratives, 164

sexuality
—black: as icon for deviant sexuality, 54–55; myths about, 210–211
—of black women: Baartman as representative of, 163–164; disruptive potential of, 163–164
—in carnival, as enforced heterosexuality, 190
—deviant: black as icon for, 16, 48; models of, 19th-century linkage of, 22
—female, and disease, 19th-century linkage of, 25–26
—iconographies, and world's fairs, 152–153
—interracial: of Jefferson-Hemings affair, 165–166; in 19th century, 165–166
—primitive, 19th-century views on, 23, 31n46

sexually transmitted disease, 19th-century preoccupation with, 24

sexual violence, against black women, by white men: Jezebel myth and, 71–72, 211; in slave narratives, 164

shoes: gold, Gregory's use of, 158–159; women's, as stand-in for genitalia, 158, 162n15

Simpson, Lorna, 7, 87–88, 126, 175, 227; *Three Seated Figures* (photo-text work), 83–84, g14; *Unavailable for Comment* (photo-text work), 91, 158, 162n15, g30; work undermining photography's claims to truth, 82–84; *You're Fine* (photo-text work), 175–176, g14

Sims, Lowery Stokes, 89

Singer, Debra S., 6, 7, 87–95, 227–228

Siopis, Penny, 7, 130, 142n3, 228; discussion of the Hottentot Venus among South African women artists, 131, 134–136, 137–138, 139; *Exhibit: Ex Africa* (mixed media), g17

Sir Mix-A-Lot, *Baby's Got Back* (rap song), 91

"Sixteen Days of Activism Against Gender Violence" (international campaign), 141, 143n20

skin color: black, association with pathology, 24, 163; of Irish Celts, 53; of Xhosa, 53

*Skin Deep, Spirit Strong* (book by Kimberly Wallace-Sanders), 5

Skotnes, Pippa, "Miscast: Negotiating the Presence of the Bushmen" (exhibition), 137, 142n3

slackness culture, 188

slave(s): Agassiz's study of, 75; codes, 76, 85n21; devotion to whites, as white fantasy, 167–168, 172–173; former, interviews of, 177n11; gynecological experimentation on, 190; in Lisbon, Portugal, 159; names of, Bible as resource for, 171, 178n40; offspring of, as slaves, 24, 121, 164; photographs of, 73–76; rape of, 164, 190; sexual exploitation, 24, 121, 125n44

slavery: in French colonies, 35–36; imagery of, in limbo dance, 192; institutionalization in American colonies, 164; myths supporting, 71

slave trade: and Caribbean, 156–157; corporations involved in, 174, 179n54; French involvement in, 35; illicit (1850), 85n19

*Small Place, A* (Jamaica Kincaid), 190

Société Anonyme, Brooklyn Exhibition, 117

Solomon-Godeau, Abigail, 88

song, French, about Baartman, 45n43

South Africa, post-apartheid, 128; artistic controversy in, 127, 142n3

*Southern Urban Negro as a Consumer, The* (book by Paul Edwards), 173–174

space(s): of absence/presence, 193–196; in Afro-Caribbean dance, 192–193; Baartman's, 6, 65–66; in carnival, 187, 191; of island/body, 192–193, 195–196; liminal, 62; "opening" versus "closing," 196, 198n45; in public arena, women in, 9; public versus private, 65–66; transgressive, *jamettes* and, 191; Wailly's use of, in painting of Baartman, 72–73, g3; Weems's use of, 92; between women's legs, 192–193, 195–196

Spain: involvement in slave trade, 179n54; Moorish influence in, Gregory's photographs of, 160

spectacle, black female body as, 8

speculative theory(ies), Cuvier's opinion of, 51

"Speculum in a New World" (article by Lemuel Johnson), 190

Spelman College, student-activists' position on "Tip Drill" video, 8–9, 210–212

Spiller, Hortense, "Mama's Baby, Papa's Maybe," 193

*Spirit of the Dead Watching* (Gauguin), 177n5

Stam, Robert, 188–189

Stamp, Kenneth M., 85n21

steatopygia, 5, 17, 23, 67n10, 105n7, g3, g4, g5, g7, g8; Baartman's, 5; in black females (plate from Lombroso and Ferrero, *La donna delinquente*), g7; Ellis's views on, 19–20

in prostitutes, 19th-century study of, 23

Stein, Robert Louis, 35

stereotype(s): contemporary, 101–102, 210–211; function of, 101; historical characters and, 101, 105n10, 210–211; in images of mammies, 168–169; sublime, 94; of welfare mother, 102, 211

*Still* (installation by Berni Searle), g24

Stoler, Ann, 36, 44n30

Strauss, Richard, *Der Rosenkavalier,* 15–16

street, as radical space, 187–188, 190

Strother, Z. S., 47, 54, 56

*Studies in the Psychology of Sex* (Havelock Ellis), 19–20

studio: Keïta's use of, 108; Simpson's use of, 82; Zealy's use of, 75–76, 82

*Sweetness and Light: Great House 4* (Roshini Kempadoo), g11

*Sweetness and Light: Head People 1 & 2* (Roshini Kempadoo), g12

syphilis, 24, 163; "Syphilis" (poem), 26

*tablier. See* Hottentot apron

Tarnowsky, Pauline, 22–23, 24

Tarnowsky, V. M., 22

Tawadros, Gilane, 157

text: Green's use of, 92–93; Simpson's use of, 83, 86n37; Weems's use of, 92; Williams's use of, 79–80, g15; Willis's use of, 91

"The Rear End Exists" (Suzan-Lori Parks), 87, 94

*There's No Place Like Home* (billboard project by Ken Lum), 161n1

"Thickness" (poem/song by Jill Scott), 4

Thomas, Hank Willis, 9, 228; *When Harriet Met Saartje,* g10

Thompson, Heather, 142n3

Thompson, Kaolin, 142n3

*Three Seated Figures* (photo-text work by Lorna Simpson), 83–84, g14

"Thunder Thigh Revue," 88

"Tip Drill" (rap song/video), 8–9, 210–211

Titian, *Venus of Urbino,* 15, 163–164, 177n5

Toll, Robert, 169–170

Tosoni, Marlaine, 7, 131; discussion of the Hottentot Venus among South African women artists, 132, 134, 136, 138

tourism: artists' interest in, 161n1; European Grand Tour, 159; Gregory's interest in, 155, 161n1

trademarks, mythical black characters as, 174

Transformation [Playing] Cards, *The Five of Clubs* [*The Hottentot Venus*], g4

travel narratives: descriptions of Africans, 52–53, 55–56, 66; incorporation into scientific discourse, 66

*Tribute to the Hottentot Venus* (photo-quilt by Deborah Willis), 90–91, g22

Trinidad, *National Geographic* piece on, 191

truth, photography's claims to, Lorna Simpson's work and, 82–84

Tubman, Harriet, 9; *When Harriet Met Saartje* (Hank Willis Thomas), g10

Turner, William, 19

Turnipseed, Edward, 18

*Uku Hamba 'Ze—To Walk Naked* (1995 video), 142n3

*Unavailable for Comment* (photo-text work by Lorna Simpson), 91, g30; symbolism of shoes in, 158, 162n15

"Underneath a Harlem Moon" (song sung by Ethel Waters), 209n7

Underwood, Charles, 171

Vari, Minette, 142n3

Vasco de Gama monument (Lisbon, Portugal), Gregory's photograph of, 159–160

Venus: African, Scott's portrayal of, 88; Black (*see* Baker, Josephine); Hottentot (*see* Baartman, Sarah); as ideal of female sexuality and beauty, 64, 72, 114; throughout history, Lawal's routine about, 88

*Venus* (Carla Williams), g27

*Venus Baartman* (Tracey Rose), g25

"Venus Envy" (*Village Voice* article by Lisa Jones), 3

*Venus Hottentot 2000* (Polaroid by Lyle Ashton Harris and Renée Cox), 89–90, g26

"Venus Hottentot, The (1825)" (poem by Elizabeth Alexander), 1–2, 5

*Venus in the Dark: Blackness and Beauty in Popular Culture* (book by Janell Hobson), 3

Venus Noire, Baker as, 203

"Vénus noire" (poem by Baudelaire), 15

*Venus of Urbino* (Titian), 15, 163–164, 177n5

*Venus* vessels (Simone Leigh), 9–10, g23

vessels: female bodies as, Simpson's imagery of, 91; Leigh's work on, 9–10, g23

video vixen, 4

violence against women: and HIV/AIDS, 141; international campaign against, 141, 143n20

Virey, J. J.: *Histoire naturelle du genre humain,* 17; views on sexual nature of black females, 17

vision, as colonizing tool, 87, 93–94

*Voyage of the Sable Venus, from Angola to the West Indies, The* (engraving by W. Grainger), 104, 106n16; incorporated into artwork by Kara Walker, g21

Wailly, Léon de, 6; *Saartjie Baartman, the "Hottentot Venus"* (watercolor of Baartman), 72–73, g3

Walker, C. J., 168

Walker, Kara, 7, 8, 96, 98, 100, 102–103, 105n1, 228; artwork incorporating Grainger engraving, g21; artwork incorporating Lombroso and Ferrero plate, g20; journal for Renaissance Society show, 104, g20, g21; silhouette installations, 104; use of Negress character, 100, 104, 105n9; Venus allusions/images by, 104–105

Wallace, Michelle, 8, 149–154, 228

Wallace-Sanders, Kimberly, *Skin Deep, Spirit Strong* (book), 5

Wallis, Brian, 74–75

Washington, Booker T., 151

Waters, Ethel, 209n7

Wayles, John, 165

Weber, Max, 117, 122–123; *Contemplation* (painting), 115, 118, 120; and negrophilia, 119–120; *Retirement* (painting), 115, 120

Weems, Carrie Mae, 3, 7, 87–88, 97, 100, 160–161, 228; on black women's gaze, 89; on documentary photography, 80–82; *The Hottentot Venus* (photo-text diptych), 92; *Sea Islands* series, g9; use of portraiture, 81, g9

Weisinger, Jean, 100

welfare mother, stereotypes, 102, 211

Wells-Barnett, Ida B., 211

Westwood, Vivian, 91

*When Harriet Met Saartje* (Hank Willis Thomas), g10

White, Deborah, 211

White Chocolate, 9

white men, sexual exploitation of black women in 19th century, 165–166

whiteness, Canadian museum community and, 117

white women: Canadian artistic practice and, 116–117; in definition of race and nation, 40; and mammy, 166

Williams, Carla, 3, 7, 98, 100, 105, 121, 126, 228; *How to Read Character* (photo-text installation), 79–80, g15; use of portraiture, 81; *Venus* (portrait), g27

Willis, Deborah, 3–11, 87–88, 100, 121, 126, 228; and Carla Williams, *The Black Female Body in Photography: A Photographic History* (book), 3–4; *Hottentot/Bustle* (photo-quilt), 90–91, g22; photo-quilts paying homage to Baartman, 90–91, g22; *Tribute to the Hottentot Venus* (photo-quilt), 90–91, g22

Wilson, Fred, 161

Wilson, Judith, 168, 187

wining (Caribbean dance), 192; assignment of cash value to, 190–191

*Women of Substance* (performance piece by Joyce Scott), 88

world's fairs, 8, 151–153

Wright, Purd, 172

Xhosa, 53

"You Flame-Foot" (poem by Pablo Neruda), 180, 182

*You're Fine* (photo-text work by Lorna Simpson), 175–176, g14

*Zaanse Schans* (photograph by Joy Gregory), g29

Zealy, J. T., 71; photographs of enslaved Africans, 75–76, 82, g9

Zola, Emile: *L'assommoir* (novel), 25; *Nana* (novel), 25–27